NEW GUARDIANS
FOR THE GOLDEN GATE

For Celeste,
May you have many happy hours and days
in our national park next door!

Amy Meyer
November 30, 2006

The publisher gratefully acknowledges the
generous contributions to this book provided by
The Ambassador Bill and Jean Lane Fund of the
Peninsula Community Foundation, Barry Traub,
and the Golden Gate National Parks Conservancy.

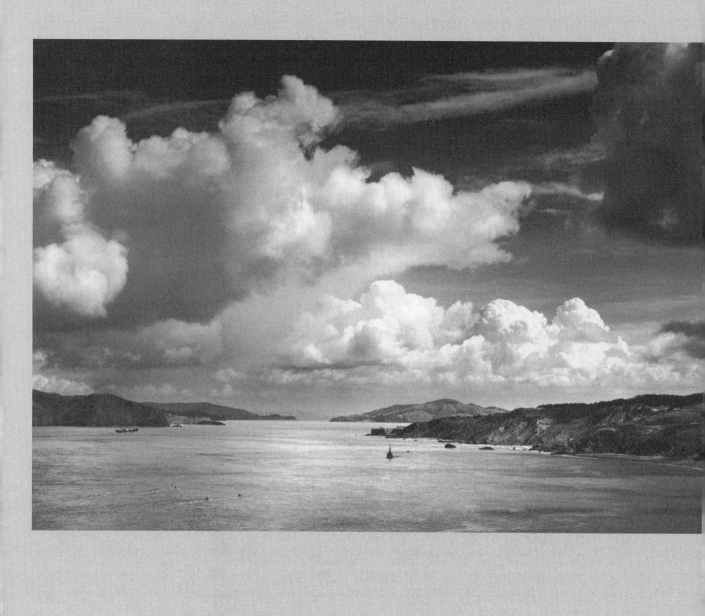

UNIVERSITY OF CALIFORNIA PRESS BERKELEY LOS ANGELES LONDON

NEW GUARDIANS FOR THE GOLDEN GATE

HOW AMERICA GOT A GREAT NATIONAL PARK

AMY MEYER WITH RANDOLPH DELEHANTY

FOREWORD BY I. MICHAEL HEYMAN

University of California Press, one of the most distinguished university presses
in the United States, enriches lives around the world by advancing scholarship in
the humanities, social sciences, and natural sciences. Its activities are supported
by the UC Press Foundation and by philanthropic contributions from individuals
and institutions. For more information, visit www.ucpress.edu.

University of California Press
Berkeley and Los Angeles, California

University of California Press, Ltd.
London, England

Library of Congress Cataloging-in-Publication Data
Meyer, Amy, 1933–.
 New guardians for the Golden Gate : how America got a great national park /
Amy Meyer, with Randolph Delehanty ; foreword by I. Michael Heyman.
 p. cm.
 Includes bibliographical references and index.
 ISBN-13: 978-0-520-23534-2 (cloth : alk. paper) ISBN-10: 0-520-23534-7 (cloth :
alk. paper)
 1. Golden Gate National Recreation Area (Calif.)—History. I. Delehanty,
Randolph. II. Title.
F868.S156M53 2006
979.4′6—dc22 2006006954

Manufactured in the United States of America

15 14 13 12 11 10 09 08 07 06
10 9 8 7 6 5 4 3 2 1

Frontispiece: *The Golden Gate before the Bridge, San Francisco, California, ca. 1932.* Photograph
by Ansel Adams. (Collection Center for Creative Photography, University of Arizona.
© Trustees of the Ansel Adams Publishing Rights Trust.)

The paper used in this publication meets the minimum requirements of ANSI/NISO
Z39.48-1992 (R 1997) (*Permanence of Paper*).

CONTENTS

MAPS AND PLATES

MAPS

PLATES

FOREWORD

I. Michael Heyman

This book records the important history of how land on the fringes of a rapidly growing urban area was saved for public use and enjoyment, instead of being developed for housing and commerce. It offers a lively and detailed account of the founding of a new national park on the extensive coastline and coastal lands north and south of San Francisco's Golden Gate.

Government necessarily played a major role in acquiring the land and regulating its use to establish the park, but governmental agencies first had to be motivated to act. *New Guardians for the Golden Gate* tells the story of people bonding together to enlighten and pressure the government to take the steps required to preserve this extraordinary landscape. Written by one of the movement's key figures, Amy Meyer, the book demonstrates how people in a democracy can organize to attain an end unlikely to occur without their intervention. It shows how public good can be achieved where market forces, so often blind to long-term needs, would have eradicated that potential.

Valuable as a "how-to" guide for those at the grassroots level who want to make a difference and achieve environmental ends, the book is also a riveting read, a tale complete with heroes and villains. From the author's viewpoint, of course, the heroes are the preservationists: local folk; activists with nonprofit organizations such as the Sierra Club and the Trust for Public Land; Representatives Phillip Burton, Nancy Pelosi, and William Mailliard; Senators Barbara Boxer and Dianne Feinstein; both the Nixon and Carter administrations; a few National Park Service officials; and private land owners who cooperated with those seeking to establish the park. The villains are a passel of land owners who could profit considerably from the spread of urbanization westward to the sea; James Watt, secretary of the interior during the Reagan years; and a number of congressmen who wanted to sell the Presidio off after the post was closed.

The book is a fascinating illustration of the dynamic nature of grassroots politics. We watch

public involvement in an early controversy on the use of a small parcel of federal land in San Francisco mushroom into a huge social movement for the preservation of some 80,000 scenic acres on the edge of the growing metropolitan region of the San Francisco Bay Area, together with 85 miles of the coast. We repeatedly see how political strategies must be formulated in the face of constantly changing circumstances and how success often depends on the right legislator being in a position of influence at the right time. Political savvy, we learn, is just as crucial for volunteer participants, and especially their leaders, as dedication to their cause.

I became involved with the Golden Gate National Parks in the 1990s, when I joined the Presidio Council. Congress had put the whole Presidio of San Francisco inside the national park boundary in 1972, anticipating that a future Congress might decide the nation no longer needed an Army post at the Golden Gate. I was one of a group of some thirty people who started planning the conversion of the post to civilian use as a park. The council's work led to congressional legislation to establish the Presidio Trust, an innovative form of park governance uniquely suited to the Presidio.

In 2000, when I returned to the Bay Area from Washington, the secretary of the interior asked me to represent him on the board of the Presidio Trust. For over two years I had the exhilarating experience of helping to conserve the Presidio as well as providing for the use, restoration, and maintenance of hundreds of structures on the site, nearly five hundred of which were on the National Register of Historic Places. One of our nation's most beautiful sites, the Presidio has been saved by congressional action, but its comprehensive transformation requires considerable private investment. The Trust has successfully shaped public-private partnerships, and the renewal of this historic place is more visible every month. The Presidio Trust's efforts now meld nearly seamlessly with those of the National Park Service.

It has been singularly rewarding to be part of the campaign for the Golden Gate National Parks, and to work with Amy Meyer and others who preserved these lands for all of us to enjoy.

PREFACE

Great achievements often have humble beginnings. In 1970 I was one of a few people living in San Francisco's Richmond District who learned that the federal government intended to construct a bulky National Archives warehouse in our residential neighborhood. The site was East Fort Miley; to neighbors it was a no-man's-land atop a rise north of Clement Street between 40th and 42nd Avenues, an almost invisible rectangle of 12 ½ acres behind the California Palace of the Legion of Honor art museum. Hardly anyone knew this hidden place, which the Department of Defense had decided it no longer needed.

East Fort Miley lies between the museum and a Veterans Administration hospital. Surrounded by the trees of Lands End, the fort overlooks the Golden Gate. According to San Francisco's evolving comprehensive plan, the site was supposed to remain open space, as part of the city's coastal greenbelt. To put yet another large institution in this corner of the city also struck nearby residents as a bad idea. So, with the support of the San Francisco Planning and Urban Renewal Association and the Sierra Club, some of my neighbors and I organized to oppose the scheme.

When I first got involved in the effort to block construction of the National Archives building, I had no idea that this scarified parcel of military sheds and bunkers, Monterey cypress, and weeds would be the starting point for one of the conservation triumphs of the twentieth century. But when we learned of a government proposal to protect some of the land around the Golden Gate in a new national park, our organizing crystallized. Led by two extraordinary savers of federal park lands, Congressman Phillip Burton and Dr. Edgar Wayburn, our cadre of citizen-activists linked the saving of East Fort Miley to the saving of coastal hills and shore stretching 50 miles to the north in Marin County and 28 miles to the south through San Mateo County.

As our campaign to create a national park gained momentum, I found myself in a leadership position. My kitchen table became a communications center, and I an organizer, publicist, event

coordinator, strategist, and spokesperson. I shared these roles with others, but it was I who seemed to have the most time for the campaign. I dived into my new responsibilities with a passion, learning very quickly what advocates need to do to carry out big projects. Before too long I would be gathering allies to meet with political leaders and power brokers, flying to Washington DC for congressional hearings, and helping to host VIP delegations in the Bay Area.

Before our first neighborhood meeting about the National Archives building, I had only stuffed envelopes for political campaigns and organized picnics and dinner parties. I was a stay-at-home mother and a dissatisfied artist, with two daughters ages nine and five. I felt cooped up, my husband worked long hours, and I thought about finding a project of my own, a community project that would involve other people and put my education and skills to use. A land preservation cause seemed like a good place to start. And I was motivated to help preserve the natural and scenic beauty of my adopted home.

My first glimpse of the Bay Area had been in January 1955, when my husband picked me up at the San Francisco airport. We were New Yorkers and had come west for George's service as a psychiatrist during the doctors' draft of the Korean War. I finished a semester of art school while he brought our car full of newlywed belongings across the country; then I joined him. For both of us the Bay Area was love at first sight. In the soft light of early evening we drove over to the East Bay hills, over the sparkling water of the bay and under an open sky. Hidden in my memory, there was only one place nearly so beautiful.

We expected to return to New York. But during George's two years of military duty in the Bay Area, we and circumstances changed. He had his reasons, and I broke my emotional bond with the East Coast. My parents owned a summer home and the former grounds of a guest lodge, on a lake a few hours out of New York City. When I was a child, they sold off a few of their 50 acres, but most of their land and that of their rural neighbors was open fields and woods, where I wandered during the happy summers of my childhood. My father actually called this land "my park." After I left for California my parents sold their house and the rest of the land. I was heartsick, and it became a major reason why I never went back to New York. I would have my own land in California.

I became an art teacher but stopped teaching when our first daughter was born. We bought a home in the northwestern corner of San Francisco near Lands End. (I still live there. From the front I can look over Lincoln Park and see the tops of the Golden Gate Bridge towers. From the upstairs back room where I wrote this book, I can see a stretch of ocean and most of the western half of the city. On clear days, I can see the outline of the coastal hills of Pacifica 10 miles to the south.)

Like so many others before me, I came to love the dramatic splendor of the Golden Gate. I jumped wholeheartedly into our park campaign when I saw that East Fort Miley was a small puzzle-piece of urban greenbelt in a larger effort to save 150 square miles of development-threatened land bracketing the Golden Gate. I realized I had stumbled on something marvelous. And because caring people quickly embraced the park idea, I could see that a campaign to save this land would have a real chance of success.

The Golden Gate National Recreation Area has been a major part of my life for more than three decades. My firsthand knowledge of how it came to be has always been an asset in advocating for the park, whether as an activist with People For a Golden Gate National Recreation Area or a member of the park's advisory commission. One day a few years ago, I saw that I had to share this knowledge with a wider audience. A Park Service friend invited me to visit a wildlife research program whose participants were bunking at the Headlands Institute in historic Fort Cronkhite. My friend was late and the interns were hanging around, so I asked them if they knew why they were able to trap and measure insects, lizards, and mice along the shore of Rodeo Lagoon instead of viewing its waters through an apartment house window. None of them knew any of the history of the Marin headlands or of the making of this national park. They asked a lot of questions, as did the ranger who came to eavesdrop in the doorway. I knew then that I had to write this story, or people would forget how the park came into being and would take the spectacular lands we saved for granted.

Much of this book is a memoir, recounting how I've worked for the park over the last thirty-five years. But since the story is much bigger than me and my role in it, I've done extensive research and interviewing of key people so that I could do justice to the park's history and the many people involved in it. To help readers understand why there was something to save in the first place, I begin the story well before my involvement in the park campaign and describe many events—debates in Congress, closed-door meetings—of which I have no firsthand knowledge. I hope the reader can navigate the resulting shifts in perspective.

The ongoing campaign to authorize the Golden Gate National Recreation Area and then see that our vision for it was carried through has been a collaborative venture, involving many people. Approaching the writing of this book in the same collaborative spirit, I got in touch with everyone I could find who worked with People For a Golden Gate National Recreation Area. When I be-

gan to write this book six years ago, nearly everyone who had participated in the park campaign was still alive. Everyone with whom I spoke was only too glad to relive the adventures and events that helped our dreams for a national park become the happy reality it is today. I am deeply grateful to all of these good people. Their names are woven into the story in the text or notes, to acknowledge their participation in both our park campaign and the writing of this book.

I asked my old friend Randolph Delehanty to collaborate with me on this memoir because of his many previously published books on urban history, parks, and the conservation of historic landscapes. Randolph has a deep interest in how institutions are shaped over time. His knowledge of American social history and his singularly valuable knowledge of local park history have illuminated aspects of this book in ways both large and small, including the selection of the photographs and maps. Randolph also did several interviews with me that are the basis of many parts of this book.

There were others who provided knowledgeable background assistance for the writing of this book. They include Carey Feierabend, Jacques Gelin, Kay Holbrook, Patsy Hunter, Frank Keiliger, Nancy Licht, Dewey Livingston, Pamela Martin, Jean Mooney, Trent Orr, Paul Rosenberg, Donald Tayer, and Dianna Waggoner.

My library research was made possible by the always-helpful staff of the Bancroft Library at the University of California, by the resources of Susan Ewing-Haley and her staff at the GGNRA Archives and Records Center on the Presidio, and by Barbara Janis, librarian of the Presidio Trust.

I wish to thank my developmental editor, Eric Engles, for helping me step back from my insider view of our campaign. By skillfully reorganizing the story, Eric helped create a narrative in which the events in different places unfold over time. I deeply appreciate how the sensitive review of my copyeditor, Edith Gladstone, improved upon my telling of the story. And I am very grateful to Rose Vekony of UC Press for her care in overseeing all the final details of the content and design of the book.

Many people doing their jobs every day for the parks also helped. Several of them are also mentioned in the story; others were Theresa Griggs, Steve Haller, James Osborne, Chris Powell, Lee Shenk, Shirwin Smith and Rich Weideman of the Golden Gate National Recreation Area staff, John Dell'Osso of the Point Reyes National Seashore staff, Michael Boland, Karen Cook, Peter Ehrlich, Tia Lombardi, and Cherilyn Widell of the Presidio Trust staff, and several members of the staff of the Golden Gate National Parks Conservancy. All gave generously of their time and knowledge.

Throughout this book the volunteers who knew just their portions of the campaign for the GGNRA can trace their share in the park's success. I am grateful for all the volunteer activists of People For a Golden Gate National Recreation Area, for the idealistic people of the high-energy Bay Area who have encouraged and supported the park, and for the elected and appointed government leaders whose political skill, environmental understanding, and concern for the public good all helped bring the Golden Gate National Recreation Area into being and have kept it a special place.

I hope readers will be inspired to work on a campaign for something they care about as much as we care for the Golden Gate, and I hope they have as much fun and success along the way.

INTRODUCTION

California's Golden Gate is one of the best-known places on earth. It is a fast-moving watery passage, a relatively short and narrow strait between the gleaming city of San Francisco and the untamed headlands of Marin County, the gateway for vessels sailing from the Pacific Ocean into hill-rimmed San Francisco Bay. Since 1937 this passage has been straddled by the Golden Gate Bridge—which is often what people think of when they hear of the "golden gate." More than that graceful structure, the words bespeak the dramatic extremes that come together at this place: the benign Mediterranean weather that can quickly change from brilliant sunshine to dank overcast or driving rain; the high winds that push billowing white seasonal fog inland under a bright blue sky; and the ever-moving water that rushes between the turbulent ocean and the calmer, protected bay.

Few people who experience this exceptionally beautiful scene and the open countryside that stretches north and south along the coast know that these lands were once gravely endangered. Not long ago, land owners were making plans that would have covered the ranches on coastal hills

with apartment towers, replaced forested glens with acres of suburban housing, and turned scenic country roads into freeways. Only because of the dedication and hard work of a group of citizen-activists were those plans deflected, the pieces joined together, and the land protected in the Golden Gate National Recreation Area (GGNRA).

This book is the story of the struggle to preserve the glorious beauty of the lands at the Golden Gate, and to ensure that its scenery and history would be kept for public benefit in perpetuity. The major events of the struggle took place in the 1970s, but the story begins at least a hundred years ago, when Bay Area residents began to realize that the natural wonders they enjoyed could be paved over and lost. And the story continues beyond the founding of the GGNRA in 1972, because the park that exists today is the product of more decades of park development and citizens' continued advocacy.

Because "recreation area" implies less protection than "national park," the Park Service unofficially began to use a new name for the GGNRA in 2000. Muir Woods National Monument and Fort Point National Historic Site were included within the GGNRA's boundary in 1972; together, all three entities are now usually called the Golden Gate National Parks. Someday an act of Congress will cause the name "Golden Gate National Recreation Area" to disappear.

When it was authorized by federal legislation in 1972, the GGNRA encompassed about 34,000 acres. Once the park got under way, conservationists were able to focus on connecting other already protected green spaces, first northward from Fort Funston to Point Reyes and along the shores of Tomales Bay and, some years later, southward from Fort Funston to Pillar Point. As a result, the park has more than doubled in size since 1972 and now encompasses nearly 80,000 acres. Most but not all the parcels within the park that will come under federal jurisdiction have now been acquired.

Today, under the ownership of the National Park Service, thousands of acres of natural habitat are edged with trails, ranches thrive, and broad swaths of trees and meadows surround retrofitted historic buildings. These buildings house an amazing variety of community programs and non-profit organizations that serve the urban community next door as well as visitors from afar. Within the present boundaries of the Golden Gate National Parks are 65 miles of coastline, 1,231 historic structures (everything from buildings to roads), the greatest number of habitable buildings of any park in the national park system, significant remnants of native vegetation harboring many native wildlife species, and, in 2002, more rare and endangered species (twenty-seven) than in any other

national park except Florida's Everglades National Park and the national parks of Hawaii. The mosaic of landscapes and historic places embraces five national historic landmarks and a dozen properties listed on the National Register of Historic Places. The park protects seven former Army forts—including the Presidio of San Francisco—and also areas and sites such as the Bolinas Ridge, the Olema Valley, and Point Bonita Lighthouse in Marin County; Alcatraz Island in San Francisco Bay; Sutro Heights, the Cliff House, and Ocean Beach in San Francisco; and Sweeney Ridge and the Phleger Estate in San Mateo County, as well as numerous historic gun emplacements and a few missile-launching sites. One of the most complex of our national park areas, the Golden Gate National Parks sponsor hundreds of visitor programs every year, mostly through park partners.

Point Reyes National Seashore and the Golden Gate National Parks together make up America's largest expanse of national parkland in an urban region, comprising more than 150,000 acres in 2006. Moreover, these two parks border on many other federal, state, local, and public agency parks and holdings that, all together, exceed 180,000 acres of nearly contiguous public open space with 155 miles of public shoreline in three counties. These other areas of public land include the lands of the Marin Municipal Water District, the Marin County Open Space District, and Tomales Bay State Park in Marin County; the city of San Francisco's Golden Gate Park; and the Filoli Estate, Huddart Park, and several reservations of the Midpeninsula Regional Open Space District in San Mateo County. The various local, state, and federal agencies that administer all these lands work together cooperatively.

Like the many other well-known parks in our country's national park system, the Golden Gate National Recreation Area serves the crucial purpose of preserving natural habitat and history. But because of its size, variety, and proximity to a large urban population, the GGNRA can serve a large and diverse population of park visitors and users, many of whom are not likely to travel to Yosemite or Yellowstone. For these city dwellers, Bay Area residents, and tourists, the GGNRA provides extraordinary opportunities for education, recreation, and enjoyment of spectacular scenery.

In 1988 UNESCO recognized the cultural and ecological importance of the GGNRA and its neighbors by designating the Golden Gate Biosphere Reserve, which includes all the lands and waters of the Golden Gate National Parks and Point Reyes National Seashore and all the surrounding open space and ocean between the Farallon Islands and San Mateo County's San Bruno Mountain and the lands of the Marin Municipal Water District. The Golden Gate Biosphere Reserve is part of an international network of biosphere reserves, more than three hundred extra-

ordinary places, of which the Galápagos Islands and the Serengeti Plain are two of the most famous. The reserves are designated to encourage research and ecosystem-based, conservation-oriented, cohesive management for lands and waters protected in a variety of ways, at various times, and for various purposes.

Our campaign for the Golden Gate National Recreation Area took place during a remarkable historical juncture. Major national studies of this country's park and recreation needs had been completed in 1962 and 1969. In 1966 the Park Service had completed the ten-year "Mission 66" program by rehabilitating all 180 national parks then in existence, in time for the fiftieth anniversary of the National Park Service. Conflicts between growing environmental consciousness and pressures for development made the preservation of wildland and public space a priority for many citizens and their elected representatives. Between 1964 and 1973, urged on by the leaders of conservation, wilderness, wildlife, and historic preservation organizations, Congress and state legislatures passed laws, court cases were decided, and voters approved initiatives that gave planners and the public important tools for protecting our nation's natural, scenic, and architectural heritage.

The National Environmental Policy Act became law in 1969 and the California Environmental Quality Act became law in 1970. Both acts include a process of evaluation that requires objective environmental analysis and public review of proposed development. The National Wilderness Preservation System Act was passed in 1964, and the National Historic Preservation Act was passed in 1966. Section 4(f) of the Department of Transportation Act of 1966 prohibited spending federal funds for construction of a road using parkland if a prudent and feasible alternative route was available. The federal Air Quality Act became law in 1967, and the Clean Water Act became law in 1972. The Endangered Species Act, intended to help prevent extinction of plant and animal species, became law in 1973. And in a Marin County lawsuit brought to protect Tomales Bay, the 1971 Marks-Whitney decision set a precedent for preserving the state's tidelands. California voters also approved comprehensive coastal protection in 1972.

All these laws reinforced one another. They mandated that existing plant and animal habitat, wilderness, clean air and water, historic buildings, public open space, and archaeological sites be considered, and detrimental effects be avoided or mitigated, before an agency or planning body approves any new plan or project. In the late 1960s and early 1970s, they had the combined effect of slowing development and making sale of land for parks—or partial or total donation of land with tax benefits—an attractive alternative for development-minded land owners.

But these farsighted laws and the accompanying conservation consciousness only created an opportunity. It fell to a group of citizens far from the center of political power to seize it. Believing that individuals could make a difference in the world and that government could do good, the founders of People For a Golden Gate National Recreation Area resolved that they would create a national park for the people. Representatives and senators from both major political parties, presidents of the United States, and park advocates shared this vision, worked to make it a reality, and made a lasting difference. For over thirty years, park advocates have successfully challenged and collaborated with Washington bureaucracies as powerful as the United States Army and as traditional as the National Park Service to make the park what it is today. The story of the Golden Gate National Recreation Area affirms the power of dreams, the effectiveness of political action, and the positive role of government.

1

SPACE AVAILABLE

It was everyone's good fortune that in 1970 the lands around the Golden Gate were hardly developed. They were next to a rapidly expanding urban area, and they were highly scenic and desirable. Although steepness and isolation had in places discouraged the bulldozers and graders, the lay of the land by itself hadn't kept the developers away.

Some of these lands had already been set aside as parks; the remainder were available for the Golden Gate National Recreation Area because historic land uses had precluded or discouraged development. The two sides of the Golden Gate itself, along with parts of the Pacific Ocean edge of San Francisco, had long been claimed by the military because of their strategic location beside the entrance to the bay. Other parts of the San Francisco shoreline had been saved in coastal parks beginning in the 1870s. The island of Alcatraz had been a fort and then a prison, first military and then civilian; by 1970 it had been abandoned. In Marin County, the rolling hills and the steep slopes of Mount Tamalpais had long been the domain of ranchers and loggers. Separated by steep ridges

from the bayside towns, and without a bridge to cross the Golden Gate until the late 1930s, sub-urban developers came upon these Marin lands only after some estate owners, hikers, summer residents, ranchers, and vacationers had come to value them and had saved some of the best places in Muir Woods National Monument and in state and local parks. Also, most of Marin's western reaches had remained as open space because the Marin Municipal Water District had set aside 21,000 acres there, and because the pastoral landscape was home to a handful of ranchers.

ARMING THE GOLDEN GATE

From the very beginning, European settlers in the Bay Area knew the Golden Gate was the key to the defense of the great harbor. Hostile ships would have to sail through the opening to enter San Francisco Bay, and it could be guarded by well-placed artillery. Fortification of the Golden Gate began in 1776, when Spain established an armed garrison—a presidio—and built a battery at the entrance to the bay to guard the harbor from occupation by other powers. The Presidio of San Francisco became the northernmost of the Spanish empire's four military garrisons in Alta California.[1] It remained a military post through the Spanish Mission period and the period of Mexican control from 1822 to 1846. The United States Army occupied the Presidio of San Francisco in 1846 during the Mexican War.

James Marshall discovered gold at Coloma on the American River on January 24, 1848.[2] As gold fever spread across the country and then the world, the tiny settlement of San Francisco grew rapidly. By 1860 it was the twelfth-largest city in the United States, and the Golden Gate's strate-gic military role grew even more important. In part to protect the gold passing through the city, the Army built new fortifications at the entry into what had become the principal American harbor on the West Coast. Between 1853 and 1861 the Army Corps of Engineers built Fort Point on the southern side of the Golden Gate, the only brick fort on the West Coast.[3] After the Civil War, the Army acquired 1,300-acre Lime Point Military Reservation on the northern side of the Golden Gate, which later became Forts Baker, Barry, and Cronkhite.

The Army modernized the harbor entry's defenses as gun range increased, from about 2 miles between the Civil War and 1890, to 10 miles between 1890 and World War I, and up to 25 miles af-ter that war (figure 1). The harbor's batteries spread south and north. By the end of World War II, several generations of gun emplacements, bunkers, and other shoreline defenses extended for more than 50 miles, from south of Half Moon Bay to Point Reyes, in a system of forty separate mili-

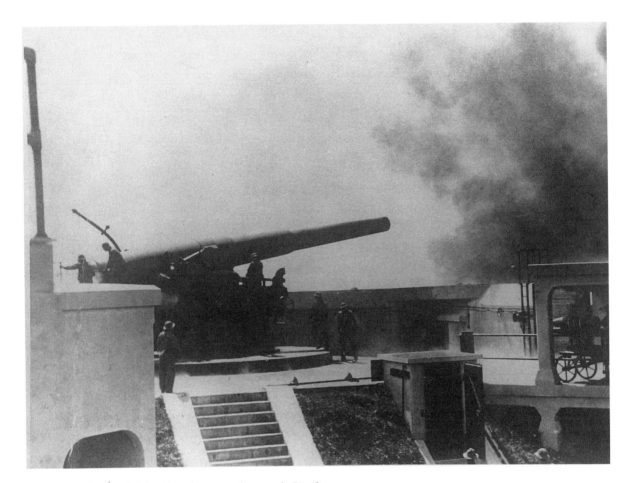

Figure 1. *Modern Coastal Defense:* From the 1840s to the 1940s, the Presidio was
the nerve center for the defense of San Francisco harbor. As the range, power, and
accuracy of modern artillery increased, the Army built a succession of batteries.
Battery Spencer was built at Fort Baker across the Golden Gate in the late 1890s.
Its breech-loading guns fired shells 12 inches in diameter and could reach enemy
ships many miles out at sea. No shots were ever fired against an enemy from any
of the forts at the Golden Gate. (Courtesy Golden Gate National Recreation Area,
Park Archives, GOGA 35301, TASC Negative Collection.)

tary reservations spread over 6,000 acres. One of these reservations was Fort Miley; the eastern part near my home would help trigger the fight for the GGNRA.

Despite their concrete structures and roads, these fortified properties included some of the most scenic land in the United States. The terrain remained relatively untouched, often preserving significant areas of natural vegetation. Because they were already federally owned and so close to urbanized areas, they would become the initial parcels within the GGNRA.

SAN FRANCISCO SAVES ITS SHORE

When the GGNRA was assembled in the 1970s, a string of city and state parks along San Francisco's shoreline already existed. Each of these was available for integration into the federal park or could remain as locally administered public land in the expanded greenbelt. These parks included Ocean Beach, Sutro Heights Park, Lincoln Park, China Beach, the Marina Green, and Aquatic Park.

For a century after 1850, most people who came to the western side of San Francisco Bay settled on the bayside flatlands and rolling hills, where the weather and topography are more gentle than beside the ocean. In 1872, when few people lived there, Mayor Frank McCoppin managed to reserve 10 percent of San Francisco's coastal "outside lands" for parks, the rest being given over to private claimants in return for a one-time assessment. This reserved land eventually became the city's famed Golden Gate Park, some smaller parks, and parcels for public uses such as schools. McCoppin's act also saved for public use the long strand of Ocean Beach framing the city's western edge (figure 2).[4]

In the 1880s the engineer and philanthropist Adolph Sutro, mayor of San Francisco from 1894 to 1896, assembled large landholdings on the high bluffs in the northwestern corner of the city on the southern edge of Lands End north of Ocean Beach. At his estate, called Sutro Heights, he created gardens that he generously opened to the public. He led the movement to preserve Seal Rocks just offshore with its seals and rookery. In 1887 Congress granted the half-dozen rocky islets to the City of San Francisco "in trust for the people of the United States." After Sutro died without a will in 1898, wrangles over his estate thwarted his expressed intention to give Sutro Heights to the city. In 1912 the voters defeated a proposed bond issue to buy 80 acres of Sutro land, including the Sutro Baths. Finally, in 1920 the city purchased three parcels of Sutro property (but not the baths) and Sutro's heirs donated 19.56 acres at Sutro Heights with the condition that it be "forever held and maintained as a free Public Resort or Park under the name 'Sutro Heights.'"

North of the Sutro Baths, the aptly named Lands End, a windswept promontory rimmed by

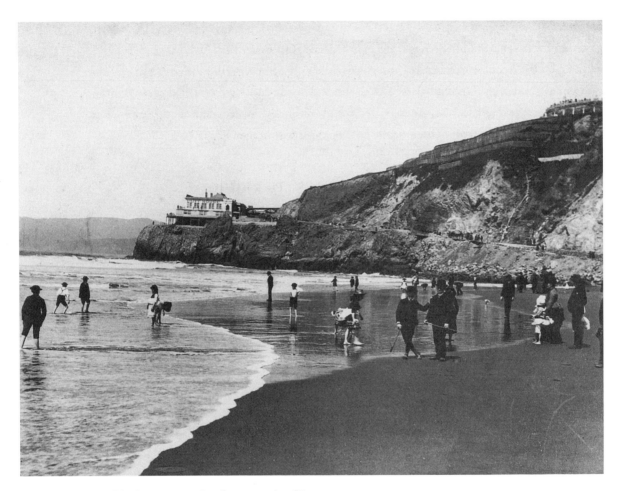

Figure 2. *The City and the Shore:* Ocean Beach at the western edge of San Francisco was the first part of the city's shoreline to be reserved for public enjoyment. First carriages, then early transit lines brought San Franciscans and visitors out to the Cliff House and the beach to dine and to delight in ocean views.

(Courtesy the Bancroft Library, University of California, Berkeley.)

rugged, landslide-prone cliffs, forms the dramatic southwestern corner of the opening of the Golden Gate. In 1970 it was under the ownership of a variety of entities. The state had 17 coastal acres named Seal Rocks State Park, which never had a sign and did not include the city's Seal Rocks. The Marine Exchange owned a vestige of an earlier communication system for shipping, an octagon house that still stands on an ocean-facing hillside. Fifty-four acres of federal land, purchased from the city in 1891, contained East and West Fort Miley, with a Veterans Administration hospital sandwiched between. Most of the hilltop of Lands End, which slopes down to Clement Street on its southern side, was (and still is) the city's Lincoln Park. In 1870 the city had designated this land as the Golden Gate Cemetery for the indigent and the Chinese, but in 1901 it forbade further burials within the city limits and closed the cemetery in 1909 so that it could become a park. The present-day golf course in Lincoln Park can trace its origins back to 1909, and the California Palace of the Legion of Honor art museum was completed there in 1924.

China Beach, just east of Lands End, was threatened with development in 1929, when the builders of Sea Cliff filed a subdivision map for the beach just below their development. The cove had been proposed as part of a chain of shoreline parks in the city's unexecuted Burnham Plan of 1905. Local improvement associations called for the preservation of the cove, but a proposal to buy it for the city failed at the polls. However, when James Duval Phelan—the mayor of San Francisco from 1897 to 1901 and an avid proponent of parks and city beautification—died in 1930, he left a bequest of $50,000 to buy the scenic cove facing the Golden Gate. In 1933 the city and the state combined to purchase the property for $160,000 and officially named it James D. Phelan Beach State Park. It is known today as China Beach after the fishermen who once frequented it.

The great lawn of the Marina Green owes its existence to the vast Panama-Pacific International Exposition of 1915. To hold the fair, a huge area of tidal lands, industrial plants, and marshy Presidio bayfront was cleared, filled, and landscaped. After the exposition ended, the Marina Green became the first part of San Francisco's bayfront to be made a park. This was under Mayor James Rolph, who also oversaw the beginning of San Francisco's citywide park system.

The origins of Aquatic Park reach back to the late 1800s, when the shoreline east of Fort Mason was one of California's pioneer industrial zones and also a favored location for Victorian rowing and swimming clubs. When industrialists proposed expanding the factory zone out into the bay, rowers and swimmers spearheaded a decades-long campaign to persuade the city to pass bond issues for a park. Even when those proposals failed, the recreationists persisted. Finally in

1922, during the administration of Mayor Rolph, the land for Aquatic Park was acquired, and construction of facilities was completed in 1938.

MARIN KEEPS ITS COUNTRYSIDE

Point Reyes National Seashore, authorized in 1962, and the Golden Gate National Recreation Area both included tracts of private and public land. Broad areas of private land in West Marin had remained open space in part because of ranching. Here, the coastal climate of rainy, mild winters and cool, dry summers creates a long growing season for pasture grasses. The open, rolling hills can support livestock without irrigation or large amounts of supplementary feed. Raising dairy cattle began here in the 1850s on the Point Reyes peninsula, and for a while Marin was called "the butter capital of California." Relatively isolated from the rest of the Bay Area before the opening of the Golden Gate Bridge in 1937, Marin developed slowly, with much of the county divided into beef and dairy ranches, a scattering of small towns, and a few estates and vacation communities (figure 3).

After the Golden Gate Bridge linked Marin to San Francisco and initiated faster growth in the eastern part of the county, the ranchers of West Marin held on tenaciously to their way of life. A number of them were careful stewards of the land and passed their lands whole to succeeding generations of family, along with the tradition of stewardship.

I learned about West Marin ranching from Boyd Stewart. Randolph Delehanty and I interviewed him in the summer of 1999. Boyd was born in 1903 and lived in one of the oldest homes in Marin County, a white 1864 Victorian on the ranch near Olema that his father bought in 1923. Sitting at his dining table, Boyd talked with pleasure about his ranch, now part of the Golden Gate National Recreation Area and managed by the fourth generation of his family. "It's a beautiful place—we make a good living, we're attached to it."

Boyd's father came to Marin from Scotland at age seventeen and worked on other ranches before buying his own spread. Concerned about overgrazing, his father was "a good rancher" who "always left one of the pastures to grow, go to seed, not grazed." Boyd learned about ranching from his father and told us that he was also influenced by the federal Agricultural Extension Service, which began in the 1920s to teach farmers and ranchers about good management practices. "It was a government agency out to improve agriculture," said Boyd. "New crops, new ways of doing things. 'Use, don't abuse the land,' was the word," he declared. Summing up the role West Marin ranch-

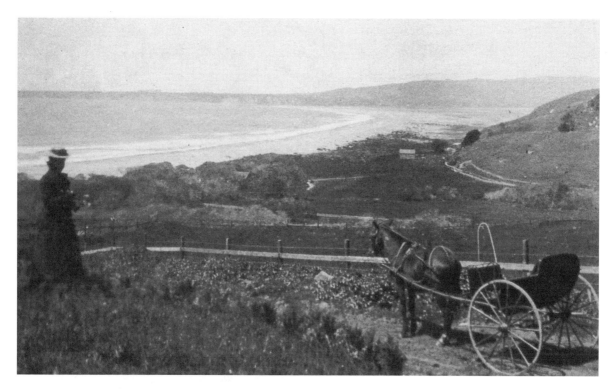

Figure 3. *A Day's Outing:* A visitor and her equipage pause above Stinson Beach in about 1900. (Courtesy Sausalito Historical Society.)

ers played in protecting the landscape, he told us, "They've not had changes in ownership here. [People] don't want to go someplace else. That's why the land was here for the parks."[5]

EARLY LAND CONSERVATION IN MARIN

By the early twentieth century, San Francisco and nearby cities such as Berkeley and Oakland had become urban centers. For some of their residents, a trip to Marin County was an important antidote to the stresses of urban life. Many Bay Area nature lovers hiked on the trails of Mount Tamalpais and vacationed at Stinson Beach and Inverness. When it became clear that many of these beautiful places were threatened with logging, housing construction, and dam building, people began advocating for their protection. Over the years, portions of these lands were indeed

Figure 4. *First Step:* The reservation of Marin County's Muir Woods, with its ancient coast redwoods, as a national monument by President Theodore Roosevelt in 1908 established the first federal park in the Bay Area. (James M. Morley.)

protected as state and county parks, and there was even one federal park, Muir Woods National Monument (figure 4). When the GGNRA was first authorized in 1972, some of these early parks were included in the new federal recreation area's boundaries and became part of a much larger contiguous area of wildlife habitat and public land.[6]

Boyd Stewart and his wife, Joseffa, were involved in the creation of the early parks, so he could tell us about some of the park advocates who had helped protect several thousand acres of Marin County's beaches, meadows, and forests as parkland. These early visionaries included Caroline Livermore (mother of Norman B. "Ike" Livermore, Jr., who would become the California state secretary of resources from 1967 to 1974), and Sepha Evers (mother of Bill Evers, who would be-

come a founder of the Planning and Conservation League). Boyd got to know them through his wife, "a girl from San Francisco who liked the out-of-doors—a musician, a professional accompanist" who gave piano lessons around the county. Boyd told us about dinners at the Livermore home in Ross at which Caroline Livermore would tell her assembled guests—"a grain broker from San Francisco, a hiker, a Pacific Gas and Electric Company vice president and his wife, and others"—about her desire to preserve Marin's undeveloped hills and tidelands. The Marin Conservation League, founded in 1934, grew out of these dinners. Some of this organization's earliest work was for acquisition of these lands.

Caroline Livermore helped raise funds for Mount Tamalpais State Park and was the driving force behind the state's acquisition of a small part of Angel Island in 1954, and the creation of a state park on the island when more acreage was acquired in 1958. (The summit of Angel Island State Park is now named Mount Caroline Livermore in her honor.) The Marin Conservation League also successfully campaigned for acquisition of the state parks on Tomales Bay and at Stinson Beach.

Muir Woods National Monument

The first park in Marin County, Muir Woods National Monument, predated the conservation campaigns of the Marin Conservation League. Muir Woods was protected early on as public land— and was available to be part of the GGNRA in 1972—primarily because of the efforts of one couple, William Kent and Elizabeth Thacher Kent.

In 1903 William Kent chaired a meeting attended by the chiefs of the U.S. Forest Service and the U.S. Biological Survey. The group discussed a proposal for a 12,000-acre park from the mountain to the sea, on land owned by ranchers and the Tamalpais Land and Water Company. In 1905, using money borrowed from a banker friend, the Kents bought 611 acres of Redwood Canyon within this area on the southwestern side of Mount Tamalpais to thwart logging, protect the redwood forests, and provide visitors' accommodations. Two years later, their plan to save the primeval redwood groves of Redwood Creek was threatened when the North Coast Water Company began condemnation proceedings on 47 acres of the Kents' private acreage in order to dam the creek and create a reservoir to provide a water supply for Sausalito. But William Kent learned about America's first preservation law, the Antiquities Act of 1906: it allowed the government to accept gifts from private citizens and gave the president the ability to create national monuments by proclamation.[7] Kent wrote to President Theodore Roosevelt and offered to donate 298 acres

to the nation. Roosevelt accepted, and in 1908 Muir Woods became a national monument. Kent insisted that the park be named for John Muir, whose western explorations, political efforts, and writing had so increased our country's awareness of its natural treasures. With later land acquisitions, nearly all of them Kent family gifts, the monument grew and now protects 560 acres, most of it virgin redwood forest. William Kent was elected to Congress in 1910 and served for three terms. During his time in Washington, he helped create the National Park Service.

Mount Tamalpais State Park

Soon after we moved to the Bay Area, George and I went for a walk in Mount Tamalpais State Park, enjoying the spring flowers and the glorious views along the highest trails of the 2,604-foot mountain. To the west and south, nearly all the land we could see was wild, from the forts near the coast to the state parklands at our feet.

Mount Tamalpais had long been a mecca for recreation. After many of its forests were logged, residents laid out hiking trails to the top, and in 1896 these were complemented by a railway—the Mill Valley and Mount Tamalpais Scenic Railway—that snaked up to the top of the mountain through 281 switchbacks, earning it the name "the crookedest railroad in the world." By 1897 train passengers and hikers could eat in a restaurant and stay in a hotel at the summit.

By the 1920s Mount Tamalpais had large numbers of weekend and seasonal visitors. Marin County had become an important retreat for affluent and middle-class people all around the Bay Area and had a modest population of permanent residents. There were spacious estates in Ross and Kentfield, and summer cottages in Stinson Beach and Inverness. Sausalito, San Rafael, and Mill Valley were small towns; the other settlements were hamlets. People took a ferry across the bay from San Francisco, Oakland, or Berkeley to Sausalito or Tiburon and then walked or took other transportation to their homes. Many of these people valued Marin's beautiful open space and loved to hike the spectacular slopes of the mountain.

Fearing roads and subdivisions, Marin hikers and conservationists began to campaign for park protection for Mount Tamalpais. To buy crucial land and avert development, a coalition of hiking clubs and conservationists raised money, the state allocated some more, and Mount Tamalpais State Park was designated between 1927 and 1929. The original 531-acre park has now grown to 6,300 acres. Nearly all the rest of the stately mountain is within the protected lands of the Marin Municipal Water District.[8]

Samuel P. Taylor State Park

After the gold rush, Samuel Penfield Taylor ran a highly successful paper-mill operation in the redwoods northwest of Mount Tam, supplying newsprint and paper bags to the San Francisco market. Then Taylor established Camp Taylor along scenic Papermill Creek, one of the first resorts based on camping as a recreational pursuit. In the 1870s and 1880s the area was one of the best-known vacation destinations in California.

By the 1920s Camp Taylor had been abandoned. The property—then owned by a wealthy San Francisco woman, Elizabeth Rogers—abutted the Stewart ranch. "No survey had been done, and there was no fence," Boyd Stewart recalled. People squatted on the Camp Taylor land. Boyd's father thought there should be a fence, so in 1924 he sent Boyd to meet with Mrs. Rogers, who lived in a penthouse in the Mark Hopkins Hotel at the top of Nob Hill in San Francisco. Boyd, then a student at Stanford University, remembered going into the grand hotel "in my best suit—my only suit," and going up in the elevator to her penthouse, where he was admitted to her suite by a maid. After a long, sociable chat he explained his mission. Mrs. Rogers pulled out Marin County plat books and they located the property. "Do you know any of the county supervisors?" she asked. Boyd said he knew a couple of them. She asked him to go to the Marin County Board of Supervisors and tell them she wanted to give the Camp Taylor property—more than 2,500 acres—to the county. "I'm not going to pay taxes on that land anymore," she said.

When Randolph and I looked astonished, Boyd explained, "The land wasn't worth anything." The old-growth redwoods had been logged fifty to seventy-five years earlier, and the second-growth redwoods were young and small. Boyd went to the county seat in San Rafael and told the board of supervisors about Elizabeth Rogers's offer. "The supervisors didn't want the land and wouldn't accept the donation," he recalled. But Mrs. Rogers stopped paying taxes on the property anyway. In 1940 the Marin Conservation League began a campaign for the county to purchase the land for a park, which the state could then acquire. In 1945 Elizabeth Rogers sold the land to Marin County, which forgave her property taxes as its contribution to the purchase, and in 1946 Camp Taylor became Samuel P. Taylor State Park.

By 1960 Marin County's residents and friends had saved several thousand acres of beaches and parks. Most people in most places would have expected towns and cities to grow up around these protected areas. But that is not what happened in Marin.

2

PIECEMEAL CONSERVATION IN THE 1960S

California grew rapidly during the 1960s, and so did the public's environmental awareness. While developers paved over some ranch lands and carved hillsides into housing tracts, more Bay Area residents were beginning to realize that the scenic beauty, wildlife, and recreation dependent on the region's remaining open space were endangered and irreplaceable, and that they could be lost forever. These opposing forces set the stage for high-stakes struggles over land use. Throughout the 1960s, conservation activists fought with pro-growth interests over the fate of undeveloped land in San Francisco and Marin County. They were able to protect the integrity of the open land north and south of the Golden Gate and held off developers long enough for the proposal for a Golden Gate National Recreation Area to emerge.

THE FATE OF THE FORTS

The military installations around the Golden Gate had expanded geographically for more than a hundred years, but around 1960 this process came to a halt. The last major weapons to be installed—the cold war–era Nike-Ajax and Nike-Hercules antiaircraft missile defense systems of the 1950s (figure 5)—were already out of date.[1] Except at the Presidio of San Francisco, which became an administrative and medical center, there was little activity on the extensive lands under military control.

The loss of military value brought the future use of these lands into question. Would the Army's forts—Mason, Miley, Funston, Baker, Barry, and Cronkhite—become public land and remain as open space, or would waiting and eager developers turn them into acres of houses, shopping centers, hotels, and office buildings? And would the Presidio remain an open, parklike Army post?

Cost cutters in the Department of Defense (DOD) began to dispose of some tracts around the Golden Gate and to return other parcels to the owners from whom they had been leased.[2] They also declared large portions of the Marin headlands "excess to military needs." Paying no attention to the contours of the rugged terrain, their maps defined 40-acre and 80-acre rectangles of available land.

Under the Surplus Property Act, the DOD asked the National Park Service and other federal agencies if they wanted these parts of the headlands.[3] But the Park Service, which thought of national parks as lands far from urban areas, did not. Neither did any other federal agency. As required by law, the General Services Administration (GSA) then declared this land "surplus," which made the land available first for state purchase, then to local government agencies, and then to private buyers.

It was still several years before saving obsolete military reservations would become politically popular and credible in Washington. So as threats to the remaining parts of this open space became more evident, as weeds twined over the cracking cement of the bunkers, and the once-smart parade grounds at the various forts became unkempt, groups of Bay Area residents began campaigns to save the Army's excess lands as open space. Their efforts helped establish two city parks on San Francisco's ocean coast, three state parks on the Marin headlands, and Fort Point National Historic Site on the Presidio under the Golden Gate Bridge.

The City of San Francisco's parks were created in 1961. The city wanted to buy two Army properties for parkland: West Fort Miley's 11 acres for $444,000 and 116 acres of Fort Funston for

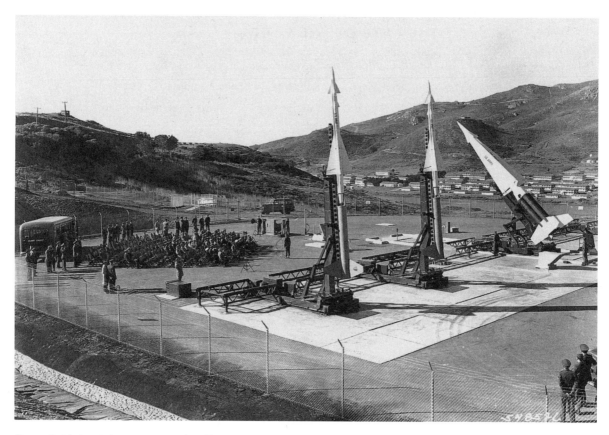

Figure 5. *The Last Defense Armaments on the Golden Gate:* Nike missiles stood poised all around the Bay Area from 1954 to 1974 but were never launched. This is Nike Missile Site SF 88L at Fort Barry in the Marin headlands in 1959, when the first Nike-Hercules (far right) was shown to the public. It replaced the earlier Nike-Ajax missiles (to the left). A unique memento of the fifty-year-long cold war, the site is now open to visitors with volunteer guides. (Courtesy Golden Gate National Recreation Area, Park Archives, GOGA-2316, 86-C-19, Interpretation Photo Collection.)

$1,100,000. Since this was a municipal purchase, the matter had to go before the voters and was put on the November 1961 ballot. The public knew little about either fort, and the measure required approval from two-thirds of the voters. The environmental writer Margot Patterson Doss arranged to have Fort Funston's chain-link fence opened on the Sunday before election day and announced the special event in her newspaper column.[4] San Francisco's transit system supplied buses, the San Mateo County sheriff's posse took care of public safety, the Zellerbach family patriarch donated a generator to light a tunnel in one of the batteries, and the Sierra Club supplied hike leaders. Thousands of people walked through the dunes past the missile site and around the gun emplacements. The ballot measure passed handily two days later.

The parks on the Marin headlands required more time and effort. In 1960 the GSA agreed to sell 58 acres of Fort Baker west of Highway 101 and 160 acres of Fort Cronkhite to the State of California for parkland, for half the appraised value of $8,000 an acre. As for 73 acres of Fort Baker east of Highway 101, the GSA announced an auction sale and refused to sell this property to the state, saying it was "too valuable for park purposes" and was "needed by adjacent communities for expansion." The mayor of the adjacent community, Sausalito, vigorously denied this claim and said the land belonged in a proposed state park. The local congressman, Clem Miller, called for a congressional investigation of the GSA's "unusual procedures" because the GSA "refuses to refer the state's request and park plans to the Secretary of the Interior and the National Park Service as provided by the [Surplus Property] Act." Bills were introduced in the House and Senate to convey the property to the state. Governor Edmund G. "Pat" Brown personally intervened with the GSA.[5] The political pressure worked, preventing an illegal land sale.

After Charles DeTurk became director of the state's park system, his agency commissioned a report on the forts. In 1965 the historian and author Emanuel Raymond Lewis conveyed his emotional response to the open Marin headlands in the report:

> For without doubt, the dominant visual feature lies here, across the Golden Gate, as a stark reminder of the San Franciscan's freedom from the crowded dinginess of eastern cities. Should this land somehow come to be developed, there is virtually no question that the Bay Area inhabitants in one rapid and irreversible stroke—and probably without awareness of what they are doing—[will] have changed the entire character of San Francisco more drastically than could be done in any other way short of nuclear devastation.[6]

The surplus land of the forts eventually came into the state park system as the result of a quiet campaign spearheaded by a nonprofit group named Headlands, Inc. Formed in 1967 by some twenty Marin and San Francisco conservationists, the organization lobbied to protect any land the Army might wish to dispose of on the Marin side of the Golden Gate. Under the able coordination of Marin County resident Katharine Frankforter, Headlands, Inc., helped arrange the state purchase of a total of 663 Army acres. They were transformed into three parks, collectively called the Marin Headlands State Parks: one east of Highway 101 above Sausalito, one west of the bridge, and one at the northern end of Fort Cronkhite. Kirby Cove, part of the middle park, was the first area to open, in July 1968. I once camped overnight with a group there. Under a full moon, fog horns sounded, mist blew in my face, and there was a faint shush of cars at three in the morning on the nearby bridge—and also the sound of two large raccoons looking for food next to my head.

It is possible to trace the saving of Fort Point back to the early 1930s, when the Golden Gate Bridge engineer Joseph Strauss designed a great steel arch at the southern anchorage to vault over the old fort, which then became a staging area for bridge workmen in 1933.[7] During World War II, for one last time, Fort Point was garrisoned by Army troops, but after they departed in 1944 it was boarded up and abandoned. In 1959 some civilians and retired Army officers organized the Fort Point Museum Association and began a campaign to save and restore the red-brick structure. Eventually they persuaded both of San Francisco's congressmen, Democrat Phil Burton and Republican Bill Mailliard, to sponsor legislation that would make the fort a national historic site. Bill Thomas, who at that time was administrative assistant to Congressman Burton, told me many years later how Burton's legislation to save Fort Point got under way:

> The lobbyist for Kaiser Aluminum and the lobbyist for Safeway came to the office and they asked me for Phil's assistance in passing a bill to create the Fort Point National Historic Site. They said Mailliard had introduced it a number of times and it had never succeeded in the Senate. . . . Phil said he would support it. I later asked the lobbyists why they were interested and apparently there was a Fort Point Association and the wives of the executives of these two companies were on the board of that association and so they were tasked with getting this bill passed and they finally realized they needed a Democrat.[8]

The bill passed and Fort Point National Historic Site was authorized on October 16, 1970.[9] Army sergeant Charles Hawkins, who had helped with the campaign to save the fort and was

familiar with the Army's vast resources, got equipment and furnishings for the new park. He retired from the Army in 1971, joined the Park Service, rose through the ranks, and managed the Fort Point site with grace and spirit from 1981 to 1989.

Most Bay Area residents did not understand that the creation of these parks in the 1960s averted drastic changes in the local landscape. They assumed that the Golden Gate was permanently protected. The scene was minimally military, and it was peaceful. The Army's presence predated the gold rush, the Golden Gate Bridge was a national icon, Lands End and China Beach were parks, and the spacious homes of Seacliff above the coastal cliffs were surrounded by trees and lawns. Yet there were accumulating threats to the forts' integrity, as described by reporter Scott Thurber in July 1970:

> The old forts which overlook the Golden Gate are scenically situated, rich in history—and, some will tell you, replete with opportunity. The opportunities are, of course, viewed from sharply differing perspectives by people with radically diverse viewpoints: subdividers, conservationists—and government agencies intent on erecting new buildings. . . . Some say [the old forts] have faced their gravest dangers since their military usefulness dwindled. . . . But it is likely that many Bay Area residents have hardly heard of some of the forts, and know only vaguely their whereabouts and history.[10]

The most important of the Army properties, the Presidio itself, was threatened too, and not by obsolescence but by growth. Except in wartime, San Francisco's Presidio had always been an open Army post. Visitors enjoyed its tall forests, scenic drives, and dramatic views of the Golden Gate. For much of the twentieth century there were no sentries at the gates. Local residents were reminded that it was a military post only by the uniformed soldiers walking along the streets or driving khaki-colored trucks. The Presidio's neighbors learned not to be intimidated by the Army's presence and enjoyed its trails and vistas as if it were a local park.

Federal budget watchdogs had tried a few times to close down the Presidio because it was expensive to maintain, but they always failed because it was a prized Army assignment. Over time, the Presidio became an administrative post: for the headquarters of the Sixth U.S. Army, the staff of Letterman General Hospital and its research institute, and engineers, clerks, and reserve trainees.

In the 1950s and 1960s, as parts of the other six forts were inactivated, the Army increased its use of the Presidio and constructed new apartments for enlisted men and their families. More

dwellings were constructed at that time than had been built in all of the Presidio's previous years. The post's neighbors became anxious about the Presidio's future as flowering dunes and open meadows were covered with housing.

In 1962 the Presidio of San Francisco was designated a national historic landmark.[11] Such recognition gave it some protection, but invaders lurked beyond the Presidio's walls and stepped forward as the Army's role diminished. A proposal for upscale housing was defeated by public outcry. In 1970 the threat of more Presidio construction projects was so real that Mayor Joseph Alioto and the San Francisco Board of Supervisors endorsed a resolution opposing any more Army housing on the Presidio.

When the DOD declared some Presidio land excess to military needs in 1969, the U.S. Food and Drug Administration proposed an office building on the site. It was defeated in a behind-the-scenes campaign led by the San Francisco Planning and Urban Renewal Association and supported by Congressman Bill Mailliard. Yet—it was becoming clear in 1970 to a number of people—other developments would inevitably be advanced. The remaining Army property around the Golden Gate could either be frittered away or be reunited with the parcels that legislators, agencies, and the public had succeeded in saving. But if the Army could no longer be the guardian of the Golden Gate, who would or could?

DEVELOPERS STALK RURAL MARIN

Marin County grew very slowly until the Golden Gate Bridge was completed in 1937 and for a while thereafter, because of the Great Depression and World War II. However, all of Marin seemed open to development in the explosion of suburban construction that began in the 1950s. Well into the 1960s, property owners, road builders, and the county's elected officials gave little thought to balancing development with dedicated open space.

It was not only the pressures for suburban expansion that favored the development of housing tracts. Dairy ranching was declining, and the economic prospects for remaining in the business looked increasingly bleak. Taxes on grazing land rose as land was reassessed for its potential development value rather than for ranching.[12] Even though the state legislature responded to this problem by passing the California Land Conservation Act of 1965, popularly called the Williamson Act, which allowed taxes to be based on agricultural use if a rancher agreed to keep his land in agriculture for ten years, no law could compel the children of ranchers to carry on a seven-days-a-week family business.

Costs also rose for dairy ranchers as government agencies regulated herd size, barn design, and the treatment of animal wastes to keep creek waters clean for people and fish. The numbers tell the story: in 1950 there were some 200 dairy ranches in Marin County, in 1960 there were 150, and in 1970 about 100 remained.[13] Adapting to these changes, some ranchers switched from dairy to beef because beef cattle have less impact on the land—the cows don't come to the barn two or three times a day for milking and their wastes are not concentrated. But many ranchers went out of business entirely.

Most of West Marin is at least an hour's drive from San Francisco. Southern Marin County, a short commute away from San Francisco, faced even more intense pressure. Here ranches that changed hands were usually subdivided. Builders clustered homes along the roads with the best access to Highway 101. Where Marin City is today, the cows on Joe Bettancourt's dairy ranch had long since been replaced, first by temporary housing for workers in Sausalito's World War II shipyard and, over time, by midrise public housing, apartments, town houses, and a shopping center. But near Muir Beach the Banducci family kept its flower farm, and George Wheelwright kept his property as a working cattle ranch. Wheelwright had bought the 700-acre ranch after World War II and named it Green Gulch.[14]

Most of the people who moved into the eastern side of the county came to live in suburban housing tracts in and around eleven developing suburban towns served by multilane Highway 101. Westward-winding roads branched off that freeway and became country roads as they went over the hills to West Marin. It was only a matter of time before developers and county officials would propose new roads and housing tracts in the more rural parts of the county, where there was more room.

The First Battle for Point Reyes

An increasing number of residents and weekenders began to realize that if all the buildings and roads that were beginning to show up on the drawing boards for Marin County were actually constructed, they would lose much of the reason why they had moved to Marin or visited there. Rather than encourage building everywhere, this new group of residents joined older ones, sometimes in the Marin Conservation League and sometimes in other groups, in their work for more conservation of the countryside. The biggest project they supported saved a remote coastal area between Bolinas Lagoon and the mouth of Tomales Bay, an area much larger than all of Marin County's other parks combined: between 1959 and 1962 they brought Point Reyes National Seashore into

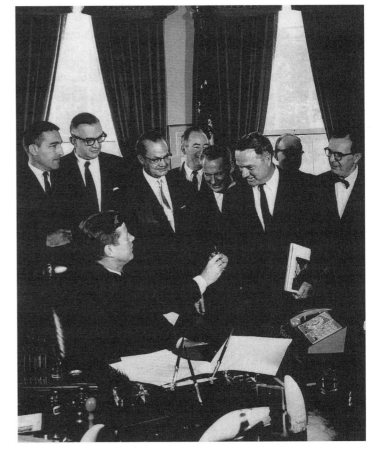

Figure 6. *Final Step:* President John F. Kennedy hands a pen to Congressman Clem Miller after signing the Point Reyes National Seashore legislation in the Oval Office in 1962. Miller led the congressional effort to create the West Coast's only national seashore. (Courtesy National Archives.)

being (figure 6). The campaign for the Golden Gate National Recreation Area would have been far more difficult and would undoubtedly have protected much less land were it not for these earlier triumphs of this group of Bay Area—mostly Marin County—conservation activists and some dedicated legislators.

Congressman Clement W. "Clem" Miller was the first hero of Point Reyes. Born in Delaware, he and his wife, Katy, came to Marin County in 1948 and eventually settled in Corte Madera, but they also had a house in the little town of Inverness next to Point Reyes. The Millers took their children camping on the county beaches on the Point Reyes peninsula and delighted in the verdant dairy ranches in the area. Clem Miller worked for the National Labor Relations Board in

San Francisco. As a federal employee covered by the Hatch Act, he could not be active in national politics. But after he left his government job he supported his family as a landscaper and began doing Democratic precinct work. In 1956 he lost his bid to replace his district's conservative Republican congressman, but on his second try for office in 1958 he was elected.

Protecting Point Reyes, turning it into a national park, was at the top of Clem's agenda as a freshman member of Congress, said Katy Miller Johnson in a 1990 interview: "I do recall Clem saying right away, when he was elected, this is the priority because this will not stay. This is miraculous that it hasn't been developed. I don't remember as clear-cut a statement as that before the election, but I remember that once we got to Washington, that was it."[15] Congressman Miller delegated to his legislative assistant, Bill Duddleson, a former Santa Rosa *Press Democrat* reporter, the task of getting the Point Reyes peninsula designated a national seashore.

Aware of the need for local support, including the approval of the Marin County Board of Supervisors, Miller visited North Carolina's Cape Hatteras, where the first national seashore had been established in 1953. There he learned how park proponents had overcome local opposition.

It took four years for Miller and Senator Clair Engle (D-CA) to develop the support they needed. With the help of the Point Reyes National Seashore Foundation, the Marin Conservation League, and the Sierra Club—and over the objections of real estate developers and local ranchers—Miller and Engle got Congress to authorize the park. The bill included language protective of ranching.

The rationale for creating the park was based, in part, on a report of pivotal importance by the Outdoor Recreation Resources Review Commission, whose study had been authorized by Congress in 1958 (PL 85-470). In January 1962 the commission reported to the president and Congress that it had examined 60,000 miles of mainland United States shoreline and determined that only 2 percent of these miles—and only 6 percent of the 21,000 miles the commission considered suitable for recreation—were in public ownership in 1962: 336 miles on the Atlantic coast and 296 on the Pacific coast (the other miles were on the Great Lakes and the Gulf of Mexico). The commission also projected sharp increases in national park visitation during the coming years.

Additionally, the House committee report on the Point Reyes park legislation declared, "There is great merit to the proposal to expand the mileage even though it can be done only through the reacquisition of land that has passed into private ownership." It described the proposed park's 45 miles of undeveloped sandy beaches, coastal bluffs, dunes, forests, chaparral, and grasslands and praised its cool summer climate and the extraordinary diversity of its topography and wildlife. A

principal thrust of the report was that Point Reyes National Seashore was to serve the growing population interested in outdoor recreation.[16]

Miller and Engle could see that it would be impossible to get, at one time, all the money that would be needed to buy the private properties inside the boundaries of the proposed park. In 1961 Congress had placed a $14-million land acquisition ceiling on Cape Cod National Seashore in Massachusetts, and in 1962 they knew Congress would grant no more than that for California's Point Reyes. Miller and Engle realized that they had to seize the opportunity to get Congress to authorize the park—thus setting its boundaries—acquiesce to the inadequate $14-million ceiling, and then come back for more money later. On September 13, 1962, President John F. Kennedy signed the park bill into law, authorizing a Point Reyes National Seashore of 64,000 acres.[17]

Sadly, the victorious Congressman Miller was killed in a plane crash as he was campaigning for reelection, less than a month after Kennedy signed the bill. With five young children to raise, Katy refused to run for her husband's congressional seat. Her relatives were on the East Coast, so she stayed in Washington and took a job with a new organization of House liberals called the Democratic Study Group. Katy married Stuart H. Johnson, Jr., in 1965. Neither she nor Bill Duddleson, Miller's former legislative assistant, paid much attention to Point Reyes for several years. They knew more money would be needed to buy all the ranches, but they thought the new park was safe. Indeed, the land acquisition ceiling was raised to $19 million in 1967.

Logging West Marin's Forests

Yet the new park was not safe. One day in the 1980s Boyd Stewart drove me down the road from his Olema Valley ranch and showed me what had happened. The continuing nationwide housing boom required timber, and logging companies wanted to fell the forests of West Marin. Douglas fir forests cover much of the Inverness Ridge on the Point Reyes peninsula. When Congress appropriated money very slowly for property inside the boundaries of the park, the Park Service could not purchase the land included in Point Reyes National Seashore quickly enough for some of the land owners, who sold their logging rights. Logging became a form of political action. Great gaps appeared against the sky when trees on Inverness Ridge were felled. This spurred efforts to get adequate funds to complete the purchase of the park, but it was a race against the chainsaws. And, as Boyd pointed out to me, on the ridgetop the scars of the 1960s were still visible twenty years later.

East of Highway 1, redwood trees thrive from the canyon bottoms to the ridgetops. In 1969 an

Oregon company began to log the redwoods along the Bolinas Ridge on the Righetti ranch, eroding the hillsides and threatening Bolinas Lagoon and Tomales Bay with heavy loads of silt. Marin County took Righetti and the logging company to court and won, then passed a logging and quarrying ordinance, admired as a model of its kind, which limited these extractive uses of the land and their environmental impacts.

Beating Back the Highwaymen

The road planners were also at work. In 1958 Governor Pat Brown had called for a vast freeway program for California. In 1965, as freeways were being built around the state, the Marin County Board of Supervisors approved the Marin County Parks and Recreation Plan 1990, which featured a number of scenic roads that fed into a projected Golden Gate Parkway. This recreational travel route was to begin at the Golden Gate Bridge, link the coastal forts, state parks, and municipal water district lands, cut through the heron and egret breeding grounds at the top of Bolinas Ridge, and end at the Bear Valley entrance to Point Reyes National Seashore. There it would meet widened and straightened Highway 1, now labeled the shoreline route, which would continue north to the county line. The road system would have fragmented more than 75 square miles of natural habitat and ranch land and given developers access to the most isolated parts of West Marin. Local residents noted that the state's chief of advance planning for freeway construction, Harold Summers, was married to Mary Summers, head of the Marin County Planning Department.

The Countywide Plan

West Marin was further threatened when the county began shaping the Marin Countywide Plan, intended to coordinate planning in neighboring jurisdictions. By this time Mary Summers had left the county planning department, and the board of supervisors had hired her and Harold Summers as consultants. The county plan the board approved in 1968 called for extensive development in West Marin. Except where protected by Point Reyes National Seashore, West Marin would provide suburban living and recreation. Its population would triple by 1990, its economic base would change from primarily agriculture to recreation and tourism, the hills on both sides of Tomales Bay would be covered with subdivisions, and Walker Creek on Tomales Bay would be dammed

for a large new reservoir. The Golden Gate Parkway was to be a national parkway between the Golden Gate Bridge and the entrance to Point Reyes National Seashore, where it would meet a freeway from East Marin as well as Highway 1.[18]

A Marina for Bolinas Lagoon

The road plan would have tied in with a proposal for Bolinas Lagoon. About 12 miles north of the Golden Gate Bridge, the shallow waters of Bolinas Lagoon ebb and flow with the tide. Great egrets, snowy egrets, and great blue herons are just its most visible avian residents. Throughout the year smaller birds can be seen on the telephone wires and heard in all the surrounding bushes and trees. Flocks of migratory birds traveling the Pacific Flyway stop at this West Marin estuary for food and water. For me, Bolinas Lagoon is a magical place to float in a kayak. Even at high tide I can see to the bottom. My paddle might bring up a bat ray, which quickly drops away. As it moves out of sight, fish swim from under the shadow of my craft—top smelt, steelhead trout, three-spined stickleback, and small leopard sharks. Harbor seals rest on the island in the middle of the lagoon, pelicans fly overhead, and herons and egrets wade near the shore. Bolinas Lagoon is full of life today, but if matters had turned out differently in 1966, it might now be a very different kind of place.

In that year the locally elected, independent Bolinas Harbor District proposed to dredge and fill parts of Bolinas Lagoon. The district intended to accommodate a 1,400-boat marina, a heliport, restaurants, a hotel, parking lots, houses, a commercial center—and a toll bridge between the lagoon's eastern and western shores. Three conservation organizations—Audubon Canyon Ranch, the Marin Conservation League, and The Nature Conservancy—joined forces to thwart this gargantuan plan. A member of the Kent family had already given 9 acres of the lagoon's island to Audubon Canyon Ranch, whose nature preserve is on the eastern side of the lagoon. The three organizations financed a quick and secret purchase of the island's remaining 111 acres from another family member, then donated what is now called Kent Island to Marin County. The county had the power to tell the local harbor district that it would not allow its land to be used for their plan. Soon after, local residents voted to dissolve the over-reaching Bolinas Harbor District.

Audubon Canyon Ranch also played a key role in preventing the Golden Gate Parkway proposal from going beyond the planning stages.[19] Over several years, its directors had used donated funds to buy hundreds of acres on the eastern side of Bolinas Lagoon, and they continued to buy property

and accept gifts of land. In 1966—their open space investment apparently saved with the dissolution of the Bolinas Harbor District but still threatened by the parkway—they initiated a land-buying program that would make it more difficult to complete the proposed highway. They saw that a parkway would erase natural features of the West Marin countryside and that precious habitat areas they had protected for breeding birds would become islands surrounded by sprawling suburbs. At the same time, other Bay Area residents who knew the area publicly attacked the highway plan.

Public Education

Audubon Canyon Ranch is an education and research center and nature preserve, and thus it was at the forefront of conservation politics in Marin County in the late 1960s. In 1968 the directors promulgated a new policy: entire watersheds, beginning with Bolinas Lagoon and Tomales Bay, should be managed to conserve their ecological unity.

In 1969 the directors also realized that to be successful they must educate local voters and teachers to support the preservation of watershed health and habitat. To develop effective advocates, they inaugurated a two-part environmental education program emphasizing docent training and conservation politics. The docent training program was announced in March 1969 at a ceremony at which the National Park Service dedicated the ranch as a national natural landmark. Audubon Canyon Ranch staff trained docents in ecology, natural history, and habitat preservation. At the same time the Environmental Forum of Marin trained leaders in environmental advocacy. Trainees from both programs carried the environmental message back to their neighbors, communities, and classrooms. They helped end the threats of road building, road widening, suburban tracts, and commercial development in West Marin, as the environmental awareness they disseminated spread throughout the county. Many of the conservationists trained in these programs became the backbone of the protective campaign to finish the purchase of Point Reyes National Seashore and then became advocates for the Golden Gate National Recreation Area.

The Second Battle for Point Reyes

By 1969 the situation at Point Reyes National Seashore was appalling. Only ten scattered parcels of land included in the park had been bought, the purchase money was used up, scenic Inverness Ridge was being logged, ranches inside the park boundary were being surveyed for building lots,

Marin County was giving out permits for new subdivisions, and eighteen houses had been built at Limantour Spit. But when the director of the National Park Service announced a scheme to sell off part of the park, feisty and educated local residents mustered national support and saved Point Reyes for a second time.

The Park Service said it would take $38 million more to complete the park. Bills for that amount were introduced with bipartisan support. Wayne Aspinall (D-CO), chair of the House Interior and Insular Affairs Committee, set a hearing for May 13, 1969. Katy Miller Johnson, warned by a friend on Congressman Jeffery Cohelan's (D-CA) staff, went to the hearing with her husband and Bill Duddleson. There they learned Point Reyes would receive no money under President Nixon's proposed budget. They also heard the director of the National Park Service, George Hartzog, recommend that 9,208 acres—over 14 square miles—of Point Reyes be sold off for subdivisions, a country club, a shopping mall, and other projects that, he said, would reduce the cost of the park to $28 million. The future of Point Reyes was threatened by the administration's impounding of acquisition dollars and the avidity of developers. Katy was shocked and angry.

She responded with a letter to a friend on the Interior Committee, Congressman Harold T. "Bizz" Johnson (D-CA), who strongly supported the integrity of the park as stipulated in the 1962 legislation. Katy sent hundreds of copies of her letter to senators and representatives, leaders of conservation organizations, and key supporters. She asked everyone to send personal letters to President Nixon, to Senator George Murphy (R-CA), who was running for reelection, and to Congressman Roy Taylor (D-NC) and Senator Alan Bible (D-NV), who were the gatekeepers for park legislation in the House and Senate. She generated newspaper articles and then gathered friends and family to stuff envelopes with copies of the articles to build even more support.

In midsummer Katy went to the West Coast and enlisted the help of the veterans of the 1958–62 park campaign and the former Marin County supervisor Peter Behr, an effective and eloquent Republican planning to run for the state senate. Peter agreed to take charge of the burgeoning campaign, called Save Our Seashore, or S.O.S. He modeled his approach on the masses of letters, busloads of people, and reams of petitions that had just won the Save the Bay campaign to regulate development around San Francisco Bay. Dozens of people went to work writing letters, collecting petition signatures, and urging media coverage. By November 1969 Republican congressman Don Clausen, who now represented Clem Miller's former district, had park petitions with 350,000 signatures in his office, and Senator Murphy had 100,000 more—all for delivery to the White House.

Meanwhile, on September 10, 1969, Senator George Murphy asked President Nixon to sup-

port Point Reyes. On the same day, however, the director of the Bureau of the Budget (now the Office of Management and Budget) wrote to Congressman Aspinall, saying that even if Congress appropriated funds to complete purchase of the park, he would not release the money. On hearing this, Congressman Paul N. "Pete" McCloskey, Jr. (R-CA), wrote to John D. Ehrlichman, President Nixon's White House counsel: "The only man who can save the Point Reyes National Seashore is the President. . . . The money is available in the land and water conservation fund. All the President need do is order that it be released, earmarked for the national seashore projects, specifically, Point Reyes. If you move this time, why not let a few of us know in advance so that we can properly give the President credit where it is due?"[20]

Congressman McCloskey was referring to the Land and Water Conservation Fund established by Congress in 1964. Its principal source of revenue is outer continental shelf oil and gas lease royalties. It is a major source of money available to federal, state, and local jurisdictions to buy land to preserve wilderness, wetlands, and refuges, to protect habitat, and to create parks. Congress must appropriate the money from the fund each year.[21]

Shortly after Aspinall received the budget director's letter, Katy got an unusual message from a member of his staff: in light of this letter, she should write to Aspinall with copies to every House Interior Committee member, about funding for all the waiting parks and, of course, in support of funding for Point Reyes. Katy sent the letters. In mid-November Aspinall started to move his committee forward and—seeing that he did not have the votes—announced that he would not consider any funding bills. Point Reyes was trapped in a nationwide park purchase crunch. There was a half-billion-dollar backlog of parkland to be bought.

At a meeting with President Nixon, Aspinall learned that Nixon wanted Point Reyes for Senator Murphy, the Republican senator from California up for reelection. Aspinall said he could not fund just one park; congressmen from states with other unfinished parks, including Cape Cod, Assateague Island, and Padre Island, had demanded funding for their parks as well. The White House was in conflict with the Bureau of the Budget over the federal funding of park acquisitions. Many Bay Area residents knew of the struggle to get funds to buy Point Reyes National Seashore, but how many knew that the president had to deal with a bureaucrat's attempts to block those funds—that there was an intramural struggle between an elected president and one of his appointed executive agencies? Trying to turn the funding of these parks from a Democratic legislative triumph into a Republican presidential decision, a White House lawyer said that if funds were not available, "then the money should come from some other program; e.g. cancel a space shot."[22]

For months the legislation to fund Point Reyes and keep it whole had been stalemated. Then, suddenly and gloriously, the tide turned. Aspinall joined forces with Congressman John Saylor (R-PA), the senior Republican on Aspinall's committee. According to Bill Duddleson, Aspinall and Saylor were "experienced poker players," and they did not trust President Nixon. They would not take up the Point Reyes funding bill until the administration agreed to fund the other parks as well. On February 10, Saylor told the House of Representatives that administration officials had given him the assurances he needed so he could support Point Reyes. The president had agreed to full funding of the Land and Water Conservation Fund, and to appropriation of the $327 million of revenue accumulated in it for use that year. Also, he had received letters from officials at the Department of the Interior and Bureau of the Budget who pledged to support funding for all the rest of the incomplete areas of the National Park System.[23] The bill included $7 million for Point Reyes, support for the $38 million needed to complete the park, and stipulations against any reduction in Point Reyes's size. It passed by voice vote.

Senator Alan Bible moved the House park funding bill through his Senate committee. He and Boyd Stewart were old friends. Now Boyd—who had previously spoken at a House committee hearing on the legislation—came to Washington once again to testify that the ranching community really wanted the park:

> The ranchers in Marin County, whom I have been asked to represent here by the Board of Supervisors, feel, as everyone else does, that this park ought to be completed. . . . Originally, as you know, they objected. . . . We recognize the value of it as a park and we are aware of the pressures of population. . . . Those of us who have loved this land for years and seen it through its many moods and seasons, recognize that this treasure can no longer remain ours to enjoy exclusively. Its beauty and grandeur must be shared with all Americans.[24]

On April 3, 1970, President Nixon signed the bill for increased park funding.

Since I was not a part of the S.O.S. campaign, I relied on Bill Duddleson to tell me why it had worked. He said that above all, "the undeniable evidence of citizen concern on a massive scale" had changed the political calculus. He also credited Katy's skillful and personal lobbying, especially of curmudgeonly Wayne Aspinall. In addition, as Bill learned from Nixon's aide John Ehrlichman during a 1991 interview, Nixon came to realize that supporting Point Reyes was politically useful. "Richard Nixon was not your natural birds, bees, and bunnies man," Bill reported Ehrlich-

man saying. "He had to be persuaded that this was not only right to do, but that it had a payoff down the line in political terms."[25]

When it was all over, the Point Reyes campaign had taught Nixon a lesson: park support did indeed have a political payoff. Bill reports Ehrlichman's claim that the Nixon White House's "good experience with Point Reyes" gave "political credibility" to similar programs and "set the stage for Nixon's support of initiatives . . . to create Golden Gate National Recreation Area in the Bay Area, along with its counterpart in the New York City harbor area: Gateway National Recreation Area."[26]

THE TIDE BEGINS TO TURN IN MARIN COUNTY

Throughout most of the 1960s the Marin County Board of Supervisors, like its counterparts elsewhere in the state, favored growth and development. In the late 1960s, however, a changing electorate began to transform county politics. New people with a more liberal perspective were moving into Marin County. They were influenced by the ecology movement that was sweeping the country. As a result, recalls and election upsets in the late 1960s replaced most of Marin's pro-growth power brokers with politicians more supportive of open-space conservation and controlled growth.

At the same time, conservation groups were improving their tactics, focusing on public awareness and outreach, and using more of a big-picture approach in arguing for the protection of the natural landscape. By the early 1970s—just in time for the coming of the GGNRA—a major development in the Marin headlands had been halted, citizens were galvanized in support of open space preservation, and the county had approved a forward-looking plan balancing moderate growth with environmental concerns.

Preventing Marincello

In the early 1960s, a few miles from the Golden Gate Bridge, just north of the headlands forts and west of Highway 101, a developer proposed to build a planned city named Marincello (figure 7). This development proposal became the focus of a crucial struggle. If approved, the development would have blocked extension of our GGNRA proposal beyond the headlands forts.

The Marincello project began when the Connecticut developer Thomas Frouge, in partnership with Gulf Oil Corporation, bought several southern Marin ranches. The steep hills and shel-

Figure 7. *Almost the Future:* The developer's model for Marincello, a new town proposed to replace the ranches on the Marin headlands in the early 1960s. Note the Golden Gate Bridge in the upper right corner. (Courtesy Golden Gate National Recreation Area, Park Archives, GOGA-3380, 87-112-447, People For a Golden Gate National Recreation Area Collection.)

tered valleys, with spectacular views in all directions from the ridgetops, were unified into a single 2,113-acre property. Frouge designed what in those days was called a "new town" where 30,000 people would live and work without commuting to San Francisco. The development would have single-family homes, garden apartments, high-rise apartments, commercial property, light industry, and a hotel on the highest ridge.

When the plan was unveiled, it immediately and deeply divided Bay Area residents. The project design was attractive enough to gain many public supporters. They said that if Marin's population was going to grow, perhaps more open space could be saved by concentrated development like Marincello than by suburban sprawl. Conservationists, on the other hand, branded the project

"Marinsellout." Residents wouldn't stay inside the project with San Francisco a few miles away. The flood of commuters on Highway 101 would need four more lanes—or even eight—and how would that traffic ever get across the graceful six-lane Golden Gate Bridge? When a Gulf Oil gas station in Mill Valley sent credit cards to Marin residents with literature extolling the new development, some recipients cut up the cards and mailed back the pieces.[27]

There was a flurry of news stories. In January 1965, three thousand miles away, the *New York Times* damned the project. "All Americans have a stake," the newspaper declared. The editors likened it to the erection of thirty-story apartment houses along the New Jersey Palisades during the early 1960s: "The 'developers' won, and New York—and all civilized people everywhere—lost one of the most beautiful river views in existence." The editors called on Marin County officials, the governor, and the California legislature "to preserve intact the sparkling waters of San Francisco Bay and the beauty of the surrounding skyline, which for so long have been part of the American legend."[28]

The developers cut the number of projected residents to 20,000 and proposed fewer sixteen-story apartment houses. Although experts warned that the site was much too steep for the development and that its economics needed more analysis, the county board of supervisors approved the project in November 1965. Nearby residents and the City of Sausalito filed lawsuits. Construction began—and then stopped. Frouge and his oil company partners had a financial falling-out, which became a lengthy legal battle.

In January 1969 Thomas Frouge died, but Marincello did not disappear with his death. Sausalito won its lawsuit against the county, with the court ruling that the board of supervisors had acted with undue haste and that the developer had to resubmit the plan for public hearings. But this ruling only delayed the matter further—and during the total delay of several years, Marin residents came to understand what the project would do to their county.

In September 1970, when I was already deeply involved in the campaign for the new national park at the Golden Gate and the campaign was common knowledge among Sierra Club activists, a hike leader from the club phoned to tell me that the Gulf-Reston corporation would again present its Marincello proposal to the Marin County Board of Supervisors. Would I tell the board about a national park that could include the Marincello land? Sure! At the meeting, corporation representatives showed handsome slides and played a tape about the "new town" they had built beyond the greenbelt of Washington DC in Reston, Virginia. Supervisor Michael Wornum, an architect and planner, responded that Reston is 18 miles outside Washington and five minutes from Dulles airport. "You want to build a 'new town' *in* our greenbelt, not beyond it," he declared. Wornum's

statement energized the hearing room, filled with Marincello opponents. They damned the project at length and were delighted to hear me tell about the proposed park.

Marincello's doom was sealed at that hearing. The project was potentially the biggest threat to the lands at the Golden Gate, and opponents had transformed it into a catalyst for our proposed national park. But our park plan was still threatened as long as the land was privately owned.

A New Marin Countywide Plan

In spite of changing public opinion, the pro-growth lobby in Marin still had considerable clout in 1970. That year, working with a committee of business-minded residents and an economic consultant, the Marin County Planning Department published a booklet, *The Visitor in Marin: The Potential for Visitor Enterprise Development in Marin*. The report called for commercial development to meet the costs of traffic, policing, litter removal, and visitors' other impacts. In West Marin they proposed 2,250 motel rooms, 1,000 recreational vehicle spaces, 4 golf courses, 500 marina slips, 219,000 square feet of restaurant space, and 106,000 square feet of specialty shops.[29]

The public rejected the planning department's development-oriented scenario. The battles for Point Reyes, West Marin, and Marincello, along with the Audubon Canyon Ranch programs, had affected many Marin residents. In 1971 the county planning staff published another report with a different approach: *Can the Last Place Last? Preserving the Environmental Quality of Marin*. Its tone was very different, as these excerpts show:

> Development should respect the sense of place created by the . . . basic land forms of Marin. . . .

> Most of the existing machinery for regulating private development . . . fall[s] short of doing an adequate job of keeping the environment from degenerating still further with each increment of growth. . . .

> Protect watersheds, upland wildlife refuges and agricultural areas by reducing the impact of developments which are damaging. This includes monitoring or regulating natural resource extraction to safe limits where sediments, land erosion or removal of vegetation cover endanger water, air or landscape quality.[30]

Can the Last Place Last? signaled a major shift and showed a change of heart that would aid our efforts to create the Golden Gate National Recreation Area. Also in 1971 the board of supervisors rezoned the minimum size of lots on most of the county's rural land, from 2 acres to 60 acres. That change helped protect agriculture but also had an unacknowledged benefit for the new park's legislation by keeping ranch land in large parcels, which would be less expensive for eventual government purchase—a notable contrast to what had occurred inside Point Reyes National Seashore after that park was authorized. Marin's final countywide plan, published in 1973, was a conservation-oriented document that, according to the former county planning director Marjorie Macris, was defined in large part by *Can the Last Place Last?*[31]

The countywide plan—highlighting the passage of state and federal acts that mandated environmental analysis of development projects—divided Marin so that urbanizing growth would occur along the Highway 101 corridor and the center of the county would remain less developed. The western third of the county would be preserved for ranching (many of the ranches are in the national parks), for recreation dependent on the area's natural qualities, and for small towns.

Thanks to the defeat of the developments and roads, as well as the new zoning and the new countywide plan, none of the ranch lands of West Marin were subdivided. A few ranchers went out of business. The others changed their ranching operations and, like the Stewarts, adapted to being in a national park. The Stewart ranch is in a narrow part of the valley next to Olema Creek, and Boyd and his daughter, JoAnn, knew that their settling pond would sometimes overload and contaminate the stream. This was about to become unacceptable, so in 1970, they closed their dairy and switched to beef cattle. The family diversified its business, which includes not only ranching but a boarding stable for privately owned horses near the ranch house and a horse camp a half mile south off Highway 1. People trailer-in their mounts to camp and ride for a week or a weekend. At the camp, Boyd built a brick barbecue over the site of old rock-lined Mexican-era barbecue pits. And the family continues to take good care of its land (figure 8).[32]

The Bolinas Lagoon plan, the proposed new roads, and the hair-raising campaigns to get Point Reyes National Seashore and to defeat Marincello showed Marin County residents how easily the glory of their surrounding scenery could be threatened—and how much effort it took to preserve it permanently. The new countywide plan garnered broad public support. However, no matter how successfully the people of Marin had resisted these earlier plans, it was evident that time

Figure 8. *Four Generations of Ranchers:* Boyd Stewart, his daughter, JoAnn, granddaughter, Amanda, and great-grandson, Stewart Campbell, embody continuity on the land in the Olema Valley. The portrait of JoAnn on her horse is by a family friend. (© Art Rogers/Point Reyes, 2000.)

was on the side of the developers because zoning is impermanent, every private owner has the right to develop his land in some way, and roads may follow development as well as precede it. When people became aware of a campaign for a second national park, their environmental education, their experience with conservation campaigns, and their endorsement of the countywide plan carried over into support for this new campaign. Together, the countywide plan and the legislation for the Golden Gate National Recreation Area would give an enduring affirmative answer to the question "can the last place last?"

ALCATRAZ IGNITES THE PARK IDEA

The island of Alcatraz, 22 rocky acres in San Francisco Bay, is roughly halfway between the northern and southern ends of today's Golden Gate National Recreation Area. Included in the original boundaries of the park when it was authorized in 1972, Alcatraz Island played a major role in getting the Golden Gate national park proposal on the drawing board and then helped provide a rationale for pushing it forward.

Alcatraz, windswept and often shrouded in fog, is the summit of a mountain drowned when the ice age came to an end. It was named by the Spanish for the cormorants who nest there, who reminded them of the *alcatraces* of their homeland.[33] Alcatraz was declared a military reservation in 1850. The Alcatraz lighthouse, the first on the Pacific coast, went into service in 1854 and the Army began to ring the island with gun batteries (figure 9). From then until 1907 the island was a military outpost, and from the Civil War until 1934 it was also a military prison. In 1934 it became a maximum-security federal penitentiary. Gangster movies made it infamous around the world, and it was nicknamed "the Rock." When I first arrived in the Bay Area, the federal prison was still in operation, and I couldn't escape the presence of the prisoners in the midst of the expansive view when I walked along the San Francisco shore.

In 1963, deploring the notorious site as ineffective and expensive, the Bureau of Prisons closed the penitentiary. The old buildings needed millions of dollars in repairs. The island was dependent on imported water, electricity was supplied by generators, and its sewage and refuse were dumped directly into the bay. Beginning in 1964, the GSA offered the island to other federal agencies. None of them wanted it. Because of the island's notorious past, the State Department discouraged a proposed monument there to celebrate the founding of the United Nations in San Francisco after World War II.[34]

With no federal agency willing to take over Alcatraz, the island became surplus government property in May 1968. The City of San Francisco asked for the island and was told to prepare a plan. In September 1969 the city's board of supervisors approved the housing, restaurant, and space museum proposal of the Texas oil baron Lamar Hunt. Conservationists began a "save Alcatraz" campaign to prevent commercial development in the middle of San Francisco Bay. Aimed at the board of supervisors and Interior Secretary Walter Hickel, the campaign included a full-page newspaper ad that was effective on both coasts.[35] Secretary Hickel ordered the Bureau of Outdoor Recreation (BOR), an Interior Department agency created in the early 1960s, to study the problem and find an alternative to San Francisco's plans for Alcatraz.

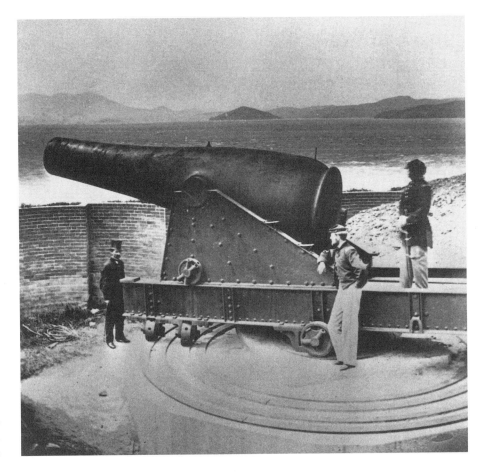

Figure 9. *Fortress Alcatraz: Before its use as a military prison and later federal penitentiary, Alcatraz was part of San Francisco Bay's coastal defense system. By the early 1860s Alcatraz bristled with 111 cannons, making it the most powerful fort west of the Mississippi. Depicted here is a Rodman gun at Battery Halleck in about 1868.* (Courtesy the Bancroft Library, University of California, Berkeley, Eadweard Muybridge; copy courtesy Golden Gate National Recreation Area, Park Archives, GOGA-2316.)

Then on November 20, 1969, a group of eighty-nine Native Americans landed on Alcatraz and began an occupation intended to call attention to the plight of Native Americans, their unfair treatment at the hands of the federal government, and the need for Indian self-determination. For Hickel and the Nixon administration, the occupation—which continued for nineteen months—turned a thorny problem into a political headache.

The BOR team presented its report, "A New Look at Alcatraz," to Secretary Hickel on November 25, 1969, five days after the Native American occupation began. The team called for the Interior Department to take over the island and suggested including the island and obsolete fortifications in a West Coast counterpart to the Gateway National Recreation Area proposed for New

York harbor. The report recommended that Secretary Hickel ask for a comprehensive study of Bay Area recreation resources and noted there might be other parks to be created across the country from underused military land.

The idea that national parks should better serve urban people had been part of Interior Department thinking since at least January 1962. That was when the same Outdoor Recreation Resources Review Commission report that helped justify the authorization of Point Reyes National Seashore informed Congress of America's outdoor recreation resources and needs. It called for a comprehensive, long-range agenda to meet the growing demand for outdoor recreation, especially in and around cities, where one-fourth of our nation's recreation facilities served three-fourths of our people. (The report had also led to the establishment of the Land and Water Conservation Fund and the BOR itself.)

But the idea of creating a whole new series of parks near urban areas—where the costs of acquisition and operation would be significantly higher than in other national parks—proved to be controversial. When the BOR completed the first version of the National Outdoor Recreation Plan in 1969 calling for a five-year, $6.3 billion federal investment in parks for urban residents, the plan was endorsed by Interior Secretary Hickel and President Richard Nixon, but the Office of Management and Budget balked at the cost and delayed its release. A watered-down version excluded the boldest ideas and reduced the cost. The National Outdoor Recreation Plan was set in type but never published, and it was a long while before the public heard anything about it.[36]

"A New Look at Alcatraz" was thus treading politically sensitive ground. But despite suppression of the National Outdoor Recreation Plan, the BOR believed there were opportunities to create new parks, and that Alcatraz could be part of such a park. Its recommendation needed the endorsement of the secretary of the interior—and the BOR got it. To the surprise and delight of many, the former governor of Alaska, a man with no urban experience, actively supported creating the new parks.[37]

On December 2, 1969, Secretary Hickel asked the BOR and Park Service to do a more detailed report, "encompassing the public lands framing the entrance to the Bay."[38] The first draft of this report, prepared in only two weeks and entitled "The Golden Gate—A Matchless Opportunity," was the first federal document to outline plans for a new national park centered on the Golden Gate. But although the BOR and the Park Service spent the next nine months revising it, it too was never made public.

This first draft of "The Golden Gate—A Matchless Opportunity" preceded my involvement in the park campaign by only a few months. During 1970, as the park campaign coalesced, those

of us advocating for the park would learn of the existence of the report but, unable to get a copy, would be forced to work for our goal with only a general understanding of what some people in the federal government had in mind.

In any case, despite government secrecy, the Alcatraz issue helped spur the Department of the Interior to study seriously the idea of a new federal park at the Golden Gate. And apparently the Native American occupation had provided an additional reason for the Nixon administration to support the park proposal. In 2002 when I interviewed Brian O'Neill, one of the authors of the BOR report, he acknowledged that many in the administration saw a Golden Gate National Recreation Area as a practical way to deal with Alcatraz: "It was actually convenient to say that you could solve the Alcatraz dilemma by incorporating it within the concept of this new national park idea."

3

A NEIGHBORHOOD ISSUE BECOMES MUCH BIGGER

As a wife, mother, sometime artist, and Sierra Club member at the beginning of 1970, I had heard about the struggles between pro-development interests and conservationists in the Bay Area, but I was not politically active. By May of that year, I had become deeply involved in an exciting campaign for a new national park. I could see that if the campaign were successful, the park would end a host of conservation and development conflicts, and the Golden Gate's stunning landscape would be safely protected for public use for all time.

During the next eight months, the campaign grew by mobilizing volunteers, lobbying legislators, and gathering together the ideas of experienced activists. Gradually a group of park advocates shaped and expanded a vision for the park. Throughout the year we had to alternate between campaigning for the park and fighting more immediate threats to the land we wanted to save. By year's end, we were far more experienced and buoyed by our successes, but we could see that we would have to intensify our efforts greatly if we were to get the park.

SAVING EAST FORT MILEY:
AN END IN ITSELF AND A BEGINNING

In March 1970 a neighbor told me that members of the new Outer Richmond Neighborhood Association were going to meet at the local library to talk about various issues in our part of San Francisco. It struck me as a good place to find a community project to work on. The featured speaker was Roger Hurlbert, a neighborhood services advisor for the San Francisco Planning and Urban Renewal Association (SPUR). Roger told us about a plan by the General Services Administration (GSA) to construct a huge federal archives building on nearby East Fort Miley, a remnant of one of the Golden Gate's numerous outmoded harbor fortifications. He said that SPUR considered the proposal a bad idea. The neighbors agreed. When I got home, I took out a map to find the fort; it was only a few blocks uphill from where I live. Vegetation behind the rusting chain-link fence that ran across the steep hillside hid the fort from view—and also made it seem inaccessible. Helping keep a behemoth out of my neighborhood would be useful; I still wanted to check out other projects.

George and I were members of the Sierra Club. Continuing my personal exploration, I next went to a Sierra Club Bay Chapter meeting. The archives building was on the agenda. I listened for a while, then said I lived nearby, and offered to look into the matter. No one knew me, but the group was glad to have a new volunteer. The chair asked Becky Evans, a chapter activist, to help me and suggested I phone the lawyer Gene Brodsky and his wife, Kitty, who also lived near East Fort Miley. They were co-chairs of the chapter's conservation committee but were not at the meeting. When I called the Brodskys, Gene said that East Fort Miley was one of forty issues facing the Bay Chapter. If I wanted to make this one mine, great. He said it didn't especially stand out from the menu of issues facing the Sierra Club.

A few days later an article about "a warehouse bigger than a football field" appeared in the *San Francisco Chronicle*. The director of the San Francisco Planning Department had called the archives "the wrong building for the wrong site." The San Francisco Board of Supervisors had passed three resolutions to retain the former fort as open space, but the city had no legal means to block or alter federal plans.[1]

I phoned Roger Hurlbert, who told me to call his boss, SPUR's executive director, John H. Jacobs. John was glad to hear that the Sierra Club was interested. "That land's important. It's supposed to be part of Headlands National Park," he said. "There's an Interior Department plan for

a park on the headlands of the Golden Gate, like one they're considering for New York and New Jersey." I felt catapulted out of my neighborhood into something extraordinary. East Fort Miley was not just an item on a menu of issues—the whole spectacular Golden Gate was involved! If people who wanted to save a much bigger area said that a public park was the way to save it, well, I could understand that.

Becky Evans and I went out to explore a suddenly more significant East Fort Miley. Under its big pine trees were several small, derelict, asbestos-shingled buildings and a row of concrete bunkers and gun bays, most of which had been built around 1900. Looking east, past the Palace of the Legion of Honor art museum, Lincoln Park golf course, and downtown San Francisco, we could see Mount Diablo, 40 miles away on the other side of the bay. Becky and I also visited the San Francisco Recreation and Park Department's West Fort Miley, on the other side of the Veterans Administration Medical Center, and looked over its fortifications, green lawn, and ocean views. When we reported back to the Sierra Club committee that East Fort Miley should be in a national park, the committee passed a resolution of support.

I phoned the Outer Richmond Neighborhood Association's president, Ken Hunter, to tell him what John Jacobs had said and what the Sierra Club had done. Soon after I met with Ken, an insurance company lawyer, and his wife, Diane, a feisty public health statistician. They were both avid hikers. Ken said that he had already sent several letters to agency officials and legislators, and that he had exchanged letters with the regional administrator of the GSA. The administrator had first replied that the archives building would "be consistent with the Administration's urban open space objectives." Ten days after that, on February 13, 1970, he had said that he might review his original decision because the president was giving priority to open space in urban communities. Then on February 20, the administrator had flip-flopped again: now it was "imperative that we continue with our planned use of the Fort Miley property" because of timing and apparent agreement by neighborhood and city officials.

But neighbors and city officials agreed that East Fort Miley should remain as open space! And if we saved East Fort Miley, we could help get a national park! I was thrilled at the idea of a big park at my doorstep, more than I'd ever dared to imagine. With an air of wondrous innocence, Ken and I told each other that a national park would be a great thing to have. Together we shaped a slogan: we would "save the headlands of the Golden Gate for public use in perpetuity."

Next we realized that parts of the federal government were now fighting each other, and that this would embroil the City of San Francisco and local conservationists. The GSA, responsible

for federal real estate, wanted to put the new archives building in the former fort because the archives' downtown building was to be razed for a freeway; the VA Medical Center wanted the East Fort Miley leftovers for a parking lot; and the Department of the Interior wanted the fort for a national park. The city, we learned, was in the same camp as the Interior Department: the San Francisco Planning Department's evolving comprehensive plan said the fort should be part of the city's greenbelt. That was good news.

Even so, the prospect was intimidating. The park would have to be supported—and the archives building opposed—by a host of people, especially the two congressmen whose districts spanned the city: Phillip Burton, a tough, old-school, big-city Democrat, and William Mailliard, an upper-crust Republican from an old California family and a retired Navy admiral. We would also need the help of our state assemblyman, Leo McCarthy (D-San Francisco), California's two senators, Democrat Alan Cranston and Republican George Murphy, and San Francisco's planning commission and board of supervisors, as well as conservation and civic organizations and more neighbors.

SPUR told us our first job was to supply potential park supporters with information and elicit letters of support and pro-park resolutions from organizations. We were helped by Assemblyman Leo McCarthy's aide Art Agnos (years later elected mayor of San Francisco). Within six weeks Ken, Diane, Becky, and I had a stack of letters and testimony extolling East Fort Miley's views, beauty, recreational possibilities, historical interest, and future place in a national park. Trundling these papers to the city's planning commission, and to city, state, and federal elected officials, we effectively demonstrated the breadth of opposition to the proposed archives and the strength of community support for the park.

Before we could go much farther in pushing for a new park, however, we had to defeat the immediate threat posed by the archives building, and a clearer idea of the GSA's plan would help us see if the federal government's needs could be met somewhere else. Roger Hurlbert visited the existing downtown archives building. "The *Chronicle* is right," he reported. "It's a warehouse. All that agency wants is fifty-two offices facing the Golden Gate." Roger suggested that the archives belonged in an industrial area with good public transportation. Undoubtedly it housed valuable historic documents, but a GSA spokesman later told a neighborhood meeting that more than half the documents were old IRS returns.[2]

Then we caught wind of something the GSA wanted to keep secret. Anna Lenn, a newspaper reporter who lived across the street from East Fort Miley, had a friend at the GSA. The friend had

told Anna that the current archives plan was only the first phase of the project. Anna shared this information with us in early May and said such deception should be exposed at a press conference. She organized her immediate neighbors into the Committee Against the Mutilation of Fort Miley and asked Ken and me to help. Ken wrote a press release headlined "Reporters Are Invited to Attend as War Correspondents," and Anna briefed me on what I should ask at the press conference.

On the grounds of the fort at two o'clock that Friday we surrounded tiny, gray-haired Anna. The reporters flipped open their notebooks. The architect of the archives building stood before us and described the drawings on his easel. Anna surreptitiously signaled me. "When you build the second phase of this project," I asked the architect, "what will happen to the bunkers?"

"Oh, when we build the archives building, nothing will happen to the bunkers," the architect replied.

"That isn't what I asked you," I said. "When you expand into the next phase of the project, what will happen to the historic bunkers?"

"Uh—when we expand the project, all of the first bunker and half of the second one will be covered."

Anna faced the group, jumped up and down, and shouted, "Expansion? Expansion? We never heard of an expansion!"

The reporters took notes. The architect rolled up his drawings and left.[3]

The archives fight wound down over the next two months. SPUR invited reporters to another confrontation at the site on a day, as it happened, when we could barely see the nearby art museum for the summer fog, much less the spectacular distant views. The GSA said it would review alternatives to the proposed building. As we stood shoulder-to-shoulder under umbrellas, I asked SPUR's associate director, Michael Fischer, "Now that they seem to be giving up, what's the next step to getting a park?"

"All you need is an act of Congress," he said and laughed.

The GSA did give up soon after that. The *San Francisco Chronicle* published "U.S. Drops Plans" on July 3, 1970. (Today the archives are housed in an enormous concrete building in a federal enclave near the San Francisco airport.)

A few months later, after initial legislation to authorize the national park had been introduced in the House of Representatives, I ran into Michael and gave him an update on our act of Congress. He apologized for having been flippant. "That wasn't nice of me," he said.

"It's OK, Mike," I replied. "You simply told us what we had to do."

THE PRESIDIO UNDER SIEGE

East Fort Miley was not the only endangered fort. Fort Mason, the remainder of Fort Funston, and the Presidio were all under siege. By 1970 a series of proposals had surfaced for a big apartment house development and a federal prison at Fort Mason, a parking lot for San Mateo commuters at Fort Funston, and a Food and Drug Administration building on the Presidio. Frustrated by expensive San Francisco land prices and rents, space-hungry public agencies and private developers were casting their eyes on the fallow land. They believed underused government-owned land translated into available real estate. Intense civic and political pressure, along with exposure in the press, had to beat back each proposal.

We heard of a new threat to the Presidio's bucolic acreage in June 1970. It became another issue we had to deal with, but it also built support for the park campaign. The city's board of education and Army brass proposed building two new elementary schools on the post, so its children would no longer need to be bused to city schools. The proposal was based on school needs projected in a 1951 survey, but San Francisco's school population had actually shrunk over the following nineteen years. We suspected that the Army was proposing these and other projects as a way of ensuring the Presidio's permanence.

The Lobos Creek school was to be built in a back meadow that the Army used as an athletic field. It was hard to organize public opposition to that site. However, El Polin school was to be built in the middle of the well-known view from Inspiration Point. Reflecting San Francisco residents' deep attachment to the city's treasured views, but aware that the city had no authority to control federal land, the city's planning commission stepped in and voted against El Polin school. Stanley R. Larsen, the Sixth Army general on the post, sent a letter blasting the mayor, telling him that the Army would go ahead and that the planning commission had no jurisdiction.

But someone tipped off Senator George Murphy, who was running for reelection. He apparently pulled some strings. Not long after, John Jacobs was standing next to the infuriated general as he shouted at Congressman Mailliard and some members of the board of education. "The White House" was stamped over "the Department of Defense" on the telegram Larsen waved in Bill Mailliard's face. "STOP THE CONSTRUCTION," it demanded.

EARLY VISIONS AND STRATEGIES

The Presidio schools had been put on hold. During the summer of 1970 our group caught its collective breath and had time to envision what lands could be part of a park at the Golden Gate, and to develop some strategies for getting that land. That summer the Sierra Club leader Edgar Wayburn joined our group and showed us how Alcatraz and the forts we cared about could be connected with Marin County land use issues. The Marincello proposal was not yet resolved and Marin County was still moving in the direction of rapid growth.

When I mentioned Marincello to John Jacobs, he said that fighting separate battles to save the forts would be a losing strategy, but getting behind the national park could save the forts, Alcatraz, the Marincello lands, and maybe a swath of Marin County—and could also help some of San Francisco's city parks. But we had a big problem: John had said there was a plan for two national parks, one on each coast, and we—and he—knew only what he had told us about the government's proposal. I had heard that the Bureau of Outdoor Recreation (BOR) had done a report about our park, but none of us had any idea of what it said, or how to get our hands on it.

The Report We Never Saw

That report was the first draft of "The Golden Gate—A Matchless Opportunity."[4] Years later, I learned that the report reached final form in September 1970. Though we searched for it, we gave up in frustration. I don't know of any effort to distribute it, and there is no copy in Congressman Phillip Burton's copious files on the park in the University of California's Bancroft Library.

I learned more about the BOR report and the circumstances of its writing when I was researching this book. After finally reading the report, interviewing two of its authors, Brian O'Neill and Ray Murray,[5] and reading the transcript of a 1993 interview of Ray, I understood that what had been kept from us in 1970 was an extraordinary government vision.

If only we'd had the "Matchless Opportunity" in hand to quote from! The preface contained an excerpt from President Nixon's environmental message to Congress: "Increasing population, increasing mobility, increasing incomes, and increasing leisure will all combine in the years ahead to rank recreation facilities among the most vital of our public resources. Good sense argues that the Federal Government itself, as the nation's largest landholder, should address itself more imaginatively to the question of making optimum use of its own holdings in a recreation hungry era."

The report made a number of points we could have used as ammunition at hearings. It declared, "There is a very real threat that this vital greenery will be eroded away piece-by-piece." Although it acknowledged that this great area of beautiful open space still existed because of the Army's forts, it noted that the forts' "present use as Federal military reservations no longer serves the highest public interest. Despite the fact that these installations are no longer essential to the defense of the Bay Area . . . the military is undertaking new construction." The report also concluded that "the remaining administrative and support functions that these reservations now serve can be relocated elsewhere. But the Golden Gate cannot be relocated."[6]

The report enumerated many specific proposals, and some of the ideas were consistent with our developing vision. But others were not: for example, a park jointly administered by the federal, state, and city governments, with each agency retaining ownership of its land. (According to Ray Murray, this proposal came about because the BOR study team "looked at how can we carve out the best possible park here, capitalizing on the surplus properties and the existing parklands. And we also felt strongly about having a continuous linkage from Fort Mason and Aquatic Park, all the way around to Fort Funston. . . . So, to make it work politically, we had to embrace the city and the state in a partnership . . . then you didn't have to look at what this thing would cost to operate under the Park Service.")[7]

And yet we would have been so happy to see the practical ideas and the statements of intent where the report suggested that Alcatraz and parts of Fort Mason and Fort Miley be transferred to the National Park Service, and that the secretary of defense be asked to place a construction moratorium on military lands at the Golden Gate, explore relocating military functions in the area, and expedite classification of portions of these lands as excess to military needs so they could be transferred.

I don't know exactly why the report was suppressed, but we may have been better off that it was, even if we were annoyed by its absence. We did not lose time worrying about how the dimensions of the BOR proposal differed from the park we imagined. Nor did we worry about how parts of the new park might be managed. We were not restricted by the proposals of other planners and could pursue our own dreams, unfettered. We simply knew we had a remarkable opportunity.

Ed Wayburn Joins Our Group

Edgar Wayburn, a San Francisco physician and member of the Sierra Club's board of directors, had been looking for years for just such a window of opportunity. He wanted in particular to pre-

serve Marin County lands he had been struggling to save since 1947. When the East Fort Miley cohorts finally met Ed, we were able to give him the prospect of a new national park, and he gave us a broad vision and extraordinary leadership.

I met Ed Wayburn and his wife in late May 1970. Seven weeks into the park campaign, on an East Coast visit, I had taken a side trip to Washington DC, where I briefed the Sierra Club's representative in the capital on what we had learned about a West Coast national park, and went with him to meet with an aide to Congressman Mailliard. After returning to San Francisco, I met with E. Winton Perkins, the regional deputy director of the Bureau of Outdoor Recreation. I'd heard in Mailliard's office that Perkins's agency was doing a report on the proposed park—did he know when it would be released? Perkins and his aides were affable but said only that there was a report and that it would be out soon. Someone asked if I had seen Ed and Peggy Wayburn in Washington. I had to say I didn't know them, and that this project had started in my neighborhood. They told me that the Wayburns would be interested. I made a mental note to find them, but someone else was ahead of me. The Sierra Club's Bay Chapter chair, Bill Simmons, had already arranged an introductory meeting at the Wayburns' home, ten blocks from mine, in the Seacliff District overlooking the Golden Gate. On a June evening Ken Hunter and I told Ed and Peggy about the budding park campaign. "I had no idea this was going on," Ed said, noticeably surprised and obviously delighted.

Ken and I learned that for many years Ed had been trying to preserve the northern side of the Golden Gate. In the late 1940s, dissatisfied with the state park system's progress in protecting Mount Tamalpais, Ed had begun a campaign to expand the park's boundaries. He realized that the boundaries of the state park should be its watershed boundaries, the whole watershed of Redwood Creek, ridge to ridge. His plan was to protect the lands between the state park, the county water district, and Muir Woods National Monument. During the 1960s, thanks in part to the campaign led by Ed, the state had purchased much of the land in Mount Tamalpais State Park. Also, with his friend and neighbor the photographer Ansel Adams, Ed had asked the regional director of the National Park Service to support designation of the Golden Gate as a national monument, but the director said the agency already had enough land to care for. Despite that rejection, Ed had had considerable success saving land in the headlands. As a member of the board of Headlands, Inc., he had helped get parcels of unneeded Army land in the Marin headlands forts into the state park system, and he had hopes of saving several thousand more acres between the Marin forts and Mount Tamalpais.

ED WAYBURN AND THE SIERRA CLUB

Born in Macon, Georgia, Ed visited the Bay Area a half-dozen times in his first eight years with his widowed mother, who came from San Francisco. Then in 1933, a couple of years after finishing Harvard Medical School, he came to San Francisco to live. An avid hiker, he "got into the countryside as much as possible" and frequented the hills of Marin County. "It was mostly privately owned, in large ownerships, and they didn't object to people hiking through. There was no thought it wouldn't always be that way."

Serving as a doctor in the U.S. Army Air Corps, Ed left San Francisco in 1942. When he returned in 1946, the Bay Area had changed. Many returning veterans had decided to settle in the region. In San Francisco, to the south, and across the bay to the east open land was being replaced by housing. "Only in the north, in Marin County, were there wide open spaces," Ed said. He felt that for Marin to remain open countryside, he would have to get involved.

In 1939 Ed had joined the Sierra Club, founded in 1892 by John Muir. By 1946, with some seven thousand members, it was the Bay Area's largest outdoor organization. At this time, it resembled the California Alpine Club and other local groups whose members hiked, climbed mountains, and camped out together. However, the Sierra Club board of directors had several members who were personally and politically powerful. Ed was elected to the Sierra Club Bay Chapter's executive committee in 1947.

Ed divided his time between conservation activism and a thriving medical practice. In 1947 he met advertising copywriter Cornelia ("Peggy") Elliott at a party and invited her to go hiking. Peggy went to the City of Paris department store and bought white shorts, a sleeveless shirt, and white sneakers. Ed and the couple who joined them were wearing jeans, long-sleeved shirts, and hiking boots. They parked at Pan Toll on Mount Tam, 1,600 feet above the ocean, hiked down to Stinson Beach, rented bathing suits, and went swimming. Then they walked back to the car. "When I finally got to the top, I thought I never wanted to see him again. I was so sore the next day that I didn't go to work," said Peggy. "And then he called me and asked me if I would like to go dancing."

They were married six months later. Over the years they often worked together as a

team. Peggy drafted or edited many of Ed's articles and helped lobby people at meetings. She helped organize meetings and conferences and entertained visiting officials.

From 1952 to 1967 Ed systematically explored America's western mountains. Through the Sierra Club, he supported efforts to give more protection to forested land, with boundaries drawn for environmental value rather than for political expediency. Ed became conservation chair of the San Francisco Bay Chapter and the club's delegate to the Seattle-based Federation of Western Outdoor Clubs. When he became its president, Ed urged the federation and the thirty small outdoor clubs to take a more active role in support of Sierra Club conservation projects.

In 1957 Ed was elected a Sierra Club director, a position to which he was repeatedly reelected until 1993. He was president or vice president of the board of directors each year from 1959 until 1971, and during this time the club became bigger, more democratic, and more influential. There were 16,500 members in 1961, and 55,000 in 1967 (today it has 750,000 members). When the club achieved broad national recognition and an effective Washington presence, Ed changed his focus to connecting national figures to the work of the club. He continued a part-time medical practice but became a lobbyist for conservation at the national level, beginning about five years before San Francisco's congressmen introduced the earliest bills to establish the Golden Gate National Recreation Area. Ed lived in Bill Mailliard's congressional district.

Praising Ed's political astuteness in 1985, the environmental writer Harold Gilliam declared, "His success stems from four principal sources: his ability to foresee the future and its needs; his intimate, on-the-ground knowledge of the areas involved; his sagacious know-how in the corridors of political power; and his legendary patience and persistence, which radiate from the quiet serenity of the man himself and infuse his co-workers with hope when all seems lost."

In recognition of his work in the public interest, Ed was honored with the Albert Schweitzer Prize for Humanitarianism in 1995 and the Presidential Medal of Freedom in 1999.

Quotations are from Randolph Delehanty's interview with Ed Wayburn, November 4, 1999; Ann Lage's oral history interview with Peggy Wayburn, 1990; and Ann Lage and Susan Schrepfer's oral history interviews with Ed Wayburn, 1976–81. Peggy Wayburn published five books on Alaska, the redwoods, and the Bay Area; she died in 2002.

Ed thought more deeply about the underlying reasons for conserving wild land and open space than most people. As a physician, he seemed to care about the health of a landscape in the same way he cared about the health of a human body. Up to that point, people had saved land primarily for its beauty but also because it was isolated, steep, lacked access, was being used for ranching, or because other lands could be settled more easily. But Ed Wayburn cared about the big-picture ecological and visual unity of what he saved.

Ed multiplied his personal efforts by working with the Sierra Club and other organizations. He had been instrumental in building the Sierra Club into a national organization with considerable influence in Washington. While continuing to carry on his medical practice, Ed had become an enormously effective advocate for conservation, using the Sierra Club as his base. He now was someone whom leading senators, representatives, chairmen of congressional committees, Interior Department officials, and eventually presidents liked and trusted, and he brought the club's work to the attention of these national officeholders.[8]

Ed's success as a lobbyist came from his affable nature and keen skill in sizing up people. "I learned early that lobbying wasn't just a matter of giving testimony, but it was trying to evaluate the people with whom you had to deal," said Ed. "A lobbyist doesn't vote. He has to be a resource person and a person whom the voter (namely, the congressman, the senator . . .) has to like as well as trust." And as a volunteer lobbyist, Ed often had greater legitimacy in the eyes of legislators than paid, professional lobbyists: "If you're a volunteer from your own state, and you go to your own state's congressmen or your own district's congressman particularly, then you're dealing with . . . what the home folks want and maybe what the home folks will support at the next election."[9]

Ed was an invaluable asset from the moment he joined our group. He steered us away from organizational mistakes and shared his influential political connections. Perhaps most important, his outlook enlarged our vision for the Golden Gate campaign: he wanted a park that would protect the large stretch of open land from the San Francisco forts all the way to Point Reyes.

Dinner with Congressman Mailliard

On June 15, 1970, a month before the archives plan for East Fort Miley was officially withdrawn, Congressman Bill Mailliard introduced the first bill for a Golden Gate National Recreation Area.[10] We didn't know what prompted him. Perhaps someone from the BOR had encouraged him to introduce the legislation. Perhaps he and John Jacobs shared the same information source about

the park proposal: a former aide to former California senator Thomas Kuchel. Perhaps our protests about East Fort Miley had had some effect.

All the land in our growing park proposal was in Mailliard's district, but his bill was painfully limited: it included just those lands immediately bordering the Golden Gate, parts of the Presidio, Forts Miley and Mason, the three Marin forts, and Alcatraz—just those lands the secretary of the interior would agree were "appropriate to preserve in an open atmosphere for recreational use." The bill was referred to the Committee on Interior and Insular Affairs, where it sat. Despite its limitations, we were grateful for Mailliard's bill, although we knew that it probably wouldn't get anywhere, having been introduced so near the end of a congressional session. But the bill gave local government officials notice of the proposed park, which might make a difference if someone came in with a development plan in the area, and it told us that Mailliard was on our side.

Having Mailliard on our side was definitely important: as a Republican his good relationship with President Nixon would be absolutely critical to our success. And over time we came to appreciate his interest in conservation issues. As the ranking Republican on the Merchant Marine Committee's Subcommittee on Fish and Wildlife, Mailliard was a knowledgeable and stalwart supporter of the Marine Mammal Protection Act and the Endangered Species Act. Nearing the end of his congressional career, he was also instrumental in establishing two national wildlife refuges in the Bay Area: San Francisco Bay National Wildlife Refuge for the southern part of the bay, and Farallon Islands National Wildlife Refuge for a cluster of islands 20 miles west of the Golden Gate.

At the end of August, while we were working on the Presidio school issue, the Wayburns suggested a dinner at their home on a Friday night so Congressman Mailliard could meet park supporters from the Sierra Club and other conservation groups. Ed would get some maps from the BOR to illustrate the idea. Mailliard would learn that everyone wanted a strong park bill, and everyone backing his reelection could see how policy was shaped in the Mailliard office. George and I fixed the salad and Ken and Diane Hunter made dessert for the potluck dinner.

Bill Mailliard arrived with his administrative assistant, Marion Otsea, and her husband. Some of us had met Marion during the East Fort Miley battle. After a while, Ed asked me to make some introductory remarks. Then everyone went to the buffet and to their assigned seats. I got to the congressman's side as he was shredding a remark just made by the local environmental writer Harold Gilliam. Speaking mildly, Hal tried again, Mailliard snapped again, and Hal stopped talking. I decided to keep asking Mailliard questions—until he stopped being nasty and began to tell stories

about his family and his exploits, and made light fun of the Sierra Club. He was terse with Ed Wayburn and with others at our table.

In the living room after dinner, Ed produced the maps he had received that afternoon. Then the source of the congressman's anger became apparent. Yes, he'd seen the maps that afternoon in his office—and they were supposed to be confidential. "A federal officer violating his charge," he said. Bill Mailliard surely felt he didn't need People for Open Space, the Marin Conservation League, or any of us for his reelection. He showed no understanding and made no promises. Ed, with his small trimmed beard and bright blue eyes, looked at him steadily and didn't flinch.

After the congressman left with the Otseas, the rest of us had a meeting. We discussed who we would support to run against Mailliard in 1972. Someone said he now understood how Marion Otsea protected the man she worked for. A few days later, Marion told me that Mailliard's pique was indeed based on Ed's obtaining the maps from the BOR. Perhaps Mailliard assumed that they came from the BOR report he had not seen, and that someone turned Ed's request for maps as reference at a meeting with the congressman present into a request made in Mailliard's name—something Ed did not and would never do.

SPUR ENDORSES A GREENBELT

On September 10, the San Francisco Planning and Urban Renewal Association held a conference on urban greenbelts in SPUR's downtown meeting room. Along with sixty other people, I listened to speakers talk about the Bay Area's need for more regional government and a more regional approach to planning for development. I vividly recall the speaker who described the 10-mile-wide greenbelt of farm fields and walking paths around London. Here was another name for what we were trying to do at the Golden Gate.

The conference confirmed what Ed Wayburn had been saying: our region had enough open space for a big park on the Bay Area's ocean coast. Unlike London's circular greenbelt, it would be a north–south linear park, through the hills and along the rugged cliffs and beaches of the Golden Gate. West of the Golden Gate Bridge, in both Marin and San Francisco, open land still predominated because of military reservations, state parks, and city parks. On both sides of the entrance to the bay, there were only a few twinkles of light along the shore at night. There were just a few Army buildings between the Point Bonita lighthouse at the western tip of Marin and the town of Sausalito. On the San Francisco shoreline, Army buildings were surrounded by trees and

open land. Only the Cliff House restaurant and the ruins of the Sutro Baths were privately owned. Except for these parcels, all accessible coastal land between the four San Francisco forts was set aside for public use in parks. These were the first links in what could be a regional greenbelt.

SPUR had an urban orientation to greenbelt matters—a necessary complement to the watershed and habitat focus of Ed Wayburn and the Sierra Club—and made a convincing argument for including the city's coastal parks in the national park. It would make for effective administration but also could help deal with pressing urban problems. A decade after the City of San Francisco bought Fort Funston and West Fort Miley, there were no trails, restrooms, programs, or patrols. Motorcycle tracks scarred the Fort Funston dunes, young men played war games in camouflage uniforms, and many of the visitors I saw there were vagrants. The environment was intimidating. SPUR knew the city's parks badly needed public funding to replace water, sewer, and electrical systems that had worn out, and also to meet higher seismic safety standards. SPUR said our proposed national park offered the city new hope for unused, underused, undeveloped, and undermaintained public land. SPUR's emphasis on how a new national park could help the city's coastal parks—and benefit their many users—gave us the basis for appealing to another large constituency of urban residents.

At the SPUR conference, I experienced the collaborative civic concern of the neighborhood, landscape architecture, planning, architecture, and business leaders that make SPUR so effective. Some of these people had helped defeat development proposals for the Presidio, Fort Mason, and Alcatraz. SPUR's leaders gradually became aware that their organization would have a major role in a park campaign. Some of the people I met that day later gave us money to help meet campaign expenses. In these ways, the conference became the springboard for SPUR to begin sharing our plan for a coastal greenbelt national park with its members and with the public.

SPUR would also help us with the technical support we needed to sustain a campaign. SPUR's downtown office had a mimeograph machine, a secretary, and a staff assistant. SPUR's neighborhood services office was in the Richmond District, where most of us lived. We appreciated Roger Hurlbert's advice, his secretary's swift typing, and his help with the content and form of letters, newsletter printing, and bulk mailings.

Subsequent SPUR meetings and noontime forums spread the word and helped gather support for our campaign. John Jacobs became one of my models for testifying at public hearings. Within the usual three-minute limit, he could gracefully fit in more information than anyone else I've ever met. SPUR's staff was up to date on the intricacies of San Francisco's political alliances and

JOHN JACOBS AND SPUR

Every urban region needs an organization like SPUR that both knows the region's past and makes plans for its future. SPUR began in 1910 as the San Francisco Housing Association, created because civic leaders deplored the tenements built in San Francisco after the 1906 earthquake. In the 1940s it became the Planning and Housing Association. In 1959, when the group's emphasis changed to urban renewal in the fight to keep a vital central city and preempt suburban sprawl, it changed its name to the San Francisco Planning and Urban Renewal Association. This was the name of the organization in 1970, and the basis of the SPUR acronym. Today the acronym stands, but the "R" is for Research.

John H. Jacobs was the executive director of SPUR from 1969 to 1981 and was a major influence on San Francisco's city planning and economic development. He was born into a blue-collar Philadelphia family, served as a paratrooper in World War II, went to college in New Mexico, worked for NATO in London, managed a factory in New Jersey, and came to SPUR from the redevelopment agency in Stockton, California, where he was executive director. "When I came, SPUR was, I think, quite influential . . . the only organization concerned with the entire community," he said.

SPUR had financial support from business leaders and a board that included people of considerable prominence socially and professionally. John's delight was winning sailboat races, and he steered a steady course for SPUR. He was able to forge consensus for the city and the Bay Area with an economically and socially diverse board of community leaders. He supported the rebuilding of the city's financial district with tightly clustered high-rises, the revitalization of the city's neighborhoods, and the preservation of open space around a dense, lively city. Getting city officials and influential people behind the Golden Gate National Recreation Area was one of his major accomplishments—and a personal joy.

The quotation is from Gabriel Metcalf, "An Interview with John Jacobs," SPUR Newsletter/Calendar, May 1999.

shared its know-how as well as equipment. In large ways and small, SPUR taught all of us about civic process, political effectiveness, and conservation in an urban region and was invaluable to the creation of the national park.

A WIN FOR THE PRESIDIO

The Presidio schools issue had not died with the telegram from the White House, and Army brass refused to admit defeat. So during the summer of 1970 we continued to watch the Presidio and also the board of education agendas. Speaking for the Sierra Club at a board of education hearing, Ken Hunter urged that any school decision wait until the BOR released its review of the proposed park, at that time expected in one month. A savvy board member moved to table the item. In early August we were heartened by a news story about a Department of Defense decision: "Mailliard said he had been 'assured' that no new construction of any kind will be allowed in the Presidio until a study of all federal lands in the Bay Area has been completed and evaluated."[11]

The Presidio command did not like that decision, however. Without public notice the school building plan came before the board of education's next meeting as "new business." John Jacobs, outraged, phoned someone. Two weeks later Defense Secretary Melvin Laird sent a "Dear Bill" letter to Mailliard. According to the Chronicle's news story, the letter deplored "the 'inconsistency' displayed by Sixth Army brass which led the Board of Education last week to believe it could approve a project for a proposed El Polin elementary school and another school later." The letter also noted that "in spite of local Army statements to the contrary, 'the planned construction of two dependent schools at the Presidio has been suspended' until fact finders for a proposed Golden Gate National Recreation Area make their report on which Presidio land will best fit into the plans."[12] When Marion Otsea asked us to help Congressman Mailliard find an alternate site for El Polin school, we were outraged.

John Jacobs marshaled his troops for the decisive battle over the schools. Completion of the BOR park study would not solve the problem; Congress would still have to pass park legislation—and the two schools could go forward in the interim. Our counterattack had to squelch the proposal. On October 5, 1970, the Army's troops and "General" Jacobs's loyal soldiers met on the board of education battlefield. John had lined up ten organizations to testify and assigned each of us an argument. The Army sent two busloads of soldiers and their families. We debated before the board.

But the deciding factor turned out to be racial equality, not views or open space. San Francisco's

school system was under court order to integrate. At an earlier meeting, someone had said that the predominantly white and Asian districts of the city next to the Presidio were integrated by African American students who came from the post. After all of us gave our park and environmental arguments, a representative of the NAACP stood up and declared, "If you try to build these schools, which will destroy the integration of the public schools in the Marina and Richmond districts, we will sue you." The board members hastily decided to continue the agenda item to a later meeting.

On October 20 the board of education passed a resolution. They dropped plans for the school in front of Inspiration Point. They would build a school at Lobos Creek, but only after the BOR completed its park study, and only if implementation were consonant with the results of the study. The board also required "full discretion in the assignment of pupils" to prevent racial segregation.[13] The Presidio schools skirmish ended that evening. We never heard anything about the schools again.

WORKING THE LOCAL POLITICAL SCENE

Getting the park we wanted depended on securing the support of the county, state, and federal officeholders whose districts were part of the areas that might be included in the park. Many of these legislators were associated with the so-called "Burton machine" run by Congressman Phillip Burton, whose district included the working-class areas of eastern San Francisco. Then, as now, the Democratic Party dominated the city; much of its political life is divided between party liberals and conservatives rather than between Democrats and Republicans. The liberal wing was made up of Phillip Burton, his brother Assemblyman John Burton, State Senator George Moscone, and Assemblyman Willie Brown. Assemblyman Leo McCarthy, Mayor Joseph Alioto, and Supervisor Roger Boas were more conservative Democrats.

None of these officeholders opposed the concept of a national park, but we were unsure at first of the kind of support we could get from some of them. Congressman Burton had written some letters about Alcatraz and East Fort Miley, so we knew he was in our camp. And of course the liberal Republican congressman Bill Mailliard—whose district included my neighborhood and encompassed all the San Francisco and Marin land in the park proposal—had shown his support for the park by introducing legislation in June.

Many of these men were up for reelection in 1970, but most had only token opposition. We gave out the same information about the park proposal to any incumbent who seemed interested—and to their real or potential opponents if they asked for it—then watched to see how they used it.

Figure 10. *Scouting the Territory:* State Assemblyman Leo McCarthy brought his children along on a Sierra Club hike at Lands End in San Francisco to demonstrate his support for the Golden Gate National Recreation Area. (Courtesy Golden Gate National Recreation Area, Park Archives, GOGA-3380, 87-112-532, People For a Golden Gate National Recreation Area Collection, Al Gonzalez, 1971.)

Assemblyman Leo T. McCarthy became a sympathetic and knowledgeable ally (figure 10). In 1970 he sent out letters and press releases opposing the proposed archives building and Presidio schools, and urging the creation of a park. The archives are "a storage closet for federal paperwork," he said, and he "took sharp exception to declarations by local Army spokesmen that there is nothing in the way of tearing out a particularly scenic portion of the Presidio to build the projected El Polin school for Army children." In the fall of 1970 Leo introduced a resolution in the California State Assembly opposing the archives and supporting the park. Like the Mailliard bill, its purpose was mainly to give notice. (In January 1971 he would introduce a similar resolution, which, when it passed, would show that the State of California supported federal protection of the Golden Gate.)

We focused much of our effort on the Marin and San Francisco boards of supervisors. Marin County's five supervisors are elected by district. Generally, a supervisor would vote for a project in his or her district if it was endorsed by local supporters. In 1970 the Marin board was leaning toward environmental protection, whereas during the 1960s a more conservative board had supported Marincello. (In 1972 a staunchly conservationist board of supervisors would consistently support the park proposal.)

San Francisco's board of supervisors has eleven members, at that time elected at large.[14] They were often helpful to us, especially Supervisors Dianne Feinstein and Ron Pelosi (the brother-in-law of future congresswoman Nancy Pelosi). In 1970 (and continuing into 1972) we could count on a bare majority of six San Francisco supervisors' votes for our park proposal. But we could not always find the eight votes needed to overturn a veto by the city's pro-development mayor, Joseph Alioto.

OUR PARK IS PART OF A—MOSTLY SECRET—LARGER PLAN

We knew the federal government had a plan for a park at the Golden Gate, but we could only guess at the process and its specifics. Finally, in the fall of 1970, the plan—as a concept, without details—was announced as part of a visionary government program to use excess military and other federal land to create local, state, and federal parks.

The Department of Defense owned enormously valuable acreage next to major cities. If the federal government sold this land to developers, some people would benefit—a few to a great degree—but all Americans would be poorer for the loss of major portions of their historic and environmental heritage. On the other hand, if these lands were protected in national parks, they would belong to all Americans, and many urban people who would never see the distant splendors of Yellowstone or Yosemite would have a national park next door.

While it was shaping "The Golden Gate—A Matchless Opportunity," the BOR was studying the federal lands around fourteen urban areas, from the Connecticut Valley to Los Angeles, as part of this Nixon administration program. The Golden Gate and New York's "gateway" harbor area had the highest priority. The program, referred to with the catchphrase "Legacy of Parks," was launched at a luncheon meeting at the White House; we read about it in the *San Francisco Chronicle* on September 15.[15]

Interior Secretary Hickel embraced the vision behind the Legacy of Parks program. When he announced it, he gave the program a populist slogan and said that its purpose was "to bring parks

to the people."[16] Later in our campaign, we often used and sometimes embellished this phrase: "We want to bring parks to the people, where the people are."

Brian O'Neill was the BOR's point man in Washington for the Golden Gate park proposal. When I interviewed him in 2002, I learned more about the inside story of this initiative.[17] According to Brian, "there was an interest in the White House in bringing the mission and values of the national park system to an increasingly urban America." But while the "parks to the people" initiative was circulating in key circles of the White House, he recalled, "it was hard to tell how political it was versus content." In any case, said Brian, "there was enough support for it over in the White House that the secretary of interior then felt that he had sufficient marching orders to move it forward." He said Interior Undersecretary Russell Train was "the insider who made a difference . . . the driving force, the environmentalist within the senior team of the White House," who brought real energy to the decision to put unneeded federal properties to use by establishing new parks.

The gateway parks became a major effort for the White House, according to Brian. Golden Gate and Gateway were on nearly parallel tracks. "They really caught up with each other at a key point in which the . . . gateway parks weren't presented individually but they were presented as a package in the White House, and it was that which led—with a lot of politicking from a lot of folks—to the President deciding this would be a major effort, an opportunity for him to draw attention to his environmental and park platform."

Brian and Ray Murray also told me more about the tortuous route that the federal proposal to create a park at the Golden Gate had traveled in the executive branch. The proposal had been laid out in the original December 1969 version of "The Golden Gate—A Matchless Opportunity," but it had then been further modified by the ambitious BOR study team. Said Ray: "We were all very idealistic and felt passionate about things, and it was the late sixties, and people believed in causes and advocacy and . . . idealism in government."[18] The report was also reworked by a Park Service study team, and by the time they were finished with it, it had doubled in size. Brian told me of the competition between the BOR and the Park Service that was going on at this time: "There was such intense rivalry on these urban studies. Everyone saw that it was an initiative that the secretary wanted and that the White House had an interest in. The National Park Service didn't want to see this new agency [the BOR] take over all the planning for new national park areas."

The revised and expanded September 1970 version of "The Golden Gate—A Matchless Opportunity" formed the basis for the Golden Gate segment of the Legacy of Parks program, but

after it was presented to Hickel it was locked away. Thus in the fall of 1970, even though the federal government was beginning to divulge word of its park plans, our group still had only a general sense of what the BOR proposed to include within the park boundary, and the only map we had seen was the one Ed Wayburn had borrowed from the BOR for the August dinner party with Congressman Mailliard.

Our group of park advocates thought that a park should include San Francisco's coastal land from the San Mateo county line to Fisherman's Wharf; the government would have to buy only the Cliff House and the Sutro Baths ruins. Beyond the Marin forts, we dared hope that the greenbelt would take in all of Marincello, not just the southern part facing the Golden Gate, as shown on the BOR map. Ed thought both our ideas and what he had seen on the map were unnecessarily restricted. It would take just a few more properties, Ed said, for our park to touch Mount Tamalpais State Park and then we would have a much bigger contiguous area of open space and habitat.

Years later, Park Service planner Doug Nadeau told me about a special team that continued to work on the plan for the "Gateway West National Park" (a team, I learned, that Michael Fischer had been invited secretly to join). A government park vision took shape on National Park Service maps. I am told that their maps at times resembled our dream—but our dream continued to grow. By the time their proposed park had doubled in size to about 8,000 acres, ours had become far larger.

PHIL BURTON'S FIRST MOVES IN CONGRESS

We'd been told we needed an act of Congress, so we needed a congressman to introduce a bill. Although the park would be in Bill Mailliard's district, we could see he wasn't bold enough to carry the legislation we envisaged. Phillip Burton, however, was plenty bold and powerful. He was also on the House Interior Committee, which would give him an inside track, and he had a very collegial relationship with Bill Mailliard.[19] Everyone agreed that we needed Phil Burton and that I was to call his office.

My daughter Dinorah and Assemblyman John Burton's daughter Kimi were in the same grade-school class. In early September I asked Kimi's mother how to approach Phil Burton about a bill for a national park. "Wait until his aide Bill Thomas is in town," she advised. "If Phil is interested, he'll work with you."

It turned out that Phil Burton was not only interested, he was also way ahead of us. Therefore, when I phoned Bill Thomas a few weeks later, he needed little explanation about our park idea. "When you called me," Bill later recalled, "I was very happy to find that someone active in the community was interested in it." Apparently, someone from the secretary of the interior's office had called earlier that year, saying they were about to publish a report recommending a Golden Gate National Recreation Area and wondered if Burton would support it.[20]

This interchange had already led to a Burton-sponsored legislative initiative. Burton had waited for the report to come out, but when it didn't, he decided to add the GGNRA to his bill to authorize Fort Point National Historic Site. Told by Burton to "write a bigger bill," Bill Thomas sent a memo on June 24, 1970, requesting House legislative counsel to enlarge Phil Burton's original Fort Point legislation by placing Fort Point within a new national recreation area. This new bill had been introduced in August. It called for a park to be created from excess federal property in the Bay Area and would include the Marin forts, Forts Funston and Mason, the Navy's Tiburon Net Depot, Fort Point, any unneeded federal property on San Francisco Bay or Suisun Bay, and much of the open space of the Presidio, including its golf course. This sweeping bill included a special plan for Alcatraz: Nixon had told Interior Secretary Hickel to get the Indians off Alcatraz, and Hickel said the island should be part of a park, so Burton called for the island to be sold to an Indian corporation as Manhattan Island had once been purchased from the Native Americans—for $24. The new park would be called the Juan Manuel de Ayala National Recreation Area, named for the Spanish captain who sailed the first European ship into San Francisco Bay in 1775.[21] We knew about this bill, but Fort Point and Alcatraz were reported as its major features, the park had an unfamiliar name, and it involved excess federal land all around the Bay Area. It wasn't what we had in mind. Worse yet, in order to kill it, since some of the bill's contents infuriated the military, adroit tacticians referred it to the House Armed Services Committee rather than to the Interior Committee, where park bills take shape. The bill was stalled, and soon the legislation for Fort Point National Historic Site was separated out and enacted in October 1970.[22]

Congressman Burton knew there could be no hearing on a comprehensive park bill so late in the second session of the 91st Congress. Yet both the Burton and Mailliard bills fulfilled an important strategic function: in the coming months, they helped us protect some of the Army lands from incursions and stave off renewed development interest in the Marincello property. Meanwhile, at the end of 1970 we in San Francisco were sure that we had found a strong ally in Congress,

CONGRESSMAN PHILLIP BURTON

Phil Burton had a gargantuan presence and wielded an effective combination of unrestrained imagination, prodigious memory, overwhelming energy, and laser-focused, effective lawmaking. Only after working with many legislators since 1970 do I appreciate how he saved more of America's natural, scenic, and historic heritage than anyone since President Theodore Roosevelt. The public lands and monuments that were protected through the efforts of this very late New Deal Democrat, this very urban man, are extraordinary.

"It took a while for me to appreciate his legislative brilliance, his singleness of purpose," said the former San Francisco Democratic Party chair Agar Jaicks. "Phil could be oppressive. He created difficulties even for the people closest to him. . . . He was going to achieve political power, assert his ideological and philosophical position . . . dedicate his entire life and energy to it. . . . Somewhere down the line he would be able to be President of the United States. . . . He grew up dreaming that that would be his final place in the political process. . . . I'm sure that dream never left him. . . . I have never been able to decipher where this incredible energy came from."

Phil Burton's father, Thomas Burton, worked at a variety of jobs and was away from home during much of his three sons' childhood. Phillip, the eldest, was born in 1926. They lived in Milwaukee, where the family fluctuated between comfort and poverty. In 1936 Thomas Burton began medical school in Chicago, and his wife provided the family's principal support.

Milwaukee had a strong social welfare tradition and a progressive government. Phil heard Franklin Delano Roosevelt speak when he campaigned there in 1936 and traced his interest in politics from that event. The family moved to a more affordable, predominantly Jewish neighborhood. They listened to radio broadcasts on Kristallnacht in 1938 when the Nazis destroyed thousands of Jewish homes, businesses, and synagogues, and they sympathized with their new neighbors. The Burtons supported Roosevelt, the Spanish Loyalists, and progressive causes.

For his medical residency in 1941, Thomas Burton moved his family to San Francisco. Phil excelled academically at Washington High School, sold newspapers, and ran suc-

cessfully for student office. Friends from those days say he had a need to dominate. On graduation from high school in 1944, Phil was recruited for naval reserve officer training and attended the University of Southern California in Los Angeles as a navy ensign and premed student. When World War II ended, he changed his major to prelaw and dropped out of the navy program. His father cut off financial support after a falling-out; Phil paid for the rest of his college education and graduated from USC in 1947. He returned to San Francisco, where he lived at home and earned money selling gas station leases. He also went to law school at night and got involved in the local Democratic Party.

Sala Galant Lipschultz met Phil Burton through a Young Democrats group. Sala had come to San Francisco in the 1930s with her family, Polish-Jewish refugees from the Nazis. Phil and Sala married in 1953. For more than thirty years, Sala cared for him, worked at his side, strategized, and helped smooth his social and political rough edges. "Politics was his whole life," she said, "except when he came through the door alone." Many party regulars hated Phil Burton's aggressive grabs for political power, and on his first try for elected public office in 1954 he lost the primary election for assemblyman to a candidate who had been dead for several weeks. With Sala's help, Phil mended some fences, ran an intensive door-to-door campaign, and was elected to the Assembly in 1956.

In California's Assembly chambers, legislators are seated two by two; John Knox was Phil's seatmate. "Legislative legerdemain," Knox called Phil Burton's style. "The premier legislative operator—I've never seen anyone before or since who had the legislative skills. He knew who his colleagues were—what to expect of them—how far he could push people whether they were Republican or Democratic." Knox recalled how much people respected Phil and his tremendous abilities. "He was a totally honest person—his reputation was that here was a person who was totally devoted to his principles. He absolutely would not deal with anybody on any other basis. . . . People on both sides of the aisle knew this." Knox added, "He knew more about my district than I did—and he knew it for every district in the state. His retention of factual material was beyond understanding. He loved the process . . . so exciting what you could do with it."

In Sacramento Phil Burton worked on a wide range of social issues, including labor, welfare, needy children, civil rights, programs for the deaf and hard of hearing, wage protection, low-income housing, and disarmament. He sponsored and carried a succession of socially progressive bills after he went to Washington.

(continued)

and we rejoiced that the two congressmen's bills had set the stage for introduction of real legislation in the first session of the 92nd Congress the following year.

MORE SKIRMISHES

At the end of 1970 and into early 1971, the Army lands we wanted in the park were still the target of groups with their own narrow agenda. As we saw it, they kept trying to spoil the area, and we had to keep telling them to stop.

In December 1970 the San Francisco wildlife advocate Bruce Keegan saw duck blinds for Army hunting on Rodeo Lagoon at Fort Cronkhite. He went to the city council of Sausalito, which unanimously voted to oppose hunting so close to its borders. Bruce called me, and I called San Francisco supervisor Ron Pelosi. Ron asked the Presidio command to ban hunting on the lagoon and introduced a resolution at the board of supervisors endorsing a ban. The resolution was to be discussed

at a board committee meeting chaired by Supervisor James Mailliard, the congressman's brother. I went to Marion Otsea, who asked me to see if I could find a Marin County regulation saying that this kind of shooting wasn't allowed on private land—without mentioning the congressman's office.

I learned that Marin County was closing down two hunting clubs, and that Supervisor Michael Wornum had just placed a resolution before its board opposing the Fort Cronkhite duck hunt. So I arranged to find out the Marin resolution's result and transmit it to the Sierra Club college student who had volunteered to represent our interests before the San Francisco committee that afternoon. At 12:30 Marion Otsea phoned: General Larsen had issued a press release about putting a moratorium on hunting. At 1:40 the Marin County board passed its resolution unanimously. At 1:45 the student phoned. At 2:00 the San Francisco board committee met and unanimously passed its resolution. On January 1, 1971, Larsen's moratorium became a permanent ban. Much of the ready community opposition stemmed from feelings that the Army operated a privileged preserve for its Presidio officers: a horse stable on Fort Barry, duck blinds on Fort Cronkhite, a yacht harbor on Fort Baker, a golf course and elegant homes on the Presidio's hills. The opposition also obliquely showed dislike of the war in Vietnam.

We had another little fight about the Presidio in January 1971. Kent Watson, the conservation chair of the Sierra Club's Bay Chapter, had asked George and me to join him in taking Ed Peetz, a family friend, to dinner. Ed and Kent's father had worked together for the Park Service at Cape Hatteras, and Ed was now chief of the Park Service's Division of Urban Park Planning. At dinner I told Ed about our group, and while Ed didn't say much about Washington, he quietly mentioned that he and the Park Service planner Doug Cornell had seen bulldozers that day on Baker Beach in the Presidio. The next morning, SPUR's Roger Hurlbert and I went out with a camera and chased dump trucks of sand and gray sludge across the Presidio. Back home I phoned the post agronomist. He was proud of his project. They were removing the sand cover at Baker Beach and giving it to a drainage pipe contractor at the other end of the post. In place of the sand, they had dumped concrete refuse and old bedsprings, then covered it with the clay soil the contractor didn't want. They would plant trees over it, he said, and make a nice beach park. It didn't sound like a park to me. Because the project was in Mailliard's congressional district, I protested to Marion Otsea, but nothing came of it.[23] I learned later that when Ed Peetz went back to Washington and told others what we were trying to do, he said we were facing obstacles and had urgent problems but were fighting hard for our park, unlike some groups in other urban areas that were also under consideration.

Soon after the Baker Beach episode, I got a notice from the Bay Conservation and Development Commission, an agency that guards San Francisco Bay and regulates development along its shoreline. The telephone company planned to lay an underwater cable across the Golden Gate and to construct a building on each side. SPUR's Michael Fischer advised me, "Don't worry about the cable. Worry about the concrete buildings—more than 15 feet high and wide—and ugly!" I complained to the phone company: "Why can't you put the equipment underground or into the cliff?" An engineer said the cable could not be stretched further. I called John Jacobs. "If they can send a man to the moon," he said, "they can stretch that cable. Tell them SPUR is putting its phone engineers onto the matter." "Who are they, John?" I asked. "I don't know; we haven't got any. But tell them anyway." So I did. Suddenly there were two engineers on the line, talking mostly to each other. When they spoke to me, I deferred to "SPUR's technical experts." They said changes could be made. They would discuss them with the SPUR engineers. I reported back to John, who said he was still looking for someone to help.

A day later I showed the cable notice to Doug Cornell. "The Army gave them permission for that?" he exclaimed. "That's our land, not theirs! It's part of Fort Point!"[24] Doug phoned the Park Service's regional director, who said he would take over the problem on the Presidio side of the Golden Gate and also offered technical help with the building proposed on the shore of East Fort Baker on the Marin side. Some months later, the phone company sank their Presidio substation into a hillside and the Marin substation was buried under a pile of rocks topped with a metal door. Michael Fischer sent me a letter of thanks, embellished with a big gold notary's seal.

SEASONED AND COMMITTED VOLUNTEERS

During 1970 the East Fort Miley fight and the organizing that followed gave us a crash course in American government—and much more. The foxhole buddies became comrades-in-arms and friends for life. We generated fat folders of testimony, letter drafts, and photos, shared homegrown apples and tastes of new desserts, and dropped in on each other's homes and offices to plot our next maneuvers. At the Sutro Super grocery store on Geary Boulevard I'd meet one of the Hunters shopping for dinner or query the Sierra Club hike leader Pete Erickson as he picked up groceries on his way home to Sausalito or share updates with Gene Brodsky in the aisle.

Years later, John Jacobs described our exuberant spirits at this time: "We were all looking to the future—we were convinced we were right. We knew the Bay Area would continue to grow

and open space continue to be threatened. There have been so few occasions in my life when I could be so certain I was right . . . usually there are nagging doubts. . . . We went forward without a doubt, a luxury we can seldom afford ourselves."[25]

Our grassroots activism grew out of progressive movements that spread across the United States after World War II. Some of our group had participated in the 1960s "freeway revolt" that kept a highway from slashing through Golden Gate Park; others had marched against the war in Vietnam; some of us celebrated the first Earth Day on April 22, 1970.[26] Our small victories during 1970 were great fun. They motivated us and augmented our enthusiastic idealism. No one would thoughtlessly exploit the Golden Gate! We would preserve our glorious hills and wildlife for everyone! But after Ed Wayburn outlined a park of 10,000 acres at the Sierra Club board of directors meeting on December 5–6 and persuaded the board to endorse the idea, we saw we would have to become much more politically sophisticated to reach our grand goal.

4

ORGANIZED ADVOCACY

At the beginning of 1971, upbeat and awaiting new legislation to be introduced in Congress, we took stock of what we needed for our campaign. We needed an explanatory paper that justified inclusion of the land we wanted in a national park. We needed maps with property and boundary lines; our existing maps were merely schematic. We needed prototype legislation that would describe our expectations for the park. And we needed an organization that could carry out a more complex campaign. Within a few months, we had all of these and more, including legislation that came close to expressing our goals for the GGNRA.

PEOPLE FOR A GOLDEN GATE NATIONAL RECREATION AREA

Throughout 1970 most of the efforts to push for the new park were the work of the loose-knit group of activists who came together to fight the East Fort Miley proposal, with the help of Ed

Wayburn, the Sierra Club, and John Jacobs and SPUR. Then on a November afternoon, shortly after Bill Mailliard had been reelected to his House seat, Marion Otsea phoned me to say it was time to organize a park campaign. I listened uncomfortably as she proposed a park support committee based in the Mailliard office. While Marion's call for a campaign committee was right, it was obvious that the committee had to be politically independent and could not be the captive of one congressman. I said I had to consult with others, eased myself off the phone, and called Ed Wayburn. "We can start an organization faster than she can," he replied.

Those two phone calls got us going. When I told John Jacobs what was happening, he endorsed an independent, single-purpose organization. "Otherwise, the park will fall between the chairs," he said. "Sierra Club and SPUR have too many other projects." Between Thanksgiving and New Year's Day Becky Evans, the Hunters, and I phoned people who would take an active role in a campaign and mailed information to them and to environmental and civic groups in San Francisco and Marin. I called Marion to tell her we were organizing an independent committee because it would have broader membership and bipartisan access—and had decided to exclude all elected officials, their representatives, and the press from the initial gathering. She was somewhat mollified when I promised I would call her after the meeting.

On the evening of January 6, 1971, in the meeting room of the public library's Richmond District branch, thirty enthusiastic people gathered to plot the creation of a national park. Ed and I put up a map, I gave a slide show, and Ed led the discussion. The park's outlines were unclear; Ed kept waving his hand beyond the upper part of the map to indicate a park that would share a boundary with Mount Tamalpais State Park. He explained the congressional legislative process and suggested "People For a Golden Gate National Recreation Area" as a name for the new group. It was clear but not brief and did not permit a neat acronym. Even so, PFGGNRA, pronounced "piffgunura," was certainly—in the words of a Sierra Club wag—"the social disease you would most like to catch."

In a fortuitous organizational ambiguity, Ed was elected chair and I was elected co-chair of the new organization (figure 11). Ed knew most of the federal and state legislators with whom we would deal during the campaign, but he also had his daily medical practice. Every week I would be meeting with the local conservation- and civic-minded activists and a variety of political figures and their aides. Ed decided to trust that I would rely on him for policy decisions. I would be dealing with the day-to-day needs of the campaign, and my title freed me to make all the necessary daily decisions. If I went to a meeting without Ed and felt unsure, I could always say I had to con-

Figure 11. *The People behind "the People For"*: Amy Meyer and Dr. Edgar Wayburn at Lands End overlooking the Golden Gate. (Eric Luse, *San Francisco Chronicle*, 1991.)

sult the chair. Frank Quinn, the director of the regional Equal Employment Opportunity Commission, took on the job of San Francisco chair, John Busterud, a former Republican California state assemblyman and Headlands, Inc., board member, agreed to be the Marin County chair, and Becky Evans volunteered as secretary.

We organized ourselves as an ad hoc committee, an informal network of supporting organizations. After a while we defined ourselves in letters and testimony as "a coalition of conservation- and civic-minded groups and individuals dedicated to the establishment of a park on the headlands of the Golden Gate."

The people at the January meeting were all middle class and white, but the park was especially intended for people who had never experienced the national parks. "Many inner-city people have never even seen the Golden Gate," Frank said. "Too many of the people for whom this park is in-

tended are too busy keeping the necessities of life together to help us." He brought in the Bank of America trust officer Lloyd Scott, an African American, to be treasurer. Also, Becky put me in touch with the Sierra Club's Inner City Outings program, which had been created in the 1960s to give inner-city youths outdoor and leadership experiences on hikes and camping trips.[1] We didn't know about the Committee for Better Parks and Recreation for Chinatown at that point, but soon after our founding meeting, that group joined our campaign.

Unveiling the Park Plan

John Jacobs and Michael Fischer invited Ed Wayburn and me to present our national park proposal at a SPUR noontime forum in February 1971. Ed and I worried about premature exposure of the park idea. While it was exciting to test it out on a potentially favorable audience—and indeed the SPUR audience was quite supportive—we were not ready to deal publicly with any negative reactions.

I showed slides and Ed explained the legislative process. The park campaign, along with a map Michael drew, had been the subject of a prominent article in the December 1970 SPUR newsletter, so we had a full audience. The map included land from Fort Funston to Marincello. But Ed kept dropping hints that he was thinking of a much larger park. By this time his mental park map, running off the left and top sides of Michael's map, took in thousands of acres of ranch land north of Mount Tam in West Marin and encompassed a park triple the size of that on Michael's map.[2]

Shortly after our SPUR presentation, Ed went out of town. Then came a bombshell. A *San Francisco Examiner* reporter interviewed John Jacobs, who was mortified a few days later to read an *Examiner* article with "off-the-record" information he had mistakenly trusted the reporter not to print. The article on February 24, 1971, came with an editorial and a cartoon (figure 12).

The article wasn't that bad, but all I could see were words that could kill the park. The article said the Presidio would be "gobbled" in a "coastal takeover." The editorial declared:

The Presidio of San Francisco is threatened as never before. . . . The public should oppose any and all schemes to take away from the Army the Presidio open space that the Army created so handsomely and protected so diligently. . . . All these plans to chop up the Presidio are born of the emphasis these days on conservation, and on creating new urban parks and open spaces. They are well-intentioned though we do suspect that anti-militarists with other motives are helping things along.

Figure 12. *Early Press:* Because many San Franciscans viewed this Army post with affection, and because it had long been a major employer in the city, a local newspaper had a hostile response to talk of the conversion of the Presidio of San Francisco into a national park. (Ken Alexander, *San Francisco Examiner,* February 24, 1971.)

I felt so vulnerable I was unable to separate the two parts of the editorial's conclusion: "All these congressmen, state legislators and federal officials should be told to back off. A Golden Gate National Recreation Area? Fine. More urban parks? Fine. But leave the Presidio alone. It's in good hands."

Sierra Club staff gave me some perspective and located Ed. Everyone reassured me it would work out. We did not send a letter to the editor. The hubbub faded away.

The Campaign Gets Under Way

John Jacobs told me that Frank Quinn envisioned a downtown office and a budget of $50,000 for the campaign. I told John I envisioned clearing a dinette counter next to my kitchen, built for *Sunset* magazine–style buffet dinners, and getting a second phone line. During 1970, we had all paid personally for whatever was needed. Shortly after the January 1971 organizing meeting, John said we would need more than our out-of-pocket money. He gathered a small group of SPUR supporters in his office so I could ask for donations to help pay our bills. Several attendees gave me checks. Only much later did I appreciate John's generosity in tapping some of his own funding base for SPUR.

My chief role in the daily campaign was to connect the efforts of volunteers—I was "a spider in a web," someone later said. Becky sent me a college student, Mia Monroe, who had tried to volunteer at the Sierra Club's downtown office but couldn't find the right job. When the Bay Chapter agreed to pay Mia for a few hours a week of secretarial work, we were in business (figure 13). (Sometimes Mia baked bread with my children after school, my daughter Sharon reminded me, so I could finish a project.) Everyone else, unless employed by another organization, was a volunteer. The only dish that dinette counter ever held was for my lunch—next to the phone.

Ken Hunter and I did a lot of writing. We prepared letters, announcements, and a few press releases, we assembled testimony for hearings, and we drafted model paragraphs for others to put in their own words. Working without today's indispensable personal computer, I would write wide-spaced drafts of letters on lined paper in dark ink, and Ed corrected them with a red pen. If Mia was not available, I tried to get one of my touch-typing neighbors to produce the final copy; my typing required too much correction fluid.

The Hunters and I made presentations to neighborhood, professional, and environmental groups and solicited endorsements in support of the park from every potentially interested organization. We gave slide shows with slides we cadged from anyone who would donate them. Someone gave us space for a photo exhibit with placards of explanation in the lobby of a downtown office building. We handed out a fact sheet entitled "A Park for the People"—the early ones were printed on SPUR's mimeograph machine—at these meetings. We also asked for financial contributions from the group if it seemed appropriate or distributed return-addressed envelopes with our information sheets. People would suggest names of potential supporters, to whom I would send a fact sheet, a letter requesting financial support, and a return envelope.

Figure 13. *Home Office:* Mia Monroe
works in the small den in my home in
San Francisco's Richmond District.
This was the nerve center for the
paperwork of the citizen-activists who
pushed for the creation of the
GGNRA. (Amy Meyer, 1978.)

We were most successful with other organizations when we drafted sample resolutions with phrases to use for endorsing the park proposal, such as "WHEREAS, the nine Bay Area counties are presently losing 25 square miles of open space each year," and "now therefore be it RESOLVED, that the [group] hereby endorses the establishment of a National Recreation Area." Some clauses were more suitable for urban or neighborhood groups, others for suburban, educational, conservation, or civic organizations. We prepared papers with lists of points for letter writing: "The Golden Gate is the western entrance to the U.S.A. and a major national symbol," and "The scale of the

proposed park is such that only federal action can achieve meaningful results." An organization could review the list, choose its reasons to support the park, and recast our phrases to suit its mission. The organization then sent its adopted resolution or official letter to legislators. We asked each group to state the size of its membership, and to cite any unanimous votes. Some groups sent their resolution to legislators with a personalized cover letter for additional emphasis. We also asked each group to send us a blind copy. I don't remember how many local endorsements we collected this way, but the number and variety encouraged more groups to add their names.

Before legislative hearings, we solicited signatures for petitions, such as "We, the undersigned residents of the Marina district, support the inclusion of the Presidio lands in the proposed Golden Gate National Recreation Area," added up the signatures, held up the sheets at the hearing, and announced the total number of supporters.

As this endorsement campaign was getting under way, Ed Wayburn and John Jacobs said People For a Golden Gate National Recreation Area needed stationery. Lloyd Scott asked a graphic artist friend for help, and she designed a simple blue and green logo. The stationery's first edition displayed the names of 68 people, printed down the left-hand side of the paper: our officers, then an alphabetic list of those who had endorsed the proposal in January 1971, other supporting activists, some friendly legislators, and a blue-ribbon group of well-known conservation and civic leaders who each knew either Ed or John.

We used the first stationery to ask more people for the use of their names and enlarged the list for the stationery's next printing. We included a return postcard with our letters of request, with the name to be both printed "as you wish it to appear" and signed, as insurance against any future suggestion that a name had been used improperly. After a few more printings, our stationery listed all the members of the boards of supervisors of San Francisco and Marin counties, the mayors of San Francisco and some Marin towns, all Bay Area state legislators and congressmen, and the two California senators. I phoned people who did not respond quickly to let them know they were about to be left out of a popular campaign and we were going to press. Almost everyone joined us. Printing a sequence of small runs of letterhead was time-consuming and somewhat expensive, but it was well worth doing. We gained visible supporters until there were 85 names on the front and 240 names on the back of the paper. John joked that if we added anyone else, a magnifying glass would have to accompany each letter.

One of Ed's major concerns was that our organization present a consistent strategy and program. During the campaign, different people wrote letters and gave testimony in the name of

People For a Golden Gate National Recreation Area. If anyone wanted to say something personal, he could always do it on his own behalf or in the name of another organization. But if he or she wanted to represent us, the statement had to be reviewed by the person who knew the most about the subject, and also by Ed or me. Ed and I signed most letters jointly, even if drafted and used by others. Everyone understood that if PFGGNRA had expressed a position on an issue to a legislator, someone else representing our group could not change it.

The *PFGGNRA Greenbelt Gazette*

Our supporters were always wanting updates on the campaign. The homely fact sheets sufficed until mid-1971. When it became evident that the campaign needed a real newsletter, we started the *PFGGNRA Greenbelt Gazette*. Ken Hunter was the editor, and Roger Hurlbert got it reproduced from text typed to fit one economical 8½ × 17 inch sheet. The moss green paper was folded so it could be mailed without an envelope; eventually we stapled in a return envelope to facilitate responses to our appeals for money. After some months our new Marin County chair, Bob Raab, was able to get the paper typeset and printed at the company where he worked. The newsletter was published "as needed": to announce legislation, to raise money for our campaign, to give news of ongoing skirmishes and triumphs, and to announce or to report on legislative hearings.[3]

The *Greenbelt Gazette* was sent out by bulk mail, addressed on my dining table. If we were applying labels late in the day and heard the garage door, we quickly stashed everything, and the volunteers got out the front door before my husband came through the back door. George would raise an eyebrow—and laugh as I put plates on the dining table. I also typed a few issues of an in-house newsletter, with a half-dozen copies for our most active volunteers, after a couple of them said they felt "out of the loop." At times, matters moved so fast it was easier to mail out a page or two to keep people up to date; there was no e-mail, of course, and telephone calls took too long.

Public Attention

The fact sheets, and then the newsletter, informed politically active people about the park campaign. They enlisted early. But hikers, bird watchers, and beachcombers also had a stake in the outcome. The Sierra Club helped us find them. For years, the San Francisco Bay Chapter has had more than a half-dozen member-led trips on most weekends and has printed a schedule of its ac-

Figure 14. *Showing Off the Land:* Before there was a park, Sierra Club hikes introduced the public to the Presidio's trails. (Courtesy Golden Gate National Recreation Area, Park Archives, GOGA-3380, 87-112-507, People For a Golden Gate National Recreation Area Collection, Ulrich Claasen, 1971.)

tivities. Fred H. Smith IV, Pete Erickson, and Tom Slattery each led hikes in Marin and San Francisco on lands included in the park proposal. Some Marin walks required permission from private land owners whose property was within the proposed boundary. Becky Evans and Marlene Sarnat organized hikes that crossed the Presidio and got permission from the Army. In this way, many people visited Tennessee Valley, the Marincello lands, San Francisco's western and northern coastal lands, and the military parcels that were to be included in the park (figure 14), and they

could see what their support would mean. The Hunters and I went on these hikes. We gave participants updates and asked for letters of support, copies of photos and slides, and money.

We were wary of stirring up potential opposition to the park. For this reason, we made little effort to attract major media attention, except when we sought publicity to help thwart development and protect the future park's integrity. Articles did appear in Marin County's daily and weekly newspapers, in the two major Northern California newspapers—San Francisco's *Chronicle* and *Examiner*—and in neighborhood and environmental newsletters. On February 17, 1971, the *Pacific Sun*, a Marin weekly, ran an article about The Nature Conservancy's acquisition of the coastal Green Gulch and Slide ranches, noting that "two more invaluable and strategically placed building blocks have been added to . . . a greenbelt that hopefully will stretch from the Golden Gate to the Tomales bluffs." "Morton Talks of Big Park Plan," was the *Chronicle* headline after Nixon's new interior secretary, Rogers Morton, spoke at a San Francisco luncheon on May 25. "Burton Bill for Expanded Federal Park," read the *Examiner* headline on June 29.

We always needed more volunteers and those articles helped. A few times we placed ads in the *Pacific Sun*. "SOS for NRA" was our caption over an invitation to readers to join Sierra Club hikes. Another, "PIFFGUNURA? You Jest!" headlined an account of who we were and our cause and invited readers to ask for a copy of the *PFGGNRA Greenbelt Gazette*. I don't know if any of those ads helped us.

As we enlarged the campaign's reach, money became a problem even though we didn't need very much. Most of our contributors gave us $5 or $10; $50 was a big donation. Faced with bills for stationery, postage, telephone, a telephone answering service (to sound more professional, we didn't use an answering machine), newsletters, and the like, and with $411 in our bank account, I pleaded for money at a meeting of our officers and most active supporters.[4] Becky Evans phoned me the next morning. A "courier" whose name she would not divulge had just given her $400 in $50 bills for PFGGNRA. I gratefully added the new money to our bank account; we now had enough for several months of work.

People For a Golden Gate National Recreation Area held a few public meetings in San Francisco, but we found it more effective to speak before local service clubs, conservation organizations, and neighborhood groups who had monthly meetings and needed speakers for their regular programs. The campaign moved too quickly for us to organize a speakers' bureau. To inform outlying Sierra Club chapters, we made a tape recording timed to a slide show and loaned it out by mail. Most of us wrote personal checks to legislators and candidates who helped us and put

their campaign posters in our living room windows. We told candidates who supported the park where else they might speak to give them—and our cause—more exposure.

REAL BILLS AT LAST

While we were getting PFGGNRA off the ground, we were also tracking the progress of park legislation in Washington. Just two weeks after our inaugural meeting in the public library, we were sadly disappointed when Bill Mailliard introduced new, hardly changed park legislation in the new Congress. Then in early February Phil Burton introduced his new legislation, but his bill had hardly changed either.[5] Again, the House Rules Committee sent it to die in the Armed Services Committee. Bill Thomas remembered confiding the problem of the legislation's committee referral to a friend, who told him that the House parliamentarian went to a bar on Pennsylvania Avenue and that they should go there and talk with him. They did, and he gave them "a few pointers on how to put [present] the bill so it wouldn't go to the Armed Services Committee."

On February 17, 1971, without co-sponsors, Phil Burton introduced another park bill, two-page-long HR 4350. The park's proposed boundary was almost unchanged, but the legislation provided for consultation and cooperation with affected agencies. It was referred to the Interior Committee, which represented progress, but it still wasn't the bill we wanted.

So, as of the end of February 1971, our dreams had not yet achieved legislative expression. None of the bills introduced in Congress so far encompassed more than federally owned, already public land. No bill matched the opportunities of ownership and geography. Later I would learn that this was not because of any lack of vision on Burton's part. When I interviewed Bill Thomas in 2001, he told me that the Nixon administration's policy at the time was to oppose national park legislation that included the purchase of private land, so Burton and Mailliard were under pressure to limit their bills to land in public ownership.

Nonetheless, as SPUR's greenbelt conference had shown and as Ed Wayburn had expressed, broad areas of public land could be connected with relatively small purchases of private land south of Mount Tamalpais State Park. And we were beginning to agree that most of the land north of Mount Tam, though privately owned, was potentially available. We felt we had to do a better job of urging Burton and Mailliard to introduce legislation we could support.

Ed Wayburn went to Washington early in 1971 and sounded out the prospects for the legislation we were discussing. The schematic maps he showed Bill Mailliard included some private Marin

properties, but only up to Mount Tamalpais State Park. "You're asking for an awful lot, aren't you?" the congressman commented but said he would support the proposal. Ed then showed the maps to Senator Alan Cranston, and to newly elected Senator John Tunney. Each said it was too much, but that he would go along with it.

Finally Ed showed his maps to Phil Burton. Ever since Phil had gone to Washington, Ed had been meeting with him on national Sierra Club business, and during that time they had developed a relationship of mutual trust and respect. This time, Phil studied the maps in silence and asked, "Is this what you want?" Ed admitted he actually wanted much more and described his dream plan. "Why didn't you present that to me?" asked Phil. Ed explained he didn't think it was politically feasible. "Get the hell out of here!" erupted Phil. "You tell me what you want, not what's politically feasible, and I'll get it through Congress!"[6] Ed later recalled, "In all my experience, I never heard anything like this before, and I doubt if I will again."

What *did* we want? Ed had a mental map of a much larger park, but this had to be put down on paper. We set out to find a lawyer who could write prototype legislation that expressed our vision. Someone suggested we call the San Francisco Barristers Club, an organization of lawyers under thirty-five years of age. Which I did. The woman who answered their phone said that on the previous day a member had told her that he was interested in the drafting of legislation. She soon located Walter Mollison, who teamed up with Jim Weinberger of the club's ecology committee.

We learned that this committee had been criticizing the Army's Presidio planning for more than a year. In March 1970 a *Barristers' Bailiwick* newsletter article had extolled the post's parklike wilderness atmosphere, scenic views, and wildlife populations and called the Presidio "a priceless asset of the city of San Francisco." The ecology committee saw the Army's master plan for the Presidio as a building location plan, not a land use plan; said the Army was threatening to eliminate most of the Presidio's remaining open space; applauded the awareness of the city's planning department; and called on the barristers to "save the Presidio from the Army."[7] We had new allies and they knew the issues!

We told Walter and Jim what we were trying to do. They reviewed bills for other national parks and then wrote a series of draft bill sections that we forwarded to Phil Burton. Bill Thomas let us know that Phil appreciated their efforts, although he had concerns about their map of the Presidio. Walter had studied the built-up areas and the surrounding open space, had written a detailed legal description of the land that would be transferred to the national park, and had mapped

islands of buildings that would remain under Army jurisdiction. When Phil met with the lawyers he stared at Walter's map over the top of his eyeglasses and declared, "This looks like a piece of Swiss cheese. The way to do this is to put the whole post in the park. Any part the Army doesn't need anymore, it goes to the Park Service."

At last, on June 29, 1971, Phil Burton introduced the park legislation we had been hoping for. HR 9498, partly modeled on Walter and Jim's prototypes, would establish a national recreation area of more than 33,000 acres. The bill was seventeen pages long and had twenty-two co-sponsors. It was sent to the Interior Committee.

The bill's strong "establishment clause" or preamble, was drafted by Bill Thomas. When I talked with him in 2001, Bill recalled that he may have begun with some language from Mailliard's legislation, and that when he had told Phil there was some tension between those wanting to save the natural and scenic qualities of the area and those who cared about public use, Phil had told him, "Put both in."

This preamble, often cited thereafter at hearings to illuminate the intent of the Golden Gate National Recreation Area legislation, has served the park extraordinarily well:

> In order to preserve for public use and enjoyment certain areas of Marin and San Francisco Counties, California, possessing outstanding natural, historic, scenic, and recreational values, and in order to provide for the maintenance of needed recreational open space necessary to urban environment and planning, the Golden Gate National Recreation Area is hereby established. In the management of the recreation area, the Secretary of the Interior shall utilize the resources in a manner which will provide for recreation and educational opportunities consistent with sound principles of land use planning and management. In carrying out the provisions of this Act, the Secretary shall preserve the recreation area, as far as possible, in its natural setting, and protect it from development and uses which would destroy the scenic beauty and natural character of the area.[8]

Bill Mailliard introduced his own new bill, HR 10220, on July 29. There were no co-sponsors and it was much more deferential to the Army. Its geography was not as expansive, and its provisions for acquisition and administration not as comprehensive as those of the Burton legislation. The nearly identical preamble would have protected only Marin County land in its natural setting. While it included the whole Presidio, the transfer of those parts of the Marin and San Fran-

cisco forts under the secretary of the interior's jurisdiction would have to be negotiated with the secretary of defense. If the Department of Defense held on to parts of the forts, it might be years before people could walk through their national park.

Phil's office distributed copies of his bill to local legislators, agencies, and our anxious group of park advocates. Not long after, Bill Thomas told us that a congressional subcommittee might hold a field hearing in San Francisco during the August congressional recess. He also let us know that if that happened—and if HR 9498 was to have the best chance to become the basis of the final legislation—park supporters not only would have to testify in favor of the park but would have to testify overwhelmingly that the Burton bill was better than the Mailliard bill. This support would help Phil urge that his legislation, after passage by the House of Representatives, become the basis of the Senate bill. California senators Alan Cranston and John Tunney introduced S 2342, "companion" legislation nearly identical to the Burton bill, in the Senate on July 26, 1971. But the first major battles would be in the House, where Phil would get as much land as he could into the park and the strongest provisions for land acquisition. Phil intended that his amended bill would ultimately replace S 2342.

Bill Mailliard also introduced another bill, a limited bill for a small park, on behalf of the administration. We brushed it aside as something he was expected to do for an administration of his own party. As the congressman from the district where the park would be located, Mailliard's own bill expressed his actual position; he responded to his constituents as far as he dared. We would need his support as a Republican to convince President Nixon to sign the legislation. Yet both houses of Congress were controlled by the Democrats, and that gave Phil the chance to use his skills and power to get as much as possible of what we wanted into the legislation. What we wanted was more than Mailliard felt he could accomplish, but he did not oppose the larger effort and personally intervened to facilitate its success.

CREATIVE CARTOGRAPHY

In the year since the East Fort Miley group had learned about the park proposal, our concept of the park's boundaries and size had radically changed. In early 1970 we had accepted a pinched view of the proposal. While the forts and the city and state parks at the Golden Gate and the island of Alcatraz seemed to add up to a dramatic park, that early proposal to save the Golden Gate for public use would have achieved more in appearance than in actuality. It would have created a park of

about 8,000 acres, much of it already public land and a third of it tideland. Its hills and habitat would soon have been hemmed in by the Bay Area's growing population, and the park would have had limited recreational possibilities. By the spring of 1971 the park we publicly said we envisioned had 10,000 acres—all of it dry land. We owed the shift to Ed Wayburn's getting us to think bigger, to push for a park that took in all the land between the forts and Mount Tamalpais State Park.

But we still didn't have a good map, a detailed representation of the park we wanted. What would be the exact boundaries of the GGNRA? What parcels could we hope to include? These questions could be answered only by drawing a real map.

Mapping the Big Picture

In the spring of 1971, with a primitive map to illustrate my talk, I went to the Mill Valley Public Library to tell a local group about the park. Bob Young, a college student from the Marin County suburban town of Terra Linda, was in the audience. Bob volunteered to draw precise Marin County maps for us. He was a sensitive, creative cartographer who had walked most of the county's trails and driven most of its back roads. As a teenager, Bob had watched the successful fight to defeat the Golden Gate Parkway along the top of the Bolinas Ridge. From that ridge, looking toward the ocean, he could see how the second-growth redwoods were replacing those felled years before. He remembered the Sierra Club's David Brower saying it was important to take the hundred-year view. Bob's first conservation work had been as an office volunteer and collector of petition signatures for the Save Our Seashore campaign in 1970.

The broad open spaces and watersheds Bob mapped into the park's boundary would accommodate every creature from mountain lions to red-legged frogs. He knew that to preserve views of hilltops from within the park he had to include ridgetop parcels on the unseen side of the hills so buildings could not peek over the ridge line. Bob converted the three-dimensional landscape into effective maps by taking the county assessor's featureless parcel maps and redrawing them on contour maps of the U.S. Geological Survey, which are usually the base maps for park legislation and for the National Park Service (figure 15).

I introduced Bob to Ed Wayburn. The two men had instant rapport. Each wanted more land in the park. "Why not include the Olema Valley?" Bob asked. "Indeed, we could," said Ed. "And with just a few more parcels, we could connect the Golden Gate National Recreation Area to Samuel P. Taylor State Park. None of these areas has been subdivided." Each aiding and abetting

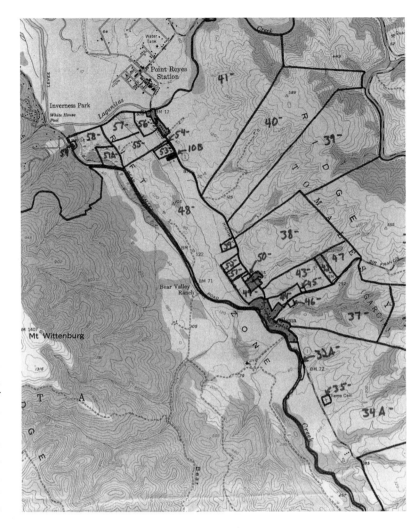

Figure 15. *Parcel Map:* Who owned what, and where boundaries should be drawn, were critical questions in defining the shape of the new national park. (Courtesy Golden Gate National Recreation Area, Park Archives, GOGA-3380 map 119, People For a Golden Gate National Recreation Area Collection, USGS Inverness Quadrangle, 1954; notations by Robert C. Young, 1971.)

the other's imagination, they visualized the view corridors and watersheds. By including all the public lands except the 21,000 acres already protected by the Marin Municipal Water District—they sensed that would have been overreaching—along with all the large privately owned land parcels and a few connecting small ones, they extended the proposed park's boundaries by 35 miles and 24,000 acres. If this big plan succeeded, the new national park would conserve nearly all of West Marin's undeveloped land between existing public parks, from the Golden Gate to Point Reyes National Seashore.[9]

Bob Young made more maps. His lists of the properties to be included showed each owner, assessor's parcel number, acreage, improvements, and assessed valuation. These lists told legislators how big a park we wanted them to fight for. Multiplied by four, since assessed value was roughly 25 percent of market value, the valuations also indicated about how much the park would cost. After Bob mapped and listed, he worked with Ed and me to draft justifications for the inclusion of each parcel.

Bob had to shape the park's boundary to be defensible against an owner's possible arguments opposing inclusion. Within its boundary he placed complete view corridors and complete watersheds that would protect whole ecosystems. When only part of a parcel met one of these criteria, he included the whole. This buffered the edges of the park. And, Ed added, the Park Service would have to pay almost as much for the severed portion of a parcel as for the whole parcel.

Acting on the requests of residents who feared that population growth would lead to widening the two-lane Highway 1 to West Marin, Bob tightened the boundaries around the unincorporated towns of Muir Beach and Stinson Beach, removing almost all possibility of further development. The boundary was so constricted at Stinson Beach that, after some townspeople protested, the Marin County Board of Supervisors requested deletion of about a dozen house lots from the park list. That was not worth a fight. Bob redrew the boundary to exclude them.

Most of the park would be in Marin County. It would connect the open space of Army, national park, state park, county park, and Marin Municipal Water District lands, as well as two unique ranches. Even if the water district lands did not actually come within the boundary of the park, and even if some state and county parks did not change hands, and even if Audubon Canyon Ranch and the ranch that had become Green Gulch/Zen Center Farm continued to be operated privately, the concept and eventual actuality would be magnificent.[10] The only buildings within the boundary were those on ranches, plus a small number of weekend cabins and isolated residences. And all the public open space of San Francisco's northern and western coastlines would be within the boundary, joined near the northwestern corner by the purchase of the privately owned historic Cliff House restaurant and Sutro Baths ruins.

MEETING NEW THREATS

Bob had mapped our collective dream. Some parcels, such as the Slide Ranch near Muir Beach, once advertised as a "Spectacular Oceanside Property" for "exclusive" developments, had been saved,

but developers had other plans for construction that could shatter some of our hopes. One had proposed town houses and condominiums for Wolfback Ridge above Sausalito. Along Tennessee Valley Road, the Marinview subdivision was growing westward in increments. And although cows grazed behind it, an impressive gateway still defined the main entrance to the lands of Marincello.

But some circumstances were in our favor. To build on former ranch lands, developers needed water mains and sewer systems. Marin County's natural water supplies are severely limited, so builders urged that water be imported from neighboring counties. Water and sewage were especially contentious issues in West Marin. The septic tanks of Stinson Beach and Bolinas homes were contaminating Bolinas Lagoon, and the lagoon had been quarantined. Some residents urged installation of an $8 million sewage treatment system, to be paid for mostly by assessments on present residents. This would encourage subdivision for more homes by the bigger land owners, in order to pay for their share of the assessment. The towns could then grow from about 1,000 to 5,000 residents and, some said, to as many as 28,000. But to preserve their small community, members of the Bolinas Public Utility District refused to permit more water connections and sought less ambitious sewage treatment alternatives. In the fall of 1971, troubled by the amount of development on the eastern side of Marin, county voters, by a margin of 8 to 1, would turn down a ballot measure calling for importation of water from the Russian River.

Not only Marin County conservationists, but others across California were awakening to the damage overdevelopment could bring. Up and down the state, coastal land owners knew that residents were getting ready to gather signatures to qualify an initiative to be submitted directly to the voters, the California Coastal Zone Conservation Act. If it passed, this act promised stringent controls on development of all the state's coastal land. Not only did land owners have water and sewage disposal problems, but they also worried that their land would lose value if the voters passed the act. In this context, it made little sense to oppose the park or prepare to develop any proposed coastal parkland.

A few people with inland property did want to discuss the issue. One day, the owner of a large parcel in the hills above Stinson Beach invited Marion Otsea and me to lunch. The parcel was inland of the proposed coastal zone and would not have been affected by a coastal protection act. The land owner asked that his property not be included in the park boundary; he could build perhaps forty homes after subdivision. He gave me a check for $100 for PFGGNRA. I called Ed Wayburn when I got home. "I didn't know what to tell him," I told Ed. "Of course Bob Young has included that parcel." Ed said, "Cash the check."

A FORTUNATE PLACE AND TIME

We saw that our park proposal could not have come at a more opportune time. Developers were stalled by public opinion, by limitations of water supply and sewage treatment, and by the likely approval by the electorate of a coastal protection act. Our hopes for a national park had now achieved legislative expression and figured clearly on maps. The House and Senate bills and the maps focused our work: we would have to organize everyone we could to write, testify, telephone, personally spread the word, take photographs, use the media, and donate funds to conduct a sweeping campaign for the best possible national park. For the next sixteen months, all of us would labor in an intensely exhilarated state of mind and soul.

5

A YEAR AND TWO MONTHS

As soon as we had bills in the House and Senate that called for a park of the size we wanted, we shared the good news with the people who had already shown their support for the park. But by July 1971 we had only twenty written endorsements, and except for the Sierra Club's they were all from local groups or local chapters of national organizations. We needed more statements of Bay Area support so we reached out assiduously, explored all our contacts, went wherever we were invited to appear, and gathered more and more endorsements. We also kept local agencies and elected officials up to date.

During that spring, in addition, Ed Wayburn, John Jacobs, and I each found ways to take some legislative fine-tuning to the Washington level. Ed carried our message when he traveled there; John phoned, and was phoned by, people none of the rest of us knew; and I worked with congressional staff.

All of this was important, but People For a Golden Gate National Recreation Area wanted

more. We wanted people from other states to support the park proposal. Beginning in August 1971, we were able to reach across the country. Over the year, the park became the subject of three congressional subcommittee hearings, and we could show national support for our park because of several special opportunities.

A CONGRESSIONAL FIELD HEARING

When Bill Thomas phoned one day in July 1971, my family was packing to go camping in the Northwest and Ed and Peggy Wayburn were packing for their annual trip to Alaska.[1] Bill told me that the rumors about the House Subcommittee on National Parks and Recreation were true: the committee would come to San Francisco during the congressional recess and hold a field hearing on the Burton and Mailliard bills. "Mr. Burton won't be at the hearing," Bill said. "He's out of the country then."

I called Ed to compare schedules. "You won't be back in time," I groaned. "None of us has ever done this before!"

"You'll be fine," Ed said.

I tried to believe him, but I was also worried about being away during the weeks just before the hearing. But Diane Hunter reassured me. "Take your vacation," she said. "Ken and I will organize."

When I got back to town, the Hunters had asked everyone they knew and everyone who had worked with PFGGNRA to come to the hearing prepared to speak, and also to help them find additional committed speakers. Diane showed me the pages of charts they had made that listed the names, addresses, and phone numbers of more than a hundred people, their areas of interest, and their organizations. The Hunters and their reporter friend Marjorie Leland of the *San Francisco Progress* had contacted all these potential witnesses. The range of occupations, economic status, and ethnicity on the witness list showed broad support for the park. Most of the invited advocates had agreed to come or would send a substitute. Others had agreed to send a letter for inclusion in the hearing record.

We tried to sort out what would be controversial at the hearing. Alcatraz was not: already publicly owned, it was a management issue. Nothing in the rest of the park depended on it. What about the ranches between the Golden Gate and Mount Tam, and between Mount Tam and Point Reyes National Seashore? Point Reyes ranchers seemed content with what they had been paid for their land and they were still in business. The big controversy would be around the Presidio. Influential

people would testify that the Presidio should not be part of a park. While the Army brass could not speak for itself, there were 38,000 military retirees in the Bay Area. Former officers socialized with political and business leaders and belonged to the same clubs. The retirees wanted the Army to keep the Presidio. And, we were told, the Presidio was economically important to San Francisco: about 12,000 people were on the post—civilians who commuted in, Army personnel and their families who worked and lived there. John Jacobs remarked that only the University of California medical complex at San Francisco and the phone company employed as many people.

Yet the post's neighbors thought of the Presidio as part of the city's greenbelt. They disliked most of the 730 units of housing the Army had built since World War II. Unlike the Presidio's handsome older housing, these structures were unsightly, and they nearly tripled the prewar number of units. Only neighborhood outcry had preserved the views from adjacent homes and protected beloved Presidio trails when the Army sited these buildings. Alarmingly, the Army had announced plans for 546 more units. People from all over the city would fight these plans, as they had fought the two proposed schools and the archives on East Fort Miley. They had begun to realize that the Army would not—or could not—protect the historic Presidio and the scenery of the Golden Gate.

Many people would support a new national park. PFGGNRA concentrated on those who knew the issues well enough to endorse Phil Burton's legislation. We were energized by his belief that he could get Congress to authorize the park that we now collectively envisioned. Bill Mailliard's legislation had much in common with Phil's, but they differed on important points. Phil's legislation would transfer more Army land immediately to Interior's jurisdiction, including all the major pieces of open space conservationists had fought to protect, and it would tightly restrict Army use and construction. It provided for consultation with local boards, commissions, and agencies and called for public hearings on the park plan. All the private ranch land, including all the Olema Valley, would be bought under the Burton bill and, for a financial consideration, ranchers could choose to live in their homes and work their land for up to twenty-five years or for the owner's lifetime.[2]

On August 9, when the committee chair, Congressman Roy A. Taylor (D-NC), called the hearing to order, he placed Burton's HR 9498 and Mailliard's HR 10220 into the hearing record. He told the crowd, which overflowed a large San Francisco Federal Building courtroom, that he and the several attending committee members had visited the proposed park area on the previous day. He introduced the other congressmen on the dais: Harold T. "Bizz" Johnson and Don Clausen, who both had helped get funding for the Point Reyes National Seashore; James

Abourezk (D-SD); and Joe Skubitz (R-KS). Congressman Abourezk said they had seen the proposed Gateway park on the East Coast, and Chairman Taylor said they would go on to Boise, Idaho, that night to hold a hearing on another park.

Congressman Mailliard presented his bill. Next, the committee responded warmly to the Marin County supervisor Peter Arrigoni. He endorsed Burton's bill and emphasized that purchase of the Olema Valley "provides for the continuity of the new recreation area with Point Reyes National Seashore." But when San Francisco mayor Joseph Alioto spoke, he was vigorously questioned by the congressmen. Alioto had vetoed a board of supervisors' resolution in favor of the park.[3] "We have signed a memorandum of agreement with the Army," the mayor said, waving a paper in the air. "The Army agrees to do its planning together with our planning commission." He read a letter from the post commander, who pledged that the Army would "delete all future family housing from the Master Plan for the Presidio of San Francisco."

Congressman Abourezk bristled. "Where will they build the new housing? Over in Marin County, in the open space over there?"

Mayor Alioto demurred. "We are very, very excited about this tremendous project that is being proposed," he said. But then he added that before the city would donate its parklands, he needed guarantees of appropriations for park maintenance, and assurance that funds would not be impounded.

"I am afraid you will never know all those things in time to decide what course of action to take," Chairman Taylor retorted, as the audience laughed.

San Francisco supervisor Ronald Pelosi had led the fight for the park in San Francisco's city hall. He passionately declared, "Within the last several years our board of supervisors has been fighting not foreign powers . . . but our own federal government. We have been deluged with plans for warehouses, archives . . . the people of San Francisco are most apprehensive about what next is going to happen to these public open spaces. . . . We are all very conscious of the magnificent job the Army has done over the years and we wish to compliment them for their attentiveness to the planting of trees and all the rest. But within recent times there has been an acceleration of building activity which, frankly, causes us the gravest concern."

The congressmen sparred with Pelosi. "Do I understand you to say that you are very appreciative of what the military has done but you are now ready to kiss them goodbye and turn the area over to Interior?" "Say that the whole area were declared excess to military needs, which the military is doing a lot of nowadays. How would the people of your city here feel about moving the Army clear

out and having the Park Service take over the entire Presidio area?" Pelosi's tone was deferential. The Army, in general, was a good neighbor. That the Army might completely withdraw from the Presidio had never crossed any supervisor's mind. As we listened to the sharp questioning of the mayor and the supervisor, some of us began to worry about how we would sound if challenged by the congressmen. To our relief we were treated gently, as were nearly all the rest of the day's witnesses.

Ken Hunter had become PFGGNRA's San Francisco chair, and Bob Raab was the chair for Marin. We had planned our testimony not to overlap. I focused on the disappearing greenbelt and our hopes for a complete park. I outlined why PFGGNRA preferred the Burton bill. Ken declared that our group "is very much concerned that there be an active relationship between the recreation area and the inner city. . . . The recreation area's personnel, from top to bottom, should reflect the urban ethnic mixture" of the city's residents. "Within the past two weeks . . . I have participated in three meetings and listened to perhaps 200 persons," said Bob. "I did not hear a single explicit expression of opposition to the park. I heard a few expressions of doubt and scores of expressions of approval."

"Do you feel any more secure with regard to housing as a result of the agreement which the mayor said he had worked out with the Army?" Chairman Taylor asked the president of the Presidio Heights Association of Neighbors. "No, sir; I do not," Bob Lilienthal replied. In his opinion there was no lasting value in having "a present mayor make an agreement with a present general."

Our efforts to get more local support had paid off. Throughout the morning, a steady stream of witnesses representing a variety of organizations came to the podium and told of their hopes and support for the national recreation area. They said the park could fulfill some of the Association of Bay Area Governments' nine-county open space plan for the region, envisioned the state's ship collection at the Hyde Street Pier as the nucleus of a western counterpart to Connecticut's Mystic Seaport, and saw Alcatraz as a jewel on the bay. Congressman Skubitz reflected on Alcatraz, saying, "It might be instructive to a young boy who went over to the island and saw the size of the cells over there—5 by 9 feet. I think it might impress him about the glamor of crime." Chairman Taylor said, "Walking through it made me appreciate freedom more."

But after saying that he endorsed the park, the president of the Presidio Society asked that the Army retain ownership and control of the Presidio and Forts Baker, Barry, and Cronkhite. He asserted that the Golden Gate's hills would have been covered with homes were it not for the Army, and that under Interior Department protection the land would be crowded with parking lots, campgrounds and campers, concession stands, shops, and hotels.

The hearing recessed for a short lunch. Bill Thomas had arranged for the leading park supporters to join the congressmen at a nearby restaurant. We tried to suppress our elation; the breadth and depth of support for the park idea were evident. At lunch, Congressman Abourezk remarked—very distinctly so everyone heard him—that while the Army allowed the public on the Presidio's Baker Beach, it wasn't their mission to manage recreational land, and that Interior was obviously the right agency for that mission.

In the afternoon, an amateur naturalist distributed long lists of the plants, birds, and animals of Point Lobos, part of San Francisco's Lands End. He hoped for preservation of its wildlife and other natural aspects and deplored the litter and motorcycles on its trails, saying, "It is hoped that if Point Lobos is included in the Golden Gate National Recreation Area these threats will be ended."

"About 70% of the coastal wetlands area of California has disappeared," said the director of Point Reyes Bird Observatory, who urged the preservation of Bolinas Lagoon, Rodeo Lagoon, and the lands around them. The Committee for Green Foothills and the Loma Prieta Chapter of the Sierra Club wanted to include 25,000 acres of San Mateo County, which would extend the park 25 miles south of San Francisco.[4]

A resident of San Francisco's poorest central-city neighborhood, and another of one of the city's wealthiest, each asked that the national park be brought as near as possible to those urban residents who needed it the most. They both pleaded for public transportation to the proposed park. So did some Marin County speakers; they wanted to reduce auto travel. The Marin representatives also called for an advisory commission, continuation of ranching, relief for the funds lost by local tax districts when parkland is bought, and preservation of small West Marin communities.

We had never considered the Native American occupation of Alcatraz a threat to the park's integrity, so we kept the island on our maps but did not comment on the situation. After the occupiers began to quarrel among themselves and conditions deteriorated, the government removed the last fifteen people in June 1971. Reflecting their continuing disagreements, two Native American leaders testified about Alcatraz. One wanted it excluded from the park and given to Native Americans. The other wanted Native Americans to help plan the future of the island in the park.

Three West Marin land owners said they supported the park and wanted the government to buy their land. One could not log her redwoods because the county had prohibited logging. Another family had intended to develop its land, but such development would be incompatible with a park. The third wanted to know how long he would have to wait to be paid for his land, once it was in the park.

After some one hundred people had testified, including bird watchers, retired generals, ranchers, teachers, students, hikers, cyclists, and the representatives of fifty-five organizations, Chairman Taylor wrapped up the session, noting that this was one of the most polite hearings he had participated in. He graciously thanked everyone for their patience and the quality of their testimony.

Congressman Johnson warned that it often took the government a long time to buy parkland, which could be a hardship for land owners. Congressman Skubitz was suspicious and surprised because ten major land owners—most of them ranchers—had not testified. Congressman Clausen, well acquainted with Marin County land owners, said the property owners organizations were following the hearing and would send letters or would go to Washington, if necessary. He was pleased with the broad cross section of opinion from such a variety of witnesses, and the depth of information the committee had received.

When Chairman Taylor adjourned the hearing seven hours after it began, the dozens of people left in the room all applauded the congressmen—and their own high hopes for the park.[5]

THREE NECESSARY STRATEGIES

We'd had a great field hearing. We weren't concerned a week later when the *San Francisco Examiner* printed an editorial titled "Genial Phil," which commented sardonically: "When you add up the land on his list—oops—there goes the Presidio. What it amounts to is that the Presidio is a row of oysters, and he is cheerfully willing to play the role of either the walrus or the carpenter, or both in a pinch." We saw that Congress was in recess for the rest of August and people were on vacation until Labor Day. The slow month would give us time to plan how to make the best use of our growing support.

Sometime during the second year of the two-year congressional session there would be House and Senate subcommittee hearings in Washington. We began to ready small delegations to fly east to testify at those hearings. And we continued our daily work of spreading the word, soliciting endorsements and money, and thwarting development in the park area.

PFGGNRA's job was to present and publicize what would be best for the park and the public in the long run. Going over maps and parcels lists for complete watersheds, contiguous habitat, and continuity of public ownership, Ed reviewed for us and Phil Burton why we should try for a park that would total at least 33,000 acres. Phil endorsed our proposal but did his own check to make sure it was complete. One map showed a several-miles-long, skinny sliver of private land

next to the road in the Olema Valley. The Point Reyes National Seashore boundary followed a creek near the western side of Highway 1 and our new park's parallel boundary followed the eastern side of the highway. "What's this?" Phil asked. We said we felt uneasy about including land on what we thought of as the Point Reyes side of the road. "So what will go in here?" he roared. "Strip development? You put on the map what you want, and leave it to me to get it."

Sometime during this quiet period, Jim Weinberger and Walter Mollison said we ought to resolve an issue that could come up about the economics of establishing the park. If the federal government bought land for the park in Marin County, and a number of land owners no longer paid property taxes, how much would this affect the school system and other districts dependent on the tax base? Would the federal government make up for the lost taxes? If questioned about this, we would have to have answers in hand. The lawyers found two people based at Stanford University who would volunteer for us in a private capacity: Martin Behr, a financial and planning consultant to various states and corporations, and Steve Beuby, a graduate student. They designed a study, and several members of the Junior League searched Marin County records for the figures. The impact was too small to cause problems. The study showed that the thirty-seven assessment districts would have a 1.02 percent loss in revenues. The average increase in property tax for a resident of Marin County would be 1.3 percent, with a maximum impact of 2.2 percent. The federal government would compensate about 30 percent of this loss with "in lieu" taxes for such essential services as fire control and mosquito abatement.[6] Only once did a newspaper reporter ask for these figures. I was glad I had them.

Also during this time SPUR successfully organized opposition to an egregious development proposal: a trial period for a short takeoff and landing airport, a STOLPORT, on the Presidio's dormant Crissy Airfield, for commuter service between San Francisco and other California cities. We knew that such service, if begun, would be nearly impossible to terminate. SPUR highlighted the dangerous proximity of the airfield to the Golden Gate Bridge and the prospect of urbanizing a mile of the proposed park's most scenic shoreline.

INSIDE PHIL BURTON'S OFFICE

After Burton's HR 9498 was introduced in Congress, there was much work to be done with Phil's staff in Washington. I communicated mostly with Bill Thomas and Nancy Larson, who kept track of the GGNRA legislation. Both of these Burton aides now worked for a subcommittee—but it

was not a subcommittee for national parks. After Phil Burton had become chair of the Trust Territories Subcommittee of the Interior and Insular Affairs Committee, he had transferred Bill to the subcommittee's office in a building far from his district office.[7] This was an improvement, Bill remembered. It had not been easy to work in Phil's district office. The atmosphere was chaotic, and "there was no chain of command," said Bill. "Mr. Burton always had to be involved."

Phil was entitled to more staff as a subcommittee chair and told Bill to hire Nancy, whom he knew from the San Francisco Young Democrats. Her title of clerk obscured her extensive experience in government offices. Nancy kept all of the maps and papers for the park under the subcommittee office couch. That way nothing would be thrown out or mixed in with the papers for Phil's other campaigns and district or committee affairs. Knowing of the tumult in Phil's personal office, I was immensely grateful. "I never knew what we would need or what we wouldn't need and so I kept everything," Nancy told me later. "Even Bill didn't know this. . . . I kept it under the couch because this was the office of Territories—this didn't have anything to do with parks— and I was always afraid that [House Interior Committee chair] Wayne Aspinall was going to walk in sometime and we would have a GGNRA map up."[8]

Bill Thomas and I worked mostly on strategy. We didn't have e-mail or home fax machines then; we wrote letters and made telephone calls.[9] I gave Bill descriptions of board of supervisors and agency hearings, accounts of what had been said by aides from other political offices, news of a vote for park support by a local home owners group, our boundary maps, our county property lists, and our inclusion justifications for each property so he could pass them on to Phil. Bill gave us our marching orders.

Working with Bill Thomas, I learned that he had his own agenda for part of our grand park plan—and was working to shape the legislation accordingly. Bill had been a blue-water sailor and yearned to protect the important but neglected ship collection of the State Historic Maritime Park at San Francisco's Hyde Street Pier near Fisherman's Wharf. He knew some of the people who had helped acquire the ships, and the park superintendent, Harrison J. Dring, was his friend. After years of rejected pleas for a bigger budget, Harry had realized the state would never give him enough money to keep his ships afloat. Desiring better care for the fragile ships, these two buddies conspired to join the collection with the building and collections of the city's neighboring Maritime Museum and make them part of our park legislation. The ships of a national maritime historical park would ride at anchor surrounded by the splendid scenery of the Golden Gate National Recreation Area.

AIDED BY ADVERTISING

In the summer of 1971, a most unusual piece of good fortune—in the form of a handsome magazine advertisement—stoked the small bonfire of national support for the park plan. An advertising agency had phoned John Jacobs in search of a civic cause for which to produce an ad. The agency representative explained that there was a contest among advertising agencies, and that the best ads in support of civic causes would be printed without cost to the sponsoring public-serving organizations. We were excited. If our plan became the subject of a full-page, four-color magazine advertisement, our park idea would get major public exposure. I hurried downtown to join John at the agency that had phoned him, and we explained what we were trying to accomplish. They liked our cause and designed an ad for our park plan.[10]

Our ad was a winner! Titled "For 6 Cents You Could Give This to Your Kids," it was a coupon ad illustrated with photographs—six cents being the cost of mailing the coupon back to us. It was first published on October 4, 1971, in the regional edition of *Time*, and was reprinted on December 15, 1971, in the regional edition of *Newsweek*. It then became the first four-color advertisement to appear in the *Sierra Club Bulletin*—and that magazine's March 1972 issue carried our plan across the United States. For a few weeks we got fifty or sixty letters a day. By the time of its last appearance in the September 1972 *Sunset*, the ad had to be adjusted because the cost of postage had gone up to 8 cents. Over two thousand people sent coupons endorsing creation of the park. Some senders also wrote to their legislators. People For a Golden Gate National Recreation Area could cite the coupons as evidence of broad support, and we got a clutch of badly needed checks.

MEETING PHIL BURTON

I finally met Phil Burton in March 1972, when Bill Thomas asked Ed and me to come to Fort Point for campaign photographs. Thrilled, I thought, "Burton thinks we will succeed!" Phil was waiting at the fort. He was much taller than either of us, and not so much wore his suit as had it draped over his body. His stocky torso balanced over tapering legs and large feet. I stood by quietly, listening and watching as the photographer got ready and Phil and Ed talked. They discussed an authorizing bill for the park and the need for another bill, an appropriations bill to buy land. The photographer snapped some pictures.[11] Still talking with Ed, Phil suddenly put his arm around my waist and held me tightly. He continued talking and did not let go. I knew I should not push

him away, but I was uncomfortable and embarrassed. At last he released me. A month later I felt I could tell Ed what had happened. He laughed and told me about the first time he had met the congressman. "We shook hands and he took my rather small hand between those two big meaty hands of his and he held my hand for the longest time. I think that's a way he has of sizing up people."

My memories of Phil are colored by my being in awe of him. Others had a more balanced view of the man. "Didn't take care of himself . . . in many ways a gross guy," John Knox said. "Tall, very fat, loped along, paunchy jowls," is what Bill Thomas remembered. "Sala dressed him in excellent suits which she said were always rumpled. Phil Burton drank, smoked a lot, didn't like exercise. . . . He could be arrogant, loud-talking, kind, considerate, sympathetic, all at the same time. The staff put up with Phil—and I was with him as long as anybody—because he got things done."[12]

THE SECOND HEARING

The same subcommittee that had visited San Francisco in August 1971 announced a hearing in Washington on May 11 and 12, 1972. By that time, eight bills to establish the Golden Gate National Recreation Area had been introduced in the 92nd Congress: three by Burton, three by Mailliard, and one each by Congressmen John Saylor (R-PA) and Don Clausen, and all were before the subcommittee.

A few days before two Marin supervisors were due to leave for Washington, the county planning department staff asked Bob Young to come in and check the maps the supervisors would display at the hearing. When Bob completed his review, the prospective park had quietly become some 400 acres larger. Bob added a 30-acre triangle abutting the entrance to Point Reyes National Seashore, some unsubdivided land near Mill Valley, a previously excluded portion of Green Gulch Ranch—and I'm not sure what else.

I had to tell George Wheelwright that a part of his ranch not previously discussed for inclusion in the park had been put inside the park on the boundary map. The extraordinarily generous Wheelwright had already given 513 acres of Green Gulch, with a half mile of coastline—enormously valuable land less than twenty minutes from the Golden Gate Bridge—to The Nature Conservancy so it could become part of the park.[13] Wheelwright was quiet for a few moments, then said that while it wasn't what he'd had in mind, as long as he was paid for this additional land, it was all right with him.

On May 11, Congressman Roy Taylor again presided over a subcommittee hearing, in a room of the Longworth House Office Building. Interior Secretary Rogers Morton had succeeded Walter Hickel. At the beginning of the hearing, Morton presented a draft of yet another bill. San Francisco and Marin County Supervisors, Ed Wayburn, John Jacobs, Ken Hunter, and a half-dozen other park advocates came from California. Their Washington-based relatives and friends—including Katy Miller Johnson—as well as national organization representatives testified. Only the Department of the Army and the principal of San Francisco's Galileo High School and three of his students opposed parts of the park proposal. I stayed home to answer questions and relay calls for news of the hearing. My kitchen counter and stove were covered with maps and copies of testimony.[14]

Phil Burton shared his vision for the park in his opening statement and undercut the smaller Republican proposals. "Part of the highlands of the park in Marin County are called Marincello. The citizens of that county have fought the plans of Gulf Oil Company to subdivide that land and build homes and apartment houses there. [My bill] does not leave one-quarter of Marincello in the hands of the oil company developers, assuring both a profit to them and promising that the park will be overlooked by a subdivision."

Burton testified forcefully about the military lands. "In many parts of the area the adminis-tration proposes either to leave jurisdiction with the Army or makes provisions whereby the mil-itary may do just about what they will with the property. In effect, this bill puts the United States Army into the park business. My legislation gives the Secretary of the Interior clear control over the recreation area but makes reasonable accommodation for military needs." An Army repre-sentative testified that the Burton bill was "objectionable to the Department of Defense because it would deprive the military departments of the use of property needed for the national defense." The committee consultant Lee McElvain asked if the Federal Property Review Board had made any study of the Presidio and Marin County forts. An Army spokesman had to admit that the General Services Administration had not made a property utilization survey of any of the forts or the Presidio.

Interior Secretary Rogers Morton spoke in support of Republican bills for the park. He en-dorsed a park of 24,000 acres. Its northwestern corner would just touch the southeastern corner of Point Reyes National Seashore, near Bolinas. The Olema Valley, Cliff House, and Sutro Baths and about 500 acres of Marincello, together estimated to cost $30 million, were not included in any of the Republican-sponsored bills. Then came a wonderful surprise. A congressman asked

about potential subdivision of the excluded Marincello lands. Suddenly Secretary Morton announced that The Nature Conservancy had informed him an hour earlier that their organization had put the Marincello land "on hold" by taking an option on the entire property and had made a major commitment to place the whole valley in the national park. I later learned that Huey Johnson, the conservancy's western regional director, had begun negotiations with Gulf Oil in 1965, following its falling-out with Thomas Frouge. Huey had made several trips to Pittsburgh to try to negotiate purchase of the property, but nothing came of his efforts until after the hearing at the Marin County Board of Supervisors in the fall of 1970.[15]

The Galileo High School principal and his students were the last witnesses. They wanted 30 acres of Fort Mason, across the street from their school, for a new city high school to replace their seismically unsafe building. San Francisco high schools are usually on about 5 acres and Galileo had 4½; the delegation said they wanted the additional land for community facilities. Congressman Taylor graciously welcomed these petitioners, but I was later told that although Principal Jim Kearny cried before the committee, Taylor's questions and Kearny's answers reinforced the earlier assertion of a park supporter that this proposal followed on two failed city school bond issues. Park supporters knew Phil Burton would not set a precedent for taking bites out of the park, and that Galileo students could cross the street to use Fort Mason's lawn for athletic programs. At the end of the hearing, Phil Burton thanked Congressman Taylor for all the time and personal effort he had given the park.

Years later, John Jacobs told me that it was at this hearing that he sensed that the National Park Service had given up trying to get the money it needed to buy land, to make what it acquired usable for the public, or to care for it. Only Congressman Saylor spoke to funding needs when he said that the Golden Gate and Gateway national recreation areas "will take all of the money for a number of years that the Department of Interior will get from the Land and Water Conservation Fund." He deplored the attitude of the House Budget Committee and the Office of Management and Budget toward limitation of national park appropriations and said it was incumbent on the Interior Department and the administration to come up with a recommendation to increase that fund. "Probably all of the money that we get from our offshore drilling should be put into the Land and Water Conservation Fund. . . . I am looking for dollars to take care of the necessary development and acquisition."

THE SUMMER OF 1972: BEHIND THE SCENES

Phil Burton's bill of June 1971 contained everything we'd hoped for up to that time, but more ideas about land additions and park management were advanced during the summer of 1972. Phil added some amendments to be considered in the House Interior Committee markup. Many of the changes he proposed were based on what he had learned during the two House subcommittee hearings.

In midsummer Bill Duddleson came in from Washington. Along with the Point Reyes activist Jerry Friedman and a few West Marin residents, he visited my home with a mission. There was an informal citizens' advisory group for Point Reyes National Seashore, which had had some effect on park planning and management, but this group wanted the established public forum of a real advisory commission, and they saw the creation of a Golden Gate National Recreation Area as their chance to get it. With the new park's complexity, they said, we would need a citizens' advisory commission even more than they did. And an advisory commission could also provide a place for the hearings mandated by the new environmental protection laws. And the two parks would most likely be adjacent for 10 miles. Didn't it make sense, they suggested, for us to write an advisory commission into the GGNRA legislation, and at the same time ask that it serve the Point Reyes National Seashore as well? I had a summer intern, Don Rubenstein, a University of San Francisco law school student. He drafted a new bill section for an advisory commission, which Phil edited and spliced into his legislation.

On August 10, the House Interior Committee cleared HR 9498 for floor action. As amended, it provided for an advisory commission and also for a transportation study, set a ceiling for land acquisition of $60 million and a development ceiling of $58 million, and provided for purchase of the Cliff House and Sutro Baths if the city donated its coastal parklands. On August 17, Phil Burton took the next step: he introduced HR 16444 with twenty-nine co-sponsors from both parties, many of them members of the Interior Committee. Substituted for HR 9498, HR 16444 was the base bill that would become the law that authorized the Golden Gate National Recreation Area.[16]

There were other positive developments. One day that summer, Interior Secretary Morton and the longtime conservationist Nathaniel Reed, assistant secretary for fish, wildlife, and parks, toured the proposed park by helicopter. Then they went to the home of Boyd Stewart for a Republican Party fundraiser. Ed Wayburn met them there, and Ed and Boyd successfully made the case for inclusion of the Olema Valley in the park. Morton and Reed seemed to appreciate the value of the

larger park proposal. We later heard that Morton told President Nixon that if he wanted to carry California in the November election, he should support the Golden Gate National Recreation Area.

Interior Secretary Rogers Morton seemed to be shaping up as one of our best allies in Washington. Many years after this time, Brian O'Neill gave me an insider's perspective on Morton's role in advocating for our park. According to Brian, Morton was "instrumental" in getting "reluctant members of Congress" to support the park legislation. He was able to do so, said Brian, because he had had "a prominent position in Congress" before becoming interior secretary and had "really good relationships there." He was skilled at shaping "the packaging, the positioning of the idea, the marketing" of the park proposal so that it "would be supported on 'the hill.'" In Brian's opinion, Morton was "a gem of a secretary, a good thinker, a good leader, as well as a good manager of the department."[17]

On July 26, a small article appeared in the *San Francisco Chronicle* headlined, "Make More Parks, Nixon Tells Aides." President Nixon had told his aides to try to "convert more surplus federal land into recreational areas under his 'legacy of parks' program." The article further reported: "Mr. Nixon said the government had made a good start in releasing land in 39 states for 144 new parks. But he said there is a tendency in the bureaucracy to 'get a vested interest' in a piece of federal property and to resist turning it over for park use. He said some bureaucrats' arms should be twisted to accelerate the program."

STALLED IN THE SENATE

Just then, bureaucrats were not our problem. We needed a senator's help. We could not get the hearing our bill required before the Senate Committee on National Parks and Public Lands, chaired by Alan Bible (D-NV). Our legislation was stalled and we were worried. Flying over New York harbor with the governors of New York and New Jersey and the mayors of New York City and Newark, President Nixon had blessed Gateway National Recreation Area. We looked on jealously while that park's legislation moved through the Senate. Three thousand miles away, we called on Bay Area park advocates to contact our two California senators or anyone else who could help us get a Senate hearing. Supporters sent stacks of letters and made dozens of pleading phone calls.

Boyd Stewart asked Alan Bible to visit. He took the senator for a dirt road backcountry drive in his truck over the rolling hills and oak-dotted valleys and pleaded with him for a hearing, but he could not get a commitment. Instead, Senator Bible's aide called me to suggest that this year (helped by the

political pressure of an election) was the year for the Gateway park on the East Coast, and the next year (without that helpful political pressure) would be the year for the park at the Golden Gate. Ed and I talked things over. Ed stated that if establishment of the park were put off for another year— or more likely two, until the second year of a congressional session, when such bills usually pass— developers and naysayers would try to nibble at the boundary, and much of the land we wanted would be even harder to get. We agreed to urge everyone to keep pushing for our western park.

Sure enough, in the summer of 1972, rumblings of discontent and opposition erupted in the West Marin posthippie coastal village of Bolinas, which prides itself on its isolation. Bolinas residents said they were surprised to learn about the park—even though plans had been moving forward for a year and a half, the legislation had been formally endorsed by over sixty-five conservation and civic groups and hundreds of individual supporters, and both House committee hearings had received generous newspaper coverage. A Bolinas home owner phoned to tell me why he didn't want the park. He and others in the town thought that 60-acre "ranchette" parcels—the minimum parcel size in most of West Marin set by county supervisors' rezoning a year earlier—would be rather good and much better for area residents than having lots of people coming to visit another national park. After all, he said, they already had Point Reyes National Seashore. I decided not to argue about the temporary nature of zoning (the zoning of one board of supervisors may be easily undone by the next board) or the fragmentation of natural habitat needed by wildlife. I told the caller that I saw what he meant—and got back to work.

THE PRESIDENT DROPS IN

About this time, the Committee to Reelect the President asked John Jacobs for help. John recalled: "CREEP it was called, because it was Nixon, and you learn to let the devil do the angel's handiwork in this kind of business—came calling on me and said 'We need to get exposure for the President,' and I don't know whether they thought I was a Republican or not—I was a Democrat, but that apparently didn't bother them. So I said, 'You know, there's a marvelous photographic opportunity to get Nixon to come in and endorse the creation of the Golden Gate National Recreation Area.' I pointed out the Coast Guard dock, where he could come in by boat."[18]

On August 31, 1972, the *San Francisco Chronicle* printed the announcement we had been waiting for: "Nixon to Visit S.F. Tuesday." The article said he'd probably fly over "Gateway West" in a helicopter, so his itinerary did not seem to present the kind of photo opportunity John wanted so as

to create momentum for the park proposal, and it did not give us a chance to plead our cause with anyone. However, over the Labor Day weekend, the prospect of the visit suddenly became much more exciting. Ed, John, a dozen prominent citizens, and I were told that we would have a chance to meet with President Nixon's Citizens Advisory Committee on Environmental Quality, chaired by Laurance S. Rockefeller—and maybe get a chance to meet with the president himself.[19]

For family reasons, Bill Thomas had taken a leave of absence from Burton's staff and had returned to his previous job with the *Chronicle*. On Labor Day, "Nixon to Dedicate Uncreated Park" was the headline over his article about Burton's bill, a bill that was now co-sponsored by Republicans Mailliard and Clausen. Bill described the Marin and San Francisco lands included in the park: "With one master stroke of the legislative brush the Burton bill seeks to solve the open space and recreational development problems of the two counties. . . . The arrival of President Nixon indicates how far 'Gateway West' has gone since it was stillborn three summers ago in Washington, D.C." He cited our local campaign and the bipartisan list of park sponsors. The article ended, "The area still requires approval of the Senate but there is great optimism this will occur before Congress adjourns. That optimism was obviously shared by President Nixon who is willing to dedicate it before the fact."[20]

"Plug for Park—Nixon Visits S.F. Today—Briefly," was the Tuesday headline. The president was flying up from his home at San Clemente "en route between White Houses" aboard the presidential jet, *The Spirit of '76*. He would take a helicopter to Crissy Field and a motorcade would take him to the dock at Fort Point. Aboard the ferry *Golden Gate*, he would take a brief tour of the proposed park and meet with his citizens advisory committee. "The President wants to focus national attention on the need for this recreation area," his press secretary said.[21]

Before Nixon's arrival, our group joined the advisory committee in a spacious meeting room in the Golden Gate Bridge's administration building. Through its picture windows, we could see San Francisco Bay sparkling in the sunshine—and not a wisp of fog. We were seated among the members of this distinguished group—I was next to the astronaut Frank Borman, the aviator Charles Lindbergh was across the room—and we were only too glad to have the chance to tell them collectively and one-on-one about the park proposal and the needed Senate hearing. I don't think any of us appreciated that the committee's executive director was the former Bureau of Outdoor Recreation deputy director Lawrence Stevens (only much later did I learn of his personal effort in 1969 to enlarge the Alcatraz study to include the Golden Gate's forts), and we certainly didn't know James Watt, who presented a slide show about the park.[22]

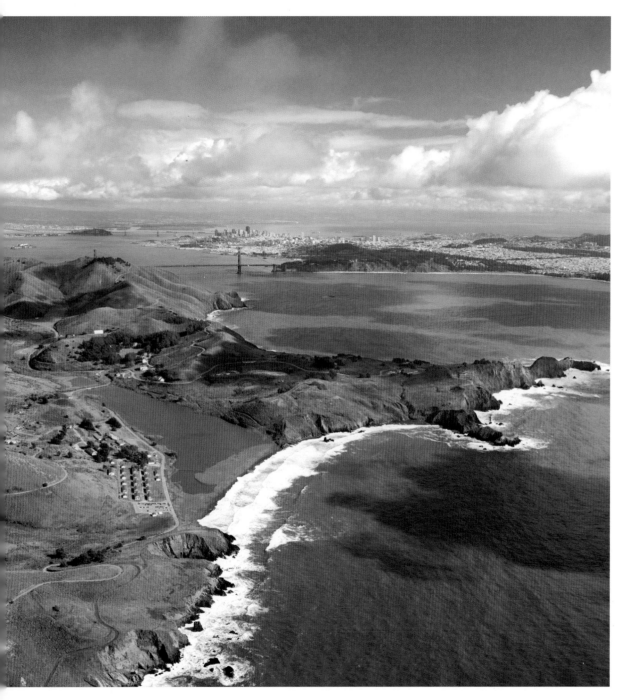

Plate 1. *Fort to Fort:* Looking southeast in the winter from the Marin headlands toward San Francisco and some of the extensive military reservations that once guarded San Francisco Bay. (Robert Campbell, 1994, www.chamoismoon.com.)

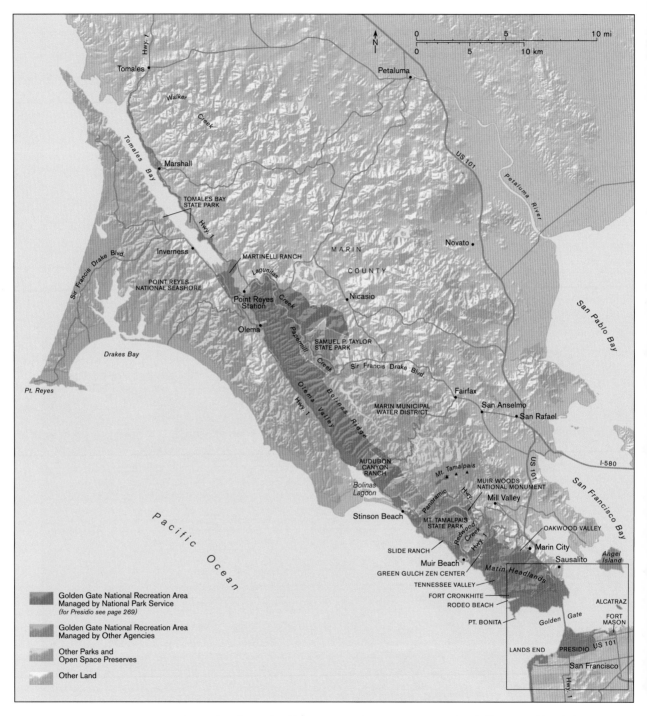

Plate 2. Point Reyes National Seashore and Golden Gate National Recreation Area, northern half, in 2006. Although the name change is not yet official, the GGNRA, Muir Woods National Monument, and Fort Point National Historic Site together are now called the "Golden Gate National Parks."

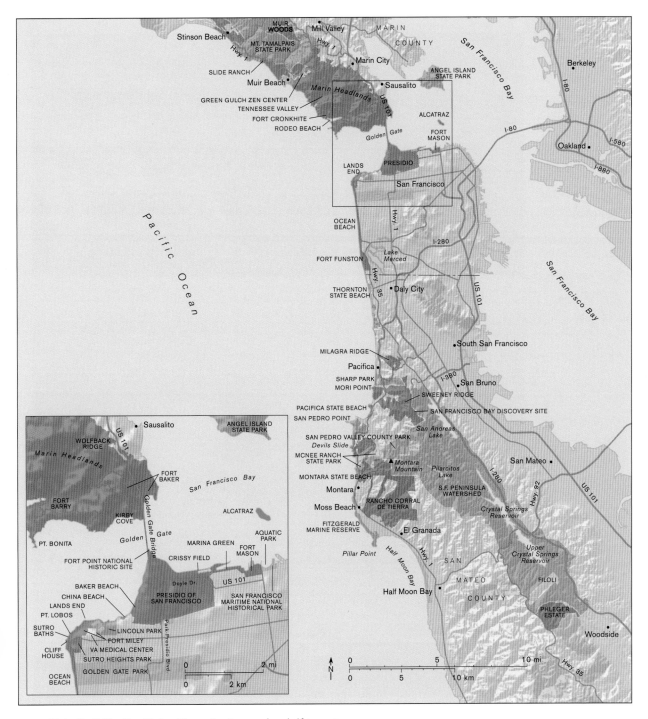

Main map labels:

MUIR WOODS
Stinson Beach
MT. TAMALPAIS STATE PARK
Mill Valley
MARIN COUNTY
San Francisco Bay
Hwy. 1
Marin City
SLIDE RANCH
Muir Beach
ANGEL ISLAND STATE PARK
Berkeley
Sausalito
Marin Headlands
US 101
GREEN GULCH ZEN CENTER
TENNESSEE VALLEY
FORT CRONKHITE
RODEO BEACH
ALCATRAZ
Golden Gate
FORT MASON
I-80
I-80
Oakland
I-580
LANDS END
PRESIDIO
I-880
Pacific Ocean
San Francisco
OCEAN BEACH
Hwy. 1
San Francisco Bay
FORT FUNSTON
Lake Merced
I-280
THORNTON STATE BEACH
Hwy. 35
Daly City
US 101
MILAGRA RIDGE
South San Francisco
Pacifica
SHARP PARK
MORI POINT
I-380
San Bruno
SWEENEY RIDGE
PACIFICA STATE BEACH
SAN FRANCISCO BAY DISCOVERY SITE
SAN PEDRO POINT
San Andreas Lake
SAN PEDRO VALLEY COUNTY PARK
Devils Slide
MCNEE RANCH STATE PARK
Montara Mountain
Pilarcitos Lake
San Mateo
MONTARA STATE BEACH
Montara
S.F. PENINSULA WATERSHED
I-280
Hwy. 92
US 101
Moss Beach
RANCHO CORRAL DE TIERRA
Crystal Springs Reservoir
FITZGERALD MARINE RESERVE
El Granada
Upper Crystal Springs Reservoir
FILOLI
Pillar Point
Half Moon Bay
Hwy. 1
SAN
MATEO
COUNTY
Half Moon Bay
PHLEGER ESTATE
Woodside
Hwy. 35

N
0 5 10 mi
0 5 10 km

Inset map labels:

Sausalito
ANGEL ISLAND STATE PARK
WOLFBACK RIDGE
US 101
Marin Headlands
FORT BAKER
San Francisco Bay
FORT BARRY
KIRBY COVE
Golden Gate Bridge
ALCATRAZ
PT. BONITA
Golden Gate
AQUATIC PARK
FORT POINT NATIONAL HISTORIC SITE
MARINA GREEN
FORT MASON
CRISSY FIELD
BAKER BEACH
Doyle Dr.
US 101
CHINA BEACH
PRESIDIO OF SAN FRANCISCO
SAN FRANCISCO MARITIME NATIONAL HISTORICAL PARK
LANDS END
PT. LOBOS
SUTRO BATHS
LINCOLN PARK
Park-Presidio Blvd.
FORT MILEY
CLIFF HOUSE
VA MEDICAL CENTER
SUTRO HEIGHTS PARK
OCEAN BEACH
GOLDEN GATE PARK
0 2 mi
0 2 km

Plate 3. Golden Gate National Recreation Area, southern half, in 2006.

Plate 4. *Where the Park Began:* East Fort Miley, the unirrigated area with the red-roofed Army buildings and parking lot, lies between an art museum and the VA Medical Center. (Robert Cameron, 1969, www.abovebooks.com; detail.)

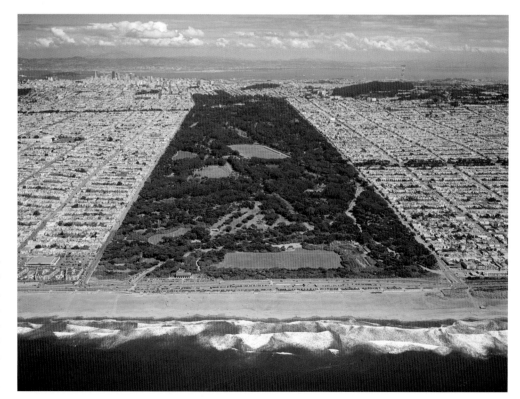

Plate 5. *Two Separate Parks, Similar Names:* Ocean Beach is part of the Golden Gate National Recreation Area. Golden Gate Park, the green rectangle on former sand dunes, is a San Francisco city park begun in 1870. (Robert Campbell, 2000, www.chamoismoon.com.)

Plate 6. *Spanning the Gate:* Fort Point, built in the 1850s, appears under the great steel arch of the 1937 Golden Gate Bridge. (Robert Campbell, 1997, www.chamoismoon.com.)

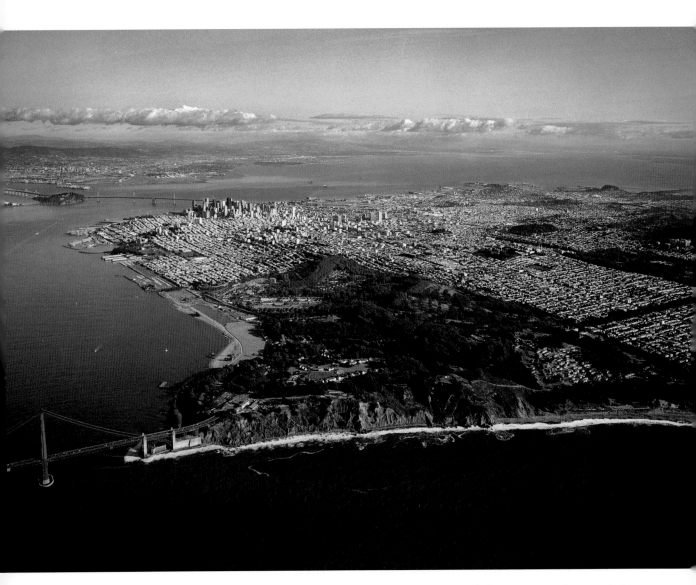

Plate 7. *Park Keystone:* The Presidio of San Francisco, established by Spain in 1776, is the keystone in an arc of seven scenic former military reservations. (Robert Campbell, 2002, www.chamoismoon.com.)

Plate 8. *Northern Waterfront:* A curved fishing pier and the Hyde Street Pier surround Aquatic Park Lagoon in the San Francisco Maritime National Historical Park. (Robert Cameron, 1986, www.abovebooks.com; detail.)

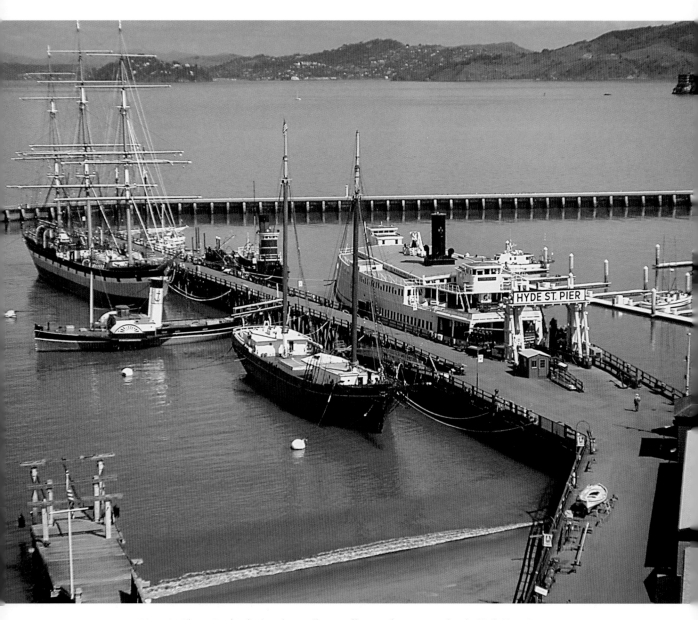

Plate 9. *Floating Landmarks:* An eclectic collection of historic ships is moored at the Hyde Street Pier. (Courtesy San Francisco Maritime National Historical Park Archives, P90-006.4w.)

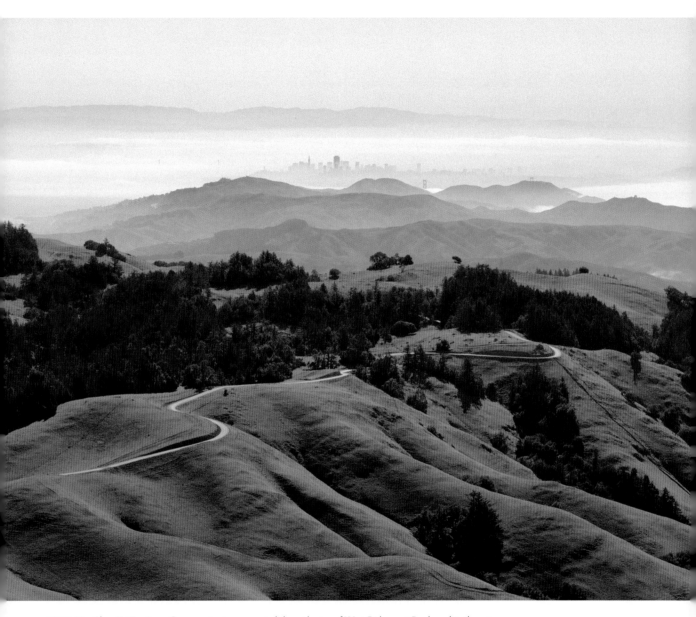

Plate 10. *Close, Yet Far Away:* Conservationists prevented the widening of West Ridgecrest Boulevard in the 1960s. San Francisco's skyscrapers can be seen beyond the green winter hills of West Marin. (Robert Campbell, 1974, www.chamoismoon.com.)

Plate 11. *Ecological Oasis:* Bolinas Lagoon is an important stop on the Pacific Flyway for migrating birds. Egrets and herons nest atop the redwood trees of Audubon Canyon Ranch hidden in one of these green canyons.

(Wyn Hoag, www.wild-nature.org.)

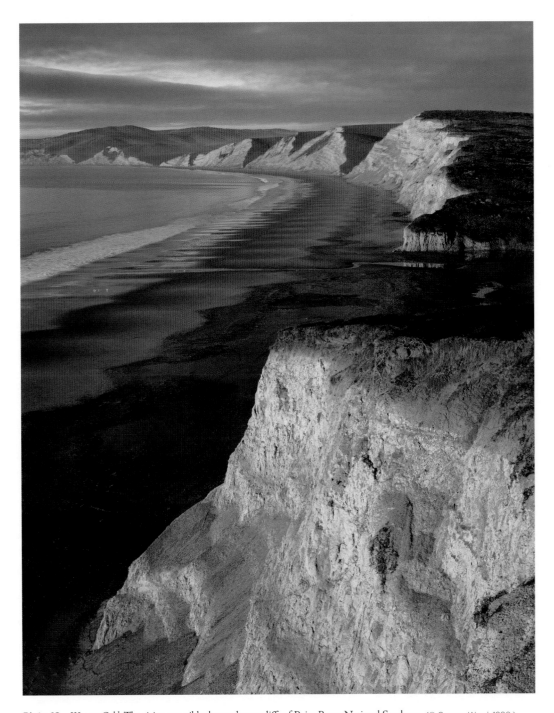

Plate 12. *Western Gold:* The rising sun gilds the sandstone cliffs of Point Reyes National Seashore. (© George Ward, 1990.)

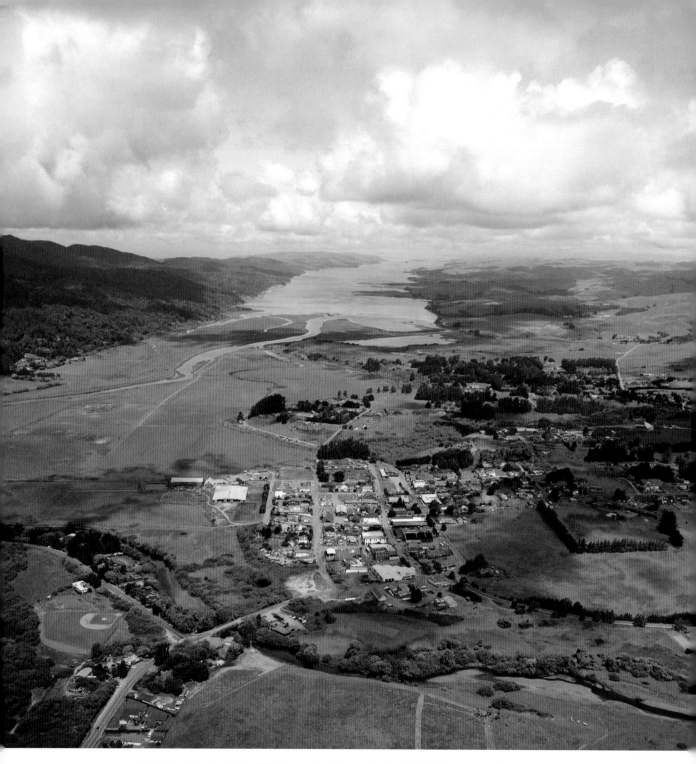

Plate 13. *Point Reyes Station:* This former railroad stop at the head of Tomales Bay now welcomes park visitors. Beneath this area lies the San Andreas Fault. (Robert Campbell, 1994, www.chamoismoon.com.)

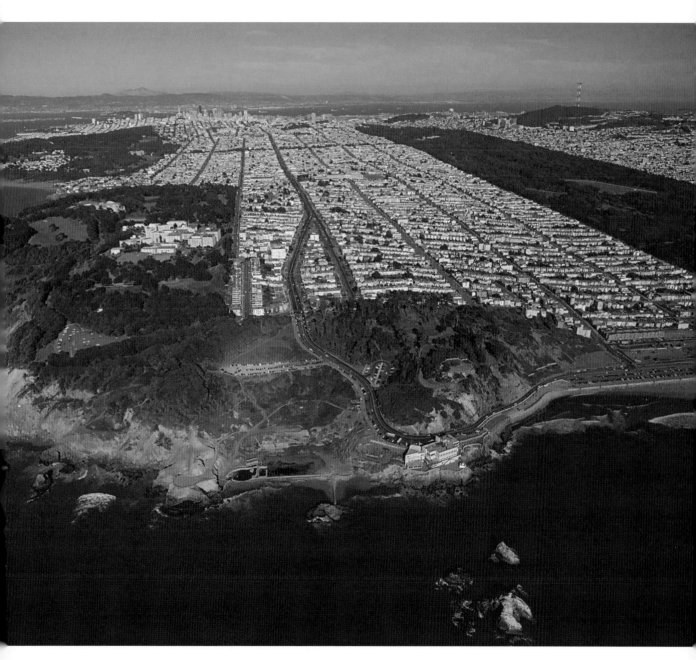

Plate 14. *Lands End*: The Cliff House, the Sutro Baths ruins, and the VA Medical Center can be seen on the south promontory of the Golden Gate. (Robert Cameron, 1985, www.abovebooks.com.)

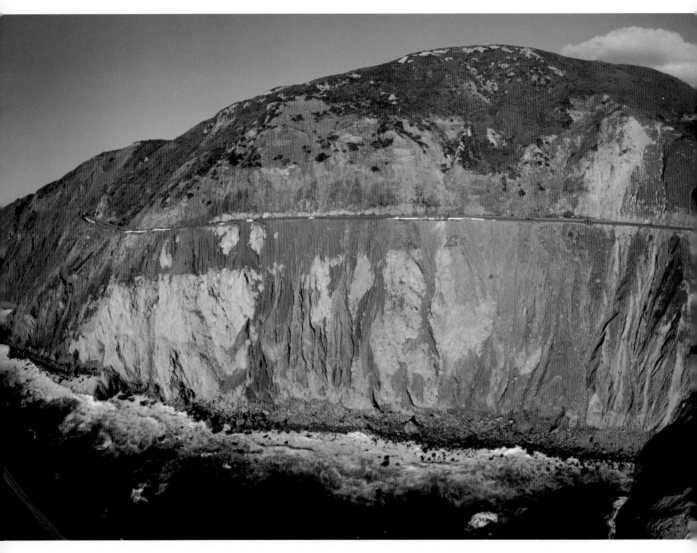

Plate 15. *Devil's Slide:* This unstable stretch of Highway 1 in San Mateo County will be rerouted through an inland tunnel, and the road will become a trail. (Robert Cameron, 2004, www.abovebooks.com.)

Plate 16. *Music in the Forest:* Quiet summer streams in the park's redwood forests become noisy torrents after winter rains, and salmon migrate upstream from the Pacific to spawn. (Robert Buelteman, © 1988, www.buelteman.com.)

Plate 17. *Hard Won:* After a decade-long struggle, Congress and conservationists were able to include Sweeney Ridge and the San Francisco Bay Discovery Site in the GGNRA. (Wyn Hoag, www.wild-nature.org.)

Figure 16. *Political Opportunity:* President Richard M. Nixon supported far-reaching environmental and park legislation, including the creation of the GGNRA. During his reelection campaign in 1972, the president and Interior Secretary Rogers Morton sailed across the Golden Gate and saw some of the land proposed for inclusion in the national park. (Courtesy National Archives.)

About noon, someone announced the arrival of the presidential party. The committee left for the boat tour, and we went down to the shore to await the boat's return. Photographs in the next day's newspapers showed a windblown president, in the company of various dignitaries, on the ferry's upper deck with the backdrop of the Golden Gate Bridge (figure 16). At the end of a thirteen-minute tour, the president and his wife stepped onto the refurbished Army pier, where we were lined up to greet them. Ed remembers the president saying as he shook hands with him, "You get after that Congress. I'll sign that bill as soon as you can get it through. I'm for it."[23]

The president's detour to the Golden Gate was thoroughly covered by the national as well as the local press. Although the event was billed as nonpolitical, the *Chronicle* reported that some 4,000 people greeted him at the airport, and 200 young people chanted "Four more years!" on his arrival at the Presidio. Nixon used the opportunity to complain that the Democratic-controlled Congress, "mired in inaction and jurisdictional squabbles," had thwarted his conservation agenda. Press fact sheets announced that his Legacy of Parks program had turned over 167 properties, more than 20,000 acres worth over $100 million, to state and local governments since its inception in 1971, including gifts on this day of 23 parcels of land, over 1,800 acres valued at nearly $10 million. Within hearing of reporters, the president bantered with Donald Rumsfeld, director of the Property Review Board, who "noted that property transfers had now occurred in 41 states but that he had until 'the end of the year' to establish parks in the nine remaining states. 'No,' the President smiled. 'You only have two months.'"[24]

"Nixon Hits Congress on Parkland Action," proclaimed the *Washington Post*. House and Senate members, said the president, "are simply not keeping pace with the concern of citizens throughout the nation for positive action." He declared that the park bill "has received some action in the House 'because of the strong support for it by Congressman Mailliard.'" After the president said the bill was "stalled in the Senate," Secretary Morton said reassuringly that "the Senate wanted to wait to see what kind of a bill the House brings out before acting." Morton also announced that the administration had changed its position and would include the Olema Valley in the park. He reminded everyone that he was still wondering how much land San Francisco would be willing to put under national park jurisdiction. The *Chronicle* editorialized, "With the President, we urge the two Houses to seize the hour and create something that will cause the 92nd Congress to be remembered for years to come."[25]

We were all very optimistic. When Bill Thomas reported to Phil Burton that President Nixon had announced his support for the GGNRA at a media event on a tour boat under the Golden Gate Bridge, and that his bill was now a cinch to pass, Phil responded, "Good, now add all the land that Ed and Amy want!"[26]

A SENATE HEARING IN WASHINGTON

Within thirty-six hours of the president's visit, Senator Alan Bible announced that the long-sought Senate committee hearing for the park legislation would take place on September 22, 1972. We

had testified at every possible hearing, talked with anyone who would listen, urged everyone to tell their most powerful friends—and their best friends and relatives—about our park, and garnered all the endorsements we could get from local and national organizations. Every afternoon after President Nixon's visit, I waited for the mail to come. I got copies of letters of support that readers had sent to various representatives and senators, more and more coupons, and some checks. Most of the coupons and checks were the result of *Sunset* magazine's publication of our coupon ad. I sent a letter of thanks to anyone who sent us more than a coupon, giving them a brief progress report and asking them to try to get others to help the cause.

It was a frantic time because we had only a few weeks to get ready for the Senate subcommittee hearing. Several bills were before Senator Bible's committee. Foremost was a near-duplicate of Phil's earlier legislation introduced by our two California senators. Another bill introduced by Senators Mike Mansfield (D-MT), Henry M. Jackson (D-WA), and Gordon Allott (R-CO) limited land within the park's boundary to 24,000 acres and provided that 45 acres of Crissy Field would be granted to the secretary of the interior by the Army within ten years—or, if agreed on, a longer period of time. There was also Mailliard's bill for the administration and Phil's later bill, HR 16444.[27]

On September 12, 1972, HR 16444 was "Committed to the Committee of the Whole House on the State of the Union." I can only guess that about this time Senators Cranston and Tunney accepted it as the "base bill" for Senate consideration, in place of their bill. All the action had been in the House and their bill had not evolved, so this brought the most up-to-date bill to the fore. It would also simplify the job of getting agreement between the two houses of Congress. There was not enough time left in the congressional session for a House-Senate conference committee. Unless they planned to leave office, all members of the House and one-third of the Senate were up for election and wanted to get home to the campaign trail well before election day.

To cover all the issues and ensure we would not repeat each other, I coordinated the testimony of Jim Weinberger, Bob Raab, Ed Wayburn, Jerry Friedman, and myself, one panel of witnesses. We represented, respectively, SPUR, the Marin Conservation League, People For a Golden Gate National Recreation Area, the Environmental Action Committee of West Marin, and the Sierra Club, five organizations with a common viewpoint. Following instructions from Senator Bible's aide, we took thirty copies of our testimony to Washington for committee members and staff, and for the press and public.

Senator Bible sat before us alone on the dais for almost the entire hearing of September 22, 1972. Senator Cranston testified for the legislation, saying it was important not to worry about

details. Secretary Morton transmitted the Army's objections to parts of the bill and warned that conflict could hold up House passage. He supported inclusion of the Olema Valley. Senator Bible agreed so obviously with the park proponents that we had little left to add to his remarks. Each county's representative supported the bill. "I kind of like the idea of city parks along the shore being included," Bible said and later remarked, "I know we cannot report a bill very different from the House legislation and expect passage this year."[28] Bible asked witnesses who wanted changes in the bill—from the Galileo High School group to those wanting to include some land near Mill Valley—what they wanted if the choice was the House bill or no bill. Each preferred the unchanged House bill. By the afternoon, a Park Service representative had stifled another objection, by agreeing that Audubon Canyon Ranch and Green Gulch/Zen Center Farm could be exempt from purchase, as long as their use of the land remained compatible with the park.

After the hearing Senator Bible said he would review the Army's concerns. He and the bill's sponsors indicated that they would give in to the military to save the park legislation.[29] We worried what that might mean, but we left Washington in a state of high expectation.

STRATEGIC MANEUVERS

Back home, for the next several weeks I checked the newspaper every morning. Every evening I waited for Bill Thomas to phone from Washington, where he was covering the park story for the *San Francisco Chronicle*. Phil Burton tried several times, unsuccessfully, to bring the legislation to the House floor on the consent calendar: House rules would be suspended and there would be no debate. In one unhappy evening phone call, Bill reported that the legislation again hadn't reached the floor that day, and that Phil and Bill Mailliard had gone down the hall "swinging the gin bottle between them."

At the end of every congressional session, bills have to compete for passage, and some are not acted on and lost. We did not recognize how much the conflict over inclusion of some military lands, especially the Presidio, was an obstacle to passage of our legislation. Bill Thomas remembered part of that battle this way: "The Department of the Army was holding tough; they didn't want to give Phil Crissy Field or anything. . . . I told Phil, 'The thing they really love out there is their golf course. If you take their golf course away they'd be in fits. Put it into the boundaries that you're going to take the golf course immediately and trade it for Crissy Field.' And he did it—beautifully—and we got Crissy Field and they got their golf course."[30] That was the early part of the story—there was more.

Apparently Bill Mailliard engineered a maneuver that would make it possible to get our park's legislation passed by the House as a noncontroversial bill under "suspension of the rules."[31] The chair of the Armed Services Committee, F. Edward Hébert (D-LA), vigorously objected to Phil's legislation coming to a vote before his committee reviewed the sections concerning military lands within the park's boundary. On October 2, 1972, Bill Mailliard sent an urgent "Dear Republican Colleague" letter to fellow representatives:

I have read with astonishment the letter sent to us all by my good friend Eddie Hébert regarding H.R. 16444, a bill to create the Golden Gate National Recreation Area, and I urge you not to oppose this bill today.

There is no intention (and the bill does *not* so provide) to transfer any of the main facilities presently being used by the Army in the Presidio of San Francisco. . . .

The entire area of this proposed National Recreation Area lies within my Sixth District of California. In my nearly 20 years in the House, no legislation has been more important to me or has had greater general support from the people . . . if it is not passed under suspension [of the rules], the bill will be dead for another year at least. . . .

As you may know, two weeks ago, the President made a special trip to San Francisco where he publicly endorsed this bill. This weekend, I had the opportunity to discuss this legislation with the President, and the Administration still strongly supports the measure, and agrees that under existing parliamentary procedure, any amendments that are required should be taken care of in the Senate. If the bill is defeated by Republican votes today, I believe it would be embarrassing to the President and I know it would be to me.

But Hébert did not give up. On October 9 he sent a letter urging his colleagues "to vote down H.R. 16444, when it is considered by the House under suspension of the rules," because it flouted the rules of the House in respect to the Armed Services Committee's jurisdiction, would transfer to the secretary of the interior "more than 1,000 acres of land currently required by the Armed Forces for essential military missions," and would cost taxpayers millions of dollars to relocate military facilities. He declared that the bill "forecloses any future use of the property for military purposes unless the Interior and Insular Affairs Committees agree to such use" and asked that a bill by Congressman Charles Gubser (R-CA) be supported instead.

Phil Burton used to say, "Every successful deed has a thousand mothers." Secretary Morton had warned him that by insisting on too much land in the Presidio, Phil could lose the Golden Gate legislation. Bill Mailliard helped out. He was not on the Armed Services Committee but obviously had collegial relations with many House members. I believe he asked Armed Services Committee member Gubser for help, and Gubser's bill gave a way out. It provided that air defense missions, reserve activity, and family housing would continue on the Presidio, but that 100 acres of Baker Beach and 45 acres of Crissy Field, excess to Army needs, would be transferred to Interior's jurisdiction. Most of the Marin forts and other military properties would also be made immediately available for transfer for national park purposes.[32]

Congressman Gubser proclaimed the result: "House Rules specifically designate Mr. Hébert's committee as having sole jurisdiction over the transfer of property on military bases. I introduced a bill on one day which received favorable committee action the next. . . . The jurisdictional problem is now resolved and the way is cleared for passage of the Mailliard-Burton bill which I support."[33]

6

VICTORY IN CONGRESS

A Park for the People

People For a Golden Gate National Recreation Area held its collective breath in San Francisco for three weeks—there was nothing more we could do. We thought the barrier to the House vote was only the other bills ahead of ours. Then—suddenly, from our viewpoint—the legislation to authorize the Golden Gate National Recreation Area was cleared for passage on the suspension calendar of the House of Representatives. Passage by the House was followed by Senate passage. We had no doubt of the president's signature—by the time the bill was signed into law by President Nixon, we had been privately celebrating for two weeks. But as we congratulated each other we took stock, almost daily, of what we had accomplished and prepared for the hard work we knew lay ahead.

PASSAGE IN THE HOUSE

On the evening of October 11, Wayne Aspinall, the Interior Committee chair and a congressman Phil had strenuously challenged, brought Phil's bill to the floor for a vote.[1] Aspinall had been defeated in his home state's primary election that year and would not be returning to Congress. He said he was bringing to the floor of the House "legislation creating one of the most important new recreational areas to be considered during the 92nd Congress."

Bill Mailliard declared himself delighted with the bill, praising it as "the most important piece of legislation in the district that I represent and probably the most important piece of legislation that I have had a hand in in my nearly 20 years." He expressed his personal appreciation "to literally dozens and dozens of the Members of this House who have helped us get to this point. With any kind of break at all, with the bill that is now before us, I believe that the Senate can accept the bill in its present form and that we can have this on the books before this Congress is finished."

A dozen congressmen on both sides of the aisle warmly endorsed the legislation that evening and expressed the need for more parks for America's growing population. In the text of the *Congressional Record* I can hear Phil's voice trumpeting: "How could any reasonable person oppose the enactment of H.R. 16444? Does anyone care to deny the 5 million people living in the San Francisco region this outstanding outdoor area when it can be accomplished without disrupting or impairing any public or private uses of the lands involved?" Phil especially praised Congressmen Bill Mailliard and Don Clausen. He thanked the leaders of PFGGNRA, read into the *Record* a list of names he had asked me to prepare for him, and praised his former staff director, Bill Thomas. By unanimous voice vote, the House of Representatives then passed the legislation to establish the park.[2]

That evening, around eight o'clock West Coast time, my daughters were getting sleepy over a bedtime story when the phone rang. A very happy-sounding Bill Mailliard told me that the legislation had passed and they couldn't find Ed Wayburn. I told him Ed was out of town. Phil wrested the phone from Bill, shouted triumphantly that the bill had finally made it, called me "a great broad," declared Don Clausen a rancher with shit on his shoes and handed the phone over to him. Clausen expressed his delight for a while and handed the phone to Mailliard and so around again, while I occasionally said "wonderful!" and "how great!" and promised to tell Ed. The girls were sound asleep when I got off the phone. Marion Otsea later remarked that the three happy congressmen could have been heard from Washington without benefit of telephone.

The bill passed the Senate the next day by unanimous vote and was sent to the president. We

waited impatiently for him to sign the bill. We wrote to the congressmen and senators and telephoned their aides. SPUR's letter to Phil Burton, thanking him for his "unceasing and successful effort" to create the park, "a magnificent accomplishment," summed up everyone's heartfelt appreciation of the contribution of every congressman and senator.

THE POLITICS OF PARKS

Our victory occurred in the context of the most political time of the year. In the autumn of 1972, political officeholders running for reelection could garner favorable headlines and appreciative editorials for park bills and events. The legislation to establish the Gateway National Recreation Area in New York and New Jersey was also going through its last stages in Congress and was on schedule to be signed into law by the president. Someone from the staff of the Regional Plan Association in New York City, which was helping shepherd the Gateway legislation through Congress, observed that not just our two parks were in the national spotlight.

The Indiana Dunes National Lakeshore—the first of this kind of national park near an urban area—was officially dedicated in September 1972. Roger Hurlbert gave me a clipping from the *Christian Science Monitor* about the dedication. At the ceremony, less than two weeks after President Nixon had visited the Golden Gate and six weeks before election day, Interior Secretary Rogers Morton and President Nixon's daughter Julie Eisenhower hailed Indiana Dunes as a park that could be visited by 10 million people within a 100-mile reach, in particular the residents of Gary and Chicago.[3] The Save the Dunes Council had launched a citizens' crusade in the early 1950s to preserve some of the southern shoreline of Lake Michigan, which was changing rapidly under pressure for home building and industrial development. Senator Paul Douglas of Illinois had championed the preservationists' cause and the park had been established in 1966.

We had a ceremony in California that matched the ceremony in Indiana. Ours was held as official recognition that enough private land had been connected by Park Service purchases to permit administration and general public use of Point Reyes National Seashore. On the morning of October 20, 1972, three weeks before election day, a group of dignitaries gathered under patriotic bunting in a meadow—about where the park's handsome visitor center stands today—before a small audience and the press. I waved at Bill Mailliard across the lawn and he most uncharacteristically shouted back, "You're a great broad, Amy!" Senator Bible, Congressmen Mailliard and Clausen, local officeholders, and Boyd Stewart joined an Interior assistant secretary and

a National Park Service associate director to "establish" the national seashore, which had been authorized ten years earlier. They placed a plaque from President Nixon, commending the legacy of parks and recreational areas accessible to all Americans and for future generations.[4]

FROM HOPE TO REALITY

President Nixon signed the legislation for the Golden Gate National Recreation Area on October 27, 1972. On the same day, he signed the bill for Gateway National Recreation Area.[5] The legislation that authorized this first stage of our national park included all the 34,000 acres of public and private land we had hoped to protect within its boundary.

Some 28,000 acres of the land within the park were in Marin County, bordering lands with scenic vistas and plant and animal habitat already protected by the Park Service and other agencies. These 28,000 acres of the GGNRA would connect more than 90,000 acres of federal parks, state parks, and other protected properties in Marin County, including the Marin Municipal Water District and Bolinas Lagoon. And thus, nearly 120,000 acres of open space would reach from the northern side of the Golden Gate to the farthest limit of Point Reyes National Seashore. Using to mutual advantage the extensive countryside protected by others, the Golden Gate National Recreation Area would forever help retain broad vistas and protect complete ecosystems in an area several times its legislated size.[6] Authorization of the GGNRA in 1972, and local adoption of the revised Marin Countywide Plan in 1973—which designated West Marin as a coastal/recreational/wildlife corridor—effectively ended commercial and suburban development in West Marin. Since population increase was severely restricted, the comprehensive permanent protection of the GGNRA also ended the threats of freeway building and road widening.

The park boundary skirted the towns of Muir Beach, Stinson Beach, and Olema. The Park Service would buy 16,000 acres of privately owned land, including the property once intended for Marincello. Ranchers and the few home owners within the area could elect to retain a right of possession for up to twenty-five years or remain on their land for life—a "life estate." In San Francisco, the Park Service would buy the Cliff House and Sutro Baths. If the state wished, the national park would take over ownership and management of any lands within the park boundary that were "owned by the State of California or any subdivision thereof." Donating such lands, turning them over to the federal government, would relieve state and local agencies of their maintenance and policing costs.[7]

Congress placed all the military lands at the Golden Gate within the park's boundary. On the Marin side, Forts Barry and Cronkhite and the western half of Fort Baker were transferred to the Department of the Interior, although the Army could continue certain missions, reserve activities, and family housing for as long as needed. The three San Francisco forts and some other small parcels of federal land were also transferred to the Department of the Interior subject to some existing uses—none of these provisions would cause real problems for park management. The Army kept the eastern half of Fort Baker, and all of the Presidio except for the park's "irrevocable use and occupancy" of 100 acres of Baker Beach and 45 acres of Crissy Field. The legislation provided that when "the easterly one-half of Fort Baker" and "all or any substantial portion of the remainder of the Presidio is determined by the Department of Defense to be excess to its needs, such lands shall be transferred to the jurisdiction of the Secretary [of the Interior] for purposes of this Act." We thought this left two areas potentially threatened with further construction: the level and accessible part of the Presidio between Fort Point and the Marina Green, and the eastern half of Fort Baker. We were worried about Fort Baker because so many people in San Francisco would fight more development on the Presidio. The threat to Fort Baker never materialized, but we were right about the threat to the Presidio.[8]

The bill also included a citizens' advisory commission for the Golden Gate National Recreation Area and Point Reyes National Seashore. The appropriations ceiling for land purchase was set at $61,610,000 and the ceiling for park development at $58,000,000 (both have been adjusted periodically for inflation).[9]

Some days after the bill was signed, we estimated the cost of the park campaign. Since our volunteers worked at home, there was no office rent. Private donations of about $10,000 covered our costs for telephone, printing, and mailing. Airfares to Washington hearings and hotel rooms (paid out of pocket by most of the park activists, and by San Francisco and Marin counties for elected officials) were, at most, another $10,000. At a total of $20,000, we figured the cost of our park campaign at 59 cents an acre.

CELEBRATION

Charlotte Mailliard, San Francisco's premier party-planner and the wife of Supervisor Jack Mailliard, suggested a luncheon to celebrate the legislation and thank the congressmen. The celebration would also boost her brother-in-law's reelection campaign. The "Luncheon for Phil and Bill"

Figure 17. *Key Players:* Congress-
man William Mailliard, left,
and SPUR's executive director,
John H. Jacobs, right, celebrating the
authorization of the GGNRA at a
luncheon for Burton and Mailliard
on November 2, 1972. (Courtesy
Golden Gate National Recreation
Area, Park Archives, GOGA-3380,
87-112-22, People For a Golden Gate
National Recreation Area Collection,
Bob Raab, PG&E.)

was set for November 2, 1972, and was not a fundraiser. Charlotte tried to get some of us to help her
with preparations and selling tickets, but we had no idea of how to sell hundreds of luncheon tick-
ets and fill the main ballroom of the St. Francis Hotel. Charlotte, with some help from Diane Hunter,
took everything in hand—and 560 people crowded through the doors for a white-tablecloth picnic
of hamburgers, potato salad, beer, and popsicles, a populist menu chosen by Phil (figures 17–18).

Facing the crowd from the dais, I was a bit puzzled: there were several tables of Japanese busi-
nessmen. And I couldn't see some of our principal supporters. I later learned that tables of tick-
ets were sold to the city's several Japanese banks, who distributed seats among the many visitors
from Japan coming to San Francisco at that time. A few tables had been sold twice, so Charlotte
and Diane had to ask guests they knew to go up to a balcony.

The luncheon was a huge success. Phil and Bill were praised for getting the park established
in seventeen months. Phil let the crowd know that he was reviewing the possibility of expanding
the park into San Mateo and Santa Cruz counties. Phil and Bill each cited the bipartisan support

Figure 18. *The Visionary and the Politician:* Dr. Edgar Wayburn, left, and Congressman Phillip Burton, right, on November 2, 1972, celebrating the GGNRA and probably plotting further park legislation. (Courtesy Golden Gate National Recreation Area, Park Archives, GOGA-3380, 87-112-23, People For a Golden Gate National Recreation Area Collection, Bob Ráab, PG&E.)

that made the legislation's success possible. Fifty people were praised from the podium for their contributions to the campaign. According to the *Examiner,* Ed declared that the GGNRA was "a precedent-setting park that will be difficult to match," and I said that our organization "plans to remain in business, as an innovative master plan is urgently required, and it is something that will need watchdogging." Neither of us can recall the rest of what we said.[10]

The general election was five days later, on November 7, 1972. A little more than 54 percent of the state's voters approved the California Coastal Zone Conservation Act. One of the effects of the act was to drastically curtail opportunities for development in West Marin. Land owners included in the park were happy to know they could sell their parcels to the National Park Service. Also on November 7, President Richard Nixon easily won reelection over the Democratic candidate, George McGovern. In California's Sixth Congressional District, however, Bill Mailliard garnered only 52 percent of the votes and Nixon lost to McGovern.[11]

Some days after his reelection, Phil Burton held a victory party for the Golden Gate National

Recreation Area at a San Francisco hotel. When the *Examiner* reporter Gerald Adams saw me there he said, "When I first heard you speak about the park, I thought you were a nice lady. I also thought you were a little crazy."

Later in November, Becky Evans from the Sierra Club phoned. "The money the Bay Chapter has been giving you . . . Now that the campaign is over, you won't need a subsidy anymore." Since the Sierra Club was involved in scores of land protection issues, and saving the Golden Gate was no longer an urgent legislative battle, I understood: PFGGNRA was on its own. But I reminded Becky that the work of turning the land into a national park had only just begun.

WE WERE PART OF A "QUIET REVOLUTION"

One of the remarkable things about the creation of this park was that the owners of private land within the park boundaries offered little resistance to federal purchase of their properties. Indeed, at several turns, property owners had actually approached us with offers to donate or include their land. I remember a morning near the end of the House Interior Committee's work on the legislation when Edna Smith telephoned. She owned 114 hilltop acres north of Tennessee Valley Road and wanted her land to go into the park; how could she let someone know? I made some phone calls and gave her instructions. Her land was included in the boundary and later purchased.

Six months after Congress passed the Golden Gate National Recreation Area legislation, Ed Wayburn told the reporter Scott Thurber: "This is the first time in my knowledge—it is the first time I think in Congressional history—that landowner after landowner came up and advocated a project that would take their land away from them. . . . This is something which I think convinced the Congress as much as anything that this was a project whose time had come."[12]

A few days after the bill was signed, John Jacobs phoned to tell me, "This is the most important change in land use we're going to see in our lifetimes." And a year after passage of the two bills, Gladwin Hill wrote in the *San Francisco Chronicle*: "What authorities have called a 'quiet revolution' in government regulation of land, America's most basic resource, is gathering momentum from coast to coast. . . . The crux of it is a transformation in the concept of land from that of a commodity, simply to be bought and sold, to that of a national resource in which all citizens have a rightful interest."[13]

The lasting value of the accessible public greenbelt we helped create in 1972 was perhaps best expressed in the May 1999 SPUR newsletter:

The founding of the GGNRA is one of San Francisco's—and SPUR's—proud moments. . . . The Golden Gate National Recreation Area is a remarkable example of a greenbelt. Its magnificent natural spaces are literally right next door to San Francisco—so close and so visible that many of us take them for granted . . . a greenbelt done right, where it exists. It is large enough in extent that it forms a predominant image of the area. It continues from coastal beaches to coast range, part of a seamless pattern of nature, including hilltops and stream valleys, allowing hydraulic processes to continue and wildlife to migrate. It forms a clear edge to what would otherwise be a sprawling metropolis. By defining the edge it gives some shape to the urban area.[14]

7

A NEW PARK EMERGES

In October 1972 the Golden Gate National Recreation Area consisted of an act of Congress and an inch-high stack of maps showing land belonging to various public agencies and private owners (see map, opposite). The park's superintendent had to get the new park ready for the public: build a staff, work out the transfer of public lands, arrange to buy the private properties, open up some areas to the public and put up entry signs there, work with members of the public to learn what they hoped to see and do in the park, and begin a written plan for the park's future.

The GGNRA's first superintendent enthusiastically shouldered these tasks. He used some of the Park Service's best and newest ideas for planning and recreation, and he brought in new strategies for citizens' participation and public-private partnerships. The people who had supported the national park—and a cadre of new people—rallied behind his effective administration. After a year the superintendent was happy to get an advisory commission to help him.

The Golden Gate National Recreation Area in 1972.

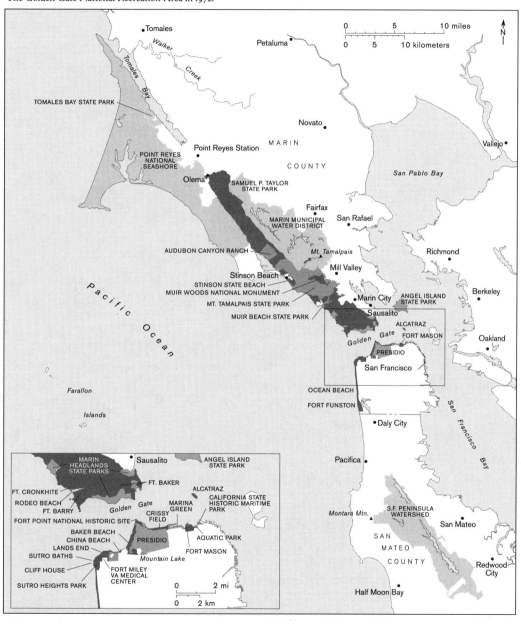

Golden Gate National Recreation Area (Legislated Boundary)
Managed by National Park Service

Golden Gate National Recreation Area
Managed by Other Agencies

Other Public Land

THE SUPERINTENDENT GETS TO WORK

"I bet you'll agree I chose the right man for Golden Gate's superintendent," the Park Service's western regional director, Howard Chapman, told Ed Wayburn and me in December 1972. "Bill Whalen's been innovative as deputy superintendent of Yosemite. He put together the 'fast, frequent, and free' tram service there." Ed nodded. Later he said to me, "I just hope Howard chose someone we can work with. We could have an awful lot of trouble if we don't get the right person."

William J. Whalen turned out to be just the kind of person the GGNRA—and we—needed. Bill was special. Having much the same effect as a parent on a newborn child, his imprint can be seen throughout the park today, more than thirty years after he first walked into his office in early 1973 at age thirty-two. Bill's college degrees were in political science and psychology and he had learned resource management from experience. He came to an office that had nothing more (or so we heard) than a commandeered desk, a "liberated" typewriter, and a handful of number 2 pencils.

In the months after Bill began his new job as the park's superintendent—a position soon renamed "general superintendent"[1]—many of the people waiting for a park to happen thought it was taking too long. Where were the advisory commission nominations? When would a certain parcel be purchased? What were the superintendent's plans for the Fort Mason piers? People phoned me all the time with questions like these—especially the one about the advisory commission nominations. I learned some answers at meetings Ed and I attended, and in my frequent phone calls to Bill. For months I relayed the basic answer to the rest of PFGGNRA's leadership and to members of the public: a huge gearing-up process was under way, and it was in able hands.

Help from the Colonel

To develop the first budget, hire initial personnel, get parklands transferred from other agencies, post signs—and also to deal with the wily mayor of San Francisco and the fractious boards of supervisors of two counties, greet hospitably anyone brought to the park by the Park Service, the Interior Department, or Congressmen Burton and Mailliard, and to meet with park supporters and potential park allies—for these and all the other start-up necessities, Superintendent Whalen needed a sizable and seasoned staff he didn't have. So the freshman superin-

tendent went to visit the highest ranking officer at the Presidio, Sixth U.S. Army Lieutenant General Richard G. Stillwell, to see if he could get some help. General Stillwell offered John Kern. "He's a very busy man," said the general, "but when you want to get something done, the busy man is the one you ask."

By 1973 Lieutenant Colonel John H. Kern had served twenty-two years in the U.S. Army Corps of Engineers. Having used every available maneuver to keep his family at the Presidio for years at a time while he served at home and abroad, he knew all the bureaucratic ins and outs of getting what he wanted. And John Kern appreciated the Golden Gate National Recreation Area. He was an Army officer whose pride was doing right, and doing it well. Did the park need a forklift? Tour vans for a flock of visiting dignitaries? Colonel Kern could find whatever was needed. His knowledge of the military lands at the Golden Gate made him an invaluable source of advice and technical assistance—and more. "He was an incredible help with all the stuff we needed," Bill remembers. "From bulldozers to missiles, John was the flea market junkie in the DOD."[2]

For the first few months, Bill and a planner operated out of the Park Service's regional office, which was then in the Federal Building in San Francisco's Civic Center. Bill needed an office in the park. John Kern told a colonel friend in Building 201 in Fort Mason, and the friend moved some people around. He gave Bill a little corner office, telephone service, desks, chairs, and other supplies from Army resources. "And as the Army tucked up its tail and reduced in size," John said, he was able to move the Army's entire western regional office out of Building 201 over to the Presidio, and Building 201 became the headquarters of the Golden Gate National Recreation Area, where it remains today.[3]

In these ways and many more, John Kern helped jump-start the national park. He also knew that park people were going to be working with Army people for years to come, and he tried to introduce People For a Golden Gate National Recreation Area to the Army. PFGGNRA leaders were invited to some events, and George and I went to a number of Army receptions. We civilians were grateful for John's help, but after the tough congressional fight over the Presidio we were cautious about anyone in an Army officer's uniform. We knew the Army's mission is to take land and hold it, and we knew many soldiers and their civilian supporters felt defeated when the Park Service came to the Golden Gate. Over time, however, after I worked with other caring Presidio officers, I came to appreciate what a wonderful job John Kern did, and how lucky we were to have him link the new park with the old Army.

Bill's tiny headquarters befitted his Lilliputian domain—for many months the park owned little acreage beyond that room. Army personnel occupied most of the building, and the Army mowed the lawns and took out the trash while Bill began to assemble a real park staff. Assistant Superintendent Jack Wheat came on board and handled day-to-day details—he saw to it that fresh white paint covered the Army's institutional green when more of Building 201 was readied for park use. Administrative Officer Reed Malin handled paperwork and procurement. Mike Stricklin became the head of the maintenance department—Bill remembered him vacuuming the floor at the end of the day when the Army went home. It was more than a year before Bill got his first full-time secretary, Ruth Kilday, who deftly handled the myriad of details in his office.[4]

Bill had come to the GGNRA after a few years with the National Capital Parks, and fresh from the glories of Yosemite National Park. When his first planner—who had worked on the legislation before its enactment—took him out to view his new domain, Bill was struck by "the beauty of the wild lands." He remembers thinking "how wonderful it was to be part of preserving those [lands] for people so close to a major [city]" and being thrilled by "all the wonderful, wonderful facilities that we were going to be inheriting from the Army." The planner, like many others in the Park Service, saw the old military buildings as liabilities, but to Bill they were the homes of future programs. The two men stopped at Alcatraz. Bill remembered that it was "just trashed" but recognized its potential: "the place has such a foreboding and a mysterious atmosphere, the first thing you have to do is . . . let the public see the place; and then we'll figure out what the hell to do with it later on."[5]

Bill realized that with a park so surrounded by an intensely interested public he had to get to know the surrounding community. He understood that public support was essential to the park's success, and he looked forward to the appointment of the advisory commission. Bill asked his staff to read the local newspaper every day, to scan "the social pages and the obituaries—everything" to get "more attuned to the life of the region." And Bill got out into the community himself. He remembered being "constantly on the go, meeting and greeting folks and going to their offices . . . developing a relationship that later on would prove to be very helpful." He spread his net widely, getting to know "people in the business community, people in the cultural, art . . . community . . . just ordinary citizens that lived in and around the park and it stood me well. I was particularly interested in developing, early on, relationships with the governmental officials. . . . I was so young, and knew that probably people would have been skeptical of that."[6]

By the middle of 1974 Bill was able to put together his own planning team, which included Doug Nadeau, who had headed up a team at Point Reyes National Seashore. Bill's public information officer, Judy Walsh, understood community outreach. Not only planners, but rangers and maintenance people participated in their public orientation workshops, Doug Nadeau recalled:

[Our team] selected a cross-section of organizations from around the Bay Area . . . looking to develop a diverse constituency. We made sure that we got groups from Hunters Point [an African American neighborhood], places in Oakland, in Chinatown, and we made sure we contacted groups that represented senior citizens and youths. . . . That resulted in our being invited and appearing at 125 community meetings where we went out with our simple slide show of the park and explaining what our planning process was. We had a lot of surprises. . . . [We] figured that low-income minority populations would . . . want basketball courts . . . soccer fields. They all said, "No, what we want to go there for is already there. . . . We need transportation to get there."[7]

BRINGING THE PIECES TOGETHER

The Department of Defense quickly transferred its land in San Francisco to the park. Baker Beach and Crissy Field, as well as land at Forts Mason and Miley and the part of Fort Funston that had not been sold to the city in 1962 became the first places where the public could walk on land administered by the brand-new GGNRA. I saw my first brown Golden Gate National Recreation Area sign at Baker Beach—I don't remember exactly when, but I do remember being thrilled: the park was real![8] Bill Whalen opened Alcatraz to the public before a year had passed. Other pieces— a few large private properties in Marin, and parts of the Marin forts—became park property during the first few years of the park's existence, and he gradually opened them for public use.

Opening Alcatraz

To make the public quickly aware of the Golden Gate National Recreation Area, Bill Whalen wanted a conspicuous success (figure 19). In the spring of 1973, he made opening Alcatraz a top priority. He recognized that having visitors there would put the park on the map, and it would also show that he had solved a thorny political problem. Park staff had collected all sorts of ideas

Figure 19. *Ready for Visitors:* Bill Whalen, the Golden Gate National Recreation Area's first superintendent, opened Alcatraz to the public in 1973. (Courtesy Golden Gate National Recreation Area, Park Archives, GOGA-3380, 87-112-9, People For a Golden Gate National Recreation Area Collection, photographer unknown; detail.)

for the future of Alcatraz. Bill intended to hold a public hearing on these proposals someday, but for now he shelved them. This island was the part of the park that everyone across the country had heard of and could hardly wait to see—just as it was.

While his staff was readying Alcatraz, Bill invited some park supporters to visit the island. Our group walked past walls scorched by fire and scarred with graffiti, over scraggly weeds and broken cement. It was a desolate place. A park ranger led us through the sally port of the fort's guardhouse, past remnants of the military prison, up the path to the oldest lighthouse on the Pacific coast, and into the infamous cellhouse. We reached the solitary confinement cells. John Kern was with us. "Amy, my wife won't let me lock her up in here," he said. "But I'll bet you're not scared." "Of course not," I declared and stepped into the cell. John slid the grille of bars across the opening, slammed the door shut, and closed the window on the door. It was pitch black and utterly quiet for thirty seconds. I remembered how some Army people viewed the park. I thought uncomfortably, "No one saw him do this and he's not going to tell anyone. No one will miss me until the boat gets back to

San Francisco, and then he's not going to say a word." "Hey, does anyone have a key to this place?" John yelled. He reopened the cell, while I tried not to show him how I felt.

On a sparkling sunny October day, just before Alcatraz opened to the public, Bill invited Congressmen Mailliard and Burton to visit the island and asked some of us to come along. Bill showed us his new park concession, the Red & White fleet's inexpensive ferry ride—admission to the Rock was free. He showed off the grounds, which were being spruced up. Then the congressmen and other dignitaries descended to the island's parade ground in a helicopter. We all took a brief tour and admired the stunning views. There was a big pile of rubble next to the ferry dock, from an apartment block the Park Service had demolished and from the buildings lost in a fire during the Native American occupation. "What I really want to do," Bill sighed, "is to put a box of concrete chunks on this dock, next to where the tourists leave, with a sign 'Alcatraz Debris/Government Property/Do Not Remove.' It would all be gone in a few months. Instead, I'm going to have to pay to ship it out of here."[9]

John Kern told about getting ready for the public opening day, October 26, 1973:

Bill planned it to a gnat's eyelash. He had a multicultural honor guard; he had a bugler there; and he planned the whole thing up to the raising of the flags. And he had a representative of both the Native Americans and the African Americans . . . and the Hispanics, and the Caucasians—everyone was represented. . . . And I casually looked around and said, "Bill, I don't quarrel with any of your plans but where do you plan to raise the flag? There's no flagpole." [T]his was only two or three days before the actual ceremony . . . and there was . . . just an aura of panic.

So, that night, with a group of some Army volunteers, we got a large lowboy tractor trailer from the Army motor pool and we made a clandestine trip up to an old, abandoned Nike site outside of Travis Air Force Base, and somehow or other a flagpole disappeared up there and we got it back. And the next day, with a work boat, we got it out to Alcatraz and we hastily erected a flagpole.[10]

Jerry Rumberg from the Park Service's regional office and David Ames from Fort Point's staff were detailed to help open Alcatraz. They hired a dozen interpreters—encouraging former guards and prisoners, not only those who had served time on Alcatraz, to apply—and named them "the

Alcatroopers." In their training the interpreters learned about the harsh realities of life on Alcatraz (eventually, the Bureau of Prisons unsuccessfully complained that it wanted the park to project a more benign image).[11]

On opening day, reporters came from around the world, and Alcatraz featured prominently on the first page of London newspapers. Its opening established the park as an operating institution. Not long after, when my college roommate and her family came for a visit, our tour was led by a former federal prisoner who had been incarcerated elsewhere for drug possession.

The Golden Gate Promenade

Some of the Army's leadership apparently deeply resented the "irrevocable" transfer of 100 acres of Baker Beach and 45 acres of Crissy Field because they were on the Presidio. Baker Beach was the smaller loss; local civilians as well as Army personnel had used it for recreation for years. Crissy Field was a different matter, and Army brass was especially determined to minimize the extent of this incursion. While cooperating with efforts to adapt the GGNRA part of Crissy Field to park use, the Army simultaneously plotted to defend the Crissy Field land it retained.

Phil Burton had tried to include 115 acres of Crissy Airfield and the land around it in the park but was able to get only 45 acres. The parcel arbitrarily designated was a rectangle on the shoreline in the middle of the area. Many people agreed that a linear strip of the same acreage on the shoreline between Fort Point and the Marina Green would serve the park better. For years I thought that Bill Whalen and Mayor Alioto had persuaded the Army command to make this shift in configuration, but apparently it happened through John Kern's initiative. He told the story in a 1995 interview:

> The legislation really intended for 17 acres of firm land above the high tide lines and 23 acres of submerged lands [at] Crissy Field, and, [at Baker Beach] approximately 45 acres of fast land, the beach itself, and 55 acres of submerged lands. I looked at these and felt that they were inappropriate. And, with Bill Whalen's concurrence, we suggested that we give a different configuration, but one that give[s] the entire beach area of both areas. And instead of 17 acres of fast lands, we transferred, or permitted, 44.7 acres, which was the original Crissy Field area and approximately 103 acres of fast lands which became everything west of the highway over in the Ocean [Baker] Beach side, to the Park Service. Plus

Figure 20. *Military and Civilian:* The Presidio's commanding officer, Col. Robert V. Kane, with San Francisco Mayor Joseph Alioto, who has just delivered funds to build a fence along the Golden Gate Promenade at Crissy Field. (Courtesy Golden Gate National Recreation Area, Park Archives, GOGA-3380, 87-112-380, People For a Golden Gate National Recreation Area Collection, photographer unknown, 1973; detail.)

some 389 acres of submerged lands that the Army held title to from the State of California. So, in effect, they got [a] much, much greater area, but it gave the Park Service those portions of the Presidio to use and to manage that really were applicable for visitation.[12]

The Army erected a chain-link fence on Crissy Field to separate the post from the park (figure 20). At about this time, Mayor Alioto was getting the Army, the Coast Guard, and the San Francisco Recreation and Park Department to cooperate with the Park Service to create a "Golden Gate Promenade." Park planners designed a trail along the ribbon of land between the fence and the water, from Fort Point to Aquatic Park. Alioto, accompanied by an estimated 1,800 hikers, cut the ribbon to open the 3½ mile promenade on October 13, 1973, as he began his campaign for governor of California.[13]

While the promenade's development was under way, with construction vehicles that looked like all the others roaming the post, the Army surreptitiously paved a new street on its side of the Crissy Field boundary, just behind the chain-link fence. We didn't find it until the signs went up. The Army named the new street "Mason Street" and renamed the former Mason Street, several hundred feet to the south, "Old Mason Street." The dividing line in Burton's bill for the 115-acre parcel in that part of the post was Mason Street, so we knew that the reconfiguration was intended to create a new barrier to taking more land and the renaming to cause confusion if Phil Burton tried again to include the rest of Crissy Field in the park.[14]

Connections along San Francisco's Shore

It is complicated to administer and police a park whose land is interspersed with parcels that belong to other agencies. Therefore, one of Bill Whalen's first priorities was to get the city and state to donate their parklands that lay within the GGNRA's boundary to the Park Service, so that the public would have the sense of a continuous park. Getting the state parks into the GGNRA proved to be difficult, but the San Francisco Board of Supervisors was cooperative about the city parks. The board placed a measure to donate the city's shoreline parks on the November 1973 ballot. PFGGNRA ran a short campaign; there was little opposition, and the voters overwhelmingly approved the ballot measure.

These properties included the city part of Fort Funston, Ocean Beach, Sutro Heights Park, the city part of Lands End (including the city part of West Fort Miley), China Beach, Aquatic Park, and the city's maritime museum. These were all functioning parks with important natural and historic features—from bird habitat to cliffs needing erosion control, from a historic seawall to gun emplacements.

While awaiting the parks' transfer, the city continued to administer them. It researched the history of each park to make sure that there were no impediments to donation, and the Park Service had to guarantee the city that the irrevocable transfer did not mean the terrain could become something other than parkland. As the transfer papers were drawn up over the next few years, the parks changed hands. After the transfer, their management also changed somewhat. Sand was no longer mined from the Ocean Beach dunes for construction projects because studies showed that it was needed for dune replenishment. Fourth of July fireworks were forbidden at Fort Funston so the bank swallow nests would not be disturbed. The trail at Lands End was partially rerouted

so it could be stabilized and completely connected. Even so, people continued to enjoy these parks pretty much as before.[15]

The only city properties within the GGNRA's boundary that were not transferred were the Marina Green and three waterfront swimming and rowing clubs. Kite flying, volleyball, and picnics would continue on the Marina Green under any administration, and there was no need to have the federal government manage the local vessels in the adjacent private and municipal yacht harbors. With long waiting lists for berths in San Francisco, it would have been infeasible to move out some of the private vessels to begin a public boating program there. Of course, there would also have been great objection to converting the two private yacht clubs—one for people of some wealth, the other more modest—to public use when there were other buildings on the city's shoreline for public recreation. So the Marina Green and its facilities did not change hands. Objections by Dolphin, South End, and San Francisco swimming and rowing club members prevented their transfer a few years later but led to changes in their management.

Buying Marin's Private Lands

In Marin County, much of the land within the park boundary was privately owned and had to be purchased. The experience at Point Reyes National Seashore had demonstrated that interested parties could corrupt the purchase process. In the 1960s the Park Service had to buy land at Point Reyes at inflated prices, because of private greed more than government ineptness. Developers and large, politically powerful land owners of the Marin Property Owners Association had fueled land speculation that ended up quadrupling the cost of the park. Even as the legislation for the national seashore was going through Congress, the county board of supervisors had permitted the Drakes Bay Land Company to subdivide a thousand of the anticipated park's most remote acres into half-acre parcels and had waived road standards. When the Park Service paid an exorbitant price for the ghost subdivision, the price precedent raised the cost of all the rest of the park.[16]

Money to buy land for national parks comes from the Land and Water Conservation Fund and is included in appropriations bills that originate in the House of Representatives. Phil Burton was on good terms with Congresswoman Julia Butler Hansen (D-WA), chair of the House Subcommittee on Interior Appropriations. For a few years, she helped Phil get our park as much money as the Park Service people who do the buying of land could use. In 1973 Phil Burton got a $5

million appropriation and $5.9 million more in "reprogrammed" funds—money appropriated for another park's purchases and not yet spent—to buy land for the GGNRA.[17]

The Division of Land Resources in the Park Service's Pacific West Region buys the land for national parks in California. Phil urged their staff to buy the private parcels in the GGNRA as quickly as possible. The division's conscientious chief, Woody Gray, did his best, ordering appraisals, establishing fair market value, and making timely purchases.

The first parcel the Park Service bought for the GGNRA was the 1,332-acre Wilkins Ranch at the junction of Highway 1 and the Bolinas-Fairfax Road. It was purchased in 1973 for $1.15 million from the Trust for Public Land, which had bought it after the Wilkins family sold it to someone with financial problems.[18] That year six additional tracts were purchased, bringing 812 more acres into the park.

Bill Whalen asked the Land Resources Division to buy the houses and lots in Tocaloma and Jewell, two tiny enclaves of mostly "second homes," on Sir Francis Drake Boulevard. "Why wouldn't you buy some sizable ranches first?" Ed Wayburn asked unhappily. "Because I've seen what happened elsewhere," replied Bill. "If I relieve the owners of uncertainty and deal with all the different personalities, the owners talk with each other and compare notes. Then they all sell at one time. If I dealt with each one individually, as each property was bought, the remaining ones would become more valuable and expensive." The twenty-five houses were acquired between 1974 and 1976.

Because California's real estate prices are subject to sharp escalation, Ed urged Bill to give higher priority to budget requests for land purchases than to those for park improvements. This allowed the Olema Valley's 7,500 acres to be acquired within a few years. We had worried: reviewing parcel maps one day, Bob Young realized that the builder of Greenbrae, an 800-home Marin subdivision, was the owner of 1,150 acres just up the road from the Stewart Ranch in the middle of the Olema Valley. We were grateful for the pace of land acquisition, and 1974 was a banner year: the federal government spent $17,252,000 to purchase fifty-three separate tracts totaling 10,549 acres.

Congresswoman Hansen retired in 1974, and the park got less purchase money. Congressman Sidney Yates (D-IL), the new chair of the park appropriations subcommittee, was less sympathetic to Phil's pleas. Lack of money for parkland acquisition was then—and continues to be—a nationwide problem. Citing numerous parks Congress had authorized, Congressman Roy Taylor declared, "[It is] extremely poor economy to cut back on these programs at a time when land acquisition costs are skyrocketing," and warned that continued delays "will just cost the American taxpayers that much more in the future."[19] Congress refused to implement the section of the

GGNRA's legislation permitting down payments on park parcels, which would lock in lower prices than if owners had to wait. Down payments would have obligated future Congresses to pay for these parcels—which I'm sure is what Phil had in mind. Despite the slowdown in purchases, a total of 114 parcels of former private land in Marin County had been purchased or received as donations by the end of 1976, and these totaled 15,994 acres.

I learned during these early years of the park that purchasing land for a federal park is far from an orderly process, an observation affirmed many times since then, both in the GGNRA and elsewhere. There are willing and unwilling sellers, and greedy and fair sellers. One may offer a bargain to the park, and yet another will plead hardship. Purchase is often opportunistic both because of what a land owner needs or wants—not just money but timing—and how much money has been appropriated. Perhaps too little money has been appropriated to acquire a bigger, higher-priority property but there is enough to buy a smaller one further down on the list that doesn't connect to parcels already acquired. If a land owner refuses an offer, then another will be approached instead. It is an untidy process, and sometimes it takes years to make a contiguous area of designated parkland available for public use.

Transfers of Remaining Military Land

After Alcatraz, Baker Beach, Crissy Field, and three San Francisco forts became part of the GGNRA, we had to wait, impatiently, for the remaining military land to be transferred to the park. After all, we thought, this only required paperwork between federal agencies. But bureaucracy was not the sole cause of the delay. The acreage was being maintained and policed by the Army, and with a limited budget, Bill Whalen did not want additional land before he could care for it. Nearly two years went by before the Army, in 1974, relinquished title to 1,073 acres of Forts Barry and Cronkhite in the Marin headlands.[20]

East Fort Miley was transferred to the GGNRA in 1975. While waiting for the transfer, we kept our eyes on this property, and one day after work Mia Monroe, who was still working for PFGGNRA, walked up to East Fort Miley from my house. Wild dogs were living under one of the deteriorated, green, asbestos-shingled Army buildings, Mia reported, and she'd narrowly avoided being bitten. The last time I'd been up there, the Veterans Administration Medical Center had been using some of those buildings. After East Fort Miley came into the GGNRA, I told Bill about the wild dogs. In a short while, all but two of the buildings were removed. The big one,

a 1902 ordnance warehouse that is the last remaining wooden structure from the cantonment of Fort Miley, was handsomely converted to maintenance shops and offices; the little one is a shed.

The transfer of other pieces of former military lands happened over a long period. They occurred as military uses gradually ended and as safety, environmental, or utility repair issues were resolved.[21]

NEW PROGRAMS IN A NEW PARK

Everyone had high hopes for the park, but few understood what it would take to "bring parks to the people." Bill started with ranger-led walks in the Marin headlands, then moved on to bigger things.

During his time with the National Capital Parks, Bill had run a successful experimental summer program in the Anacostia neighborhood of Washington DC. In 1974 and 1975 he decided to try that "Summer in the Parks" program at the Golden Gate. He called it "Camps and Fun Trips."[22] Working with Ann Belkov, who came from Washington to help direct the camps, he arranged for groups of children, ages eight to twelve, to visit one of five sites. On the Fort Point Environmental Living Fun Trip, the children experienced what life was like for Civil War soldiers in 1861 as they marched, stirred up big kettles of stew, ate what they had cooked, cleaned camp, and joined in the teamwork of cannon drill. Up to fifty children at a time could visit the Gerbode Preserve Environmental Awareness Camp or the Battery Alexander Folk Life Camp, both in the Marin headlands. The two other programs were on Alcatraz and at Baker Beach.

Bill had to advertise these programs and orient local group leaders. Before those two summers, he sent a ranger from his growing staff to visit San Francisco's poorer neighborhoods to publicize the programs. When a day-care agency agreed to participate, program staff provided guidance for the group's leaders and advice on transportation. Then children from a school or social service agency would take day trips to one of the five park sites for five weekdays, supervised by their own teachers. Several small groups from different organizations could jointly use a camp. The children also required equipment, such as sleeping bags for "overnights." John Kern gave advice and helped find supplies—for these programs and others.

In 1975 the *San Francisco Chronicle* reported on "Senior Citizens at Camp—A Park Service First." With the aid of college student counselors, thirty-eight men and women from Daly City, south of San Francisco, whose average age was seventy, traveled by bus to spend the day in nature study,

hiking, doing handicrafts, and cooking out at the Presidio's Baker Beach.[23] In 1976 children from Marin County joined in the programs, camping out overnight and baking sourdough bread at a gold rush camp in Fort Cronkhite.

These government-sponsored experiences were intended as introductions to the park, and they ended in the mid-1970s. By that time, a large number of local people knew about their national park next door. The programs were partly replaced by others sponsored by private groups, such as the Sierra Club's Inner City Outings.

AN ADVISORY COMMISSION OF CITIZENS

The park's authorizing legislation called for an advisory commission for both the GGNRA and Point Reyes National Seashore. The commission would meet with and advise the secretary of interior, or the secretary's designee "on general policies and specific matters related to planning, administration, and development affecting the recreation area and other units of the national park system in Marin and San Francisco Counties." The charter for the commission, shaped by the congressmen and Bill Whalen, called it the Citizens' Advisory Commission (CAC) and stated that "the duties of the Commission are solely advisory." Commissioners would consider matters of concern at public hearings. Of course the secretary of interior wouldn't come to our meetings; his designated representative was either park's superintendent. Votes on resolutions would constitute the commissioners' advice.

The CAC assumed an important role, at both the GGNRA and Point Reyes. By influencing public expectations and policy on park use, land management, public outreach, public participation, infrastructure, and transportation, the CAC helped shape the park's development and made public participation an integral part of the national parks in the Bay Area.

Participation in government is a daily activity for an extraordinary number of Bay Area residents. We joke that community involvement is a contact sport. As soon as the park legislation passed, people began to write or phone the Park Service, their legislators, and People For a Golden Gate National Recreation Area to ask about getting nominated for an advisory commission seat so that they could influence the future of their two parks.

The park's legislation entrusted the secretary of the interior to appoint fifteen unpaid citizens for three-year terms on the commission. The charter was written to solicit a diverse group of nominees from around the Bay Area. Six members would be chosen by the secretary himself, from

persons informally and politically suggested to him. The others would be nominated by the counties, regional government agencies, and PFGGNRA. We were asked to nominate two members to represent PFGGNRA, and three people to represent "minority groups and other interests in the Bay Area," to ensure the presence of African American, Asian American, and Latino commissioners.[24] The commissioners were expected to have a broad perspective on the park and wide-ranging interests rather than to represent a single interest or location, such as equestrians or Stinson Beach.

People took the commission very seriously, and its makeup became a political matter. "At the time, there was a lot of oversight on these commissions that was exercised at the White House," Bill Whalen later said. "They wanted to have people that were more representative of the society as a whole. So there was a balancing act going on that took a while to resolve."[25] Prospective nominees sought endorsements from legislators, from agency and nonprofit boards, and from well-known individuals. With a Republican president and a Democratic congressional majority, everyone from California's two Democratic senators to the local Republican county central committee reviewed the nominations.

Ed, Bill Thomas, and I received appointments. Evenly divided between Republicans and Democrats, the commission was sworn in at its first meeting on March 16, 1974. One issue—who would become our chair?—came up even before that ceremonial and informational meeting. Bill Whalen favored Frank Boerger, a retired colonel and John Kern's former boss at the Corps of Engineers, whom John had suggested for one of the secretary's personal choices. John praised Frank as "a very brilliant, affable, common sense–type guy who knew how to conduct public meetings and the like." Bill lobbied some of the commissioners behind the scenes. "The one real thing that I did, when you look back on it, [that] was manipulative in nature and by design," Bill said later, "was in selecting its first chairman. I knew that once the names had been released on who was on the commission, that it was a very diverse group, a very energetic group, a very astute group, but that they were not going to be a group that were going to be easily led or managed. I mean, there were a lot of chiefs on that commission, and so it was going to take the right kind of person."[26] Frank would turn out to be that right kind of person.

At our second meeting, Frank was elected chair, and I was elected vice-chair. Phil Burton visited and told us the administration had requested ten million dollars to buy parkland during the coming fiscal year. He expected the Congress to help him get five or ten million dollars more. He took us all to lunch.[27] Commissioner Joe Caverly, the general manager of the San Francisco

Recreation and Park Department, said negotiations were under way to transfer the city parklands within the boundary to the Park Service. Bill Whalen announced that the State of California would not donate its parklands and was insisting on payment.

Our next meeting included a discussion about bylaws and briefings on planning, funding, and budget. We passed our first resolutions: in support of enlarging the park and for increased public transportation.[28] At four subsequent meetings, Bill briefed us on parkland acquisition; special-use permits; recreation, education, and interpretive programs; maintenance; the U.S. Park Police; the Coast Guard; the Presidio master plan, heliport and railroad use; Army housing; Army rifle range use; historic preservation; hostels; bicycles, horses, and trail use; grazing management and range capacity; fire management; native and exotic plants and animals; and fisheries management. Legislating a park was one thing; making it real was something else again!

After ten months, when we seemed sufficiently grounded and had had enough time to get better acquainted, Bill put us to work. During that time, we had easily persuaded him that although our main job was to advise the secretary of the interior, we would sometimes want to tell our congressmen and senators or other agencies of our concerns; it was agreed that we could send any resolution we passed with a cover letter wherever we wanted it to go. At our December meeting, we unanimously passed a resolution—more for the administrators of the Golden Gate Bridge than the interior secretary—about the need to improve pedestrian and bicycle access to the bridge. We also commented on the interim trails proposals of an ad hoc trails committee appointed by Bill and chaired by Margot Patterson Doss. On Saturday, January 25, 1975, we held an eight-hour public hearing about the future of the piers and warehouses of Fort Mason. The question before the commission, to be addressed by about a hundred witnesses who had signed up to testify, was what sort of recreational uses they would like to see in and around these huge buildings on the San Francisco waterfront. Bill explained that this public participation process was just the beginning of how the entire park would be planned.

As an independent and broadly representative body, the CAC could help resolve conflicts. For a time, Bill Whalen's responsibilities also included oversight of the Point Reyes park, and he asked the commission to help with a dispute over the size of its wilderness area. While the campaign to assure purchase of the seashore was under way, Katy Miller Johnson and wilderness advocates had tried to have Congress designate more than half of Point Reyes as wilderness, in accordance with the Wilderness Act of 1964. They asked Phil Burton to support a 36,000-acre wilderness that would include 25 miles of ocean and Tomales Bay shoreline. The subsequent Park Service proposal of

5,000 acres included no shoreline. Katy had sent Phil Burton an article by Bill Duddleson, who protested that the Park Service proposal seemed a mere pittance. Phil wrote to Joseph Rumberg, the western regional director of the Park Service: "I support efforts to preserve vast and important sections of this land in its wilderness state. . . . I firmly believe that the National Park Service, working in consultation and conjunction with the various citizen groups which have repeatedly demonstrated their concern for this area, can achieve the truly magnificent Point Reyes National Seashore which was envisioned."[29]

Bill Whalen invited a few conservationists and a few ranchers to explain their concerns, separately, in two private meetings with a few commissioners. Rancher Joe Mendoza, a commission member, came in with the ranchers. Suddenly he said, "I don't know why I'm objecting to wilderness. I don't like people out there anyway." That broke the ice. A few weeks later, at the commission's public hearing, several hundred people supported a big wilderness area, and we commissioners found it easy to agree with them. In 1976 Congress designated 33,373 acres of the 74,000-acre park as wilderness.[30]

PLANNING WITHOUT PRECEDENT

In the mid-1970s the process of planning for national parks was changing across the nation from a "top-down" or "father knows best" style to an approach that encouraged public participation in the planning process. The complex realities of the GGNRA—including large numbers of visitors in some areas, diverse users, landscapes ranging from untouched wild canyons to intensively used meadows and beaches, and proximity to a rapidly growing urban area—put the GGNRA at the leading edge of a kind and scope of planning that had never before occurred in the Park Service. From the earliest years of the park, planners relied to an unprecedented level on public input and involvement as they sought to preserve the various inherent values of the parklands.

Master planning in the national park system began in the 1920s. Park planners strove to uphold the National Park Service Organic Act, which had been passed in 1916.[31] They classified areas within parks into management zones to provide a place for everything from lodging to wilderness. Management policies for the Park Service were summarized in three separate handbooks that tried to classify the differences between natural areas, historic areas, and recreation areas. There was no system for public review of park plans. In the 1940s "package master plans" consisted of a sheaf of 24 × 36 inch-pages that showed the visitor centers, campgrounds, trails, restrooms, storage areas,

maintenance yards, and other facilities. The accompanying text gave scanty definition of resource management strategies, did not evaluate the park's natural and historic attributes, and did not require planners to show how they reached their decisions.[32]

The first plan for Point Reyes National Seashore, finished in 1965, reflected this tradition. Rather than protect the park's natural and scenic resources, it applied policies developed for intensively used recreation areas to the park as a whole. As a result, subsequent development damaged natural areas. Cuts and fills along a road up Inverness Ridge caused significant erosion, and a new parking lot at Drakes Beach covered half of a major freshwater marsh. The public became vociferously critical of Park Service management. Lack of funds held off other destructive projects; one of the more notorious, I heard, was the proposal to dam Limantour Estero for waterskiing.[33]

The situation began to change in 1969, when a young group of men and women with a fresh outlook and a penchant for vivid descriptive prose, dynamic drawings, and effective graphic design replaced retiring planners. The Point Reyes planning team's new captain, Doug Nadeau, made a personal commitment (though he could not always express it aloud) to consult with local constituencies, minimize development, and maximize protection of the park's natural attributes.[34]

The 1971 draft plan for Point Reyes was better than the earlier plan, but it would have encouraged recreational driving by paving a farm track through Muddy Hollow in the middle of the park. Calling for fewer cars and more wilderness, the Point Reyes hero Peter Behr led county residents in a campaign against the road, yet in 1972 the Park Service approved a Point Reyes plan with the road corridor.[35] It was not until Congress authorized the GGNRA that people began to see Point Reyes as more of a backcountry park with low-key uses.

Between 1970 and 1972 another team of planners was scrambling to describe the future appearance of our park at the Golden Gate—and trying to keep up with proposals that were enlarged every few weeks. Before the Olema Valley was included in the legislation, PFGGNRA heard that a planner had drawn a six-foot-wide trail to connect the northern end of Golden Gate with the southern end of Point Reyes, and we told him everyone would have to walk north in the morning and south in the afternoon. As the boundaries of the Burton bill expanded, much of this early planning became obsolete.

In 1974, because the two parks shared a ten-mile boundary in the Olema Valley, and because Bill Whalen was determined to have his own planning team, the Park Service finally combined the planning for Point Reyes National Seashore and the GGNRA. Doug Nadeau became plan-

ning coordinator for the joint planning group. John Hart later wrote, "It was clear from the beginning that [the planners] could not limit their attention to the newly acquired lands; though parts of it were parks of long standing . . . the greenbelt was an undeniable fresh whole. And the constituents looked different when seen as pieces of the assembled puzzle." Supported by Bill Whalen, Doug abandoned the three management classification handbooks.[36]

Bill appreciated the citizens' advocacy that led to the GGNRA. He knew about the earlier planning debacle at Point Reyes and the high expectations for public process. Ric Borjes, the park's chief of cultural resources and museum management, later told me how our park has been viewed since that time: "Here, people are politically savvy and they're allowed direct access to management. In Golden Gate you're fully visible and must go to the public for input and partnership."[37]

Bill Whalen gave the public a preview of his thinking in May 1974. He wanted to explore people's concerns and determine "operating objectives now, so we don't make mistakes." The preliminary land use report he shared said that the fully developed park could expect 20 million visitors a year— 90 percent of them in San Francisco—and that people wanted many different kinds of recreational activities. Local communities would provide commercial services such as food and lodging outside the parks.[38]

The planners' goals were to preserve the parks' inherent qualities and find ways for people to enjoy a wide variety of experiences. By May 1977 GGNRA staff had held nearly two hundred meetings and workshops. This commitment to gathering citizens' input, Doug Nadeau would later say, was "setting the national standard for public involvement."[39]

The planners proposed a number of alternative futures for both parks. *A People's Guide to the Future of the National Parks Next Door*, the cheerful popular summary of the formally titled "assessment of alternatives for the general management plan," was widely distributed (figure 21). Its five alternatives ranged from minimum change to emphasis on recreation. People were encouraged to mix and match parts of the alternatives to fashion the park they preferred. There was little controversy during five advisory commission hearings in different parts of the Bay Area. People chose low-key activities for more natural areas, and in more urbanized areas they emphasized recreation. When this review was completed, the general management plan's draft was distributed in June 1979. After five more public hearings, more commission committee review, minor adjustments, and two staff reports, the commission unanimously approved the general management plan/ environmental analysis GOLDEN GATE/POINT REYES on December 8, 1979. The GMP, as it came to be known after administrative approval, was published in September 1980. It stated that thou-

Figure 21. *A People's Guide to the Future of the National Parks Next Door.* This popular newspaper-brochure charmed local people into active participation in park planning. (National Park Service, Golden Gate National Recreation Area and Point Reyes National Seashore, 1977.)

sands of people throughout the Bay Area "contributed their thinking to create a vision of the national parks next door."[40]

The park plan that resulted from this drawn-out and somewhat experimental process has worked well and effectively served the parks and public for more than two decades. The GGNRA plan emphasized protecting the diversity of native plant and animal life, preserving historic buildings with considerable modification of interiors for education, recreation, and other park uses, locating development in areas previously disturbed by human activity, and extending public transit service while alleviating the impact of traffic. The planners wanted interpretive programs to fos-

ter public involvement through various kinds of cooperative activities. Additionally, the Point Reyes plan called for opportunities for habitat and wildlife research and would support and monitor wilderness preservation and grazing.

As anticipated in the plan, the highest levels of use are in areas near the urban center, so there have been many changes at Fort Mason and Crissy Field but few in the Olema Valley or anywhere in Point Reyes. Planners anticipated the ongoing struggle to protect and enlarge isolated populations of native plants and wildlife in several places near the Golden Gate. However, they thought that large areas of natural landscape would not need much more than careful preservation and trails and picnic tables, but this has turned out not to be the case.[41] Parts of the park have needed much more habitat restoration and erosion control than anyone then realized because exotic plant species had invaded them and because so many acres had been altered by the military or, north of the Marin forts, overgrazed.

Doug Nadeau is justifiably proud of his role in the planning effort for the two national parks. "As far as precedent-setting work is concerned, the bottom line is that Golden Gate carried out the most difficult, extensive, and effective public involvement process ever accomplished by the National Park Service. The process set the standard for the rest of the Service and many other agencies."[42]

8

EXPANDING THE PARK

Since 1972 Congress has more than doubled the size of the Golden Gate National Recreation Area—from about 34,000 to nearly 80,000 acres. Between 1974 and 1980, Congressman Phillip Burton introduced and carried the bills that made most of the additions possible. After several thousand acres were added in Marin County, Phil made bold efforts to protect land in San Mateo County, bringing about 25,000 acres inside the GGNRA boundary. Other additions followed on Phil's accomplishments. Expansion of the park greatly increased its ecological and recreational value and safeguarded the scenic value of the parklands saved in 1972 (see map on next page).

PFGGNRA started working for boundary revisions almost the day the park legislation was signed. When the park bill passed and people began urging that more property be protected, we started a list. As Park Service signs appeared on the San Francisco shoreline and in the Marin headlands, we listed Wolfback Ridge, the rest of Tennessee Valley, areas on each side of Redwood

149

The Golden Gate National Recreation Area in 1980.

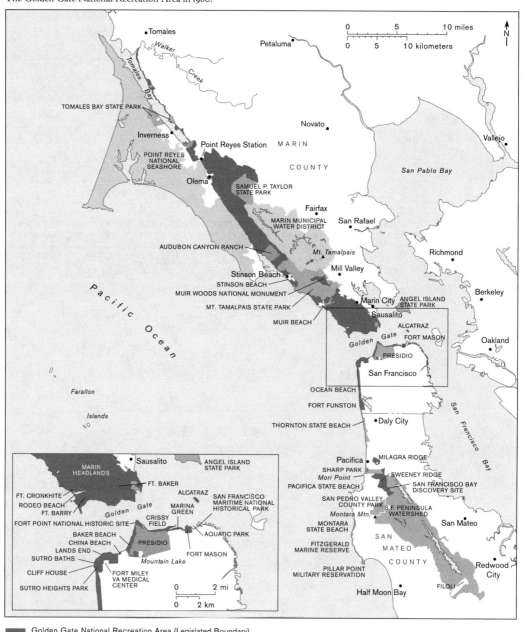

Golden Gate National Recreation Area (Legislated Boundary)
Managed by National Park Service

Golden Gate National Recreation Area
Managed by Other Agencies

Other Public Land

Creek between Muir Woods and Muir Beach, and some parcels near Stinson Beach. We added part of Playland at the Beach in San Francisco; the amusement park had closed and was ripe for development. We also listed new parcels for Point Reyes National Seashore. We avoided parcels that were not contiguous with park boundaries, strips of land adjacent to homes whose owners would be the primary beneficiaries, and subdivided parcels if their cost would exceed their value for the park. Bob Young mapped all these parcels for us. We made the first cut and asked conservation groups, neighborhood activists, and national park staff to review the proposals. We helped proponents with maps, parcel lists, and statements justifying inclusion.

THE FIRST ADDITIONS TO THE PARK

In 1974 Congress added many important properties from our list to the GGNRA and Point Reyes parks, mostly at their edges. These additions prevented development that would have caused habitat fragmentation, traffic jams, and loss of trail access and views on several thousand acres in several directions, and would have diminished the value of what had previously been saved. The additions included several small parcels—I joked that the smaller the parcel, the more trouble it is. We were (and still are) vigilant about small parcels because an owner may fail to tell a new county planner that the land is in the park or may build without a permit.

Wolfback Ridge and Southern Marin

Wolfback Ridge, five minutes from the Golden Gate Bridge, was the special concern of Mayor Robin Sweeny and George Sears of Sausalito.[1] Ed Fitzsimmons planned to build more than three hundred houses on this tree-covered hill with splendid views. At the 1972 Senate hearing, Robin and George had asked for their city that this land be added to the park. At that late date in the legislative process, Phil Burton and Alan Bible would make adjustments only for willing sellers—and Fitzsimmons wasn't willing. His subdivision had been approved by Sausalito's planning commission, but that approval was contingent on his getting access to the landlocked property from a private road whose owners would not sell. Fitzsimmons had appealed to the city council for approval without the access requirement, and the council had denied his request. Fitzsimmons knew his land was likely to be added to the park; an unconditional approval would have significantly raised the price of his 157 acres for the Park Service.

In early 1973 Ed Wayburn told Assistant Interior Secretary Nathaniel Reed about the Fitzsimmons property and some other parcels. In March Reed asked the House and Senate Interior committees to consider adding these parcels to the GGNRA as "minor boundary adjustments," as provided for in the GGNRA legislation. The committees said these changes were not minor and that new legislation was needed. Accordingly, Phil Burton introduced HR 10834 on October 10, 1973, for himself, Bill Mailliard, and twenty-eight Democratic and Republican colleagues.

Then Margot Patterson Doss got word that Phil's father had died and that Phil would fly in from Washington. Margot thought it would be good to occupy his mind and time with a visit to the park—and give Phil a chance to see some of the land we wanted to add. On October 27, 1973, she phoned me, and I phoned Robin Sweeny. Robin said she'd gather a group and suggested that we start this venture from the Sausalito firehouse on the eastern side of Highway 101. I called Diane Hunter, who called Jan Holloway, and they came over to my house.[2] Thinking Phil might want some food if the trip lasted a while, they made sandwiches with what they could find in my cupboard—tuna fish. I pulled together some maps and information. We raced across the bridge.

Phil was intensely interested in what we showed him. Robin pointed out the Fitzsimmons property, high above the highway. Phil pointed to the lower hillside. "Whose is that?" he asked. "State highway right-of-way," someone replied. "Let's put that in—and that—and what's that?" A man raced down the hill to fetch the town's planning director. He arrived maps in hand and named the owner of each parcel of vacant land. Phil said he would include it all. Someone was aware that Phil knew Ed Fitzsimmons and asked what he was saying about the legislation. Phil answered, "I told Fitz what I was going to do and of course he was pretty unhappy about it. I'd feel the same way if it were my property. But I told him I thought it was the best thing for the park and I was going ahead with it."[3]

The car caravan moved on north, up the highway. Months earlier, local resident Jo Julin had phoned to complain that we had missed several hundred acres in Tennessee Valley and in the smaller valleys that pocketed out of it. Jo guided the group to these sites, and Phil agreed that the entire valley area must go into the park. Perhaps an hour and a half had elapsed. It was time for Phil to return to the city. All the other cars drove off. Jan, Diane, and I grinned at each other and sat down on a log and ate the tuna sandwiches.

Phil added the land he had seen on his field trip to HR 10834. The bill included every parcel we wanted to protect in the park. PFGGNRA continued its advocacy role in support of this bill, but our role was perceptibly diminished—these were not groundbreaking changes but additions

to an already authorized park. Bill Thomas was gone; now a few different aides handled the information that we sent in. Using the 1972 legislation as a base and with his ever-increasing position of seniority and legislative power, Phil could introduce a bill that would go to the National Parks and Recreation Subcommittee of the House Interior Committee. He had become a member of that subcommittee, and he could guide the bill through the legislative process without the evident endorsement of testifying constituents or a pile of supportive letters.

A New Congressman Aids Park Expansion

In February 1974 President Nixon nominated Congressman Bill Mailliard to be the permanent representative of the United States to the Organization of American States. The whole park was in Mailliard's congressional district. He had been in office twenty-one years and was, many people guessed, somewhat tired of his job; furthermore, the prospects for his getting reelected were not good: in the decennial reapportionment process, his district had been redrawn to include more Democratic-leaning areas, and he had received a bare majority of the vote in the 1972 election in his old district.[4] He kept a promise he had made to Phil Burton: when he decided that he would not run again, he phoned Phil to tell him.

After Mailliard was confirmed as the OAS representative, he vacated his congressional seat, and Governor Reagan called a special election to fill out the unexpired portion of his term. Assemblyman John Burton, Phil's brother, was willing to leave his safe seat in the state legislature and quickly became the leading candidate to replace Mailliard. John actually ran for two positions in the June election: one to serve out the remainder of Mailliard's term and the other to be the Democratic nominee for the next full two-year congressional term and thus on the November ballot. In the special election, he received forty votes more than his eight opponents combined and also won nomination for the full term.[5]

John Burton (D) was sworn into office on June 25, 1974. He quickly showed his understanding and support for the national parks in his district. He cared about Army damage to the Presidio's Lobos Creek, about 10 acres the Army continued to occupy within Fort Point National Historic Site, about the condition of a Presidio beach, about the development of parcels in Muir Beach next to the GGNRA, and about the size of the Point Reyes wilderness.

John endorsed the park expansion legislation Phil had introduced in the House in late 1973, concerning land entirely within his district. He helped with its passage during the early months

he was finding his way around Congress. The House and Senate committees each heard and passed the bill, with nearly identical committee reports that said the land additions were needed to avoid later adverse development, round out boundaries, assure scenic quality, or provide access for recreation. But the Senate committee deleted the 120 acres of state highway right-of-way Phil had included.[6]

Congressman John Burton was reelected in November 1974. He got some credit for the park enlargement bill that was sent to President Gerald Ford for signature on December 26, 1974. Public Law 93-544 added about 727 acres, including the land on Wolfback Ridge that belonged to Ed Fitzsimmons.[7]

More Land for Point Reyes

One of the early requests to add more land stemmed from the 30-acre parcel at the entrance to the national seashore that Bob Young had creatively included in our 1972 boundary map. The parcel belonged to the Kelham family. Even though it is on the Point Reyes side of Highway 1, in 1974 the Park Service bought the parcel for the GGNRA. Pleased with the purchase price, the Kelhams asked Senator Alan Cranston to include an additional 270 acres they owned across Bear Valley Road in a future park expansion bill. Cranston did so but logically allocated the land to Point Reyes National Seashore. This bill passed in 1974, adding a total of 448 acres to the Point Reyes park.[8]

STATE PARKS—IN AND OUT

Several California state parks were put within the boundaries of the GGNRA in the original park legislation, including Stinson Beach, Angel Island, Mount Tamalpais, the Marin Headlands State Parks, and James D. Phelan Beach State Park. PFGGNRA and Bill Whalen urged the state to donate these parks to the federal government so that they could become part of the GGNRA. As long as Ronald Reagan was California's governor, however, the state would not consider donating its park properties to the GGNRA.

When Edmund G. "Jerry" Brown (D) was elected governor in 1974, we thought we saw a chance to effect the transfers. In 1975 State Senator George Moscone (D-San Francisco) introduced legislation to transfer all the state parkland within the federal park boundary to the GGNRA. His

bill was actively supported by Assemblyman Michael Wornum (D-Marin) and by civic and conservation groups who had endorsed the original GGNRA legislation.

Diane Hunter and I went to Sacramento to tell the state park commission about the advantages of transfer, including unified planning and lower administration and maintenance costs. While meeting with the commission's top staff official, we said the state parks on the Marin headlands seemed especially neglected. "We have nothing in our system called the Marin Headlands State Parks," he countered, reaching for a book on his shelf. While Diane and I stared at each other, he opened the book and discovered the listing for three parks encompassing 673 acres.

The legislature sent a bill to the governor's desk, but state park employees objected to the proposed change of ownership, and Governor Brown vetoed the legislation. In 1976 Assemblyman Wornum and Assemblyman John Francis Foran (D-San Francisco) each introduced legislation to transfer the land. Both bills were unsuccessful.[9] Finances and politics eventually persuaded the state, over several years, to donate much of its land within the GGNRA boundary and its historic maritime park to the federal government. The state kept Mount Tamalpais and Angel Island State Parks.

EXPANDING SOUTH INTO SAN MATEO COUNTY: THE PROLOGUE

Portions of San Mateo County's steepest and most scenic land, with miles of untouched habitat and sweeping views, are now part of the GGNRA. These important properties include Sweeney Ridge, the Phleger estate, and the lands of the San Francisco watershed that are located in San Mateo County. A long struggle preceded the addition of some of these lands in the 1980s and 1990s. The story of this struggle gives some indication of the quality and scale of the acquisition.

In the late 1960s, just when Marin County residents were fighting plans for a Golden Gate parkway, a plan for a skyline scenic parkway sent shock waves through San Mateo County. This parkway was proposed to traverse the north-south ridge that runs lengthwise through the county, a few miles from the coast. Fifteen miles of the 2,000-foot-high ridge are in the 23,000-acre watershed surrounding the reservoirs that store San Francisco's water supply; the watershed is also a state fish and game refuge and has not changed much since human beings arrived on the scene.[10] Fortunately, conservationists blocked the parkway's route, which would have broken up this complex habitat and destroyed much of its scenic and ecological value. Interstate 280 was constructed a few miles to the east, along the eastern edge of the watershed.

The idea of adding land in San Mateo County to the GGNRA surfaced early in PFGGNRA's park campaign and during the 1971 House committee field hearing in San Francisco. After the hearing, the local Sierra Club chapter and the Committee for Green Foothills sent the House committee a list of the parcels they wanted to protect. PFGGNRA did not echo their request. We did not feel ready to take on the park politics of a third county. The support of their congressman, Pete McCloskey, would be crucial to any success, and he had decided to wait and see. San Mateo residents had not been seasoned by an earlier campaign for parkland, unlike the Marin residents who had fought two rounds for Point Reyes National Seashore.

No Bypass for Devil's Slide

Yet San Mateo conservationists had years of experience in a campaign to save the open land on their county's western side. Their fight to prevent construction of a huge freeway bypass at Devil's Slide was well under way when the first GGNRA boundaries were set in 1972. For thirty years county residents stalled development along the coast and ocean-facing hills and helped preserve significant potential parkland.

I had my first chat about Devil's Slide with a conservationist in 1971, driving down coastal Highway 1 to a meeting with the Sierra Club leader Olive "Ollie" Mayer. She told me that a development corporation owned 1,100 acres at the top of Sweeney Ridge above Pacifica. Wouldn't it be possible to join it to the 19 acres of the adjacent publicly owned San Francisco Bay Discovery Site and put it all in the proposed Golden Gate National Recreation Area? Ollie expounded on this theme as we drove. I demurred. Our park plan ended at Fort Funston, and this land was several miles to the south.

Between Pacifica and Montara, we came to a narrow part of Highway 1 cut into the face of a cliff several hundred feet high. We drove close to the center line and away from the sheer rock face that dropped into the ocean below us on the west. "This is Devil's Slide," Ollie said. I recalled reading about bad over-the-edge auto accidents. "The highwaymen want to build a freeway to replace this," she explained. The road sits atop an unstable block of stone 600 feet long. Lubricated by winter rains, it is slowly sliding downward, a trend evident since the road opened in 1937. Drops in sections of the roadbed and rock falls from above have repeatedly blocked and closed the road ever since.

The state's Division of Highways and some developers promoted building a freeway bypass around the slide to prevent accidents, create dependable access, and also accommodate their vi-

sions of opening the San Mateo County coast for suburban development. The Devil's Slide by-pass idea had originated with Henry Doelger, the developer of San Francisco's Sunset and Daly City's Westlake districts.[11] In the 1950s he bought 7,000 acres of coastal San Mateo County land, intending to build a city for 60,000 people on the side of Montara Mountain. An inland six-lane freeway stretching from Pacifica to Half Moon Bay would give his development the access it needed. Developers and corporations that owned other large properties on the western side of the penin-sula supported Doelger's desire for a wider road.

Proponents tried to get approval for the freeway and funding to build it, and opponents tried to block them. As in Marin, San Mateo's mountainous central ridge precludes easy access to the western side of the county, so the opponents decided to prevent not only the bypass but also im-provement of the roads connecting Interstate 280 with the coastal road. Residents rallied against suburban subdivisions and for new parks, as well as protection of the coast, native habitat, en-dangered species, and ranching.[12]

Assuming that the highwaymen were intending to wait until the next major landslide and road closure and use the emergency to assure funding of the bypass, open space advocates began to organize. But those who wanted a bypass also rallied. The county supervisors approved the bypass in February 1972. Although the National Environmental Policy Act (NEPA) had been law since 1969, no government entity had done any environmental analysis of the project. The state said that although federal money would be used to build the road, it was a state project and NEPA didn't apply.

Conservationists understood the potential impacts of the bypass, both on Montara Mountain and as the spearhead for uncontrolled growth around Half Moon Bay, on the San Mateo coast. They thought that NEPA had been enacted to make just such issues evident. The Sierra Club, the Committee for Green Foothills, three other environmental organizations, and a dozen indi-viduals challenged the approval of the project. Declaring that it required an environmental impact statement, they filed suit under NEPA on May 22, 1972. Citing "possible adverse aesthetic and recreational impact . . . resulting from freeway construction across a mountain barrier that has heretofore sheltered the southerly rural area from the north–south commuter access and the rapid suburban sprawl that accompanies such access," Judge William Sweigert ruled in favor of the con-servationists on December 6, 1972.[13]

The San Mateo activists' success in Judge Sweigert's courtroom came a month after President Nixon signed the GGNRA legislation, and Phil Burton was already talking about extending the

park. Two years later, well into the start-up of the GGNRA, we were able to start working on expanding the park's boundary to the south.

GGNRA South Fails

Eight months after the Citizens' Advisory Commission asked the Park Service, in October 1974, to study the suitability of adding more land to both the GGNRA and Point Reyes National Seashore, the Park Service announced a study of 150,000 acres south of San Francisco, from Fort Funston through the western parts of San Mateo and Santa Clara counties to Santa Cruz County.[14] People For a Golden Gate National Recreation Area wanted to help, but Bob Young, our cartographer, did not know this area. Then a former Sierra Club board member phoned me about an Antioch College graduate student, John Wade of Palo Alto, who was studying the park potential of peninsula lands.

John made maps and developed the justifications for 220,000 acres, which became the basis of the citizen-based park expansion proposal. The Sierra Club activist Marlene Sarnat started a regional group of PFGGNRA to advocate for "GGNRA South" and found a chair for each of the three counties. We wanted to protect a broad area from the ocean to Interstate 280 by connecting dramatic coastal hills and cliffs, black-soil agricultural fields, and forests to the wild lands of San Francisco's watershed. We proposed to protect all of the contiguous, unsubdivided lands of the coast and coastal slopes, between San Francisco and Wilder Ranch State Park north of Santa Cruz, some 70 miles from San Francisco. Residents of coastal towns voiced support at an advisory commission hearing in May 1975. The Metropolitan Transportation Commission and the Association of Bay Area Governments agreed, wanting to protect the coast side from further increases in road capacity and development on land too steep for building.[15] Local congressmen Pete McCloskey and Leo Ryan (D) expressed their support.

Even though our expansion plan had broad-based support, it also faced vociferous opposition. In Marin County, years of open space planning and greenbelt advocacy had preceded the GGNRA park bill. Residents had even "greenlined" the ridges between some towns on Marin's eastern side so that open land defined each town's boundary. With the firm "controlled-growth" stand of residents and the board of supervisors, nearly everyone had welcomed the two national parks. In contrast, some residents in the western part of San Mateo County expressed deep animosity to what they perceived as government takeover of land. The county's broad western side is a much

more varied region than West Marin. Steep grassland, forested slopes, and miles of commercial flower, pumpkin, and brussels sprout fields surround its coastal communities. People who bought parcels of ten to several hundred acres considered it the last frontier and declared passionately that no one would take their land. In La Honda, someone started the rumor that the Park Service, as an agency of the Department of the Interior, wanted the land to prospect for oil.

The proposed extension was also much bigger than the combined acreage of the two existing national parks. The ridge that divides the rural coastal area from inland urban and suburban terrain is much farther from the coast, so the expansion was overwhelmingly big. Residents wanted to save their own property in particular and agriculture in general and could be swayed by people who wanted nothing to do with government and by realtors who saw their livelihood threatened. They did not realize that tenant farmers grew many of the crops they admired on farms belonging to corporations awaiting an opportunity for suburban development.

Because of this opposition, the big San Mateo County dream quickly dimmed. A vocal cadre of back-to-the-land residents calling themselves "People Against the Golden Gate National Recreation Area Extension" produced a flyer headlined "Protest Now or Pay Later—Help Fight Against This Giant Federal Land Grab Proposal." They knew we had been successful up north. The *Country Almanac* reported that Congressman McCloskey "faced an unprecedented crowd of 200 at a constituents meeting at San Gregorio," and at a special hearing of the La Honda–Pescadero school board "some 400 angry people packed the room and interrupted the presentation with jeers and catcalls" and turned it into "an organizing session to launch the opposition." On November 5, 1975, Congressman Ryan introduced a bill for a two-year study, limited to his district.[16] Over a dozen environmental and planning organizations, twenty-six consulting agencies, eight labor and real estate associations, and any property owners association of more than five members could participate— a recipe for paralysis. When Ryan explained his bill to the county board of supervisors, two hundred land owners jeered him and called for its withdrawal.

We had tried for too much with too little preparation. Marlene Sarnat valiantly met with residents, but in the negative climate her people lost focus, worked at cross-purposes, and undermined her and one another. Marlene and Sierra Club activist Bill Freedman started Common Ground as a forum for discussing the issues, but the legislators were no longer interested. People wanted the process to begin over again. "Put it aside for now," advised the president of the Committee for Green Foothills. A coastal resident said, "We're grateful to you for coming here, shaking the redwoods and waking us up, but now we want to solve these problems ourselves."

THE NATIONAL PARKS OMNIBUS ACT OF 1978

As everything was going wrong down south, PFGGNRA responded to calls for more parkland for West Marin. One of our goals was to protect the open land within the Lagunitas Creek Loop—some ranches surrounded by a creek that meanders toward Tomales Bay. We wanted to focus private development at Point Reyes Station, since that crossroads town is the commercial center of West Marin. Bob Young shared his paperwork with Park Service planners. The new area was in John Burton's congressional district; John discussed protection with the affected land owners, who said they favored more legislation. In November 1975 John included the Lagunitas Creek Loop in a bill he introduced to add about 6,000 acres to the two parks.[17] The bill also called for adding the Bolinas Mesa to Point Reyes National Seashore.

Then the news from the rural area of San Mateo County reached rural West Marin. At a turbulent rural forum meeting in Point Reyes Station, ranchers would not publicly say they were willing to sell. One man wanted a new freeway, some feared the effect on the local school district, and others wanted visitors to stay away. Senator Alan Cranston's aide at the meeting could not reassure the irritable crowd. Jerry Friedman, John Burton's West Marin spokesman and a Point Reyes advocate, advised him that the legislation would hurt him politically. John withdrew his bill, so there was no room to negotiate.

Meanwhile, San Francisco park advocates also asked for a small addition. They wanted parts of the former Playland at the Beach to be included in the GGNRA. Playland, a beachfront amusement park, had closed in 1971. A developer had bought it, divided the 10 acres into four parcels, and proposed 800 apartments for an area zoned for 600. When neighbors fought his plan, he priced the land at $10 million. Since that amount could buy several thousand acres of Marin ranch land, PFGGNRA tried to protect only Parcel 4, the 3.3-acre northernmost piece. Fronting on the Great Highway, that parcel rose 200 feet to the boundary of Sutro Heights Park. Apartment houses on the park's boundary would obscure expansive south-facing views and degrade its Victorian-era ambiance. Park advocates and neighbors joined in opposition to the project and sought protective legislation.

After being stalled for nearly two years, the proposals to enlarge the parks in Marin and San Francisco reemerged in 1977. The Marin ranchers really wanted their land in the park, and after discussions helped along by Boyd Stewart, they told John and Phil Burton they wanted to sell. Seeking more input from West Marin communities, John met with over eighty constituents in

January 1978 in Bolinas. Some said they didn't mind if Point Reyes National Seashore encompassed more of the Bolinas Mesa if they weren't bothered by it—perhaps the congressman could keep the name of the town off park maps? John said, "I believe I can get the type of conditions to meet most of your concerns," but added: "The community of Bolinas, which I love dearly, is not going to dictate conditions to the rest of the nation."[18] Knowing that it would diminish the value of other land in the park and could make an area unmanageable, John would not support the county board of supervisors' request to buy parcels only from willing sellers.

Shortly thereafter, half of the Lagunitas Creek Loop, the Bolinas Mesa land, and the 3.3 acres of Playland's Parcel 4 were included in a bill to add over 3,700 acres to the GGNRA and about 2,000 acres to Point Reyes National Seashore. Phil Burton rolled this expansion into an omnibus park bill of proposals that had been languishing all over the country. Bill Thomas went to Washington to help him with this epochal legislation. In May 1978 the House of Representatives passed the gargantuan National Parks Omnibus Act. "It's a marvelous bill," Phil boasted, "but I hope no one gets a hernia trying to carry it around."[19]

President Jimmy Carter signed Phil's bill on November 10, 1978. Public Law 95-625 affected the districts of nearly half the members of the House of Representatives. It authorized more than one hundred projects for parks, rivers, historic sites, and trails in forty-four states and was expected to cost about $1.2 billion. It included the biggest single expansion of the wild and scenic rivers system. It set aside nearly 2 million acres of wilderness within eight existing national parks, added 1.8 million wilderness acres, and tripled the national wilderness system.[20]

This bill, in conjunction with other 1977–78 legislation carried by Phil Burton, increased the number of units under National Park Service jurisdiction by 10 percent. Conservationists reverently said he had protected more land than anyone since Teddy Roosevelt. One sent a telegram to express his appreciation: "I have tried my best to fit you with a uniform for Halloween befitting your stature in the conservation movement in America. However I feel the jock may be too small as I have never seen anyone with bigger balls than you have."[21]

THE CLIFF HOUSE AND SUTRO BATHS

The promontory of Sutro Heights commands the northwestern corner of San Francisco above Lands End. It overlooks Ocean Beach, the Cliff House, and the Sutro Baths ruins. Living nearby, I relish the area's spectacular views on afternoon walks and enjoy an occasional meal at the Cliff

House; my family used to visit the antiquated museum exhibits in the Sutro Baths building before it burned down in 1965. The original baths had been closed before we moved to the neighborhood, but my husband delighted in the huge swimming pool that had been converted to an ice-skating rink. In the late 1800s Sutro Heights, the Cliff House, the Sutro Baths, a mile and a half of shoreline to the north and east, and 80 acres of Lands End were owned by Mayor Adolph Sutro, who had made his fortune from the Nevada silver mines. He built the baths and the second incarnation of the Cliff House and made his home on Sutro Heights.

The GGNRA's original boundary included Sutro Heights, the Cliff House, and the Sutro Baths site, but between 1976 and 1980 the Park Service acquired each piece at a different time and in a different way. The city of San Francisco donated Sutro Heights Park to the GGNRA in 1976; vestiges of its buildings and sculpture could be seen amid its groves and gardens. In 1977 the Park Service purchased the Cliff House—one of the fifty top-grossing restaurants in the country—and its 3.66 acres for $3,791,000.

Getting the Sutro Baths into the park was much more complicated. The Sutro Baths had been one of the world's largest indoor saltwater swimming pools.[22] It was never a commercial success, and in 1964 the shuttered building was bought by developers who planned to build a high-rise apartment complex on the site. In 1979 the property was owned by Cliffside Properties, Inc., a holding of a New York investment company that claimed its 3.92 vacant acres were worth $9.4 million. Three appraisers agreed—within a few hundred thousand dollars of each other—with that estimate of its value. The company said it would build a 698-room skyscraper hotel on the unique shoreline site (figure 22). Few local residents believed that the San Francisco Planning Commission and the state's coastal commission would ever permit such a big building in that location. A Park Service appraiser said the property was worth $1.6 million, and the Park Service moved to condemn the parcel.

When Jimmy Carter was elected president in 1976, Cecil Andrus became secretary of the interior, and he selected Bill Whalen as director of the National Park Service. In April 1979, shortly after the court's decision in the condemnation case, Bill Whalen visited San Francisco. He announced at a luncheon at the Presidio Officers' Club that the Park Service had no intention of paying the $9.2 million for the site that the U.S. District Court jury had ruled it should pay. As the *San Francisco Chronicle* reported, "Whalen nodded toward City Planning Director Rai Okamoto and said: 'I'm going to give you back this (Sutro Baths) problem. I'm going to give them (the owners of the site) the opportunity to build a hotel out there.'" Sitting at one of the luncheon tables, we groaned

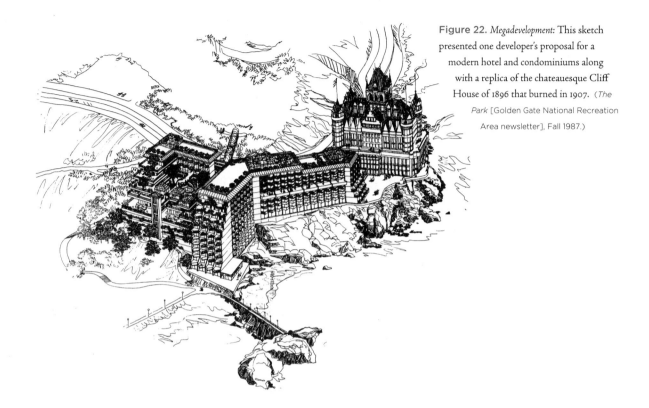

Figure 22. *Megadevelopment:* This sketch presented one developer's proposal for a modern hotel and condominiums along with a replica of the chateauesque Cliff House of 1896 that burned in 1907. (*The Park* [Golden Gate National Recreation Area newsletter], Fall 1987.)

in anticipation of a horrible fight. "He can't do that," Ed Wayburn sputtered—and said nothing more because he knew, as the rest of us did not, that only Congress could remove the parcel from the park. The next day a *San Francisco Chronicle* editorial praised Bill Whalen. "Instead of donning the mantle of wealthy and openhanded Uncle Sugar, he came down hard and announced to all and sundry that $9.2 million for this 4.4-acre chunk of land was simply too much money."[23]

Since there was no building application on file and all of us except Ed thought the property was no longer in the park, we asked the San Francisco Planning Commission to rezone the site. In May 1979 commission president Toby Rosenblatt proposed that the area be given special consideration. We heard about continuing behind-the-scenes negotiations while we waited for hearings. By April 1980 nothing had happened, so the commission voted to control and guide any development that might be proposed by reclassifying the site as a "special-use district." I was in the hearing room when a Cliffside Properties representative shouted at the commissioners that he

would see them all in court. Eventually, as the result of a court decision, the federal government bought the Sutro Baths for $5,567,500 in 1980.

"LORD" BURTON ADDS MORE LAND

Encouraged by Jimmy Carter's and Phil Burton's protective bear hug of our nation's land in 1978, we became optimistic about expanding the GGNRA still further, even into San Mateo County. We were not disappointed: while we were still marveling at Phil's strategies and success, he was at it again.

One of Phil's targets was the 1,100-acre Sweeney Ridge in San Mateo County. One edge of this scenic, undeveloped area is bordered by a small part of the western boundary of the San Francisco watershed lands. Sweeney Ridge is also the site reached by Gaspar de Portolá and his party in 1769 when they became the first Europeans to glimpse the capacious harbor of San Francisco Bay. In January 1979 Phil introduced HR 3 to add Sweeney Ridge and related land to the park (the bill number indicates it was the third bill introduced in that session of Congress).

Back in 1971 the City of Pacifica had bought 19 acres atop the hills above the town for a San Francisco Bay Discovery Site, which conservationists such as Ollie Mayer hoped would become the nucleus for preservation of all of Sweeney Ridge. But the West Aspen Company also had a stake in Sweeney Ridge, having paid $2.5 million for three and a half miles of ridgeline with the intention of building 3,000 homes that would have scenic views. After passage of the 1972 park legislation, Pacificans United to Save Our Hills and other organizations continued to urge protection of Sweeney Ridge and kept up their efforts after our 1975 park expansion defeat (figure 23).

In May 1977 Phil Burton asked Bill Whalen for a study of Sweeney Ridge, and Bill assigned it to the Park Service's western regional office. But Phil didn't wait for the study to be finished. In 1978 Congressman Leo Ryan (D-San Mateo) was killed in Guyana. Phil sensed a power vacuum—and broad support for Sweeney Ridge protection. Early in 1979 he asked Martin Rosen, president of the Trust for Public Land, to "pre-acquire" the property for the GGNRA. Yet the Park Service's finished study, while noting the spectacular views from Sweeney Ridge and its scenic and historic attributes, concluded that "the resource values" had "limited significance." "Sweeney Ridge Flunks National Park Priority Test," said the *Pacifica Tribune* on October 19. Phil Burton called Bill Whalen into his office. "He towered over me," Bill recalled. "I came up to his belt buckle. 'Obviously you don't understand that if I ask you for a study, it's because I know the answer I want,' he said."

Meanwhile, West Aspen pursued its development application and said that its price for the

Figure 23. *Pacifica Activists:* Leaders of
Pacificans United to Save Our Hills,
Ferd Simons (left) and Ken Miles show
their 1978 campaign map for Sweeney
Ridge. (*Pacifica Tribune*, 1984.)

land was $15 to $20 million. On November 14, the *Pacifica Tribune* reported Burton saying that the
Interior Department's failure to recommend Sweeney Ridge for inclusion in the national park sys-
tem "won't have any impact at all on my committee and I don't think on the House."

Phil was now chair of the House Subcommittee on National Parks and Insular Affairs. The sub-
committee's staff director, Dale Crane, noted that a compelling reason to include Sweeney Ridge in the
GGNRA would be to protect San Francisco's watershed land (figures 24–25). "Watersheds are being
'cannibalized' across the nation," he declared. Dale told me he urged Phil to put the watershed into his
Sweeney Ridge bill—which Phil did. Phil also added a string of parcels along the shore between the
San Francisco County line and Pacifica, thus connecting this southern addition to the original
GGNRA. This was the content of HR 3—and then gradually Phil joined it to other bills until Sweeney
Ridge and the adjacent additions of HR 3 became just one section of yet another omnibus bill.

Figure 24. *Deep Forest:* Most of the scenic San Francisco watershed lands in San Mateo County have no public access and are frequented only by wildlife. (Robert Buelteman, © 1987, www.buelteman.com.)

Between 1979 and 1980, Phil introduced this and two more bills for additional parkland in the 96th Congress. The two others were drafted after Jerry Friedman took Phil on a Marin County field trip, and Phil started a list of parcels to add to the northern part of the GGNRA and to Point Reyes National Seashore. The GGNRA properties, from the head of the bay up to Walker Creek, included a few ranches and some homesites and the fringe of shoreline that connects them along a narrow 15-mile stretch between Highway 1 and the eastern side of Tomales Bay. Other properties included the rest of the ranches in the Lagunitas Creek Loop and parcels to be added to Point Reyes National Seashore.

Figure 25. *Cahill Ridge:*
The San Francisco Water
Department allows hikers,
cyclists, and equestrians to take
docent-led trips on the ten-mile
Fifield-Cahill Ridge Trail.
(Robert Buelteman, © 1987,
www.buelteman.com.)

The first of Phil's park bills to be approved was signed into law by President Jimmy Carter on March 5, 1980, as PL 96-199. Titled "To Establish the Channel Islands National Park, and for other purposes," it affected at least twenty-five national parks, battlefields, and monuments. It revised the boundary of the GGNRA to include "those areas depicted on the map entitled 'Point Reyes and GGNRA Amendments' and dated October 25, 1979." It added about 5,000 acres in Marin County to the GGNRA, including the remaining ranches in the Lagunitas Creek Loop and Samuel P. Taylor State Park. It gave $5 million for land acquisition and added 2,133 acres to the Point Reyes park. The bill also increased the $61.61 million land acquisition appropriations ceiling

for GGNRA by $15.5 million and reduced the development ceiling by $10 million. I can only assume that the reduction was to get the increase in the funding for acquisition: timely land acquisition continued to be the most pressing need.

During this time, Phil was putting legislation together with only minimal information from us, such as parcel numbers and maps. I don't know how conservation activists in other parts of the country got their wish lists into Phil's legislation. They may have gone to their own representatives and senators, who then went to Phil, or they may have gone to him directly, or they may have approached him through the Sierra Club or the National Parks Conservation Association. The cumulative result shows that Phil had a vision for the nation, and that he sometimes led us and made connections we didn't see, as well as following our recommendations.

But not everyone saw Phil's efforts in the same way. There was admiration for Phil's new legislating—and some criticism. "Building an Empire—Burton Is 'Lord' of Parks, Territories," said the *Washington Post*. "The sun, in fact, never sets on Burton's empire." An earlier *Post* editorial, "One Man, One Park," questioned whether House members who passed three bills totaling $130 million for twenty-two projects in fourteen states by a 3–1 margin really understood what they were doing. The *San Diego Union* called Burton a "Masterful Machiavelli" and a "Park Barrel Legislator."[24] Datelined one year in the future, a June 1980 story in the *Big Sur Gazette* began:

> Yesterday at a meeting before the Washington Press Club, President Phil Burton announced the completion of the California Recreation Area (CRA), marking the first time in American history that an entire state had been converted into a federal park. The announcement followed the recent completion of the relocation efforts of the population of the former state of California. President Burton concluded his opening remarks with the exhortation that "the long dark night of human occupation of the coastline has come to an end."[25]

The second of Phil's bills was signed by President Carter on September 8, 1980, and became PL 96-344. The bill added the 15 miles of land along the eastern side of Tomales Bay to the GGNRA. It also extended terms for the current members of the Citizens' Advisory Commission from three to five years, or until June 1, 1985, and it extended the life of the commission for twenty, rather than ten, years. (After President Reagan's election but before Carter left office, Phil got us all reappointed, fearing that Reagan would fill our commission with political appointees.)

HR 3—or, in its Senate version, S 2363—was Phil's third park bill signed in 1980. A snippet

of the colloquy regarding the House conference report on this legislation, printed in the *Congressional Record* of December 3, 1980, gives a good idea of how Phil got the support of his colleagues:

MR. PHILLIP BURTON: [The bill includes, among] other things, the Sweeney Ridge proposal in the State of California. It includes an expansion of the LBJ National Historic Site, and it gives recognition to our former colleague, the distinguished former Secretary of the Interior, Mr. Rogers Morton, as well as other items, not the least of which is some modest recognition of the role played by our distinguished colleague, the gentleman from Kansas.

MR. [Keith] SIBELIUS: Mr. Speaker, will the gentleman yield?

MR. PHILLIP BURTON: I yield to the gentleman from Kansas.

MR. SIBELIUS: I thank the gentleman for yielding.

Mr. Speaker, I fully support the adoption of the conference report on S 2363. This report embodies many of the key components of an earlier omnibus bill which originated from the Subcommittee on National Parks and Insular Affairs, and all of the provisions of this report have already been adopted by the House in an earlier bill.

There are numerous provisions of this report which constitute important items of significance to the perfection of our National Park System, and I think it would be highly desirable that these matters receive final action by the 96th Congress.

MR. [Robert] BAUMAN: Mr. Speaker, will the gentleman yield?

MR. PHILLIP BURTON: I yield to the gentleman from Maryland.

MR. BAUMAN: Mr. Speaker, I would ask the gentleman: Is this the bill that contains the Rogers C. B. Morton memorial?

MR. PHILLIP BURTON: That is right. It is our fourth or fifth effort. We finally made it.

MR. BAUMAN: I want to thank the gentleman once again.

After this exchange, Phil showed a chart that listed the sections of each of the five titles of the legislation. Some of them had also been included in other bills—presumably in case this one did not pass—and were already law. Title I dealt with eight parks. Title II had twelve sections; section

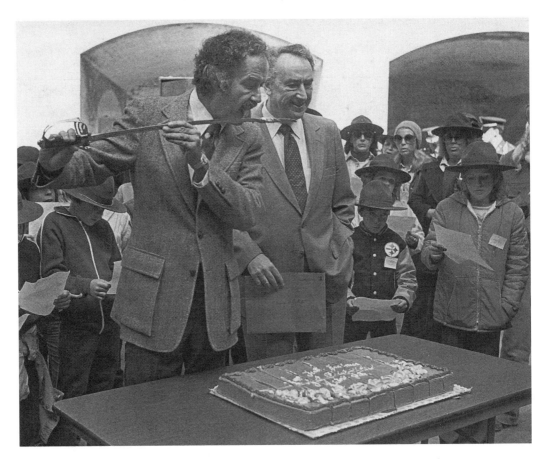

Figure 26. *The Taste of Victory:* Congressman John Burton licks the saber as his brother, Congressman Phillip Burton, looks on at the celebration of the tenth anniversary of the Fort Point National Historic Site. (Courtesy National Park Service, Richard Frear, 1980.)

207 included GGNRA additions in both Marin and San Mateo Counties, the former already within PL 96-344 and the latter in the text of the original HR 3. Titles III, IV, and V provided for twenty parks or studies for them and also dealt with miscellaneous related park matters. Among the people to be honored at sites named in the bill were Martin Luther King, Jr., Georgia O'Keeffe, Roger Williams, and Rogers C. B. Morton. A lake was named for Keith Sibelius.

When President Carter signed this bill on December 28, 1980, it became PL 96-607. The legislation placed the 23,000 acres of San Francisco's watershed inside the GGNRA boundary. It in-

cluded 11 miles of beachfront and cliffs, ending at the 48 acres of the Pillar Point Military Reservation next to the town of Princeton (no one in PFGGNRA knew of this latter parcel). It included 1,064 privately owned acres on Sweeney Ridge (two parcels adjacent to developed areas of Pacifica were excluded), as well as 700 acres of adjacent San Francisco and San Mateo County public land.[26] This legislation would protect a far broader area of habitat than PFGGNRA had originally hoped for and would provide some new points of public access between coastal Highway 1 and the city of San Francisco's watershed. The bill also added an eighteenth member to the Citizens' Advisory Commission to provide for more input from San Mateo County.

THE END OF AN ERA

PL 96-607 was Congressman Phillip Burton's last major legislative effort to increase the acreage and protection for our nation's public lands and for the Bay Area's national parks. Having persuaded Congressman John Seiberling (D-OH) to take over the national parks subcommittee he had chaired, Phil Burton resigned that post on the Interior Committee at the beginning of the 97th Congress and after the election of Ronald Reagan. He became chair of a subcommittee of the Education and Labor Committee and kept up with his environmental concerns by hiring the environmental writer Joan Moody as his press secretary. He also turned his attention to California's decennial congressional reapportionment and redistricting process.[27]

With Phil's leadership, PFGGNRA had helped shape a series of successful park preservation campaigns. We felt we had made the most of Phil Burton's dynamic guidance and legislative skills. However, the Reagan administration soon showed that it was hostile to parks and conservation. We then understood that with this new administration, Phil's incredible proactive political power and his ability to protect the GGNRA and other parks would wane. For a while he helped defend the public lands as new legislators came forward to try to deal with the new political situation. But like other private citizens, representatives and senators, and state, county, and city officials from all around the United States, all of us from the Bay Area would soon have to make enormous efforts to secure the results promised by the public lands legislation passed between 1970 and 1980 (figure 26). Only by such efforts would we be able to keep those gains for land protection from eroding away.

9

ON A NEW POLITICAL FRONTIER

The Nixon and Carter administrations—for a variety of reasons, some profound and a few expedient—showed their concern for the environment and for our national parks. Many of our most important laws for environmental protection and the first legislation for national parks in urban areas were enacted during the Nixon administration. During the Carter administration, vast areas of land were conserved for their natural attributes and public benefit. During both administrations, Congress appropriated relatively more money for land acquisition than it had in the past.

The Reagan administration was starkly different. Its assault on the environment and our national park system began almost as soon as President Ronald Reagan took office in 1981, and in the Bay Area we soon felt its effects. Even though Congress had authorized the purchase of Sweeney Ridge and had approved the money to buy it, Reagan's secretary of the interior, James Watt, tried to prevent its acquisition. He also tried to reduce the size of the Golden Gate National Recreation Area.

Two years after Reagan came into office, the local political landscape began to change as well. There were new faces in the Bay Area's congressional delegation, and California also elected new senators. Each of these changes shifted political power and required new strategies, both for expansion of the boundaries of the parks and for parkland purchases.

SECRETARY WATT ON THE ATTACK

In January 1981, newly sworn-in President Ronald Reagan nominated James Watt for secretary of the interior. Watt was a member of the "Sagebrush Rebellion," a group of moneyed westerners who believed that federal ownership and regulation of large areas of the West deprived them of personal liberty. As soon as his position was confirmed, Watt began to radically change Interior Department policies to reflect that political philosophy.

The Interior Department has two, sometimes conflicting, mandates. It is supposed to protect national parks, seashores, historic sites, recreation areas, range lands, and Native Americans and to conserve wilderness, wildlife, migratory birds, and endangered species. The department also regulates the exploitation of natural resources by leasing land for mining, drilling for oil, grazing livestock, and developing water resources. Therefore a secretary of the interior needs to balance resource protection and resource exploitation. But Watt abandoned even the pretense of balance.

In February 1981 Watt proposed oil drilling in four Northern California coastal locations, including off Point Reyes. He froze all federal parkland purchases, saying that most of the country's unique lands had already been protected, that enough of each kind of ecological system had been saved, and that the government had to manage better what it had before buying any more. He called national parks in urban areas "playgrounds," unsuitable to the national park system. The Carter administration had proposed that $335 million be spent to buy parks in the 1982 fiscal year. Watt said he would spend $45 million—and only for "special cases."[1]

Bill Thomas, now public relations officer for the Park Service's western regional office, said the land-buying freeze could affect 50 properties totaling 2,800 acres in the GGNRA and 91 properties totaling 3,208 acres in Point Reyes National Seashore. Marin County planning director Marjorie Macris said, "There are a lot of property owners who have been anticipating being bought out by the feds. . . . Some have obligated themselves financially. If the rug gets pulled out from under them, they may turn around and ask for a lot split or permits to put houses on their land." Phil Burton was "aghast at the pronouncements of the Reagan Administration regarding the na-

tional park system . . . the mindless across-the-board freeze."[2] Conservationists praised past Republican presidents Theodore Roosevelt and Richard Nixon and said Watt had abandoned traditional Republican values.

At his Senate confirmation hearing, Watt said he did not see the need "for a massive transfer of public lands to state or local control or private interests." Then in March he contradicted himself by proposing that the Park Service divest itself of Gateway National Recreation Area and turn its management over to New York and New Jersey. Leaders in both states were outraged. "If they really were conservatives, they would care about conserving the best of America's past and in making national parks truly national institutions," said Congressman Jonathan Bingham (D-NY). Phil Burton said that if the Park Service dropped management of urban parks, it would lose "all contact with the great urban constituency. And how in hell will the cities and states come up with resources to maintain these parks?" He declared that the Reagan administration was "an environmentalist's nightmare come to life."[3]

Eleven months later Watt finally gave up his divestiture proposal, saying "any lands administered by the National Park Service, such as the Golden Gate National Recreation Area, would not be affected" by a plan in the administration's 1983 budget proposal: to sell federal lands to help reduce the national debt. But parkland purchases would be deferred so that money from the Land and Water Conservation Fund could be used for park repairs. "We have doubled the National Park System through that fund," Representative Morris K. Udall (D-AZ) told Watt. "To me, it was a sacred fund. You have destroyed that fund for [use in] the purpose it was intended."[4]

THE SECOND BATTLE FOR SWEENEY RIDGE

Secretary Watt's frontal assault on the GGNRA took place on Sweeney Ridge. The Trust for Public Land had a three-year option with the West Aspen Company to buy the property for $9.6 million before December 31, 1981. After that the price would rise by $2 million and would later rise again.[5] In 1981 Congress appropriated $9.6 million to buy Sweeney Ridge. But then in November 1981 Watt said he wanted to use that money elsewhere. Martin Rosen of the Trust for Public Land (TPL) got a six-week extension from West Aspen to buy at the lowest price, but the Interior Department canceled all purchase plans for Sweeney Ridge.

By this time Tom Lantos (D) was Pacifica's congressman, having defeated Bill Royer (R), who had succeeded Leo Ryan. Royer had been supportive of the inclusion of Sweeney Ridge in the

GGNRA during his time in office, and we were concerned when he lost to Lantos in 1980. But we needn't have worried: Congressman Lantos quickly demonstrated that he would be a champion for the protection of Sweeney Ridge and for the park. As a member of the House Subcommittee on Environment, Energy, and Natural Resources, he asked subcommittee chair Toby Moffett (D-CN) to hold an oversight hearing in Pacifica for "the Plymouth Rock of the West." Although not on the subcommittee, Congressman Pete McCloskey agreed to participate. Announcing the hearing, Moffett said, "Someone is ignoring the clear intent of Congress, and I intend to find out who it is, and why."[6]

Watt refused to come to the hearing or to send a deputy secretary. He allowed the Park Service's regional director, Howard Chapman, to attend, but Watt knew Chapman would say he did not set department policy and could not explain it. An aide to Moffett said, "Our problem is that many of the questions we'll have to discuss are of congressional intent and why Congress' orders are not being carried out." Watt also enraged the congressmen and subcommittee staff by refusing permission to inspect Interior Department files.[7] I phoned Bill Thomas for further insight. He had none. But Watt's intimidation had spread to the Park Service's regional office. Watt wanted to know about anyone who spoke up on the issue—a threat to anyone whose livelihood he could affect who disagreed with him. "I am supposed to record the name of anyone who calls me on this issue," muttered Bill. "I am not recording yours."

Ten days before the hearing, someone on Tom Lantos's staff asked me to help list witnesses for the hearing. They had a roster of about twenty official speakers; my job was to help find local people to testify. I contacted and helped group twenty area residents into panels—each consisting of three to nine people having a related outlook—to testify.

The day before the hearing, TPL's Harriet Hunt, Lantos's aide John Mitchell, and I met with Charles Cushman, a leader in the Sagebrush Rebellion and a member of Watt's National Parks Advisory Board, at the San Francisco Bay Discovery Site. He had announced that putting Sweeney Ridge in the park would dilute the national park system, which he believed had "become a dumping ground for every bit of open space that comes along." Cushman was in Pacifica to be Watt's mouthpiece. "We just can't afford a boondoggle that will cost as much as Sweeney Ridge," Cushman declared, claiming that Burton, McCloskey, and Lantos had made Sweeney Ridge "a pet project" instead of leaving the decision to the "professionals" in the Park Service.[8]

Congressman Toby Moffett convened the January 29, 1982, hearing in Pacifica's city council chambers. Howard Chapman stood grim-faced at the back of the crowd. A righteously angry,

contentious atmosphere pervaded the room. Congressman Lantos declared, "What we are up against is the arrogance of a non-elected bureaucrat in interposing himself between the expressed will of the Congress of the United States and the actions that he's supposed to carry out."[9] Congressman McCloskey spoke of the unsuccessful efforts he had made in December to persuade Watt to buy Sweeney Ridge on TPL's terms. He said an appraisal should be finished by February 15. Chapman made it clear that the sixty- to ninety-day appraisal process had not begun. Moffett demanded the department's Sweeney Ridge records. Men carried file boxes to the front of the room and dropped them on a table before the congressmen. A series of public officials testified, followed by all the rest of the witnesses. The audience applauded everyone except Cushman. At the end of a full day of testimony, we applauded all the congressmen.

After the Pacifica hearing, the fight against Watt moved to Washington. Over several months Congressman John Seiberling, chair of the House Interior Committee's Subcommittee on Public Lands and National Parks, conducted oversight hearings on national park problems. Traditionally, Interior Department officials and subcommittee aides meet before such hearings to collect facts and prepare questions for congressmen to use with witnesses. Watt continued to bar these meetings and said his staff would meet only with congressmen—who would not have the time. Seiberling charged that Watt's policy "appears to be a deliberate attempt to thwart our subcommittee's efforts to conduct effective oversight by denying us a major means of gaining access to the information we need." At the subcommittee's February 5, 1982, hearing Huey Johnson, who had become California's director of natural resources, angrily listed the administration's abuses in California. "The Reagan Administration has declared an ideological war on our lands and future generations," he declaimed. "In the classic pattern of a scoundrel, Watt has wrapped himself in the flag and cynically proceeds to plunder our state."[10]

Phil Burton had intended to take a less active role on House Interior Committee issues, but he had to protect the parklands he had secured. In March, calling for Watt's resignation, Phil cited Watt's "behind the scenes orchestration" of Park Service opposition to the acquisition of Sweeney Ridge and his unveiling of new wilderness legislation plans. "When the bill's fine print was examined, all my worst fears were confirmed," said Phil. "Watt's proposal is a complete fraud and deception. [It would] gut permanent protection [of wilderness areas] in 18 years or whenever the president decides. . . . At every turn he has taken a position antagonistic to his constitutional and statutory responsibility to be a trustee of public lands for future generations."[11]

NO MONEY FOR LAND PURCHASES

The battle for Sweeney Ridge continued, but it was not our only local battleground with Secretary Watt. Under his aegis, the Interior Department resisted acquiring any of the land that had already been authorized for purchase. A consequence of Watt's personal advocacy for private ownership was that some owners of parcels within the park boundary lost patience and began making development plans.

The Watt "nightmare" made PFGGNRA review just how much more land still had to be bought for our park to fulfill our expectation of a seamless landscape. Although the pace of acquisition for the GGNRA had slowed after the first few years, some money had been appropriated by Congress annually, and the Park Service had gradually acquired most of the private properties included in the park in 1972 and 1974. Sometimes the Park Service bought the land at market price. Sometimes the agency accepted—at purchase price plus the cost of the private effort— property held or optioned by a nonprofit land trust or conservancy, a type of organization that bridges the transfer of private land to public agencies when public funds are not yet available. This is what was intended at Sweeney Ridge. (Marincello too was acquired with such assistance.)[12] Land owners donated a few gifts of private land (sometimes, as with Green Gulch Ranch, facilitated by a land conservancy). By these various means, thousands of acres of privately owned land had come under Park Service jurisdiction in the GGNRA and Point Reyes National Seashore by 1980. But much remained to be acquired.

The money in the Land and Water Conservation Fund with which the Park Service buys private land for parks comes from oil lease royalties. More than 4.5 million acres have been protected by four federal agencies at the cost of over $7 billion since the fund's inception in 1964. Every year, Congress appropriates money from the fund to buy land for national, state, and local parks, but the annual amount has fluctuated greatly, and it has never been enough to do all that needs to be accomplished within a year.[13]

When funding is short, the purchase of private land for parks can become a highly politicized process. Fearing that the money might not become available in a reasonable time, land owners feel betrayed. Some of them protest waiting for years on a list—a priority list that is based on park needs such as access, contiguity, protection of habitat or species, and threat of development, as well as the amount of time the land owner has been awaiting purchase. They

compete for higher priority, and some hire professional lobbyists who urge park advocates to join them in pressuring their legislators for personal attention. Land owners who supported authorization of the park and have been counting on purchase come to feel they have only gained a cloud on the title to their land. Some will speak out against the authorization of any more parkland.

Passed by Congress in 1982, the 1983 appropriations bill for the Interior Department included $142.5 million for parkland purchases. By June 1983, however, the department had blocked expenditure of almost $100 million of the acquisition funds. The department refused to negotiate with willing sellers, to buy inholdings, or to give purchase authority while land costs continued to rise. Martin Rosen of TPL put it to me this way: "Watt's minions were under orders to shrink the park estate, not expand it. The message was that we in TPL and such organizations were fools—and if our money was tied up in earlier 'bridge' purchases that was too bad—we were to be hung out to dry."[14]

Point Reyes superintendent John Sansing told Congressman Seiberling's subcommittee that there was no acquisition budget for his park. The Park Service owned only 63,000 of more than 71,000 acres within the boundary. The Park Service's regional director suggested that a 210-acre property near Bolinas be deleted from the seashore. Angry park advocates protested. The owner got a county permit for 21 building sites. The county also permitted a willing seller near Inverness Park to subdivide 17 of her 44 acres; she had mortgaged the entire property several years earlier in expectation of purchase.[15] Marin County could not legally stall development indefinitely on land remaining in private hands. Land with a development permit or subdivided would later cost the government much more.

Such delays in the promised purchases of land can have serious consequences. Since owners have the right to develop private land within the park boundary and not yet bought, parcels may be lost to development as frustrated owners pursue other options. A last resort—deletion of property from within a legislated boundary because its park value has been too degraded or its price has gone too high—will almost always permanently lessen the habitat and scenic value of some of the investment already made in a park.

A NEW CONGRESSWOMAN COMES TO BAT FOR THE PARK

In 1982 Phil Burton was on the warpath against the Reagan administration. Reagan had won office in a landslide that also gave control of the Senate to the Republicans—and the Democrats had only a twenty-six-seat advantage in the House. One of Phil's counterattack strategies was to defend—and add to—the number of Democrats representing the congressional districts of his home state. John Burton had not done well in the 1980 election, so Phil took control of the decennial reapportionment process to make use of two new congressional seats allocated to California, and also to shape a safer district for his brother.

Phil gave John Burton much of Marin County, the city of Vallejo in Contra Costa County, the eastern portion of San Francisco, and Daly City and Colma in San Mateo County. Phil said the ethnic and economic composition of this district resembled others, and that it was traditional to defend incumbents. He called the contorted reapportionment map "my contribution to modern art." On March 2, 1982, the *Times* of San Mateo County headlined, "Burton Defends New Reapportionment Bid," and Republicans charged that Phil Burton's redrawing of Bay Area congressional districts made Daly City "the basement of Marin County."

However, after the new district was approved, John Burton decided not to run for Congress again, for personal reasons.[16] Barbara Boxer, a devoted park supporter who had worked for John for two years and served on Marin County's board of supervisors for six years, ran in his place and was elected to Congress in 1982 from the new four-county district (figure 27). Barbara immediately set the pattern of caring, effective park advocacy that she would maintain during her ten years in the House. A few months after she was elected, she pleaded with the House Subcommittee on Interior Appropriations, chaired by her friend Congressman Sidney Yates (D-IL): "Five ranches in the northern section of GGNRA, in my district, are considered by the Park Service as high priority acquisitions. All five landowners have been willing sellers, and as acquisition is delayed, a steady march of development continues through neighboring valleys." Her plea could not be met with available appropriations, so it was years before those ranches were bought—at greater cost but before they could be developed.[17] Yet on land included in the GGNRA but not yet purchased, two homes appeared on the eastern shore of Tomales Bay, and a partly built house, constructed without permits and found by Point Reyes park staff, was removed by order of the county from a property fronting Sir Francis Drake Boulevard.

Figure 27. *A Park Dynamo:* Barbara
Boxer became a congresswoman in 1982
and a senator in 1992. Here she reports
to some of her constituents. (Courtesy
Senator Boxer's office, 2002; detail.)

DEATH OF A GIANT

Congressman Phillip Burton never got to finish his battle with James Watt. He had sacrificed part
of the safety of his own congressional district to make a secure district for his brother. Previously,
Phil's achievements on many fronts had made it possible for him to coast to victory against weak
candidates every two years, but now the Republican Party saw a chance to defeat him. The party
heavily subsidized the campaign of a real opponent, the popular state senator Milton Marks. In
November 1982 Phil kept his seat, but it was after an unexpectedly tiring campaign. Those close
to him could see that his health was deteriorating.

On April 10, 1983, at age fifty-six, Phillip Burton died suddenly of an aortic aneurysm. His
body lay in state under the lofty dome of San Francisco's city hall. Legions of Democratic Party

Figure 28. *Sala and Phil*: When Congressman Phillip Burton died in 1983, his wife and political ally, Sala, was elected to complete his term. She won reelection in 1984 and continued working for the park until her death in 1987.
(*San Francisco Examiner Magazine*, September 3, 1995.)

workers, union activists, conservationists, the elderly, the poor, and San Franciscans high and low came to pay homage to their indefatigable champion. Two planes filled with members of Congress flew to San Francisco for a memorial service on the lawn of Fort Mason.

Potential candidates immediately began to circle the vacant congressional seat. Phil's wife, Sala, had to decide quickly if she wished to be a candidate. Among her activities over the years, she had helped organize the California Democratic Council, been a member of the state Democratic Party's steering committee, and been chair of the Democratic Women's Forum. Two days after Phil's death, she summoned all of us who had worked with him to a press conference and announced her decision to run for office. A reporter asked if she would be able to fill her husband's shoes. "I will fill my own shoes, and let me tell you I have big feet," she declared. On June 21, 1983, in a special election, Sala Burton garnered 56.9 percent of the vote in a field of eleven candidates.

Phil had been fond of saying, "She's the popular Burton. I keep Sala busy repairing all the fences I've busted" (figure 28). Sala was appointed to the Interior and Education and Labor committees, on which Phil was serving when he died. "'All those familiar faces,' she said, 'they gave me such a warm welcome. . . . People used to say that Phil ate shredded precinct lists for breakfast. But that

was so untrue. . . . He would fight for things he believed in until the very end. . . . And I want to represent, as my husband did . . . those people who don't have a lot of lobbying being done for them.'"[18]

"She was so concerned about carrying on Phil's legacy that one of the first things she championed was passage of the California Wilderness Bill," said her aide, Judy Lemons, who had worked for Phil. "She went all-out to champion the legislation." Judy added that Sala "considered all of the GGNRA in her district—Marin, Sweeney Ridge—as Phil had."[19]

WATT'S DOWNFALL AND LEGACY

Watt embodied the environmental policies of the Reagan administration, and thus his arrogance, not his damage to the environment, undid him. In February 1982 federal auditors ruled that Watt had improperly used $4,300 of government funds for two Christmas receptions. In July 1982 Congressman Robert Matsui (D-CA) disclosed that Bureau of Reclamation employees in California, Oregon, and Nevada had been verbally warned by the bureau's regional public affairs officer not to talk with reporters whose stories might be critical of Watt, the Interior Department, or the Reagan administration—or risk losing their jobs.[20]

In the spring of 1983, following his puritanical attempt to keep the Beach Boys from performing on the Washington Mall on July 4, Watt received from the White House a large plaster cast of a foot with an obviously self-inflicted bullet wound. On September 21, 1983, at a U.S. Chamber of Commerce meeting, Watt described the members of an advisory commission he had appointed: "We have every kind of mix you can have. I have a black, I have a woman, two Jews and a cripple." On September 24, a *San Francisco Chronicle* editorial titled "Watt Shoots His Other Foot" called the episode "the Secretary's latest misadventure" and declared that Watt "is now as popular as a rattler or loco weed everywhere between the Pacific Ocean and the Great Divide of the Rockies. . . . His latest performance has brought with it repeated calls that he be given a ticket out of Washington and out of public view, a proposal we advanced much earlier in the secretary's governmental service."

After eighteen days of scorching press, James Watt resigned as secretary of the interior on October 9, 1983. However, as staff of Friends of the Earth succinctly observed: "You don't change Ronald Reagan by getting rid of James Watt," and "The general in charge of Ronald Reagan's war on the environment may be gone, but the commander-in-chief and just about all the officers remain."[21]

During his thirty-two months in office, Watt changed Interior Department policies, regulations, enforcement of regulations, and management in the nation's 750-million-acre public domain. He fired the entire professional staff of the Council on Environmental Quality, which had been established during the Nixon administration to ensure that federal agencies would carry out the provisions of the National Environmental Policy Act.[22] Park Service director Russ Dickenson survived, but by the time Watt left only one of his top eleven assistants was a career Park Service employee. Watt's appointees remained embedded in top Interior Department positions. "He stocked the agency with dozens of second- and third-tier appointees who labored daily, in obscurity, to translate his philosophy into policies," Martin Rosen said years later. "Whenever there was administrative discretion they could prevent what they didn't favor by delay or disinterest."

Conversely, Watt's tumultuous tenure helped strengthen environmental organizations. Numerous environmental political action committees came into being before the 1982 election—a new development in U.S. politics—to elect people to office who would oppose Watt's policies. From the beginning of 1981 to the end of 1982, the Sierra Club grew from 180,693 to 336,561 members, and the Wilderness Society grew by 30 percent to more than 65,000 members. Other environmental groups also expanded, and financial donations increased. Environmentalists endorsed candidates for 153 House seats (121 won) and 15 Senate candidates, who won in 11 states.[23] In the Bay Area, everyone focused on the future of the GGNRA had followed Watt's outrageous environmental attacks in the media and discussed them with colleagues and friends in the community. People who had never been conservation activists were drawn into discussions and fundraising projects.

President Reagan nominated California rancher William Clark to succeed Watt. At his confirmation hearing, Clark testified that the administration was considering spending more money to buy land for national park and wildlife refuges. In 1984 Congress appropriated a scant $1 million for the GGNRA and $2.5 million for Point Reyes.[24]

SWEENEY RIDGE AT LAST!

In hearings and at meetings from March through July 1983, congressmen and senators insisted that the Department of the Interior give up plans to reprogram money for Sweeney Ridge, abide by the congressional mandate, and begin negotiations to acquire the property. On July 28, 1983, the Senate passed a supplemental appropriations bill with an amendment by the new California sen-

Figure 29. *At Last!* A park ranger proudly unveils the new sign welcoming the public to long-fought-for Sweeney Ridge. (*Pacifica Tribune*, 1984.)

ator Pete Wilson (R) that "would lend 'the force of law' to a directive to Interior Secretary James Watt to proceed with the purchase of Sweeney Ridge." The Interior Department was ordered to prepare a new appraisal within thirty days and then proceed with its purchase, by negotiation or, if necessary, by condemnation.[25]

The purchase of Sweeney Ridge for $8.5 million was announced on February 15, 1984. Martin Rosen told me the story: "Our lawyer was Put Livermore and he and William Penn Mott helped

vouch for the *bona fides*. Secretary Clark and Director Dickenson went into Clark's office. The appraisal had been for $9.7 million. They came out with a number—take it or leave it. Clark said, 'I don't care what the full market value is; this is what I'm going to pay.' We took it—we had to save the land." After the transaction was completed, Martin explained to directors of the Texas International Corporation (West Aspen's parent corporation) that the Trust for Public Land had paid more than $8.5 million for Sweeney Ridge. The corporation covered TPL's costs with a generous donation (figure 29).[26]

THE GGNRA GROWS FARTHER SOUTH

Sweeney Ridge was the first property in San Mateo County to be purchased for the park, and for many years it seemed as if it would be the last. The dream of "GGNRA South" seemed unattainable. While local conservation groups became increasingly effective, the political climate did not support sweeping new legislation, and no member of Congress could quite match Phil Burton's farsightedness and legislative wizardry.

The situation began to look more hopeful in the early 1990s. Two congressional representatives, Tom Lantos and Anna Eshoo (D)—whose districts included nearly all the San Mateo County land PFGGNRA had hoped to protect in 1975—emerged as supporters of park expansion. They carried park legislation to protect portions of western San Mateo County, supported by the rest of the Bay Area's congressional delegation and by Senators Barbara Boxer and Dianne Feinstein, both newly elected in 1992 (figure 30).[27]

As the political situation changed, so too did the opportunities for more parkland. Polly Phleger Goodan had offered the Peninsula Open Space Trust (POST) the opportunity to purchase the hills and redwood groves of her 1,232-acre Woodside estate after her mother died in 1990. She wanted the estate to remain intact and be enjoyed by the public. POST and Harriet Burgess of the American Land Conservancy collaborated in a strategy to match major private fundraising with government money from the Land and Water Conservation Fund. "All the garden clubs in the USA supported this, which ensured broad political support," said POST's executive director, Audrey Rust. POST sold the home and 25 acres in a corner of the property—with conservation requirements and development restrictions—to help finance the project. With generous private donations and funding from the Save the Redwoods League, the private fundraising was accomplished in time to get the federal matching funds and complete the pur-

Figure 30. *Celebration:* Mayor Feinstein and Amy Meyer enjoy the tenth-anniversary festivities for the GGNRA in October 1982. As a San Francisco supervisor and mayor, and later a U.S. senator, Dianne Feinstein has always supported the Golden Gate National Parks. (Courtesy National Park Service.)

chase of the remaining acres of the Phleger Estate, which were then transferred to the GGNRA in early 1995.[28]

A much-contested addition to the park in San Mateo County was the spectacular ocean-front promontory of Mori Point. Its purchase in 2002 ended one of the longest-running park battles in the county. Over the years, Pacifica residents had fought off a succession of hotel, conference center, equestrian center, and casino plans, but it seemed inevitable that someday some project would be approved. Then in 2000, the owner-investors of the property put it up for sale at public auction, hoping for $8 to $10 million. The minimum bid was $2.5 million. This was at the height of county land price speculation, caused by explosive growth in Silicon

Figure 31. *Saving Mori Point:* Congressman Tom Lantos tells how he and the Trust for Public Land and the Pacifica Land Trust saved the dramatic 105-acre promontory on the San Mateo County coast. (© 2002 Richard Rollins, www.richardrollinsphoto.com.)

Valley. Park advocates feared that a new multimillionaire would buy the 105 acres for an estate. TPL took an option on the property and obtained more than $3.5 million in loans, grants, and private donations. Of course, there was no way to tell how high the price would go on the auction floor. To scare off would-be developers, Pacifica Land Trust members got weekly articles into the *Pacifica Tribune*, garnered editorial support, and marched with signs outside the auction room. The bidding ended at $3.3 million. Since park supporters had met the expectation for major contributions toward federal parkland purchases—as for the Phleger Estate—Congressman Tom Lantos sponsored a bill to add Mori Point to the GGNRA. President Bill Clinton signed PL 106-355 into law on October 24, 2000 (figure 31).

THE WIN AT DEVIL'S SLIDE

Judge Sweigert's 1972 decision in favor of environmentalists did not permanently end the threat of building a massive freeway bypass around Devil's Slide. Jerry Brown, elected governor of California in 1974, proposed that the highway department—renamed Caltrans—fix the unstable slide section instead of constructing a 7-mile bypass, but when George Deukmejian (R) became governor in 1982, the old freeway builders were back in charge.

A federal emergency was declared in 1983 when a major landslide closed the road for eighty-four days, and fixing Devil's Slide became a top transportation priority. Congressman Tom Lantos obtained $50 million in federal funds to repair the road. Environmental studies took a year and a half. When Caltrans selected the old freeway bypass instead of a modest fix of the slide-prone section, the conservationists went to court. They filed four separate lawsuits, and the complex challenge required the work of five attorneys. Although much of the legal help was pro bono, advocates had to raise thousands of dollars to support the lawsuits.[29] Judge Robert Peckham, citing the 4(f) section of the 1966 Department of Transportation Act, which protects parks from road intrusions if there is a prudent and feasible alternative, ruled that Caltrans had not considered impacts to McNee Ranch State Park, which the bypass route would have bisected.

When Devil's Slide slumped again in the winter of 1993, the San Mateo Board of Supervisors asked a panel of geologists and engineers to review the proposed highway alternatives. The panel recommended that a tunnel be built through the mountain behind the slide as a permanent, safe, and environmentally superior solution.

The supervisors then asked for a preliminary design study. Conservationists enlisted tunnel experts and organized Save Our Coast/Citizens Alliance for the Tunnel Solution. The SOC/CATS group gathered 30,000 signatures and qualified Measure T—for tunnel—for the county ballot. In November 1996 it passed by a resounding 74 percent and changed the county's coastal plan to require a tunnel instead of the bypass. Afterward, in an extraordinary process, all interested parties, friends and foes alike, including all relevant local, state, and federal agencies and elected officials, met monthly. Their final agreement was signed in September 2002. Thanks to Senator Boxer, the tunnel has remained eligible for emergency funding. While the tunnel is under construction, federal, state, and county land management agencies will shape a program for the future care of the surrounding land. The abandoned portion of the cliff-hugging road will become

a bicycle and pedestrian trail. "It's been a titanic struggle and it's finished," said the local conservation leader Lennie Roberts of the thirty-year fight to defeat the Devil's Slide bypass.[30]

INNOVATING TO EXPAND THE PARK

During the GGNRA's first ten years, as mandated in the park's authorizing legislation in 1972, land inside the park boundary became part of the park in one of three ways. A public entity such as the Army or Marin County donated land; the Park Service bought property with money appropriated by Congress from the Land and Water Conservation Fund; or an agency or a nonprofit organization kept a site under its jurisdiction and was required to care for the land in a way that did not diminish its park value.[31]

Through the 1970s, ending abruptly in 1980, this legislative language set the expectations of People For a Golden Gate National Recreation Area as we worked on park expansion. The pace of land acquisition was always too slow and there was never enough funding, but we always felt we were making progress. We diligently mapped and justified boundaries for additions to the park and did all we could to urge Congress to appropriate land acquisition funds in a timely manner. There was a $12 million burst of spending in 1980, at the end of the Carter administration.[32]

James Watt, however, changed our expectations for park expansion and acquisition. During those perilous times, conservationists greatly intensified their efforts to help the federal government meet the cost of adding new land to any of the national parks. In the Bay Area, advocates found new strategies that took advantage of local conditions to designate and acquire additional acreage for the parks.

PFGGNRA has remained an advocate for expansion of the GGNRA, but since the 1980s we have increasingly backed up other organizations' innovative campaigns to add land to the park. This is what we did when the city bought part of Parcel 4 of Playland, when the Phleger Estate and Mori Point were added to the GGNRA, and when local residents, foundations, land preservation organizations, land trusts, the state, and some town or city governments have tried to supplement federal appropriations, so as to leverage purchase of desirable parcels. In a number of cases such groups have taken an option on property or purchased a parcel outright, to avoid losing the land before Congress includes it within the GGNRA boundary. They have donated private funds,

parcels of land, or park improvements. And they have used agricultural conservation easements to protect ranch land next to the parks, to prevent development and enlarge the protected areas of habitat and scenery.

Playland

No one could have anticipated how PFGGNRA helped acquire a portion of Playland at the Beach for the park. Phil Burton had included one-third of the land of the demolished 10-acre amusement park in the GGNRA in his 1978 park omnibus bill. Senator S. I. Hayakawa (R-CA) had said he would not vote for the omnibus bill unless Phil limited the GGNRA's purchase of Playland to 1.9 acres so the owner could develop some of the property. Phil had to agree to the restriction but kept Parcel 4, a 3.3-acre parcel, inside the park boundary. In the early 1980s, after acrimonious hearings about the density of the project, the developer filled his three other parcels with apartment buildings. The GGNRA had not bought its half of Parcel 4, and the developer then brought forth a plan for 120 more apartments. Park supporters and neighbors were demoralized, but then two new residents, Cheryl Arnold and John Frykman, joined the fight and revitalized the group as the Coalition to Save Ocean Beach. The group applied for city open space funds and got about $1.5 million. Then the GGNRA bought the least expensive 1.9 acres—the cliff face—but the $1.5 million was not enough to buy the rest.

I joined the neighbors in visits to Assemblyman Willie Brown (later, mayor of San Francisco), to Todd Cockburn, a city administrator who needed the remaining 1.4 acres for a temporary construction staging area for a giant city sewer project, and to City Attorney Louise Renne. Willie Brown suggested trying to lower the number of units permitted on the property. The Ocean Beach coalition persuaded the planning commission to reduce the number of condominiums to 61 because the owner had sold over half the land to the GGNRA. Todd Cockburn agreed that it made no sense to rent the parcel for staging when, for a couple of hundred thousand dollars more, the city could buy it. Then the coalition learned that the developer was in financial trouble. He wanted a permit extension covering the time of the sewer construction in order to find more money—and potentially raise the property's value by a million dollars—which meant that the city would not buy it. We went to Louise Renne about the extension, and she rejected the work of a staff attorney who was inclined to give the owner some unusual concessions.

The evening before the planning commission hearing on the permit extension, Gerald Adams of the *San Francisco Examiner* phoned me. Did I know that the developer had been accused of double-mortgaging his property and was probably fleeing the country? In the morning, I called Louise Renne's office. A city attorney apprised the planning commissioners and Cheryl Arnold lobbied them. The commission postponed the matter to the following week, where we all learned that the owner had indeed left the country. His partners could not convince the commission to grant the extension. Following bankruptcy court action, San Francisco's public works and park departments jointly bought the parcel. After it was used as a staging area, national and city park planners drew a design for planting and paths that the public endorsed. Because of underlying utility easements, the city will retain ownership of the parcel, and the GGNRA will manage it along with its nearby properties.

North and South

When Barbara Boxer was elected to the Senate in 1992, Lynn Woolsey was elected to fill her congressional seat. The Marin County supervisor Gary Giacomini and Congresswoman Woolsey tried for several years during the 1990s to protect 30,000 acres of ranch land on the hills above the eastern shore of Tomales Bay, on the landward side of Highway 1, across the road from the shoreline GGNRA land. They wanted these acres to be within the national park boundary, but to make it much less expensive they sought only conservation easements and some access, rather than outright purchase. Their efforts to expand the park were unsuccessful, but the Marin Agricultural Land Trust was already buying agricultural easements in order to preserve beef and dairy ranching. This organization's continuing efforts in this area are successfully protecting the hills, but as a buffer zone outside the park's northern borders.

In the south, further additions to the GGNRA are being negotiated through the Peninsula Open Space Trust. In 2001 the Gordon and Betty Moore Foundation and the Lucile and David Packard Foundation each pledged $50 million toward POST's $200 million parkland purchase campaign, Saving the Endangered Coast. POST's first acquisition under this new program was the Rancho Corral de Tierra, 10 miles south of San Francisco, which extends from the city's watershed lands almost to the ocean. It is an outstandingly scenic and environmentally valuable 4,262-acre property with the headwaters of four coastal watersheds and numerous threatened,

rare, and endangered plant and animal species. Congress approved the addition in 2005.[33] Most of the ranch will be added to the Golden Gate National Recreation Area. POST's leadership in protecting this magnificent coastal region is well supported by generous local contributions of land as well as money. While some properties POST hopes to protect will probably be added to the national park in the future, areas not contiguous with the park will be administered by other agencies.

10

SUSTAINING THE VISION

After President Nixon signed the 1972 Golden Gate National Recreation Area legislation, people reveled in their expectations for the expansive park. But not everyone saw its future in the same way. Mia Monroe was working with me one day and went to answer the doorbell. She came back to whisper that it was a young man she knew, so I said I would see him. He said he had a grand idea: a revolving restaurant on the top of Mount Tamalpais. Trying to mask my reaction, I said the mountain was still part of the state park system. That was OK, he said, but could he have my support anyway? I told him his idea was old—only the revolving was new—but it was different from the kind of recreation the public expects in this location. He was not dissuaded. "Others will like this idea," he said. "I want to take it to people in Marin." "Try the Marin Conservation League," I told him. "What will I need to show them?" he asked. "Bring a big map, and perhaps a drawing of what you intend." "Is there anything else I need?" I couldn't resist adding, "Only a pair of sneakers. Because when you've finished explaining, you're going to have to run like the wind."

Most people here would scoff at the idea of a rotating restaurant atop Mount Tamalpais. But there have been a number of other proposals—some outrageous—about what the park is for and how to use and manage it, such as the idea of the five San Francisco supervisors who went to an alcohol-laced lunch with a newspaper columnist and then announced a ballot measure for a gambling casino on Alcatraz to solve the city's financial problems. Several friends of the GGNRA had to phone the supervisors' major campaign contributors, who persuaded these supervisors that this illegal proposal would only embarrass them, showing an amazing lack of gratitude for a national park.

The people who fought for a Golden Gate National Recreation Area have consistently supported a vision of uninterrupted scenery and wildlife habitat, and recreation based on the park's natural and historic features. Although park visitors from widely diverse backgrounds generally agree and have similar ideas for what they want to do or want others to do in the GGNRA, some former private and public owners, various user groups, and park neighbors have tried to promote special interests in conflict with this vision. Some of these ideas raised policy issues that had to be discussed by the Citizens' Advisory Commission or else were settled behind the scenes or by negotiation. Most disturbing were actions by public agencies within or next to the park—including the Park Service and the Interior Department—that threatened the park's integrity. These prompted intense defensive efforts by PFGGNRA and other activists, including one issue that had to go to federal court and a congressional oversight hearing.

POLICY AND MANAGEMENT IN A DIVERSE PARK

Management of a park as large and diverse as the Golden Gate National Recreation Area is unusually complex. Because the park is part of three counties and four congressional districts and borders numerous cities and other publicly owned lands, what happens in the GGNRA is of concern to myriad public agencies and officials. Several million people can easily reach parts of the park, and those parts are used heavily, whereas other parts are more remote and rarely entered.

As expected, the public comes to the GGNRA to enjoy its beaches, trails through the verdant countryside, and historic buildings and fortifications, rather than to find commercial recreation. The GGNRA's management fulfills the expectations of most park visitors. Except for those who tour by auto, most visitors approach excursions actively, intent on enhancing and enjoying their physical and mental health. They stroll, hike, jog, ride horses, and pedal to view the splendid scenery

Figure 32. *Hero of the West:* Lyme disease, prevalent in the eastern United States, occurs much less often in California because the ticks that carry the bacteria spend part of their life cycle attached to the western fence lizard; a protein in the lizard's blood destroys the bacteria. The small lizard's beneficial relationship with people demonstrates one reason why it is important to protect species and their habitats. (Edward S. Ross, 1953.)

from miles of trails. They come to see fields of wildflowers, tiny orchids, towering redwoods, deer, tidal pools, and elephant seals; to watch for the different birds of the forest and shore; and to learn about military and local ranching history. In the context of an increasingly urbanized Bay Area, Point Reyes National Seashore and Golden Gate National Recreation Area have become places of refuge for native species and busy people (figures 32–33).

Nonetheless, there are always some people who want to use the landscape more intensively, without limits, and resent national park regulations. Off-road bicyclists, motorized watercraft operators, dog owners, recreational vehicle drivers, and promoters of large events have all claimed vociferously that the GGNRA should be what its name implies: a "recreation area" where they can enjoy themselves as they wish. Hikers, birders, equestrians, photographers, and others who believe that in a park you "take nothing but pictures, leave nothing but footprints,"[1] have just as vigorously supported protection standards they believe the Park Service intends in policy and by law.

One of the ongoing issues facing park administrators has been how to manage the impact of visitors on the residents of Marin County communities near the park. Long before the GGNRA, southern Marin had weekend traffic jams, and the development pressures on West Marin promised far worse. The coming of the park halted most development, but in 1974, when the Park Ser-

Figure 33. *Morning Light:* Black-tailed deer graze in the early morning in the protected San Francisco watershed lands of San Mateo County.
(Robert Buelteman, © 1987, www.buelteman.com.)

vice combined Point Reyes National Seashore and GGNRA planning, some West Marin residents began to grumble about the potential influence of tourism on their small communities. "Local Reaction: Keep Coast Safe 'From' Not 'For' Tourists," declared a headline; a few people opined that the cure was as bad as the pressure for development.[2] When the GGNRA chose a plan for the reuse of a circle of historic Army buildings as a conference center on the eastern side of Fort Baker, the Sausalito City Council went to court to oppose more visitors in the area. The conference center will be developed, but the lawsuit stalled the project for several years, causing the buildings to deteriorate further and raising the cost for the Park Service and the project's sponsor.

The Park Service has generally tried to pursue policies that would alleviate these concerns. At Fort Baker, for example, the increased public visitation is expected to lead to better public transit and actually reduce vehicle traffic in the area. Also, the Park Service has strictly limited overnight accommodations inside the GGNRA and Point Reyes. Both parks have hostels in renovated historic buildings, each has an environmental education center where groups of students may stay for several days, and each park provides backcountry camping. Most overnight visitors must rely on car and trailer campgrounds in nearby state parks or on private land, as well as inns, bed-and-breakfasts, motels, and hotels in nearby towns or in San Francisco.

POLICY MAKING AND THE CITIZENS' ADVISORY COMMISSION

Although park superintendents have sole responsibility for making local park policies conform to national policies and for carrying out those policies, ours have not had to operate in a vacuum— at least until recently. From 1974 until 2002, when Congress did not reauthorize it, the Citizens' Advisory Commission listened to the requests and complaints of the public, considered the pros and cons of policy changes, and made recommendations to park administrators in Point Reyes National Seashore, Golden Gate National Recreation Area, Muir Woods National Monument, and Fort Point National Historic Site (figure 34). Doug Nadeau, GGNRA's retired chief of resource management and planning, said the CAC "has been seminally involved in all significant park management and planning issues since its establishment."

The CAC was a "wonderful buffer between the bureaucrat—the paid professional doing the job—and the public," said Bill Whalen in 1993. "The public could better accept what it was I wanted to do when [it was done] through that commission. I could say things back to them through the commission that they accepted." For this and other reasons, the CAC was "an absolute Godsend. . . . They sat through incredibly long hours of testimony and concerns of citizens throughout the Bay Area on how the park was being run, operated, and managed, etc. They listened thoughtfully, made thoughtful recommendations, the whole time I was there—and I think all the way through."[3]

A 1981 report issued by the Charles F. Kettering Foundation well described the role of advisory committees like the CAC and affirmed their value: "Federal advisory committees are a source

Figure 34. *In the Field:* Park superintendent Brian O'Neill holds down the corner of a map while members of the GGNRA and Point Reyes Advisory Commission and park staff crowd around him on a site visit in 1990. (Photographer unknown.)

of frustration to just about everybody involved: the members, the agencies, the White House. Although they are a frustration, they have become an integral part of the policymaking process. Today, even the most vocal critics of advisory committees recognize that government must be able to get advice from knowledgeable and experienced citizens from all sectors of society. Advisory committees are an important element in making government responsive."[4]

The Commission at Work

The Citizens' Advisory Commission began slowly but after a few years was holding up to fourteen full commission meetings annually because of the ever-increasing complexity of issues in the parks. We met most often at Fort Mason in San Francisco, but also in Mill Valley, at Point Reyes

Figure 35. *Public Hearing*: The hearing room at Fort Mason was often crowded when park staff presented matters before the Citizens' Advisory Commission. The GGNRA's legislation called for a commission because public input is key in making—and keeping—a park that serves a diverse community. (Photographer unknown, 1994.)

headquarters, and a few other Marin sites, and in Pacifica and Redwood City in San Mateo County (figure 35). At these public hearings, attendance ranged from fewer than twenty to more than nine hundred people. On the average, about fifty people—public and staff—attended for about three hours. Anywhere from one person to one hundred people would ask to testify on an agenda item. Each meeting began with an open time for public expression on non-agenda items.

Additionally, each commissioner was a member of at least two committees and participated in some twelve to twenty committee meetings annually. The chair or I—or both of us—attended every meeting. The committees were mostly organized geographically and met with only invited members of the public. All the issues pending in, say, southern Marin, or Point Reyes, or the Presidio, would be sorted out and discussed in committee before park staff presented them at a public hearing. Commissioners' awareness of community sensitivities helped prevent unnecessary

Figure 36. *Bicycling:* Cyclists enjoy riding on many designated biking trails throughout the GGNRA. Here the Tam Valley Bike Club cycles on Coyote Ridge. (Courtesy Tam Valley Bike Club and the Tamalpais Community Services District, photographer unknown.)

conflict between the park's superintendent and the public or encouraged bolder action on an is-sue than the staff might have thought possible.

Conservation organizations, the two park superintendents, civic and neighborhood groups, individuals, and commissioners themselves brought issues to the CAC. We gave advice on poli-cies for the Presidio; relocation of a Coast Guard station; plans for wireless telecommunications facilities, several visitor centers and the California Marine Mammal Center; and rehabilitation of the Cliff House. The commission helped devise policies for numerous fairs, festivals, and other events. When San Francisco neighbors protested a big blues festival at Fort Mason, the CAC helped the park set attendance limits. We recommended policies to limit horse stable facilities, prevent overgrazing, repair erosion, and relocate trails. When the 1976 state coastal commission's plan for

Marin County called for car campgrounds in the Olema Valley, we advised rejection of all car campgrounds in the park, because we felt that demand for such lodging would increase exponentially if any were allowed, and the facilities would divide unbroken areas of habitat and scenery.

The commission worked especially hard on the most contentious and potentially precedent-setting issues. After mountain bikes were invented in the mid-1970s, cyclists wanted to use the Point Reyes National Seashore's wilderness trails, which were closed to all wheeled vehicles except wheelchairs. In 1985 the secretary of the interior asked our commission to advise him whether mountain bikers should be able to ride in the Point Reyes wilderness. Although we were asked to shape policy for one park, we knew that our vote would set a national precedent. Mountain bikers came from near and far to support the proposal, but they were not as effective as local park users, representatives of national conservation organizations, and Bill Duddleson. We voted down the proposal, convinced that permitting bicycles in the wilderness would irrevocably damage the 1964 Wilderness Act, and the secretary accepted our advice (figure 36).

In 1976 hunters asked the commission to support public hunting in Point Reyes National Seashore. Although hunting is permitted in some national parks, it was not in Point Reyes. In the 1930s a local land owner had introduced axis and fallow deer from the San Francisco Zoo at Point Reyes for hunting. With few natural predators and in a favorable climate, they had multiplied so prolifically that park rangers were "reducing" the population by hunting on a regular basis to keep the population from "crashing" through starvation. Backed by Brian Hunter from the state Department of Fish and Game, spokesmen for twenty thousand organized hunters came to a meeting. Ed Wayburn asked Hunter if axis and fallow deer were game animals in the state code. He said they were not. One commissioner said it would be like shooting tame animals. However, only a few members of the public had noticed the agenda item, and their arguments against hunting were ineffective. The hunters expected us to support their cause at our next meeting, when, as was the commission's usual practice except in emergencies, we would vote on the issue. John Sansing, the Point Reyes superintendent, did not want hunters in a park with multiple entrances and 2.5 million visitors a year. I was already scouting for opponents when he asked me to help find some more. At our next meeting, eighty people spoke vociferously against hunting in the park. Only two hunters spoke; perhaps they thought they had already won. The proposal was unanimously defeated.

Sometimes the CAC did more than respond to requests for advice on a park issue and advocated for the interests of the two parks in general. We urged timely land acquisition, expansion of the fee demonstration programs, and adequate appropriations for the Park Service. Commissioners

worked behind the scenes with legislators and heads of agencies and represented the commission at the public hearings of other commissions and boards.

Most commissioners made it a priority to get to know the two parks as well as possible. Commissioners turned out for field trips as often as park managers could arrange them. It takes a lot of hiking or cycling to know the park—and sometimes we found things no ranger had seen. On a memorable field trip in the Olema Valley, Ed Wayburn insisted that we follow a certain trail—until we came on an unoccupied South Sea island movie set tucked into a grove of trees. A dismayed John Sansing and the rest of us then followed Ed along the ridge to the site of a utility power line project. The access route for the power line was much wider than necessary; the extra felled redwoods could make the project manager a tidy personal profit. Evidently, park staff had not supervised the contract.

The Commission over the Years

Over its twenty-nine-year history, the CAC fulfilled its role effectively and was considered a natural and necessary asset by park superintendents. The issues we dealt with changed as the parks grew and matured, and as the Bay Area's population expanded and visitation to the parks increased, but our combined knowledge and experience were formidable. We were current or former elected officials, county planning and park commissioners, county park directors, agency and nonprofit organization board members and directors, business leaders, journalists, doctors, lawyers, teachers, engineers, and more. Our personal commitment to the National Park Service's basic principles buttressed all our advice.

Frank Boerger, our hardworking and much respected chair, died in 1990. Richard Bartke, a lawyer and former mayor of El Cerrito who represented the Association of Bay Area Governments and had been a member of the commission since its inception, was unanimously elected to succeed Frank. Rich did an outstanding job. He sent us periodic "Notes from the Chair," well leavened with humor, so we knew what was going on in the park beyond the news clips sent by our staff assistant. He saw that the commission got its own stationery for letters and resolutions. New commissioners gained experience and then got a chance to chair one of the various committees. Even so, the commission preferred not to rotate the jobs of the CAC chair and vice-chair. I was reelected vice-chair through all the years of the CAC, a position in which I could continue to be an activist.

Sadly, the advisory commission ceased to exist in October 2002, when Congress failed to re-authorize it for another ten years. During the presidency of George W. Bush, it has been the administration's policy to review advisory commissions closely and in many instances not reauthorize them. When the reauthorization of our commission came before the House Natural Resources Committee, a Park Service representative testified that it had been around longer than other commissions and was no longer needed. In order to communicate with the public, and to meet National Environmental Policy Act requirements for certain planning issues, both the GGNRA and Point Reyes National Seashore now hold infrequent public meetings chaired by a facilitator. Staff present the issues on the agenda and people (including some former commissioners) voice their support or concerns, but there is little discussion, and the parks no longer have the sounding-board of a knowledgeable, broadly based group of advisors.

Our advisory commission did well for all these years for a variety of reasons. A foundation of our success was a local tradition of over a hundred years of political activism for land use conservation and planning. Commission members were selected from as broad a local geographic base as practicable, and for what each one could contribute in expertise or community linkages, with almost no concern for political party affiliation or patronage. Bill Whalen made a big investment in training us, setting standards and procedures that were passed down through successive commissioners. We worked as a team and subsumed individual agendas for the good of the parks as a whole. Superintendents rarely tried to use the commission as a rubber stamp. They saw that a self-respecting commission could provide extra eyes and ears on the land and in the community, could generate lasting support for the park and the Park Service, and could help keep political peace with myriad local agencies and organizations.

THE WHOLE EARTH JAMBOREE

Early in 1978, Stewart Brand, the founder of the *Whole Earth Catalog* and proponent of New Games, decided to celebrate the catalog's tenth anniversary at an event for up to twenty thousand people. He wanted the event to take place in the Gerbode Preserve on the Marin headlands during the last weekend in August. Participants in the Whole Earth Jamboree would enjoy a fair, watch performances, and play group games. Two hundred leaders would camp out overnight in the preserve. The resulting controversy ultimately pointed the way to better protection of areas in the park with high natural value.

The Gerbode Valley, the heart of the hard-won Marincello lands, is surrounded on three sides by steep hills and is especially fire-prone in late summer, the height of the dry season. On a Critical Natural Factors map, park resource managers had marked most of the valley as having "critical" and "high" biological sensitivity. The preserve is full of wildlife, from butterflies to bobcats. It is also less than ten minutes from the Golden Gate Bridge. The bridge, Highway 101, and the narrow roads into the headlands have lots of traffic on a sunny weekend. A festival attracting far fewer people would create bottlenecks and would require a security force to deal with traffic and emergencies.

Stewart Brand was an advisor to the California governor, Jerry Brown, who was starting his campaign for United States president. Both men were viewed as environmentalists. Architect Buckminster Fuller, singer Mimi Farina, and poet Richard Brautigan were expected to come, and Brown said he might put in an appearance. When told he needed a security force, Brand said he could get the California National Guard. The GGNRA superintendent, Lynn Thompson, seemingly bewitched by Brand's proximity to power, granted him a permit for the jamboree.

Many people weren't happy with Thompson's decision. Girl Scout leader Karen Hyde wrote to Thompson, "I suppose I am just a bit disgruntled because I requested permission to bring in a group of some 12 Girl Scouts, carefully trained in perching lightly on the land, for an overnight. Permission was denied emphatically. My naturally unsuspicious mind turns to thoughts of greased palms and political finagling. Who is Stewart Brand that he should be allowed to do to the 10th power what was denied to me?"[5]

I learned about the event in late spring, when a woman phoned who would tell me only her Sierra Club number. At the club's headquarters in San Francisco, I connected her number to a name I recognized: the wife of a park ranger living on Fort Barry. I phoned her back, assured her she would remain anonymous, asked her to let me know anything new, and said that a group of us would do all we could to stop the jamboree.

People For a Golden Gate National Recreation Area knew this event could set a bad precedent. I spread the word among conservation groups and they voiced their objections. After all, wildlife could not be asked to move out of the Gerbode Preserve on weekends.

By waiting until the matter became public, Lynn Thompson had avoided timely consultation with our advisory commission. Ed Wayburn and I and a few other commissioners put up a fight, but so many commitments had been made that a majority of commissioners voted only to halve the attendance to 10,000 participants, 5,000 a day. The Park Service accepted this advice. The ob-

vious alternative site was the rifle range across the road from the Gerbode Preserve. But Stewart Brand insisted on using what he called "a gorgeous uninhabited little valley," declaring that "keeping this valley available for events like this, say a couple of weekends a year, is being creative about the use of the valley."[6] On August 8, Thompson mailed out a form letter stating, "We have come to the conclusion that the Gerbode Valley is an appropriate place for this event on a trial basis. The environmental summary for the event concluded that there will not be significant environmental impact." In truth, however, park staff had done little environmental review.

George Sears, a lawyer who lived in Sausalito, threatened a lawsuit, saying that the superintendent had abused his authority. George, his wife, Mary Ann, and Robin Sweeny helped shape items for Sausalito's *Marinscope* newspaper. It published weekly articles about the jamboree—with details gleaned from the anonymous ranger's wife—and about the campaign to stop it. The *Marin Independent Journal* and the San Francisco newspapers eventually printed some articles as well. When the *Marinscope* reported that the National Guard was to be used to support a private event where an entrance fee would be charged, copies of the article were sent to public officials, and the Guard's support was withdrawn. But we seemed unable to get the permit canceled or changed without going to court. We preferred not to create the public spectacle of conservationists fighting in court. If the decision went the wrong way, of course there could be worse damage.

At last someone realized that Marin's board of supervisors might have an opinion about the matter. Although the jamboree was to be in the park, there are private homes nearby, along the boundary. The matter was put on the board's calendar. The county fire chief warned of critical fire danger—and a day later said the event could be safe. That day, I dropped in on Boyd Stewart's ranch, 25 miles from the Gerbode Valley. I told Boyd how frustrated I was. "What!" he shouted. "I used to graze that land. If a fire ever started down there, it would engulf the houses to the east!" He dialed Robert Roumiguiere, the board's only Republican. "How could the fire chief permit anything like this? You have to keep this from happening," he demanded.

On the Thursday before the jamboree, the fire chief went out to the Gerbode Preserve for another look. Someone made sure reporters were present. The fire chief declared the valley "a canyon" and "a funnel." He said that with thousands of participants a fire would cause mass chaos. The county supervisors asked the GGNRA to move the event to the rifle range.

Having promised the county that he would meet its demands, Lynn Thompson moved the jamboree. Despite all the media attention, fewer than eight thousand people came, causing a bit of traffic chaos. There were many No Smoking signs, and the county fire department stood by.

People played with giant Earthballs and stilts, watched jugglers, aikido demonstrations, puppets, and hang gliders, and applauded performances on the small stage. Booths featured organic food and drink or environmental information. Wavy Gravy, wearing clown makeup, multicolored hair, and a hard hat, asked volunteers to help him empty the garbage cans. He called himself a psychedelic relic.

Environmental review is much more thorough now than it was in 1978. Also, the 1980 General Management Plan for our two parks helps determine appropriate use of park areas. The Gerbode Valley is categorized as a natural area. No major event may be held in any natural area in the parks.

RIGHTS OF FORMER PRIVATE OWNERS

In 1983 I got a phone call from Ed Haberlin, chief of the Division of Land Resources for the Park Service's western region. Could PFGGNRA help uphold a law and protect a national park policy? Ed's problem originated with the request of a single owner, and if Ed granted his request it would affect parks nationwide.

A provision in the legislation for the GGNRA, Point Reyes, and some other national parks gives limited rights of "use and occupancy" to land owners inside the park boundaries who have sold their property to the federal government. Upon sale of a residence and land to a national park, an owner may retain a right of use and occupancy for a number of years or for life. If the owner chooses a number of years, the purchase price is reduced by 1 percent for each year; if for life, the price is determined by the owner's age and based on an actuarial table. Although it would not expire until 2012, a resident of Duck Cove on Tomales Bay wanted to extend his right in Point Reyes National Seashore for ten years. An assistant secretary of the interior had suggested that he buy a piece of land within the park's boundary and donate it in exchange for ten more years of occupancy.

Ed Haberlin told me that the owner's interest ends when such a right expires. If money and political pull provided an extension for this man, it would set a precedent for parks across the country. Also, rights of use and occupancy can be sold. If a twenty-nine-year right became a thirty-nine-year right, it would be more valuable because of the additional ten years. The assistant secretary was Ed's superior, but if I could organize public disapproval of this exchange, perhaps it would become impossible to carry out.

The next weekend I visited Duck Cove with some friends—by climbing over a locked gate. In effect, a broad swath of Point Reyes National Seashore bisected by a half-mile-long road had

been closed off to park visitors for more than twenty years. Superintendent John Sansing told me the closure was for the security of cove residents' homes, and he would do nothing about it. His deputy, Marc Koenings, thought the closure was wrong and a few weeks later gave me a tour of the area. Few people were even aware of this part of the park, and the Point Reyes activist Anne West and I were stumped about how to expose the plan and get enough people to oppose it.

I called the National Parks Conservation Association for advice. They directed me to national park officials connected with two national parks, Apostle Islands and Fire Island. They told me I was right, said similar requests in their parks had been turned down, and wished me luck.

Only the press could save this situation. A reporter from the *Point Reyes Light* in Point Reyes Station did the first article on December 1, 1983, and the story was picked up by the *Coastal Post* in Bolinas and the *Independent Journal* in San Rafael. I sent the articles to Bill Thomas. He growled that the newspapers were too small.

The Marin Conservation League sent a letter of protest to Superintendent Sansing. The advisory commission heard the matter on December 7, 1983. Commissioner Jerry Friedman reminded everyone that people who had to leave their homes in Redwood National Park and other parks would have tremendous resentment if a wealthy person could buy his way into an extension. The commissioners advised disapproval of the plan. Ed Wayburn and I sent a letter to Sala Burton. Nothing happened.

We needed a dedicated reporter from a major paper. Someone suggested the *San Francisco Examiner* reporter Jim Schermerhorn. Jim said he would help and wrote an article to expose the plan. He then tried for many weeks to get his paper to publish it. His editor seemed to think the story would be of little public interest, but at last it appeared in the *Examiner*'s Marin edition. Although Bill Thomas kidded me about getting it into the local edition of a paper with less circulation than the *Chronicle*, the *Examiner* was a big-city paper, and no one in Washington would know its editions or circulation.

On March 19, 1984, Interior Secretary William Clark replied to several questions Congresswoman Sala Burton had submitted to him through the House Interior Committee. Concerning Duck Cove, Clark wrote:

There is no legal basis for extending a period of occupancy once the contract providing for it has been fulfilled. In the case in question, however, a separate 10-year term to commence at the expiration of the 40-year reservation was being considered under the Secretary's au-

thority to exchange lands and interests therein for other lands needed for park purposes. Although such exchanges are authorized, we will not engage in them unless they are clearly in the Government's best interests. Having considered all aspects of the case in question at Point Reyes, we have elected not to proceed and have so notified the party involved. The proposals at Apostle Islands and Fire Island have likewise been declined.

The decision by Secretary Clark was important not just for the resolution of the Duck Cove issue itself but also for the repercussions it had for other areas in the GGNRA and for other national parks. In the 1990s, rights of use and occupancy gradually expired on nearly all the small houses included in the GGNRA—fewer than thirty—in Tocaloma, Jewell, the Olema Valley, Stinson Beach, and near Muir Beach. Few owners had chosen a "life estate." The Park Service had paid fair market value for these inholdings in the mid-1970s, but residents of Jewell and Tocaloma accused the agency of heartlessly destroying their communities when told that their time was up. The *Point Reyes Light* backed the dozen unhappy residents. Other inholders generally left without incident. If Interior Secretary Clark had not responded as he did to the Duck Cove proposal, there would have been precedent for the residents or their successors to perpetuate the inholdings, preventing the park-related uses of their buildings and land. Similar expirations are gradually occurring at Point Reyes, generally without incident. Houses in good condition become park employees' housing or serve other park purposes; those in poor condition and with no historic value are demolished.

DEFENDING EAST FORT MILEY

Protecting the park from inappropriate uses, such as hunting, mountain biking in wilderness areas, and large-scale events in natural areas, where some or all of the battle could be fought in public and with the help of the CAC, was easier than protecting it from two ever-looming federal agencies, the Army and the Veterans Administration. The Presidio was a beloved Army post, and the Veterans Administration Medical Center (VAMC) had been using part of East Fort Miley for years before it was included in the park. Both agencies were determined to hold onto as much land as they could. But while the Presidio brass had shepherded Bill Whalen like a protective big brother, VAMC bullies waited behind the trees for the new kid on the block. At East Fort Miley—the starting place of the park, and the site of the never-built archives of 1970—PFGGNRA waged a

twenty-year battle with the neighboring VAMC over land the VAMC wanted to use for parking and expansion. Since "fellow federal agencies" avoid infighting, our battle on behalf of the park was also a battle on behalf of the Park Service, and it became a case study in park defense.

The first incident with the VAMC came in 1973 during the park's infancy, at a historic bunker in West Fort Miley, the first property formally transferred to the Golden Gate National Recreation Area.[7] The Park Service planner Doug Cornell visited the 2.4-acre site on its first Sunday in the park—and found piles of construction rubble and hospital refuse. Doug phoned me on Monday. I walked up the hill to see and phoned Bill Thomas at the *Chronicle* for advice. Bill chuckled and said he'd have a photographer meet me in an hour. On March 20, 1973, the paper had a page-three photo of me standing amid debris under the headline "Park Site Used for Landfill." Bill's vividly descriptive article (without a byline) told of the GGNRA's first acquisition, and how the VAMC was abusing it. Bill Whalen said we had probably bought him six trouble-free months with the VAMC. He was right, and six months was all he got.

In 1974 the VAMC asked to use the East Fort Miley parking lot temporarily for cars displaced by construction projects. Bill Whalen said OK—but more projects followed. When Bill became the director of the National Park Service in 1977, over ninety cars parked there every day. All of us who had fought for that land stared unhappily at the parking lot. We pleaded in vain with the new GGNRA acting superintendent, Jerry Schober, to remove the concrete pad beyond the area the VAMC was using. Hence when the VAMC proposed annexing the parking lot, Jerry asked three of us to come to a meeting and help stop the land grab. We needed little encouragement to be obnoxious to the hospital director so that Jerry could appear reasonable. We told the VAMC we would not trade a park for a parking lot: its staff should restripe its own lots for more cars and should use car pools and public transit. The VAMC dropped the land transfer idea, but more cars came to the lot.

Sometime after Lynn Thompson became the GGNRA superintendent in 1978, we asked Phil Burton to get the lot closed, but his brother was now the district's congressman. Protective of John, Phil asked Margot Patterson Doss to tell us "there are more veterans than conservationists." More time went by. When the next GGNRA superintendent, Jack Davis, had a dental appointment his first morning on the job early in 1982, five Park Service employees commandeered a bulldozer and ripped up half the lot's cement before they were stopped. No one was punished. I learned about it when someone on John Burton's staff phoned to yell at me. The GGNRA did not repair the lot, but it soon filled anyway to its 225-car capacity.

The VAMC announced plans to build a 200-bed nursing home in the spring of 1979. One neighbor said, "If anyone deserves the great view from Fort Miley, it's the veterans"—but it also meant more cars. Federal construction projects must try to be consistent with state and local development codes and regulations. The California Coastal Commission staff said the building was consistent, but Michael Fischer, now the commission's executive director, said land in the coastal zone would be badly affected by the increased parking deficit. At the commission's federal consistency determination hearing, park activists turned out in force. The VAMC's representative could not answer any questions. The commission determined the new building would not meet consistency requirements.

In 1981 PFGGNRA asked Alan Cranston, chair of the Senate Veterans Affairs Committee, to look into building a parking garage for the VAMC. The San Francisco Board of Supervisors and the Park Service supported our request. After a few years, Senator Cranston got a $4 million appropriation. The VAMC's director said that would buy a two-story, 200-car garage. I told this to San Francisco supervisor Bill Maher's aide; Stephanie phoned the head of the city's Department of Parking and Traffic. He said that for that amount of money, on free land, every stall ought to be paved with gold. I passed on that message to Senator Cranston. He told the VAMC to bid a four-story, 430-car garage.

In 1984 Congressman Edward P. Boland (D-MA) inserted a provision into an appropriations bill to give 6 to 12 acres of East Fort Miley to the VAMC. Ohio congressman John Seiberling came to the fort's aid. During House debate, Seiberling called a point of order against the provision because it constituted legislation in an appropriations bill, in violation of a House rule. Boland had to concede the point of order. Congresswoman Sala Burton soon announced that the VAMC could extend its lease on the parking lot for five years. She hoped the hospital would seek a four-story garage.[8] On the promise of a garage, the VAMC was able to build the nursing home, but when the garage opened in April 1991, the parking lot stayed open. The VAMC now said it needed both of them.

Returning from a trip a few weeks later, George and I got into an airport van. Two men joined us; one told the driver to take him to the VAMC. I asked if he were on the staff. "I am Larry Stewart," he puffed, "director of the hospital." "I am Amy Meyer," I glowered. We stared grimly at each other—and talked. At last, Stewart declared, "I'm not going to close that parking lot. If your superintendent wants it closed, he will have to close it." Back home, I went directly to the phone. Brian O'Neill was now the GGNRA's superintendent. I told him what Stewart had said. Brian

said they would be meeting in a few days. I called a half-dozen people—some had been involved for seventeen years—after I learned the date and time. The morning of the meeting, each one phoned Brian near 7 A.M., his usual time of arrival at work. None got past the receptionist, but all sent the message that they knew about the big meeting and were counting on him. Brian called later in the day to say the lot would close on July 11.

Because of topography, autos must enter the fort through the hospital's grounds. On July 10, after notices were posted at the entry to the lot, a ranger asked me to come see two stakes, between which the VAMC intended to place a gate to close the auto entrance. A gate would also cut off the U.S. Park Police unit stationed in the fort's bunkers. The scandalized ranger covered his face as I pulled one of the stakes out of its wet cement base and tossed it in the bushes. The VAMC did not finish the gate.

After the closure, a park crew removed the lot's remaining paving, covered the area with dirt, and seeded it in late fall, when rain could be expected. In the spring, a few scraggly lupines came up. I complained. Park staff were too busy to look. Another winter's rains. Spring. It was now 1993, and the place looked like the remains of an urban gas station. I insisted Doug Nadeau visit. He groaned, walked over to a lupine, and pulled it out of the ground. Its root was L-shaped. "They didn't remove the lot's base course," he said. He left. Months passed. Nothing changed.

Meanwhile, the VAMC administrators were fuming. This was not a park. Why had they been forced to give up their parking lot? The 1989 Loma Prieta earthquake had damaged the VA hospital in Martinez, California, and its patients were using the Fort Miley hospital. People for blocks around were angry because staff and patients parked all over the neighborhood.

Larry Stewart went to Senator Barbara Boxer to protest the loss of the parking lot, and a member of her staff called Brian for a meeting. He asked me to come with him. I agreed, but beforehand I called the new deputy superintendent, Len McKenzie, and suggested getting the site bulldozed so that no one would ever again think of it as a parking lot. Then I went with Brian to meet with the senator's aide. The public had understood that the VAMC garage replaced the parking lot, I said. The land belonged to the park and everyone who had fought for it would be furious with Senator Boxer if she tried to reopen the lot. The GGNRA had started there twenty years ago. The VAMC would have to live within its means, and it would have to respect the park. The meeting ended well. Soon afterward Len McKenzie sent out a bulldozer to contour the lot. Gardeners reseeded it and it flourished.

THE PRESIDIO POST OFFICE LAWSUIT

The law authorizing the Golden Gate National Recreation Area at the end of 1972 did not please the Department of the Army or most of the Army command at the Presidio. The Presidio remained an active Army post, but it gave up 145 acres, and the legislation also stipulated that any Presidio buildings had to serve essential Army missions. Any area the Army did not need was to be transferred to the Park Service. The secretary of the army also had to consult the secretary of the interior about new construction on unbuilt open space.[9]

Resenting the loss of some of its land and control, and fearing worse in the future, the Army seemed resolved not only to protect what it still had but also to assert its authority over its use of the Presidio.[10] The first sign of this attitude came in 1973, when the Army constructed its new Mason Street without consultation. When we saw the paving, we realized it would be hard to challenge a street realignment but we did not forget it, and five years later this incident helped lead to a change in the GGNRA's legislation.

An amendment in Phil Burton's 1978 omnibus parks bill gave the Presidio more protection. A new building could only replace a demolished one and could be no larger. There also had to be a public hearing. Known popularly as the "one up, one down" provision, this amendment was to keep the Presidio from use as ordinary real estate, and to keep its open space intact.[11] But starting in 1983, when military budgets were significantly increased during the Reagan administration, the Army willfully ignored this section of the park's legislation.

The Army Breaks the Law

Although we informally reviewed plans for new Presidio buildings every year, Presidio-watchers in 1983 were somewhat complacent because for over ten years Congress had given the Army little money for new construction. We also expected "one up, one down" to protect the Presidio.

But then the Army began to plan what it only much later labeled "a one-stop shopping center" for its half of Crissy Field. In June 1983, post commander Eugene Hawkins told the advisory commission that the Army needed a 9,000-square-foot replacement for the Presidio's small post office, an "internal sorting space for Presidio mail—and I underlined the word 'Presidio.'" The post office was to be next to Doyle Drive, an ugly part of Highway 101 that crosses the Presidio. Commissioners asked questions and protested. Park staff said nothing. Superintendent Jack Davis wrote to

Hawkins in July. He asked that parking for jeeps be minimized and asserted, "We do not feel that the project will adversely affect open space or natural values." A draft environmental assessment was not distributed.[12] In September the Army showed the commission plans for a new commissary.

Over a year later the Army presented a five-year construction program that included barracks and a child-care center, saying it was "banking" building demolition credits. Again, park staff said nothing. At the same commission meeting, the Army representative made a one-sentence remark about the post office: it would be built several hundred feet closer to San Francisco Bay than originally planned.

The move toward the bay brought the post office building away from Doyle Drive and into the open. Construction began in August 1985. In September Margaret Moore, a Presidio neighbor out walking her dogs, saw the concrete pad and phoned me. I told her I saw no way to oppose the project. Margaret laughed when I told her about the Presidio's too-small post office: that was where neighbors mailed Christmas packages because there were no lines.

A Call to Action

It took two newspaper reporters to expose the depth of the Army's deception. Gerald Adams's October 9, 1985, story, inspired by a $5 million marsh restoration project for Crissy Field, revealed that "the marshland construction would coincide with a $100 million Army building program—the first Presidio expansion in years." A Burger King restaurant "to be located within a few hundred yards of the new lagoon" (at the park's fence line), a 26,000-square-foot expansion of the post exchange, a convenience shop, a post office, and an 86,000-square-foot commissary and warehouse would also be in "the suburban-style shopping complex." Two barracks, a child-care center, and a bowling alley would be constructed elsewhere. Dale Champion reported that there was a plan to transform "1.5 miles of San Francisco's most scenic bay shore into a grand mixture of sandy beaches and dunes, greenery and lagoons," and that in planning the adjacent area the Army was concerned about an acceptable Burger King design.[13]

In the ensuing public uproar, conservation, civic, and neighborhood organizations—and a few anonymous people who seemed to know the Army well—sent letters to the editor and to anyone in power they thought could help. Susan Kennedy, formerly an aide to Phil Burton who now worked for Sala Burton, phoned me. "Phil is rolling in his grave," she declared. "I'll bet they plan to close the Marina District post office near the Presidio."

PFGGNRA obviously had to do something. We needed all the facts and we needed a lawyer. The Sierra Club activist John Hooper volunteered to help get the facts. Ed Wayburn was the Sierra Club's vice president for national parks. He said the club should be the client for a lawsuit rather than our ad hoc PFGGNRA group, and we should phone the Sierra Club Legal Defense Fund (SCLDF).[14] The SCLDF lawyer Deborah Reames went out to look at the concrete pad—and said we were too late. We had not made a timely legal challenge and failed to stop the project before significant construction took place.

But then Deborah, John, and I met with others at the SCLDF office. The Army had declared that by "banking" previous building removals, they had met the "one up, one down" requirement, but the law did not provide for "banking." Susan Kennedy's hunch was valuable: if this was a regional post office, it meant the land was excess to Army needs—and had to be given to the Park Service. Moreover, the public hearing for the project had not been meaningful: the building program had been explained piecemeal with no presentation of cumulative impacts, no environmental assessment had been circulated, and the program required a full environmental impact statement. Legal action was possible.

Sala Burton sent letters to Army Secretary John O. Marsh, Jr., and Interior Secretary Donald Hodel protesting that "Congress was very specific in its intent to limit development." A few weeks later, she announced that the Army had suspended plans for its $100 million building program, and that she would meet on the Presidio with the new post commander, Colonel Robert Rose, and an Army deputy assistant secretary, Michael Owen, on November 15.[15] Kevin Shelley was working for Sala Burton and took me into the meeting room. The congresswoman responded positively only to the improved child-care center in the Army's seductively attractive dog-and-pony slide show. An officer protested that they could not build what was needed under the "one up, one down" law for the park. Michael Owen seemed to get the message. He loudly declared, "That is the law, sir, and the law must be obeyed."

There was a public rally five days later before the advisory commission. A score of witnesses testified against the Army's plans. Kevin Shelley said that if the Crissy Field project was not put on hold, Sala Burton would exercise a "potent option"—asking for a congressional oversight hearing on the post office and the other building plans.[16]

Two days later, the House Armed Services Committee member Dan Daniel (D-VA) sent a letter to Sala to tell her that an $8.2 million commissary, a $2 million bowling center addition, a $4.1 million shopping center, and a $510,000 post exchange had been approved for construction

on the Presidio with nonappropriated funds—that is, the funding would come from profits generated by commissaries, bowling centers, and similar Army facilities. On November 26, Secretary Marsh told the SCLDF attorneys, "To my knowledge, the requirements of the legislation . . . have been fulfilled." Having heard that the barracks would be 35 feet from the Crissy Field fence line, a few of us checked out the site. Red-tipped stakes showed that one large building would be next to the boundary fence. The Army was again staking its claim to limit park expansion at Crissy Field, with the barracks and the post office at the eastern and western ends. Construction of the post office continued.

It wasn't until we read the *San Francisco Chronicle* on January 8, 1986, that we learned that two outside lawyers had understood our complaint. The Army's own judge advocate at the Presidio found that "the Army and U.S. Postal Service moved the site of the new post office 400 feet without public notice and did not properly assess the environmental impact of the project"—these were National Environmental Policy Act violations. And Sala Burton had asked the Library of Congress for help: the article also reported that attorney Pamela Baldwin of the American Law Division of the Library of Congress had said "most of the Presidio's building project violates 1978 amendments to the law that created the Golden Gate National Recreation Area." The article noted Sala Burton's announcement of a congressional oversight committee hearing in San Francisco in the spring, and Deborah Reames's statement that her client "is seriously considering" a lawsuit.[17]

Deborah worked on the lawsuit while John Hooper, Margaret Moore, Margaret's friend Ann Fogelberg, and I informed and involved more local supporters for wherever we'd need them—and especially for the oversight hearing. On January 15, Congresswoman Barbara Boxer wrote to Secretary Marsh, branding the Army "deceitful" and the Presidio command "willful and unresponsive" to the public outcry.[18] On the same day, Deborah Reames wrote to tell Secretary Marsh that the Sierra Club intended to file a lawsuit.

The Devil's in the Details

Deborah filed suit on January 31, 1986. As we walked to lunch I asked, "What happens next?" "There's a panel of fifteen judges," she told me. "Three on the panel would be better ones for this case. The one I really want is [U.S. District Judge] William Schwarzer." Soon after, we learned that Judge Schwarzer would hear our case.

John Jacobs woke me up the next Sunday morning, after his run along Crissy Field. Did I

know that carpenters were working on the post office that morning at 7:30? I phoned Deborah. When I got to her office on Monday, she was arguing with Ed Wayburn on the phone. The suit was intended to halt the $100 million Army building program, but now Deborah felt the case was good enough also to sue over the post office. Her fiancé was in the construction business and said she should do it before the steel framing went up—a matter of days. Ed feared Deborah might lose the whole thing if she included the post office. She persisted—and convinced him.

Deborah amended the Sierra Club's complaint to stop completion of the post office. On February 6, she asked for a temporary restraining order. The court heard the argument and granted her request on February 13, when she submitted a memo calling for both a temporary restraining order and a preliminary injunction. Her devastating memo declared that the post office would be tripled in size, that its size clearly exceeded current Army needs, that the project was being funded entirely by the Postal Service, that the workforce would increase five-fold and the number of jeeps fifteen-fold, that it was located without respect for the national park or consideration of alternative sites, and that there had been no meaningful public involvement. The Sierra Club had tried to get the Army to stop, and the Army only pretended to consider stopping construction. The legal issues could be sorted out fairly only if construction stopped. As he issued the restraining order on February 13, Judge Schwarzer agreed with every argument Deborah had made; on February 14 he said he would issue a preliminary injunction.[19]

Some weeks later, the judge asked Deborah and me to accompany him on a bus trip to the building sites. He obviously knew the Presidio very well. At each stop an Army officer explained a proposed project. I especially remember two stops: at the first, the officer said that Old Mason Street would be dead-ended next to the new commissary. Judge Schwarzer snapped that this meant all Presidio through-traffic near the bay shore would be forced onto the new Mason Street next to the Crissy Field park boundary. And at the second, the barracks site, the officer waved his hand toward the general area. I showed the judge the stakes and how the building's edge would line up with the boundary fence. The judge let us know he saw how the Army's building program barricaded the park between the post office and the barracks along the length of the dividing fence.

Congress Provides Oversight

On March 27, 1986, Congressman Bruce Vento, a former schoolteacher and a Phil Burton protégé, conducted an oversight hearing in the park headquarters public meeting room (figure 37).

Figure 37. *On Site:* When the Army illegally attempted to build a regional post office on Crissy Field in 1985, citizen-activists stopped the construction. The day before a congressional oversight hearing in March 1986, the Park Service took Congressman Bruce Vento, the House National Parks Subcommittee chair, and some of the activists to view the project site. Here the congressman (arm extended) looks down on the partially built structure that was eventually cleared away. (Tom Levy, *San Francisco Chronicle*, March 26, 1986; detail.)

He immediately made it clear that he found both the Army and the Park Service at fault because they failed to uphold an unambiguous law. As he questioned witnesses, their testimony led to an inevitable conclusion.

Sala Burton said the park legislation was intended to open lands to the public and phase out uses inconsistent with the GGNRA. Mayor Dianne Feinstein offered to mediate, but Vento bluntly responded that the city was in a "growth mode," that its economic vitality put pressure on immensely valuable open space, and that people were pretending the GGNRA didn't exist.

Army deputy assistant secretary Owen threatened to consider reducing the Army's mission. Colonel Rose said it was impossible for the Army to operate within the letter of the law. Vento

bristled. "You thought the law wasn't workable but sought no redress? Did you write to your superiors?" And, he asked, did "public hearing" mean "discuss without notice"? He said the 1978 legislation amendment should have had "a dramatic effect" on construction. Park Service representatives had to admit they had not consulted their solicitor, that their search for coordination was not in keeping with the law, that public concerns had not been recognized, and that plans for specific projects had to come before the public.

The retired general Stanley R. Larsen complained, "The Army can't go through this every time they want to build a pipsqueak building." Vento reminded him, "the land is in a national park." Perhaps they should tear down some historic buildings, Larsen said. Vento retorted, "How about redesigning a historic building for a post office? Follow the law; it's the pattern for the future." I was one of the large group of witnesses from the general public that opposed the Army construction.

At the conclusion of the hearing Sala said, "I found the Army wouldn't budge. . . . So now we have a different situation. I say the post office must go." Congressman Vento added that he could not foresee "a resolution of the issues regarding the Army's construction program with the post office remaining."[20]

Vindication

The settlement agreement was signed on July 16, 1986. Since the Park Service could not use the post office, the Postal Service and Army would remove all aboveground construction and concrete and restore the site. If the Army later wanted to move its post office, it would have to do so in accordance with the park's legislation and environmental law. A new commissary could be erected, followed by removal of four old commissary buildings. There would be no Burger King. Barracks, the bowling alley, and some other buildings could be constructed, but some sites would be adjusted. Old Mason Street would remain a through street. Only the child-care center could be built immediately. The Army would consult with an Interior Department representative and have a full hearing for each project. Notification for each hearing would clearly describe the project and its relationship to the Army's Presidio missions, state what would be demolished, include a map, and give environmental documentation, a fact sheet, and drawings. For Army projects, the advisory commission would sit at the table but the GGNRA superintendent would convene the public hearing. On October 6, 125 people came for a tour and the first hearing.

In November a community assistance team from the American Society of Landscape Architects took the Presidio as its subject and shared its study report with everyone. Tito Patri, chair of the society's design committee, said, "the study is intended to provide a framework for 'cooperative land-use decision making.'" The Army began construction of the buildings permitted by the court decision. Dissatisfied with the height of the proposed new commissary building, the San Francisco Planning Commission had the Army place a cherry-picker crane at the height of the roofline to check how much it blocked out Presidio views. They shared their photomontages with park staff and the advisory commission and made a spirited personal appeal to the Presidio post commander. The Army, under protest, lowered the roofline by five feet.[21]

Deborah Reames and I pursued the restoration of the post office site for three years because the Army refused to allocate the necessary funding. Deborah finally wrote to the Army's Forces Command in Georgia and told them she would take the matter back to court. The money became available soon afterward.

11

SAFE HARBOR FOR OLD SHIPS

In 1976 the long-held hopes of Bill Thomas and Harry Dring seemed realized when the State of California and the City of San Francisco transferred their holdings in the California State Historic Maritime Park and San Francisco's Maritime Museum to the Golden Gate National Recreation Area. The ships and museum fit well in the GGNRA: from the Aquatic Park site of the museum or the nearby piers at which the ships are moored, Alcatraz is a scant mile and a quarter out in the bay, Fort Mason is next door, and the maritime stories embodied by the historic ships are indissolubly linked to the Golden Gate.

Yet it gradually became evident that this maritime unit of the GGNRA—unlike the redwood forest of Muir Woods National Monument and the red-brick Fort Point National Historic Site—was no better off than a poor relation within the GGNRA's big land-based park family. The maritime unit acquired more ships for its collection during its twelve years in the GGNRA, but it did not flourish.

In 1988 Congress separated this maritime corner from the GGNRA, named it the San Francisco Maritime National Historical Park, and gave the new park its own superintendent, staff, and budget. As a separate park, it has attracted more visitors and better funding. Today the maritime national park includes the 1939 Aquatic Park National Historic Landmark District, exhibits six national historic landmark vessels dating from 1886, and has several vessels and structures listed on the National Register of Historic Places as well as over 130 historic small watercraft. Park headquarters and a 32,000-volume library are located in National Historic Landmark Building E in Fort Mason Center, and the 1909 National Register Haslett Warehouse houses the Argonaut Hotel and a visitor center. Artifacts, ships' models, photographs, and art are displayed in the former city museum building at the foot of Polk Street.

THE GOLDEN GATE'S MARITIME HERITAGE

For centuries, boats and ships were the best means of transportation around San Francisco Bay. Native Americans were the first to navigate the bay's cold waters and its tributary creeks and rivers. In the late 1700s and early 1800s, European captains sailed through the Golden Gate and explored the bay, as Mexican settlers came overland from Sonora. Russians and Aleuts ventured down from Alaska to hunt sea otters and fur seals. The region was far from the home countries of these pioneers, and until the mid-nineteenth century only a few settled permanently along the Northern California coast and on the shores of the bay. New England whaling ships began to visit San Francisco in the 1820s, after seasons in the Arctic whale fisheries. Richard Henry Dana visited in 1835 and described the city as a quiet outpost in *Two Years Before the Mast*.

After word of a gold strike reached the East Coast, men joined what became the gold rush of 1849 and headed by ship to California. During the gold rush, thousands of sailing ships brought prospectors, adventurers, and merchants through the Golden Gate. Ship crews abandoned their vessels in Yerba Buena Cove on San Francisco's eastern shore and outfitted themselves with gear and clothes for mining. River steamers brought the miners to Sacramento and Stockton, closer to the foothills of the Sierra Nevada where they panned for gold. Soon women and families also crossed the isthmus of Panama or sailed around Cape Horn, and a new American state got under way. In 1860 Dana visited again and found a bustling city. By this time, the city had filled in Yerba Buena cove, burying abandoned vessels under piers, warehouses, and the flat streets of today's financial district, where streets named Front and Custom House Place tell the story.

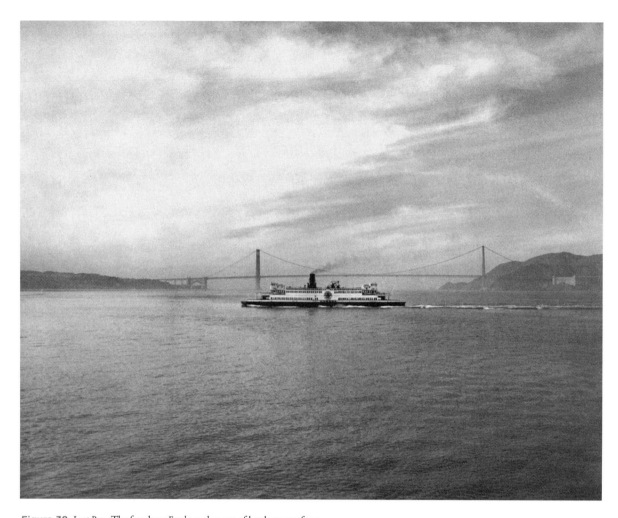

Figure 38. *Last Run:* The ferryboat *Eureka* makes one of her last runs from Sausalito to San Francisco in February 1941. The Golden Gate Bridge made automobile ferries obsolete. Today the *Eureka* is berthed at the Hyde Street Pier in the maritime national historical park. (Courtesy San Francisco Maritime National Historical Park Archives, Bruce Herriges Collection, P90-006.4n.)

Big, fast ships with masses of square sails—Yankee clipper ships from New England and other square-riggers from England, northern Europe, and elsewhere—came to the port beginning in the 1840s. For thirty years they brought in European goods and coal and transported California wheat to the other side of the world. When the grain trade declined, the square-riggers carried goods across the Pacific, and after World War I some of these ships were modified to serve the coastal trade of the Alaska fisheries. Numerous sailing vessels also carried northern coast lumber to San Francisco. From the 1860s until the 1930s, passenger steamers plied scheduled routes between Seattle and San Diego. On the bay, scow schooners similar to barges hauled bricks, lumber, baled hay, and other bulk cargo, and ferries carried rail cars—and later autos—as well as passengers.

After the golden spike joined the two parts of the transcontinental railroad in 1869, San Francisco's processors and merchants could ship whale products directly to eastern markets. By 1875 the city was American whalers' largest home port. Local fishermen made a good livelihood from the varied fish of San Francisco Bay. Many came from countries around the Mediterranean and used small traditional European boats to harvest salmon, rockfish, and crab. Sailboats harvested the plentiful Sacramento River salmon runs.

A depot for freight and for railroad and ferry passengers was constructed in 1875 on the San Francisco shore, and in 1898 it was replaced by the Ferry Building at the foot of Market Street.[1] Repairing the damage of San Francisco's 1906 earthquake required shiploads of lumber. When the Panama Canal opened in 1914, vessels no longer had to go around Cape Horn and transcontinental shipping could compete effectively with railroad transportation. Shipbuilding for the merchant fleet was briefly renewed during and after World War I.

Sadly, soon after, San Francisco's glorious era of local and trans-Pacific trade and transportation—and of shipbuilding—came to an end. Ferry service began a steady decline when the Bay Bridge and the Golden Gate Bridge opened in the 1930s. Cars and trucks supplanted many of the bay vessels. In 1958 the last of the old-time ferries crossed the bay to San Francisco from Berkeley (figure 38). More and more ships were built abroad, and the shipbuilding industry disappeared from San Francisco in 1955.

The Port of San Francisco is isolated on a peninsula and not efficiently connected to the rail lines of the continent. Its finger piers are not suited to modern container cargoes. The city's port declined, while the ports of Oakland and Richmond across the bay, whose geography permits container ships to anchor alongside the shore and allows easy access to the transcontinental railroad

system, were favored by shipping lines. Other West Coast ports attracted more business, and many goods began to be shipped by air.

SAVING MARITIME HISTORY

The city museum of maritime history and the state collection of historic ships had their beginnings on the northern waterfront of San Francisco shortly after World War II, more than twenty years before anyone thought of a Golden Gate National Recreation Area. They were founded with the sort of civic pride and pleasure that led to the GGNRA, but they evolved rather differently.

In the late 1940s the sailor and self-taught maritime historian Karl Kortum had his eye on a collection of ship models owned by socially prominent Alma de Bretteville Spreckels. The collection had been exhibited on Treasure Island until World War II; since then it had languished in a warehouse.

Karl wanted the collection to start a museum; the perfect location, he thought, was a little-used recreation building in Aquatic Park. During the Depression of the 1930s, the Works Progress Administration had selected Aquatic Park as a public-works improvement site and in 1939 built a $1.8 million casino, designed in the streamline-moderne style. The great white building stands like a luxury liner moored on the land; it even has wind scoops on the roof. Every opportunity for architectural embellishment with nautical motifs was exploited on its exterior and interior. Greenish slate carvings by Sargent Johnson decorate the entrance and the murals of undersea life in the lobby are by Hilaire Hiler. The building is flanked by two large bleachers, beyond which are two tall streamlined loudspeaker holders. The bleachers were constructed so that spectators could watch swimming meets and sunbathe, but the five thousand planned-for swimmers never came. The waters of Northern California are too cold for most people, and only a few hardy souls swim in the bay.

Karl called on the *San Francisco Chronicle* editor Scott Newhall, who brought in the publishers of San Francisco's other major newspapers. They gathered a group of prominent citizens—including Admiral Chester Nimitz, *San Francisco Examiner* publisher William Randolph Hearst, Sailors Union of the Pacific president Harry Lundeberg, and Bank of America president A. P. Giannini—to become directors of the new San Francisco Maritime Museum Association.

Dave Nelson, who worked for the *Chronicle* at this time and is the last of the original directors of this organization, told me of its accomplishments.[2] Dave was instrumental in convincing Alma Spreckels to donate the collection of models. "We tied our boat to Alma's yacht," he told me. He

visited Mrs. Spreckels several times in her Pacific Heights mansion, where, he said, "she greeted me in an elegant dressing gown, with a diamond pin as big as your fist, and those little fuzzy-wuzzy slippers." Dave's persuasive talents were backed by the charming Scott Newhall, and Alma Spreckels donated her collection to start the museum.

The City of San Francisco permitted the museum association to use the Aquatic Park Casino, and Karl Kortum became its chief curator. On opening day in 1951, 150,000 people crowded into the new museum to view exhibits of ship models and carved figureheads of farseeing men and buxom women from clipper ships such as the *Davy Crockett* and *Lord Clive*.

In 1950 the association had learned that the square-rigged 1886 Cape Horn sailing ship *Balclutha* was lying in the mudflats in Sausalito. A board member underwrote a note for $25,000 to buy the ship, and his colleagues each pledged $1,000 in case the venture failed. What happened next was "the most remarkable community effort since the City's four papers were printed on one press after the fire and quake in '06."[3] Eighteen labor unions donated 150,000 hours, and businesses donated $100,000 in goods and services for the ship's rehabilitation. In 1955 tugboats nudged the *Balclutha* into her place at Pier 43. Her return made several national newspapers, the *Times* of London, and even the cover of the *Saturday Evening Post*. The association earned nearly $100,000 in ticket sales that year, which paid all the bills for the ship and the museum.

The association wanted more historic ships to be on display at the nearby Hyde Street Pier. After much political persuasion, the California State Parks Commission agreed to establish a small historic fleet. It acquired the *C. A. Thayer*—the last commercial sailing ship to operate from a West Coast U.S. port—and the steam schooner *Wapama*, as well as the nearby 1909 red-brick Haslett Warehouse. The museum association gave the park commission the 1890 side-wheel ferry *Eureka*, which carried passengers and autos on San Francisco Bay from 1922 to 1941. When the Hyde Street Pier exhibits opened in 1962, five ships were there at anchor. Later the state added the 1891 scow schooner *Alma*, typical of the boats that carried bulk cargo down the rivers into San Francisco Bay.[4] In 1970 the association acquired an English tug, the *Eppleton Hall*, similar to the ones that towed ships in San Francisco Bay during the gold rush. The state also acquired smaller ships and artifacts. Karl Kortum's boyhood friend Harry Dring, who until that time had been in charge of the *Balclutha*, managed the state park.

Meanwhile, Karl, a prodigious collector, amassed a great many artifacts, maps, paintings, and photographs for the city museum. For lack of storage space and staff to accession the collections, many of Karl's objects were stashed in the changing rooms under the Aquatic Park bleachers.

Buying the ships is the least costly part of operating a maritime historical park. Shipwrights have to plan their restoration and maintenance; volunteers can assist only under skilled professional direction. Ongoing preventive maintenance is all-important. The San Francisco–based association and the state could not fund the ships' expensive ongoing needs. When Harry Dring prodded Bill Thomas to ask Congressman Phil Burton for help and Dave Nelson agreed, Phil included both the state and city maritime museums in the GGNRA.

In September 1976 the *Chronicle* announced that all city and state park properties around Aquatic Park would come under national park management by year's end.[5] The state, the city, and the association gave the federal government all their maritime assets. Harry Dring became conservator of ships and Karl Kortum became curator of collections. The state's skilled shipwrights became federal employees. Glennie Wahl, a conscientious historian, became area manager. She was dismayed by the uncataloged agglomeration of artifacts under the park bleachers.

The City of San Francisco parkland leased by three swimming and rowing clubs near Aquatic Park was included in the GGNRA as well. In 1976 the clubs' proposed transfer to the GGNRA appeared as an agenda item before the city's Parks and Recreation Commission, to which I had been appointed by Mayor George Moscone. Club directors asked the commission not to transfer their facilities to the Park Service because they didn't want inexperienced members of the public using their finely crafted wooden boats. They said that the clubs were open and democratic, not wealthy or exclusive. However, a group of women reminded the commission that the clubs were democratic for men alone. The men on the Recreation and Park Commission wanted to be forced to make the change, so the group of women took the matter to court and won. The commission decided not to cede the area to the GGNRA but had to comply with the court decision. The clubs had to accept women and permit the public to use their facilities. Rather than integrate or admit the public, the San Francisco Rowing Club closed. The Dolphin Swimming and Boating Club and the South End Rowing Club added space to provide changing rooms and lockers for women members and the general public. The clubs charge a daily fee for people who want to change clothes there for a swim in the bay.

MORE SHIPS

Three more historic ships were acquired for public display between 1972 and 1976. The 1907 steam tug *Hercules* had worked on the bay and along the West Coast for fifty-five years. The owner, John Seaborne, loaned her to the Maritime State Historic Park in 1972. In 1974 he wanted to sell her and claimed she was worth $35,000 to $40,000; he asked for $30,000.

Bill Thomas and Harry Dring were desperate to keep the *Hercules* from sinking or being sold for scrap. Bill asked me to help. I could think of nothing and no one until I met Dick Jordan. A would-be sailor of wooden ships and newly minted lawyer stuck between finding out whether he had passed his bar exam and getting a job, Dick offered to help.

Harry cursed and plotted in the museum's wheelhouse office on the ferryboat *Eureka* while Dick held Harry's cat in his lap. Dick composed a paper extolling the historic value of the ship: "She guided sailing ships safely through the Golden Gate, towed locks to Central America for the Panama Canal, and brought massive log booms down from Seattle." The paper was sent to everyone they thought could find political support or cash.[6] Congressman John Burton asked the California State Parks director, William Penn Mott, for help. Mott wrote that he was getting an appraisal. Seaborne said he would settle for $27,000—if he were paid before July 1. But Mott expected the ships to be transferred to the national park, so he wanted the federal government to buy the *Hercules*. The state offered $18,000; the ship's scrap value was $15,000. Harry got the owner of each scrap yard on the bay to promise not to take the *Hercules*. Seaborne raised the price by $1,000 each week.

In March 1975 John Burton announced that the ship had been listed on the National Register of Historic Places, as "one of the most significant ships in the early history of Bay Area maritime commerce." In September 1975 I learned that the State Parks Foundation had acquired the *Hercules* for $32,000. The Crowley Maritime Corporation's tug *Sea Scout* towed "the venerable *Hercules*, lacking her own steam power, across the bay" to drydock. The corporation also contributed $45,000 to refurbish her. Dick had a celebratory lunch with Bill and Harry.[7]

The second ship was the submarine *Pampanito*, acquired by the park association in 1976 when the Navy decided to scrap all of its World War II submarines. The park association restored her, berthed her at Pier 45, and charged admission. This income now pays for the *Pampanito*'s maintenance and some of its public programs.

In 1976 the *Jeremiah O'Brien* steamed down from the Suisun Bay's "mothball fleet" north of San Francisco to San Francisco drydock. I was one of several members of the Citizens' Advisory Com-

mission who joined local dignitaries aboard the vessel. She is the sole intact survivor of the 2,751 Liberty ships built during World War II. Many of these ships sailed from Fort Mason for the World War II Pacific theater. The National Liberty Ship Memorial preserved the *Jeremiah O'Brien* with the help of a crew of volunteers and now operates and maintains her.[8]

A SEPARATE PARK

The cost of keeping up the historic ships loomed very large in the GGNRA's budget. In his 1978 national parks omnibus bill, Phil Burton provided special funds for the historic ships: income from a few park properties, the biggest of which was the Cliff House restaurant, would stay in the park rather than being sent to the U.S. Treasury, and some of the money would be used to take care of the ships. This eased the shortfall but was insufficient. Collections were still uncataloged, and the ships still received insufficient care. When the *C. A. Thayer* was towed across the bay to an Oakland drydock for replacement of rotted timbers, park staff were concerned that she might sink between the tugboats that pulled her. Harry Dring died in 1986, deeply disappointed about the condition of the ships.[9]

One night I joined a group of parents and teachers on the *C. A. Thayer* for an overnight visit by a grade school class. The bay's waters seemed calm. After my time on the midnight watch, I got into my below-deck bunk—and frantically gripped its sides to keep my nylon sleeping bag from sailing off the hay mattress while the anchored ship pitched and rolled. I'd heard that the ships often sustained damage during storms—and now I could see why. Soon after, Congresswoman Sala Burton obtained funding for a breakwater to buffer the ships from the bay's swells.

In 1986 Bill Whalen was executive director of the National Maritime Museum Association, whose trustees thought that if the ships were not in the GGNRA they would have a better chance for funding. Bill lobbied members of Congress for a separate maritime park. Bill Thomas was asked to draft legislation and to ask Congresswoman Sala Burton to introduce the bill. Sala agreed, but she was ill with cancer and died the day the bill was to be introduced. House Interior Committee chair Morris Udall introduced the bill, adding a provision that the museum building be named for Sala. On June 27, 1988, President Reagan signed the law to establish the San Francisco Maritime National Historical Park.[10] The separated park was activated in July 1989. Bill Thomas became its first superintendent, Karl Kortum remained on staff as cu-

rator of collections, and the small cadre of shipwrights was reorganized and expanded to keep up with repairs.

Since its separation from the Golden Gate National Recreation Area, the historic fleet has received a more reliable flow of federal appropriations. Glennie Wahl's staff had done historical and structural studies of all the ships, and these plans are used to guide necessary rebuilding. The superintendent can schedule hauling and repairs of the vessels, improvements to the pier and the museum building, and creation of new exhibits.

Bill Thomas retired in August 2002, and Kate Richardson, a twenty-five-year Park Service veteran, became superintendent in December 2003. Since her arrival Kate has overseen completion of the $40 million rehabilitation project for the historic Haslett Warehouse and the $12 million restoration of the 1895 C. A. *Thayer* schooner. "I want to elevate the visibility of this national park locally and nationally," she says. Kate vouches for her commitment to reach out to the community in a collaborative way. Her staff is working on plans to return the structures, grounds, and artworks of Aquatic Park to their 1939 grandeur, and two major improvement projects for the bathhouse buildings are under way.

Now the ships, exhibits, artifacts, art, books, and photographs of the maritime national historical park tell of West Coast maritime life from Native American times to the present day. The park's assets include parts of ships recovered when developers dug foundations for skyscrapers on the downtown streets where the ships were buried after the gold rush. Across Jefferson Street from the Hyde Street Pier the Haslett Warehouse contains the park's 10,000-square-foot first official visitor center. The rest of the building, reborn as the Argonaut Hotel, is a new source of income for the park. Aboard the collection of historic ships moored at the Hyde Street Pier, visitors can see, hear, and touch part of the city's seafaring past. They learn about West Coast maritime history from park programs along the pier and in the visitor center and museum, and they can pursue research in the park's outstanding library.

The association that started it all has been renamed the San Francisco Maritime National Park Association. It continues today to support the park's activities and events through development and membership programs. It manages the well-known and -loved *Age of Sail* program on the ships, which teaches schoolchildren the challenges of being a sailor in 1906, the year of San Francisco's great earthquake.

THE GGNRA'S OTHER MARITIME HISTORY

Not far from the national maritime park are other places that tell of the Golden Gate's maritime history. Many of these sites are administered by the GGNRA.

In 1849 the Marine Exchange built an observation post and signaling station on Lands End at the far northwestern corner of the city. A lookout on the San Mateo coast would watch for ships coming from the south and would ride to the Lands End station. From the station, an operator would signal by semaphore to a station atop Telegraph Hill on the city's eastern side. That semaphore told watchers on the streets and wharves that a ship was coming into the bay and what kind of ship it was. By 1853 the wooden semaphores were replaced with an electric telegraph system, the first on the West Coast. For some years, this system was joined with stations at Point Reyes, on the Farallon Islands, and at Point San Pedro on the San Mateo coast.[11] In 1926 the Marine Exchange built an octagon-shaped house for its keeper and equipment at Lands End. The GGNRA eventually took possession of this building and is seeking a park use for the unusual structure.

For a century, many ships coming through the Golden Gate foundered on two huge submerged rocks, one at Point Lobos at Lands End and the other, called Mile Rock, about a mile west of the narrowest part of the Golden Gate channel. Other ships were destroyed near the Cliff House, on Ocean Beach, and at points along the Marin coast. At low tide, observant walkers along the Lands End trails and on the Marin headlands may see the remains of a few of the many vessels that were wrecked before the advent of modern navigational equipment. A map in the maritime national park visitor center displays their locations. Tennessee Cove in the Marin headlands is named for the SS *Tennessee:* in 1853 her captain saved his 550 passengers but lost his ship when he brought the vessel onto the beach after he missed the Golden Gate in a fog. The ship's massive engine may sometimes be seen in the sand at the southern end of the cove.[12]

To prevent shipwrecks on the coast and in the entry to the bay, several lighthouses and light signals have been built on the Golden Gate's shoreline. In 1855, a year after the first lighthouse was erected on Alcatraz, the Point Bonita light and its foghorn—the first—were put in service on the Marin shore, on a hill above the present lighthouse, which was built in 1877. The cold and windy evening half-mile walk to the Point Bonita lighthouse to see the full moon rise is the most exhilarating park-sponsored walk I've taken in the GGNRA. There is also a light and foghorn at Lime Point just under the Golden Gate Bridge. On the southern side of the Golden Gate, the Park Ser-

vice maintains the nine-sided tower of the former Fort Point Light Station. The 1864 lighthouse was decommissioned in 1934 when construction of the bridge blocked the light's beam. In 1906, after the *City of Rio de Janeiro* broke up on Mile Rock and 131 people died, a light signal was placed on Mile Rock and the top of the rock was subsequently leveled for a helicopter pad. Today, all of the shoreline warning lights are automated.

12

THE NATIONAL PARK NEXT DOOR

All across the United States the Park Service protects remarkable scenery, national historic landmarks, features of our cultural heritage, and wild lands. Even so, few parks have started with such widespread public affection for the land as the Golden Gate National Recreation Area. People cared about this place long before PFGGNRA and its small band of local supporters came on the scene. Knowing that everyone wanted to save the Golden Gate gave wings to our determination to secure the park and energized our work with every level of government.

By collaborating with the people who live near the park, allowing them to have a sense of ownership, successive superintendents have nurtured this local spirit and concern. Trust in Park Service protection has carried over from the park's conception to its inception and into the ongoing accomplishment of park protection and fulfillment of development plans. Our superintendents have made effective use of what is now a much larger number of involved citizens. Park administrators have worked well with most of the advocacy groups most of the time. And to help the Park

Service look after the park, the superintendents have cultivated the assistance of a wide variety of park partner organizations.

No other park houses as many nonprofit groups that offer such a broad range of programs and activities to supplement the programs carried out by park staff. Because of the comprehensive philanthropic and volunteer-coordinating efforts of the Golden Gate National Parks Conservancy, and such partnership organizations as Fort Mason Center on the San Francisco waterfront and the Bay Area Discovery Museum and Slide Ranch in Marin County, the GGNRA has become an integral part of the communities that surround it. Programs in this park have wide-ranging private as well as underlying public sponsorship. These programs provide recreation, learning opportunities, meaningful involvement, and cultural activities for people of all income levels, abilities, ages, and backgrounds, whether they are local, national, or international visitors.

FORT MASON BECOMES A CULTURAL CENTER

Soon after he came to the GGNRA, Superintendent Bill Whalen decided to court park partners. The site of his earliest major attempt was the industrial waterfront on Fort Mason's western side.

The Army constructed three big piers and four two-story warehouses on this site between 1910 and 1915, after filling in a cove. Designated the San Francisco Port of Embarkation in 1932, Fort Mason saw military personnel and equipment pass through until the end of the Korean War; in war and peace it was the Army's most important West Coast embarkation point. The eastern side of Fort Mason was also historic. Beginning in 1797, Black Point on San Francisco Bay was armed for coastal defense. Three homes, Quarters 2, 3, and 4, which date from 1864, are the oldest buildings still standing in this area.

In 1973 I visited the fort's derelict piers and warehouses. Pigeons flapped through the iron rafters, vagrants lived in the corners, and the walls were stained with seeping water. Pier 1 contained the sorry vehicles picked up in drug busts, and in the only warehouse with a functioning heating system the government had housed the Susan B. Anthony dollar coin program. When Bill Whalen looked over the dilapidated structures, he realized they would be too costly for the government alone to rehabilitate and maintain.

Today these concrete buildings retain their industrial appearance, but they are home to a multitude of activities that showcase San Francisco's diverse cultural life. Sixteen hours of every day, the Fort Mason Center—as it is now called—is full of people going to a variety of classes; visiting small

museums and galleries; attending theatrical, dance, and musical productions; and going to meetings, festivals, demonstrations, and exhibitions. They stroll and jog between the three piers and five warehouses, and they eat—indoors and outside—fine vegetarian cuisine, deli sandwiches, and bag lunches. Most programs are inexpensive, and some are free. The small specialized museums of crafts and arts have an admission-free day each month and there is no charge for some of the other exhibits. In total, about 1.5 million people visit Fort Mason every year, and it hosts thousands of meetings, conferences, performances, and other events. In most national parks, cultural interpretation is for historic sites within a natural landscape. At Fort Mason, modern urban culture is alive in an urban landscape.

A Vision

Fort Mason's transformation began with Bill Whalen's farsightedness and innovative thinking. He was sure that the answer to Fort Mason's problems was for the Park Service to partner with nonprofit organizations. Within the Park Service bureaucracy, "I sensed an invitation to study the buildings to death," he said. And he doubted they would be able to find the tenants. "I didn't look very far in the rule book," he said. "I moved ahead. No one stopped me."[1]

His ideas for how to develop Fort Mason had been shaped by an earlier job at Ford's Theater in Washington—a national park site—where he had been responsible for reviewing plays to determine "if the material was appropriate for the general public to see." After a while, he realized how "stupid" it was, "passing judgment on the First Amendment rights of others." So, as superintendent of the GGNRA, Bill was clear about how the Park Service should be involved in developing Fort Mason as a cultural center:

> I decided that government probably best not oversee the artistic and creative things that we hope for in Fort Mason, and so I pushed very hard to have a group established who would be a non-profit group, and that they, in turn, would be the ones who would make the selections. . . . I just decided that what we probably needed to do, through the Commission, was establish some broad guidelines about the use of the space, and then allow the nonprofit group . . . [to] select out of the finalists. . . . I feel that government should only get involved where it absolutely has to. If the private citizen, private non-profits, can run something and run it well, that's better than having the government try to do the same thing—and cheaper too.[2]

In 1975 I had little sense of bureaucratic limitations and was much taken with Bill's vision. As an advisory commission member, I drafted a paper to express what he seemed to want, which park staff rewrote. The commission held an all-day Saturday hearing in San Francisco's county fair building in Golden Gate Park. Nearly a hundred people presented program ideas, some wonderful, some outlandish. The commission passed a resolution in agreement with those who wanted programs at Fort Mason to reflect the region's diversity and be available at low cost or free of charge.

Four groups of organizations competed to take charge of rehabilitating Fort Mason. Each group was led by people who knew how to develop cultural programs and could bring together event promoters, schools, directors of theater, arts, and environmental organizations, and other groups. Organizations vied for affiliation with the four groups; some joined two, three, or even all four groups, so that they would be included no matter who won. No one expected established organizations with downtown venues and higher admission prices to come—and they didn't. After public hearings, the Park Service selected the group led by Ann Howell, a Junior Leaguer from the Midwest, who became the founding executive director of Fort Mason Center.

About this time Bill Whalen invited me to sit in on a conversation with Bill Thomas about the sort of events he envisioned at the center. To establish a context, Bill Thomas told Bill Whalen about the park's hidden nude beaches, about potentially offensive language locally used in plays and programs, and about events where it would be best to ignore the smell of "pot" if there was otherwise no problem. Bill Whalen had dealt with the urban counterculture that threatened the calm of Yosemite Valley; he was experienced and understanding. The permissive tone prevailed.

Redevelopment

For two years Ann Howell worked on the huge problems of stabilizing Fort Mason's buildings and finding tenants for them. The board hired Marc Kasky as associate director in 1978, two years after the center's role within the park had been defined. Two years later Marc replaced Ann as executive director. He was warmly appreciative of what she had done to start Fort Mason Center. "Ann Howell was a visionary," Marc said many years later. "What she wanted to do is what happened."[3]

While getting a master's degree in urban planning from Yale, Marc saw that developers and politicians had most of the power in city planning and decided that he was interested in empowering communities. For three years after coming to San Francisco, he was executive director of the

storefront San Francisco Ecology Center in North Beach, where the programs mirrored the Bay Area's natural and human habitats and social systems, "everything from San Bruno Mountain to street life, and from wildlife to architecture."

At Fort Mason Center, Marc delighted in the opportunity to work with multiple organizations in 300,000 square feet of built space. The Fort Mason Foundation, incorporated in April 1976, would manage the center. A cooperative agreement delineated what the Park Service expected, which is now expressed in the center's mission statement: "To create and preserve a cultural, educational and recreational center which reflects the unique history, talents and interests of the people of the Bay Area, in partnership with the National Park Service." The center's managers knew that there should be programs for everyone, "especially those who can't go to the Grand Canyon," Marc said.

Before programs could get under way, the buildings had to be rehabilitated. The garbage and dead pigeons had been removed by the time Marc arrived, and the center had begun to present events in January 1977, but most of the space had been vacant since 1962. Roofs and broken windows leaked, doors were swollen with dampness, copper piping had been stripped out of bathrooms, and elevators needed major repairs. The center and the Park Service sought grants and appropriations for repairs and for new roofs and doors, for windows with clear rather than opaque glass where permitted by historic preservation rules, for plumbing and bathrooms, for passenger elevators and disabled access, as well as to improve the electrical system and resurface the parking lot. Ninety percent of the funds came through local foundations, usually as three-year grants. Pier 3 was the first made usable—by the Coca-Cola corporation for a 1979 event. Other corporate events followed.

In 1979 the center got an NEA grant for a master plan competition. A local jury chose the winning firm from eighty applicants. Near the end of 1979, Marc saw that without substantial new grants the center would soon run out of money. He told the board that if it raised $40,000 through the rest of the year, he would commit to making Fort Mason Center self-sufficient in 1980. The center's staff wanted to produce programs. Marc wanted the center to manage the site on behalf of different groups—beginning in 1980, others would be the producers. The staff fought the change and people were laid off, but the board went along with Marc's idea.

Suddenly Fort Mason Center became a magnet. All the people who wanted to produce festivals and hold classes "came in droves," Marc said. In twenty years it grew to about seven hundred different groups every year. They had three to four thousand different producers in those years.

The board and staff focused their efforts on repairs, maintenance, attracting organizations, and marketing. Since 1980, the center has paid all operating costs from rental income. Events yield more income than resident groups. "It's better than I ever imagined," Marc said.

Managing the Center

Fort Mason Center has thrived in part because the Park Service was willing to relinquish much of its direct control. For that to happen, Marc had to earn the trust of the Park Service. He went to park "squad" meetings to share the experiences of running a nonprofit and tell about the center's activities. In turn, he learned about the operations and responsibilities of the national park system. The superintendent and staff became comfortable with Marc and his staff as "Park Service without uniform."

GGNRA administrators allowed the center to develop an independent, self-selected board of directors. Marc felt that the "culture" of this board has helped make the center so successful. He "indoctrinated" each new director. The directors bring such skills as marketing, architecture, and public relations to the board, but they represent only themselves, not constituencies such as "children" or "resident groups"—not even the Marina District, where the fort is located. Directors use their personal skills to help deal with the center's finances, buildings, calendar, and other concerns. A director with a discordant outlook soon leaves. The ones I've personally known are community leaders. They come from all around the region and reflect its diversity.

The center acts as a buffer between the public and the Park Service. It is the one group that deals with the hundreds who want to use the space. The park staff refers groups directly to the center, "and program providers do not meet up with bureaucrats who look for reasons not to do something," Marc said.

Since 1980, 8 to 15 percent of earned income has gone into capital improvements annually "to bring the place up to a standard of presentation that will attract additional activities—and by extension, revenue." For over thirty years, the Park Service painted building exteriors and repaved the parking lot, but now the center has taken over these responsibilities.

Knowing that the center could not expect much government aid, the board launched capital campaigns. The campaign of 1985–86 yielded $6 million from foundations, some of whose grantees were using the center and knew their assistance would not only improve the facilities but also help keep the rents down. In 1989, with capital improvement funds, Cowell Theatre was built in Pier 2.

Fort Mason was designated a national historic landmark in 1985, which means that the buildings and grounds have to retain their industrial character and cannot be landscaped or colorfully painted. "So we simply tried to make the space as good as the activities," Marc said. "What there is an audience for is what takes place in this setting. . . . If we put our egos aside and draw others out, we give people the chance to try things out. . . . Those programs without an audience don't come back. The public decides." If someone complains about a controversial program, "staff encourages them to sponsor a program on the other side of the issue."

Marc Kasky became director emeritus in 1999, and a member of the center's board of directors. Looking back on his years as director, he said he had accomplished his goal of a deeply ingrained and sustained culture and philosophy for Fort Mason Center. The public supports the center's goal of a place for affordable, democratic programs reflecting the interests of a wide range of people in a welcoming atmosphere.

Into the Future

Alexander Zwissler, Fort Mason Center's third executive director, said, "We're going to stay the course. We just love this place and we're going to keep making it better and better." Under Alex's leadership, activities have continued to grow. In 2004 some two thousand groups and individuals produced over 15,000 events and programs. A number of long-range planning initiatives have begun. Corporate and other private events still help subsidize nonprofit and charitable activities. The center has combined Park Service funds with earned income to upgrade fire protection systems, telecommunications, and lighting and to enhance access and make other improvements. Appropriations leverage private contributions for capital expenses, so Fort Mason Center actively seeks congressional support and funding for Park Service projects at Fort Mason.

In 2005 another major change was getting under way. Historically the GGNRA was responsible for major maintenance and the infrastructure. Instead, under a long-term lease agreement, Fort Mason Center will have responsibility for the buildings and sheds, while the Park Service will retain responsibility only for the piers' substructures.

To reduce auto traffic and the need for more parking space, the center is working with community groups to improve public transit. Some day, Alex hopes, one of San Francisco's historic streetcar lines will run to the center through the old railway tunnel under the eastern side of Fort Mason.

People from around the country telephone for information about how to start a similar program

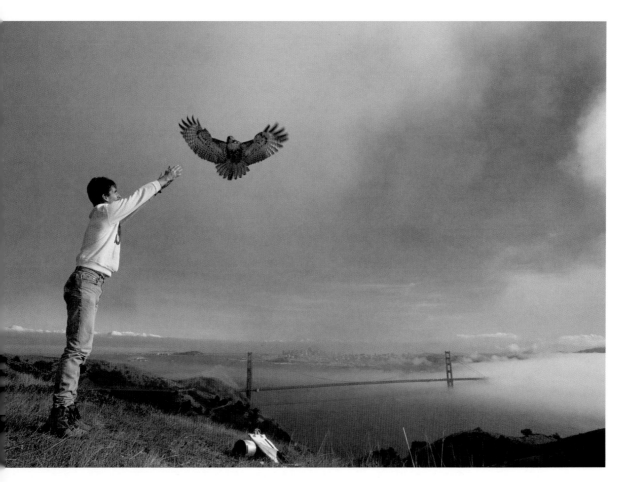

Plate 18. *Back to the Wild*: A Golden Gate Raptor Observatory volunteer frees a banded red-tailed hawk from atop the Marin headlands. (Michael Sewell, 1997, www.visualpursuit.com.)

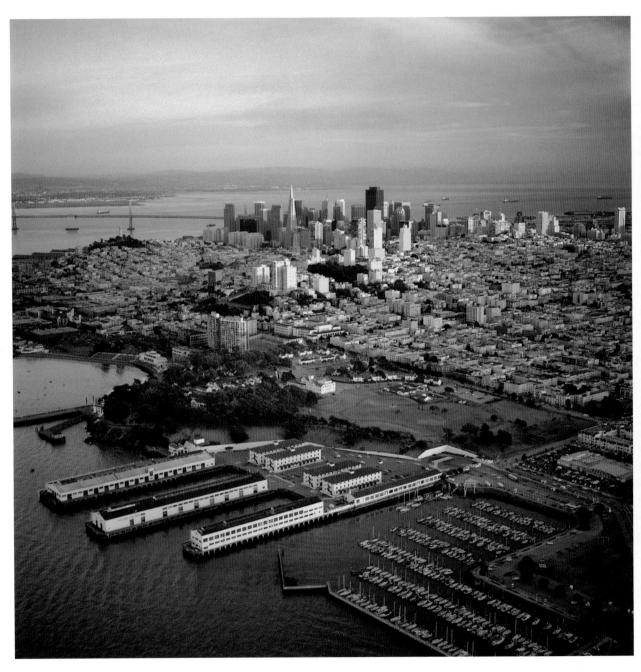

Plate 19. *Park Headquarters:* The site of a Spanish battery built in 1779, today Fort Mason is the headquarters of the Golden Gate National Parks and numerous nonprofit organizations. (Robert Campbell, 1996, www.chamoismoon.com.)

Plate 20. *Festivals and Fairs:* The historic Quartermaster Corps piers at lower Fort Mason are now the scene of many cultural activities. Here the American Craft Council exhibits exceptional crafts from all over the country. (Janice Tong, Fort Mason Center, 2004.)

Plate 21. *Military Heritage:* A National Park Service ranger explains the operation of a 1904 "disappearing gun" at Battery Chamberlin on the Presidio. (© Brenda Tharp, 1994.)

Plate 22. *Island of Rare Life:* Flowers originally planted by the prison staff and their families have taken over parts of Alcatraz. The island preserves the genetics of its historic plants in a landscape frozen in time. (© Brenda Tharp, 1993.)

Plate 23. *On the Edge:* Two couples share the beach at Tennessee Cove in the Marin headlands with shorebirds. (© Jed Manwaring, 1996.)

Plate 24. *Sifting through the Past:* Local universities in partnership with the National Park Service and the Presidio Trust carry out archeological excavations on the Presidio. (Photographer unknown.)

Plate 25. *Raymundo Trail:* Part of this secluded trail on the Phleger Estate runs alongside West Union Creek, home of red-legged frogs and steelhead trout, both federally listed threatened species. (Robert Buelteman, © 1992, www.buelteman.com.)

Plate 26. *Rare Appearance:* Lucky picnickers hold still as tule elk pass by on Tomales Point at Point Reyes National Seashore. (© Jed Manwaring, 2000.)

Plate 27. *Elusive Creatures:* Mountain lions are occasionally spotted in the remote areas of the GGNRA. (Michael Sewell, www.visualpursuit.com.)

Plate 28. *On the Trail:* Hikers explore a trail in Tennessee Valley, a few miles from the Golden Gate.

(© Brenda Tharp, 1995.)

Plate 29. *Centerpiece:* Equestrians riding north in the Marin headlands. Mount Tamalpais is in the distance.

(© Brenda Tharp, 1994.)

Plate 30. *Fascination:* Two youngsters on a field trip to Muir Woods National Monument peer into a bug box.
(© Brenda Tharp, 1991.)

Plate 31. *Surf's Up!* A lone surfer heads for the waves at Rodeo Beach in Fort Cronkhite just north of the Golden Gate.
(© Brenda Tharp, 1994.)

Plate 33. *Tide Pooling:* At low tide, a mother and her son look at the marine life of a tidal pool. The park's shoreline harbors complex intertidal communities. (© Brenda Tharp, 1997.)

Plate 32. *Riding the Wind:* Winds off the Pacific striking the cliffs at Fort Funston create exciting updrafts for hang gliders.

(© Jed Manwaring, 1996.)

Plate 34. *Web of Life:* The delicate mission blue butterfly lays its eggs only on certain species of lupine. The GGNRA protects much of the specialized habitat of this endangered species.
(Photographer unknown.)

Plate 35. *Birding:* Bird-watchers hike along the California Coastal Trail in the Presidio, past restored native dune vegetation that attracts a wide variety of species.
(© Brenda Tharp, 2003.)

Plate 36. *Crissy Field Reborn:* Private philanthropy and thousands of volunteer hours transformed the Army's Crissy Airfield into a bay shore park enjoyed from dawn to dusk. (© David Sanger Photography, www.davidsanger.com.)

Plate 37. *Parks and Politics:* When Republicans targeted Congressman Phil Burton's seat in the 1982 election, the Sierra Club magazine featured Burton on its front cover. (Mush Emmons, *Sierra,* September/October 1982.)

Plate 38. *The First Decade:* In 2004, Congresswoman Nancy Pelosi celebrated the first ten years of change from post to park at the Presidio of San Francisco. (Gary Wagner, © 2004, www.garywagnerphotos.com.)

Plate 39. *Building Renewal:* The Presidio is a treasury of American military architecture. The entire Presidio is a National Historic Landmark District and its historic buildings are rehabilitated in compliance with the secretary of the interior's standards. (Courtesy the Presidio Trust, Amy Wolff, 2004.)

THE GOLDEN GATE
NATIONAL **PARKS**

MARIN
HEADLANDS

TENNESSEE
VALLEY

SUTRO
HEIGHTS

FORT
FUNSTON

ALCATRAZ

CRISSY
FIELD

MUIR
WOODS

FORT
POINT

OLEMA
VALLEY

STINSON
BEACH

POINT
BONITA

SWEENEY
RIDGE

LANDS
END

FORT
BAKER

THE
PRESIDIO

CLIFF
HOUSE

KIRBY
COVE

MOUNT
TAMALPAIS

FORT
MASON

Plate 40. *Many into One:* Michael Schwab's award-winning graphics of sites in the Golden Gate National Parks help unify the public image of these diverse park areas. (© Michael Schwab Studio, courtesy Golden Gate National Parks Conservancy; used with permission.)

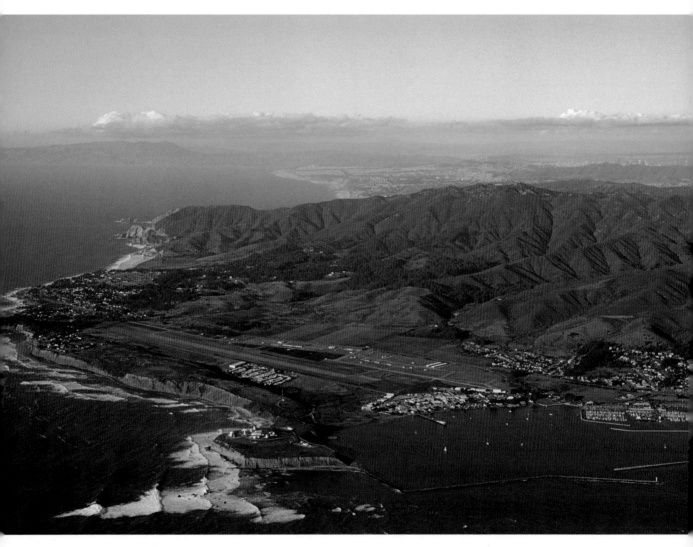

Plate 41. *This Just In*: The Peninsula Open Space Trust bought the historic Rancho Corral de Tierra in San Mateo County in 2002. In December 2005 Congress made it part of the Golden Gate National Parks. (William K. Matthias, © 2001.)

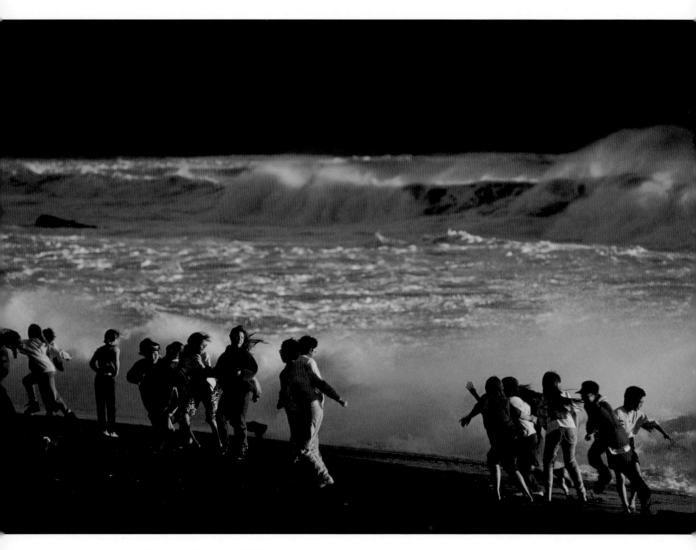

Plate 42. *The Sounds of Life!* Late on an afternoon outing, kids play tag with the surf at Fort Cronkhite Beach.

(© Jed Manwaring, 1998.)

elsewhere. In May 2001 Fort Mason Center and the Presidio's Thoreau Center for Sustainability co-hosted the first national conference on the development and operation of multitenant, non-profit centers.

Bill Whalen started something unique for the GGNRA and for the Park Service. "It's gone beyond my expectations of 1972," Bill said. Indeed, Fort Mason Center has gone far, and it's wonderful.

THE GOLDEN GATE NATIONAL PARKS CONSERVANCY

Most national parks have a cooperating association—a Park Service–approved but independent organization that helps support the park with private funding and volunteers. The cooperating association for the GGNRA is the Golden Gate National Parks Conservancy.[4] The Parks Conservancy works closely with the GGNRA's administrators on the plans for projects it intends to help fund, as well as on the implementation and the operation of these projects once they are completed. It is the major source of funding for the trails, visitor centers, exhibits, education programs, and outreach brochures that the Park Service might otherwise never fund or might finish only after much too long delay. The Parks Conservancy has a crucial role in connecting GGNRA volunteers with the projects and jobs that most need doing, and it organizes and provides leadership for them to help the park care for its habitat, wildlife, historic buildings, and trails. Parks Conservancy employees and volunteers provide the public with a diverse array of educational and cultural classes, programs, and activities.

When the Parks Conservancy started in 1981, it followed the model of other cooperating associations. It was the brainchild of Bill Whalen—who had returned to the GGNRA after three years as director of the National Park Service—and Greg Moore, an original member of the GGNRA's planning team who had become the park's chief of interpretation. They decided the park needed its own custom-designed, nonprofit, public support organization. Up to that time, the park had received some money from the modest earnings of the Coastal Parks Association, which sold books on Alcatraz Island and at Muir Woods and also gave money to Redwood National Park and Point Reyes National Seashore.[5]

Greg helped start the Parks Conservancy and then took a leave of absence to go to graduate school in environmental planning. The organization grew slowly. In its first independent year, it raised $40,000. When Greg came back to the park in 1984, the association had only a part-time

coordinator and was not yet incorporated. A year later, when the organization needed a full-time executive director, Greg left the Park Service to fill that position. By that time, Bill Whalen had left the Park Service and become a consultant in the private sector.

I was concerned about the Parks Conservancy during these early years. The Park Service's administrators cramped its ambitions, limiting the organization to conventional publications, and to book and souvenir sales. Such an association would never earn enough to provide major help to this complex park. All of its directors had the expertise and ability to do more than the Park Service would allow. One was the curator of history at the Oakland Museum, another had founded Chronicle Books, one was an attorney, and the Parks Conservancy's first chair, Virgil Caselli, was the general manager of Ghirardelli Square and had been part of the campaign to save San Francisco's cable cars. There was little precedent for the association's proposed range of activities, so Bill Whalen suggested that Greg contact the Friends of Independence in Philadelphia and a few other groups. This helped, but upper-level Park Service managers continued to be leery about a real partnership. Brian O'Neill had become the GGNRA's superintendent, and Greg worked with him to loosen the constraints and to expand the agency's limited expectations. The organization moved out of "the traditional relationship with the Park Service . . . to a more complete array of nonprofit support skills including philanthropy and volunteerism, and even taking on and advancing projects and programs that we thought [would have] long-term benefit for the park," Greg said.

By 1990 the Parks Conservancy was able to burst its bonds. Its successful projects were hard to criticize, and the association took advantage of the obvious community affection for the park. "Golden Gate has a tradition of doing things in a different way, and . . . of superintendents who are willing to go through doors that are not necessarily wide open," Greg noted. Park Service regional office concerns subsided as, on a national level, park administrators came to accept that philanthropy and volunteerism could further the agency's ambitions and mission as federal appropriations failed to keep pace with national park expansion.

Now the Parks Conservancy is integrated into park planning and operations. The association chooses projects not only for their impact on the operating needs of the park but also for the excitement that motivates volunteers and donors. The Parks Conservancy does not modernize utility systems or fund seismic stabilization; such needs must be met with government money. Larger donors expect that "we will turn their generosity into tangible services and park projects, and that we will do it with a sense of quality and timeliness," Greg said.

Rehabilitating Crissy Field

In 1973 when Mayor Alioto dedicated the Golden Gate Promenade, the barren 45-acre strip of coastal land was fenced off from the rest of the Presidio, and much of its shoreline was bordered by rubble, mud, and weeds. Landward views were blocked by Army equipment stored behind chain-link fences, and people said the front door of the Golden Gate looked like its loading dock. A decade later some Bechtel Corporation executives' wives organized Monday cleanups to supplement Park Service maintenance crews after weekends because the scruffy appearance seemed hardly to matter to the public—thousands of people came anyway to walk, bicycle, run, and relax along the path beside the bay.

The Park Service and Parks Conservancy made some improvements, but these early changes were mostly cosmetic. Beginning in 1987, plans began for a full rehabilitation of the promenade—and then a dramatic change occurred: in 1988, Congress announced plans to close the Presidio. When the Presidio closed in 1994 and all of the former post came under Park Service jurisdiction, the Park Service and the Parks Conservancy decided to transform 100 acres surrounding the promenade and to call the site Crissy Field, after the Army airfield that had formerly occupied much of the site. This transformation of the Presidio's northern waterfront has been the Parks Conservancy's most spectacular success.

The association raised money first to determine the scope of the project it would undertake and then to set up a planning process under Park Service auspices, with public hearings before the advisory commission. After contracts were let, workers removed rubble and contaminated soil, reshaped the Golden Gate Promenade, and recontoured the scarred landscape to include an 18-acre tidal saltwater marsh and a trail-laced swath of meadow. After the tidal basin was excavated, hundreds of volunteers planted thousands of native plants around it. San Francisco Bay has lost 85–90 percent of its tidal salt marshes since the mid-nineteenth century, so every restored acre of wetland helps the recovery of natural ecosystems. The meadow replicates the historic configuration of the airfield. Two historic Army warehouses have been reused for the Crissy Field Center, which offers imaginative and scientific park programs for visitors of all ages, and for the Warming Hut, which has a snack bar and Parks Conservancy store.

During the renovation, archaeologists discovered an ancient Native American midden and consulted with descendants of the tribe that had lived in the area. The midden was left unexcavated and the marsh design was adjusted. Interpretive signs tell the story. Dredging the marsh yielded

thousands of nineteenth- and twentieth-century artifacts of Army life, a treasure trove of buttons, bottles, and crockery—a small portion is usually on display somewhere in the Presidio. While this work was under way, pedestrians on the Golden Gate Promenade could follow what was happening because the conservancy placed attractive explanatory signs along the pathway.

Many of the volunteers in the Crissy Field planting program came to the association through the habitat restoration program founded by Greg Archbald, formerly an environmental lawyer. He saw that the GGNRA could not deal with the French broom, pampas grass, bull thistle, and dozens of other invasive, exotic plants that have escaped local gardens or come in with cattle feed to overwhelm the park's native species. Greg came to the conservancy's staff in the late 1980s and organized a corps of volunteers to weed out the exotics and plant native seedlings throughout the park. At Crissy Field, these volunteers now provide site stewardship: they continue to weed and plant under Park Service supervision, knowing that the philanthropic community must not be disappointed with the level of ongoing care for this magnificent and highly visible project.

The Parks Conservancy's deputy director, Carol Prince, oversaw the Crissy Field project for five years. "It took fourteen years from start of planning to opening day to do Crissy Field, the marsh, meadow, the ed center, the warming hut—the whole thing—and the same three people were there at the beginning and the end: Brian O'Neill, Greg Moore, and Ira Hirschfield from the Haas Foundation," she said.[6]

In November 1999 Carol and I were in a crowd that came to watch the breaching of the sandbank at the mouth of the dredged lagoon so the marsh could fill with water from the bay. "There are very few guys who know how to operate a front-end loader of that size," Carol recalled. "This operator was brought in specially for the purpose." He'd put in the scoop and dig a huge bucket of sand and toss it. Then he made his machine do a dance—he'd lower the long arm with its empty bucket and have it make a little bow to the excited crowd—and then dig again, backing up the sandbank as the break got wider and deeper. Then he raced double-time backwards up the berm to high ground and the water rushed in—and everyone cheered.

About sixty thousand people came to the public opening on May 6, 2001, a radiantly sunny day. "I especially remember one young Hispanic family on the big day," Carol said. "A man in his early twenties, bandanna around his neck, his two-year-old daughter dressed in white, and his wife. He said to me: 'Today is the way you always think things are going to be, but never are.'" I understood his feeling. One evening that week, I leaned chin-in-hands on the railing of the balcony

of the Crissy Field Center and looked over the marsh and meadow as the sun went down. The size of this transformed site is a neat reminder of the 115 acres Phil Burton hoped to get for the park in 1972. It made me feel so very joyful in the success of our hopes of more than thirty years.

The Golden Gate Raptor Observatory

Situated on the Marin headlands, the Golden Gate Raptor Observatory is a long-term Parks Conservancy project with international significance. Every autumn, tens of thousands of birds of prey come to the Marin headlands, site of the largest confluence of hawks, eagles, falcons, and vultures in the Pacific states. Preferring to fly over land, where rising updrafts and thermals on wind-facing hills help them maintain their altitude, the southerly migrating birds are funneled into a relatively narrow area at the southern tip of the Marin peninsula before they make the trip across the Golden Gate. At the two-mile gap between the Marin headlands and San Francisco, a bird may use a tail wind to travel quickly across, or may wait around for a while before crossing, or may decide to go no farther.

Many of the raptors passing over the Golden Gate can be observed from the Army's Hill 129, now called Hawk Hill, at Fort Barry. The site was discovered by Lawrence Binford of the California Academy of Sciences. Someone called me from the academy in 1972—I do not remember if it was Binford himself—to tell me of this phenomenon and to impress on me that future planning for the headlands had to protect it.

The Golden Gate Raptor Observatory was established in the early 1980s to study the migrating raptors. A few staff members and some three hundred volunteers are headquartered at Fort Cronkhite. The program charts broad migration patterns and monitors long-term changes in species numbers. This is done through a banding program that began in 1983, along with an annual raptor count ("Hawkwatch") at Hawk Hill. During Hawkwatch, 20,000 to 37,000 raptors, of 20 different species, are counted per season. By 2003, volunteers and staff had banded nearly 20,000 raptors and recovered more than 600 bands from places as far away as British Columbia, Idaho, and Mexico.

Since 1990, a few hawks each year have been fitted with tiny tail feather radio transmitters and followed for up to two months. In 2000 the observatory developed the "Robolure," a bird skin fitted with tiny motors to make it seem to flutter and fly, which volunteers use to attract and net raptors for banding. It will be of worldwide value for bird-banding programs.[7]

Alcatraz: Bleak Island Resurrected

Major parts of Alcatraz have been rehabilitated and buildings stabilized with funds raised by the Parks Conservancy, aided by infusions of government funding for infrastructure, and by money and in-kind contributions of repairs from filmmakers and producers of special events. Thanks to volunteer interpreters coordinated by the conservancy, visitors can experience both the natural qualities of the island and its dark history. They go bird watching and see splendid views from the shoreline Agave Trail. A Parks Conservancy video, "We Hold the Rock," is featured in an award-winning exhibit about the Native American occupation. The association also paid for a structural analysis of the island's historic lighthouse and prison buildings to set the stage for public funding for their restoration and retrofitting.[8]

Even before the 1969–71 Native American occupation, the island of Alcatraz had given major impetus to the creation of the GGNRA. The shuttered prison had also called forth numberless visions for its reuse. On November 19, 1977, the Citizens' Advisory Commission held a hearing at Fort Mason on the various proposals for Alcatraz that were still current. The meeting attracted 128 people and lasted for more than five hours. Advocates for a 240-foot peace monument, a 100-story aluminum tower, an island university, a United Nations monument, a gambling casino, and other projects presented their competing ideas.

Commissioners endorsed none of these proposals and advised the GGNRA administration to continue what it had been doing since 1973. They felt that the public would benefit most if the island were fully cleaned up to enhance its scenic qualities and refurbished to illuminate its complex military and prison history. They recommended that the gardens be renewed and natural wild areas restored so that more birds would visit and nest there, and that paths and benches be provided so that visitors could enjoy bay views.

The 1977 hearing was the beginning of public involvement in a successful planning process that set priorities for the rehabilitation of Alcatraz's historic features and native habitat. Public interest in the island also became the basis of a major volunteer effort. The Parks Conservancy has trained a cadre of VIPs (volunteers in the park) to help show visitors around the island. VIPs do the introductory historical narration on the boat to the island, welcome passengers at the dock, and rove the island answering visitors' questions. One is the volunteer librarian for the island's books and videos. Some conduct "behind the scenes" tours of places in the prison normally closed to the public; the volunteers are encouraged to research their own topics and shape their own pro-

grams. VIPs also make sure no one misses the last boat to the mainland. Additionally, under the direction of the local chapter of the Garden Conservancy, a national organization, Bay Area residents are rehabilitating the historic gardens of Alcatraz.

Today black-crowned night herons nest in the Alcatraz cypress trees. Several species of gulls nest on the roofs, in the ruins of historic buildings, and along some of the paths. During the nesting season some paths are closed, not only to protect the fledgling gulls from the tourists who pour in to visit the prison but also to protect these tourists from the gulls' aggressive parents. Crumbling nonhistoric buildings have been removed so that there is less concrete and more open space. Native grasses and bushes have spread over the bared ground and over berms made of rubble covered with soil. Bushes and flowering plants that grew in the gardens of the Alcatraz wardens' families are flourishing. Spiky century plants dominate the southern end of the island. The repaired fortifications and prison walls remain formidable and contrast vividly with the immediate landscape and the views. Knowing that it would be too expensive to save all the buildings, the Park Service is stabilizing a historically outstanding group and the underlying fortifications. There are history and natural history exhibits about the island. The cliffs and shoreline remain in their natural state for bird colonies and marine life.

Alcatraz was listed on the National Register of Historic Places in 1976 and was designated a national historic landmark in 1986. Every year it is visited by more than 1.3 million people. In 1997 the Park Service added evening tours of the island. During the summer tourist season visitors have to buy their ferry tickets several days in advance.

Volunteers, Money, and Students: More and More

When the Parks Conservancy celebrated its twentieth birthday in August 2001, it had cumulatively contributed $54 million toward the planning and execution of key projects. In addition to the Crissy Field renovation and the work on Alcatraz, there are many tangible signs of what this influx of money brings to the park: Muir Woods and the Marin headlands each have a new, handsome visitor center, and significant trail improvements in both areas protect fragile landscape and habitat; thousands of schoolchildren each year participate in Park Service programs in ecology, history, technology, and art; and hundreds of volunteers work in native plant nurseries and help maintain park areas in the site stewardship program.

For years the Parks Conservancy has been the most successful national park–cooperating

association in the country. The organization is part of the Association of Partners for Public Lands, a network of federal and state agencies headquartered in Washington DC, and the conservancy holds its record for fundraising. The Parks Conservancy's advantage in fundraising is that the GGNRA is new and is surrounded by its users, said Greg Moore, who has been its courtly, extraordinarily effective leader for twenty years. He feels that the donations his association receives are an extension of the park's original community support. In 2000, when it was engaged in the first phase of the $34.2 million rehabilitation of Crissy Field, the organization raised $14.4 million. The Crissy Field project was funded by local families, foundations, and businesses. The only national park project whose cost and campaign exceeded it was the national campaign with national corporate sponsors for the Statue of Liberty and Ellis Island.

To motivate people to be generous or to volunteer, Greg said, you have to collaborate, be flexible, "open to ideas you never thought of," and able to share ownership. When people's ideas are appreciated, they feel rewarded for their initiative. The conservancy's donors and volunteers are now backed by a staff of more than two hundred people. Contributors volunteer at visitor centers, help at the plant nurseries, do habitat restoration, do fundraising, and work at fundraising events.

Greg says the Parks Conservancy will look for park areas whose highest and best future can be achieved only with substantial time, money, and volunteers. His work requires adequate Park Service appropriations because "private donors can't think that their support erodes public investment." He said the association's contributors add ideas to projects, remembering how the Haas family, principal donors to the renovation of Crissy Field, proposed the Education Center. "Not only did they believe in the park and what the park mission was all about but they also had a strong conviction about the community piece of that park, and those values helped motivate us."

Greg wants the Golden Gate National Parks Conservancy "to connect community volunteerism and philanthropy to preservation and public enjoyment of the Golden Gate National Recreation Area. Our niche is to stitch together people motivated to be generous, to be active, to be environmental stewards, and to put that work into action for this incredible group of park lands."[9]

OTHER PARK PARTNERS

Over the years, the Golden Gate National Recreation Area has encouraged many other park partners. The Parks Conservancy and Fort Mason Center are only the largest partner organizations on a long and impressive list.

Most partners are tucked into the park's harder-to-care-for historic buildings and serve an important role in maintaining them. The GGNRA has 1,231 historic structures (everything from buildings to roads), including more buildings that can be occupied than any other park in the national park system.[10] Buildings listed on the National Register of Historic Places must be renovated in accordance with the National Historic Preservation Act of 1966; the intentions, values, and practices of earlier times should be visible in the rehabilitated structure. This stipulation often requires more money than tearing down an old building and starting again. It also requires timely effort because unused buildings deteriorate. Many of the planted landscapes also need special care because they are designated "historic," and native plants that harbor native wildlife in remnant natural habitat often require special protection from invasive exotic species.[11] The cost-per-visitor of maintaining the historic structures is relatively small when compared to other parks because of the large number of visitors, but the absolute costs of the park's landscape, buildings, and programs is relatively high. The partners help make up the shortfall in appropriated funds by contributing money and labor.

The GGNRA's wide-ranging partnerships contribute significantly to public programs. The Marine Mammal Center fosters scientifically based decision making about oceanic wildlife. The Headlands Center for the Arts provides programs and services for artists and the public. The Bay Area Discovery Museum reaches out to young children and to the region's multiethnic population (figure 39). Slide Ranch shares the experiences of a working farm and also provides opportunities for disabled people. The Headlands Institute, part of the Yosemite National Institutes, anchors environmental education to the core curriculum of the state.

Some of the newer park partnerships connect people to the land through community-based schools that undertake site stewardship. At Oceana High School in Pacifica, south of San Francisco, the administration, teachers, and students are developing a multidisciplinary environmental science program. The students collect seeds for the native plant nursery in the school, propagate the plants, and plant them on nearby Milagra Ridge, their adopted stewardship site. In Marin County, San Francisco City College has a program on Wolfback Ridge, and Dominican College has one in Oakwood Valley. The students become community mentors. There is no one model for these programs and different models are being tested all the time.

Brian O'Neill, who became the GGNRA superintendent in 1986, is the Park Service's acknowledged leader in the forging of partnerships (figure 40). He spends many days each month explaining partnerships to park personnel around the country. What the complex GGNRA has

Figure 39. *Kids' Space:* Since 1991, the Bay Area Discovery Museum has occupied nine renovated Army buildings at Fort Baker in Marin County. The innovative children's museum offers indoor and outdoor art, media, environmental and science activities, theater, cultural festivals, school programs, summer camps, and parenting workshops. Here lion dancers celebrate Chinese New Year at the museum. (Courtesy Bay Area Discovery Museum, Terrence McCarthy, 2003.)

lost by not having a full-time superintendent, it makes up somewhat by having the one most skilled at teaching his own staff to multiply the effects of their work through the efforts of others.[12]

Brian credits his predecessors with starting most of the park's partnerships. He explained that the park's size and diversity forced superintendents "to think out of the box from the start" and challenge the traditional Park Service philosophy that "the best way to do it is to do it yourself." Early on, he said, superintendents had to "find partners who could join with you in defining a

Figure 40. *Hands-On Superintendent:* GGNRA superintendent Brian O'Neill, shown here weeding on his day off, has led the way in fostering volunteer citizen stewardship and innovative community-based programs for habitat restoration. Volunteers have torn out acres of invasive plants and replaced them with native species, some of which were on the brink of extinction. The restored habitats attract native insects, birds, and animals. (Greg Archbald, 1989.)

shared vision for how an activity, a program, or a building could be reused to serve the needs of the park."

Brian is responsible for bringing the partnering approach to a new level and changing the nature of the partnering relationship at the GGNRA. Instead of being the "doer," the Park Service is now more often the broker, the convener, or the facilitator for tapping into the energy of the community. This concept of community-based stewardship gives people an emotional sense of ownership of place and empowers a growing constituency that supports the park.

The older style of park partnership, said Brian, was based on the park asking, "What can you

BRIAN O'NEILL

Born in Maryland, Brian went out west every year from the age of two. His father arranged his business trips so that he worked while Brian, his twin brother, Alan, and their mother explored national parks. In high school, the boys helped organize a student summer school trip to the western parks. Thus began an O'Neill family nonprofit corporation. The twins planned and took trips with their mother throughout their college years. Brian met Park Service people as they arranged tours and got permits and knew he wanted to work with the national parks after college. (Alan O'Neill also went into the Park Service and rose to become superintendent of several parks.)

After graduation, Brian worked on a study of the national trails system—then got a "gofer" job at the new Bureau of Outdoor Recreation, where all the exciting park work seemed to be happening. He worked his way up in Washington for eight years until he became one of the four principal authors of the first Nationwide Outdoor Recreation Plan. From 1973 until 1979, Brian worked out of a regional office in Albuquerque and was involved in historic preservation, National Register nominations, Land and Water Conservation Fund purchases, planning, and technical assistance programs in a five-state area.

The Bureau of Outdoor Recreation was renamed the Heritage Conservation and Recreation Service, and in 1979 Brian became the agency's assistant regional director in San Francisco. Then James Watt became interior secretary, abolished the agency, and absorbed it into the Park Service. Brian then became the GGNRA's assistant superintendent, and in January 1982 the Park Service deputy regional director Jack Davis came to GGNRA to be Brian's boss. Brian was then thoroughly mentored by a traditional national park manager. Usually, the superintendent deals with external affairs, and the assistant superintendent handles day-to-day park operations. After a while, however, when Jack saw that the park needed Brian's ability to work and socialize in the local community, the two reversed roles.

do to help us?" Many people still help in that way. Local residents donate time and money to the Parks Conservancy and the Point Reyes National Seashore Association. They volunteer for trail and beach cleanups and habitat restoration. In contrast, the new partnerships "are about developing a common vision of what two entities can do together to further the public good."

For example, sensitive to growing concern in San Francisco about homelessness, Brian looked for a way for the Park Service to respond. He found space for the Home Away from Homelessness, a program that takes kids from shelters and introduces them to the out-of-doors to try to give them a sense of place and stability. The program grew from outdoor education at a Marin headlands beach cottage to include a drop-in tutorial program for families in a park building and links up with the San Francisco Unified School District.

Brian pointed out that partnerships require knowledgeable staff to manage them. Even so, there are limits to how much some partnerships can grow within a park. Sometimes a program grows better, rather than bigger. Sometimes a program must expand out of the park to a school or other site.

Brian said, "My satisfaction is creating visions and then finding the wherewithal to achieve them." He quotes what President John F. Kennedy said when many doubted it would be possible to send a man to the moon and bring him back: "Now that the vision's been set, the answers will be found." Brian knows—and the Golden Gate National Recreation Area has benefited immensely from the vision he has brought to his job and how he has shared it—that the Park Service must be open to new thinking and to the larger community if it is to maintain its respected stature and reach its full potential.

13

FROM POST TO PARK

The Transformation of the Presidio

I felt sure I would be in a rocking chair when the Army gave up the Presidio, but the post was marked for closure in 1988. A nonpartisan, independent commission chartered by the secretary of defense recommended closing eighty-six military bases, and the Presidio was on the list.[1] (To avoid political damage to individual legislators and lobbying on each installation, Congress had to accept or reject the list in its entirety.) During the 1971–72 congressional hearings on the park proposal, keeping the 1,491-acre Presidio had been the topic of greatest concern. Most people were glad its future was protected by the park but thought closure of the Presidio improbable— so they were stunned by the announcement that the post would close (figure 41).

The closure of the Presidio as a military base raised a host of issues that had not been addressed in the original legislation for the GGNRA: Could the Park Service manage the Presidio? Who would pay the building renovation and environmental cleanup bills? How would the more

Figure 41. *Off to War:* The 51st Iowa Volunteer Infantry Regiment marches out of the Lombard Gate on its way to the Spanish-American War and the Philippines in 1898. (Courtesy Golden Gate National Recreation Area, Park Archives, GOGA-1766, Presidio Army Museum Negative Collection.)

than 790 structures be used? Eight years went by before Congress passed a bill to address these issues, and even then the details remained a work in progress.

TOWARD A NEW AND FUTURE PRESIDIO

We were fortunate in 1988 to have two congresswomen committed to protecting the Presidio as public land: Barbara Boxer and Nancy Pelosi. Nancy had been elected to Congress after Sala Burton died. As a member of the Democratic National Committee, chair of the California Democratic

Party, a major fund-raiser for the party, and one of the D'Alesandro political family of Baltimore, she was better known to national Democratic activists than to local voters. Nancy built local support during the primary campaign, beat the other candidates, then handily won election sixty days later. She was sworn into office on June 9, 1987. The Presidio was in Congresswoman Boxer's district, but Nancy—like both Burtons before her—regarded the entire Golden Gate National Recreation Area as her personal responsibility, even though almost all of it is north and south of her congressional district. Nancy gradually took on the leadership of the campaign to deal with the closed Presidio. Judy Lemons, who had worked for Sala, became Nancy's chief of staff.[2]

In January 1989 Barbara Boxer and Nancy Pelosi met with a group of environmental and civic leaders and Park Service representatives in the Phillip Burton Federal Building in San Francisco for an initial discussion about the Presidio's future. The congresswomen's first reaction was to resist the closure, because they knew the city would lose economically if the Army left and foresaw the extraordinary financial and political resources the conversion of the post to a national park would require. They also worried about a closed Presidio being seen as valuable real estate. A San Francisco realtor had wisecracked in the *Chronicle* that selling the Presidio could pay off the national debt. So Barbara and Nancy told us they would try to keep the post from closing. We did not argue with them. But we took advantage of the meeting to sound a warning: if the Army cut back on maintenance while waiting to see what would happen, the Presidio's buildings could sustain major damage. The Park Service representatives agreed.

While the congresswomen were trying to keep the base open, others began to imagine what it could become as part of the Golden Gate National Recreation Area. A month after our January meeting Michael Alexander phoned me. A former photojournalist for *Time, Life,* and other national publications, Michael also had some business experience. He often bicycled through the Presidio. He thought the Presidio could make an enormous contribution to civilian life and to the GGNRA. "I think people don't know what's really there," he said, and suggested a program of guided walks. I told him he should work with the Sierra Club. "I could volunteer about five hours a month. Would that be enough?" Michael asked. Fingers crossed, I said I thought so.

Under the auspices of the club, Michael worked with leaders from San Francisco Architectural Heritage and the Golden Gate National Parks Conservancy. They researched the history of the main post and in April announced a walking tour only to members of their organizations. They expected 35 people, but a crowd of 350 awaited them at the main post flagpole. Military police, surprised by the invasion, followed the walkers in patrol cars and intoned into bullhorns:

"Stay on the sidewalk. If you get off the sidewalk, you will be arrested." But of his first, stomach-jumping sight of the crowd, Michael later said, "At that moment, I knew we had a national park."

Toby Rosenblatt was asked to help with the Presidio conversion. A Stanford MBA, Toby lived across the street from the Presidio. He served on a number of boards in the fields of education, city planning, and hospital care, was often elected chair of those boards, and had been president of the San Francisco Planning Commission. Toby had had some involvement with the Presidio when he was on the planning commission, had worked with Superintendent Brian O'Neill, and had been on SPUR's board. He offered to help negotiate a memorandum of understanding between the city and the Park Service for the City of San Francisco's involvement in the Presidio planning process. When completed, the memorandum said that the GGNRA would do the planning, the city would participate, and the city would pay for a full-time planner on the GGNRA's planning team. "They made me the Mayor's representative to the planning process," Toby said.[3] The Presidio had been an open post, available to the Bay Area public and visitors, and reasonably well managed. Toby's initial concerns were the loss of money to maintain the buildings and grounds, and the financial benefits for the Bay Area that came with the Army being a large, stable civilian employer.

After the announcement of the Presidio's closure, Nancy Pelosi worked very closely with Congressman John Murtha (D-PA), chair of the Military Construction Subcommittee of the House Appropriations Committee. According to Craig Middleton, who was then Nancy's press secretary, Murtha "had control over vast sums of money related to military installations." Craig spoke of the big difference between the military and the Park Service budgets. "We were working to try to get [the Presidio] off the list, but then we were also working to try to get as much transition money as possible, and investment in the Presidio, despite the closure, by the military. . . . Everybody knew that we had infrastructure problems here and other major issues that the Park Service would never have the funding to deal with. . . . Murtha became a very important figure in all of this, rather behind the scenes."[4]

The Park Service Begins to Plan a Park

About a year after the base closure announcement, the congresswomen accepted the fact that the Presidio would close.[5] The Park Service began to plan in earnest but stumbled along for more than a year until Don Neubacher came from Point Reyes National Seashore in 1992 to direct the

planning team and become deputy general manager of the Presidio Project. In 1993 the Park Service's director, Roger Kennedy, asked Bob Chandler, the highly regarded superintendent of Grand Canyon National Park, to be the general manager and report directly to him. Everyone was grateful that Brian O'Neill and Bob worked well together, since Bob's pipeline to Kennedy was outside the usual chain of command and could have been a problem.

Yet it was hard for anyone to define the ends and means of a Presidio plan when Congress had not yet determined how the Presidio would be managed, or how much it would appropriate for the post's makeover and future operation. Also, the Army and the Park Service were at fiscal cross-purposes.[6]

The Presidio Council

Toby Rosenblatt became a member of the board of directors of the Parks Conservancy in 1990 and its chair in 1991. He said Brian O'Neill wanted a group of advisors—people with diverse experience who could look at the Presidio as a place for the whole nation to use and enjoy—who would add to the Park Service's planning process. In response, the Parks Conservancy's leadership created the Presidio Council and asked James Harvey, chair and CEO of Transamerica Corporation, to be its chair.[7] An outgoing, generous man, Jim Harvey was a highly respected member of several corporate and nonprofit boards and was able to enlist wide support for the Presidio.

Toby credits where the Presidio is and where it's going to Jim Harvey. A few people could argue very effectively in Congress about why this place must be a national park and about public purpose, said Toby, "but the concept of how to create a governance [structure] . . . on the economic side of it that Congress would live with . . . was really Jim's concept." The Presidio Council, according to Toby, "wasn't a 'representative' board. Everybody around that table . . . like architect Maya Lin . . . had already been recognized in accomplishment." Members came from Washington, Philadelphia, and even the American Academy in Rome. Led by the investment bankers Tully Friedman and Warren Hellman, the Parks Conservancy raised more than $2.5 million for the planning process.[8]

What Congress Gives, Congress May Also Take Away

In 1993 Congressman John J. Duncan (R-TN) tried to have Congress undo Phil Burton's guaranteed protection of the Presidio. On March 17, Duncan said he and sixty co-sponsors from both

parties would introduce legislation to sell the Presidio's golf course, medical research facilities, and the Public Health Service hospital, one of the two former hospitals on the Presidio. It would cost between $700 million and $1.2 billion to convert the Presidio to a national park, whereas money generated by sale of parts of the Presidio could fund a public benefit corporation to care for the remainder.[9] Duncan asserted that the Presidio would be the most expensive park in the country, "costing 3 times as much as Yosemite National Park and more than 4 times as much as the Great Smoky Mountains National Park." That last park was in his district.

In May Duncan tried to change the park boundary to include only the Presidio's coastal strip, and to dispose of the rest. Congressman George Miller (D-CA), another Phil Burton protégé and Nancy Pelosi's staunch ally, stopped this attack in the Interior Committee. On June 30, Duncan called placing the entire Presidio within the park "an obscure 41-word sentence in legislation establishing the Golden Gate National Recreation Area" and complained that 6 million square feet of buildings didn't belong in a national park. He tried to decrease the Presidio's funding. Opposition organized by Nancy Pelosi foiled Duncan's bill.

The Presidio Council had to find a way to manage the Presidio's future so that Congress could support national park status for the entire Presidio. Jim Harvey got deft pro bono help from McKinsey and Company, which specializes in management issues. McKinsey analyzed the management and economics of public sites from Williamsburg to Disneyland. It became evident that the Presidio would require a unique form of governance and funding.

People for the Presidio

Early in 1993, I sensed that local organizations were feeling ignored. Their support for a new kind of governance at the Presidio would be crucial. Frequent opportunities to get firsthand information about the post's transition from congressional aides and the Park Service would give local leaders a chance to relay information to their members, give them perspective, and help them understand what appeared in the media. Marc Kasky gave me meeting space at Fort Mason Center and I called thirty-five people. Fifteen to twenty-five of them came to each monthly meeting. We discussed legislative, planning, and leasing issues with Brian O'Neill, Bob Chandler, and congressional aides. At Bob's suggestion, I named the group People for the Presidio. "It was a matter of getting things up and running," Bob later recalled. "With the Army leaving, it was about providing assurance to the community about public safety and that the Presidio would not be over-

run by homeless people." He arranged Presidio visits for members of Congress and their staff. "Some of them, all they had seen was the pet cemetery. . . . All they saw was the dollar signs— that the Presidio would drain the Park Service dry."[10] The Park Service told People for the Presidio that the Presidio would cost $25 million a year.

Congress Looks at Presidio Management

On October 14, 1993, Nancy Pelosi introduced HR 3286, a Presidio management bill. On October 26, opening a national parks subcommittee hearing on the bill, Congressman Bruce Vento said, "Phil Burton gave us the Presidio without instructions." He reminded everyone that the Presidio was a national historic landmark, that the Park Service would need to maximize revenue to reduce its costs, and that the Presidio's new tenants would have to pay fair market rents.

At the hearing, committee member James Hansen (R-UT) said that he couldn't see giving expanded responsibilities to an agency that couldn't afford seasonal employees. Perhaps other alternatives would not be as costly. Committee member Craig Thomas (R-WY) said he was not aware of the national significance of the Presidio; perhaps it was a state or local concern. Nancy Pelosi urged Congressman Thomas to visit. National resources should not be squandered and the Army and the Park Service should make a cooperative investment in the Presidio's future, she said. By leasing its hundreds of buildings, there would be "limited exposure of the American taxpayer." It was clear to everyone that no matter what happened, there would be big environmental cleanup expenses.

Roger Kennedy, the National Park Service director (and a former member of the Presidio Council) said there was no less expensive way to sustain this historically significant property. Presidio Council members Mike Heyman and Bill Reilly endorsed a public-private partnership and decried the idea of any sale: "You don't sell your milk cows," Bill insisted. Toby Rosenblatt said it would be fifteen or twenty years before selling the Presidio produced any revenue. The Presidio was zoned as open space, and all development plans would be fought by an aroused public. Congressman Vento had asked me to research the history of the Presidio's inclusion in the GGNRA. I reported that Phil Burton knew of several previous attempts to close the Presidio and had intended to protect all of it. And Michael Alexander protested, "It's a national historic landmark—you can't sell it!"

Later that autumn, Judy Lemons and I talked about the Letterman Hospital complex. The hospital and medical school of the University of California at San Francisco (UCSF) was inter-

ested in the buildings. If leasing these 1.2 million square feet of buildings could get under way, it would demonstrate Presidio reuse to Congressman Duncan and his fellow naysayers. A new paragraph was substituted for almost all the text of HR 3286. When President Clinton signed the bill in December, its purpose was to make possible the immediate leasing of Letterman Hospital.[11]

The Presidio Trust Idea

On November 3, 1993, Nancy Pelosi introduced a new Presidio management bill, HR 3433. Craig Middleton recalled later that this bill named the entity that would manage the Presidio "the Presidio Corporation" and noted that "it didn't take long to figure out that that wasn't really a very good thing. . . . It sounded like a business entity—which it wasn't. . . . So in the second rendition of the legislation, we called it the Presidio Trust." In March 1994, claiming it would save hundreds of millions of dollars, Duncan introduced a bill with 64 co-sponsors to sell off parts of the Presidio and to create a public benefit corporation.[12]

The Pelosi bill kept the trust within the Interior Department but took away much of Interior's control. Nancy Pelosi needed some information to fine-tune the bill, but Department of Interior solicitors "were taking an awfully long time to get information back to members of Congress," Craig Middleton remarked. "There continued to be delay after delay." Judy Lemons warned me that the lost time was endangering the legislation. She worried that the California Desert Protection Act, carried by Dianne Feinstein for the retired senator Alan Cranston, would come before the full Senate at the same time as the trust bill, and that the Senate would never give California both.

Judy worked closely with Interior Committee staff as HR 3433 made its way through the House. Congressman Vento's subcommittee hearing was on May 10, 1994. Nancy Pelosi declared that base conversion costs would have to be paid whether the Presidio was or was not a park. Sale of most of the Presidio under the Duncan bill was characterized as a one-time return of revenue, of far less value than keeping the Presidio whole. On June 20, Duncan asked his colleagues to support a $14 million reduction in the Presidio's 1995 appropriation. This bill was defeated by 26 votes, so the margin of safety was only 14 votes; Duncan's margin of defeat kept getting smaller. Judy Lemons told me, "Nancy says 'Failure is not an option,'" but in San Francisco we read the newspapers and worried.

The House passed HR 3433 by a vote of 245–168, on August 18. The companion Boxer–Feinstein Senate bill was S 1639, but as the end of the congressional session approached, the Sen-

ate Committee on Energy and Natural Resources approved the House bill 20–0. "Which," said Craig, "left us lined up at the very end of the session, when everything—90 percent—of what passes, passes. . . . It had passed through the House, through the Senate. It had gone through conference. The conference supported, passed the House [bill]. It was just about to pass the Senate." And then what Judy had predicted would happen happened: "Senator Feinstein had two bills up, both in the conservation area, and one was the desert protection bill and one was the Presidio Trust Act. Last day of the session Senator [Malcolm] Wallop [R-WY] put a hold on the bill. . . . Senator Feinstein was forced to make a decision as to which bill should go through, and the Senator chose the desert bill, as was probably very appropriate to do. So we had to start all over in 1995."[13]

THE PARK SERVICE TAKES CHARGE

The Presidio Trust bill was about managing the park. Closing the Presidio and transferring it to the Park Service was on another, already fixed timetable (figure 42). On September 30, 1994, one of the oldest continuously active military installations in the nation was closed. General Mallory—who "left as almost a defeated general, having been the one who oversaw the closure of the Presidio," according to Brian O'Neill—would not allow the Presidio's new managers to uncover their new signs until midnight, as the celebration "From Post to Park" wound down. The celebration had solemn overtones of responsibility: it was a fundraising dinner in a tent on the main parade ground sponsored by the Parks Conservancy. The following day, a Saturday of perfect autumn weather, park supporters celebrated on the parade ground with music, speeches, and food. "I was feeling really good," Bob Chandler remembered. "I was totally committed to insuring that we were going to take as good a care of that place as the Army had. A lot of the things that we did very quickly were things that had been neglected for some period of time. . . . We really wanted to demonstrate to the people of San Francisco, particularly the neighbors, that this change from Army to Park Service was going to—in many respects—be a change for the better. They would see that visually as they moved in and about the Presidio."[14]

While all the management debates and post closure efforts were under way, the Park Service had continued to plan the Presidio's future, and the Parks Conservancy subsidized extensive public outreach. In July 1994, after two years of public hearings, and before it actually took over Presidio management, the Park Service published and distributed its Final General Management Plan Amendment (GMPA)—so called because it amended the Presidio section of the park's 1980 gen-

Figure 42. *The Army Departs:* On October 1, 1994, after 147 years on the Golden Gate, the Army conveyed the Presidio to the National Park Service for rebirth as a national park. (Charles Kennard.)

eral management plan. The GMPA envisioned "a global center dedicated to addressing the world's most critical environmental, social, and cultural challenges." It also stated that "a federally chartered partnership institution will assist the National Park Service in managing the Presidio. This partnership will be responsible for assigned areas and conduct building repair and maintenance, leasing and property management, program development, and fundraising." The Park Service and park partners would provide extensive programs about global environmental issues and the Presidio's resources and history and would promote cultural diversity and international understand-

ing. The Presidio Trust legislation had designated Building 102, one of the Montgomery Street barracks, as the Park Service's Presidio visitor center and named it for William Penn Mott, Jr.[15]

The visionary GMPA had much local popular support. It would provide space for good works, education, and visitor activities within the historic buildings and grounds. But others looked beyond the glowing vision and thought the plan was wishful thinking because it did not deal with who would pay the enormous costs of reaching these goals. Members of Congress, their aides, House and Senate committee staff, and some members of the Presidio Council and the Citizens' Advisory Commission questioned the GMPA's economics. "They had done no financial analysis of whether their proposals, in fact, could be accomplished," Toby Rosenblatt recalled. At long last the Park Service became convinced of what the Presidio Council was recommending and what ultimately Congress said it wanted: completion of a financial analysis of the GMPA before bringing it to Congress.

An independent financial consultant concluded that the GMPA could work economically if some of the Sixth Army remained at the Presidio, the Letterman site was leased to UCSF, and Congress continued a yearly $14- to 16-million appropriation in perpetuity—an appropriation that would have to go up with inflation. Without these funding sources, with a plan principally for nonprofit tenants who would do good works and provide public programs, the GMPA was not fiscally feasible. If the Presidio's annual operating cost and capital requirements were added to the rest of the GGNRA's budget, it would make the GGNRA the most expensive national park in the country. "That just wasn't going to fly," Toby said.[16]

A BILL FOR A PRESIDIO TRUST: 1995–1996

Election-year politics may have played a part in the trust bill's death in 1994; perhaps some legislators thought they could change it when the bill would be reintroduced in the next congressional session. Americans elected many conservative Republicans that November, and House Republicans elected the swaggering Newt Gingrich (R-GA) Speaker of the House. His pronouncements so dominated House debates for the next two years that it was known as "the Gingrich Congress." The conservatives were more receptive to Congressman Duncan's renewed attacks on the Presidio. The 14-vote margin disappeared. Craig Middleton said the strategy changed from "how much we fund the Presidio to what's the long-term future and how do we ensure that the place is protected while also ensuring the taxpayer is protected."[17]

On March 22, 1995, Representatives Nancy Pelosi, Stephen Horn (R-CA), Benjamin Gilman (R-NY), and Tom Lantos introduced HR 1296, "to provide for the administration of certain Presidio properties at minimal cost to the Federal taxpayer." The Presidio Council had received pro bono studies of nineteen management models from outside financial and real estate experts. "For nearly 150 years, the federal government has invested in the Presidio as an Army post. The best way to protect this asset is by creating a management and financial mechanism that will enable it to be used and to pay for itself," Congresswoman Pelosi declared. The trust would manage the rehabilitation and leasing of the properties under its jurisdiction and retain revenues to offset costs, so as to reduce the need for federal appropriations. Various methods of financing for capital improvements would be reviewed and approved by the Treasury Department, Congress would have oversight through routine reporting and auditing requirements, and the trust would adhere to the GGNRA legislation and to the Presidio GMPA. The trust would have a number of private sector authorities not usually available to a federal agency.[18]

At People for the Presidio, we supported the Pelosi bill by marshaling support through such national organizations as the League of Women Voters, the Sierra Club, and the National Parks Conservation Association, and through local organizations. Members sent letters and spread the word at meetings. Mary Murphy and Redmond Kernan, who would make the best impression on conservative legislators, testified at House and Senate hearings.

"People in San Francisco and people elsewhere in the country put on an intensive lobbying effort to get the bill passed," Toby said. The Presidio Council generated nationwide support that appealed to a broad group of constituencies. Members testified at congressional hearings and contacted their Democratic and Republican legislators, influential local residents, and recognized opinion leaders, who in turn asked representatives and senators across the country to support the creation of the Presidio Trust. The council's political efforts, backed by modern office technology that could send identical letters to 535 representatives or 100 senators showing the support of 38 nationally prominent people, helped ensure critical votes in favor of keeping the Presidio whole. Parks Conservancy directors who knew members of Congress sent very specific and individualized letters and made personal phone calls. "About six or eight of us from San Francisco went back and met with Congressman Gingrich and probably a dozen other congressmen, introducing, reintroducing the idea to them and using every connection we could think of and find to influence the key people in the House and the Senate," Toby remembered.[19]

"Each Senator had received either phone calls or letters from people in his or her state, with

people calling from Alaska, from Washington, from Oklahoma . . . so it was a national effort," Craig said. A letter assembled in San Francisco was signed by twenty-five or thirty people, said Toby, "a combination of both people from the business community, mostly CEOs at different Bay Area corporations, and a wonderful collection of neighborhood and environmental organizations. Almost everyone that one would expect to have an interest in the Presidio weighed in. And that letter became a central piece of information to demonstrate strong Bay Area support that the California delegation could use." Judy Lemons, everyone's heroine, worked tirelessly behind the scenes. Mike McGill, Dianne Feinstein's chief of staff, helped with strategy when people were preparing to testify.[20]

Nancy Pelosi was determined that the Presidio would remain, in its entirety, a national park; that no part of it would be sold or privatized; and that it would not become a federal asset outside of the national park system. She managed the bill on the House floor. Dianne Feinstein and Barbara Boxer co-sponsored the Senate bill. "Barbara . . . was on the Budget Committee in the Senate," Toby said. "They [some senators] put into the budget a proposal to sell the Presidio, and I think they were hoping to get 500 million dollars. And it was a combination of Barbara Boxer and Hank Brown [R-CO] [who] were able to convince the Budget Committee to withdraw that [selloff]. . . . Dianne had a very good ability to work across the aisle, and particularly on that committee [Energy and Natural Resources] with [Senator] Murkowski. She was able to generate great respect from the other side. And so she was very good at negotiating her bill through the Senate."

In a kind of symmetry, the 1996 bill, like the one in 1994, was the very last Senate vote in that session of Congress—only this time the bill was voted on and passed![21]

THE PRESIDIO TRUST

Between 1989 and 1994, the Park Service's Presidio Project team had struggled to create a management plan for the Presidio, with no clear idea of how it would be governed in the future. Using the Citizens' Advisory Commission for broad public participation and review, Brian O'Neill, Bob Chandler, and the Presidio Project staff had shaped the GMPA that the Park Service thought would guide the Presidio's transformation and use.

The 1996 legislation that established the Presidio Trust countermanded the assumptions of the GMPA. Securing the deal with the Gingrich Congress left the Presidio in danger, because the bill treated this part of our national park like a business start-up. "Self-sufficiency" had earned

the needed political support, but it meant the Presidio could be sold if the Presidio Trust didn't become self-sufficient by 2013. And Congress had promised only fifteen years of start-up money to fix some buildings and get some tenants. No other national park or national historic landmark had ever been threatened with dissolution if it could not pay for itself. Park advocates celebrated the legislation, but we also knew that the Presidio's salvation came with an unusual and heavy obligation and that the trust legislation could set a dangerous precedent. And while the deal relieved the Park Service of a big responsibility, many people felt that the agency had lost a jewel from its crown.

The First Board of Directors

The Presidio Trust is not part of the Interior Department. It was designated a freestanding federal agency reporting directly to the president, so as to raise its stature and help assure future appropriations.[22] The seven board members are personally responsible for the policy, planning, and financial success of this federal agency—as if it were an enterprise in the private sector.

Six of the seven members of the board of directors—three Democrats and three Republicans—were appointed by President Clinton. Don Fisher, Mary Murphy, Ed Blakely, Bill Reilly, Toby Rosenblatt, and I were chosen for our general knowledge and skills. The secretary of the interior appointed John Garamendi; his role was to connect the trust to the Park Service.[23] Since our swearing-in would start the clock ticking on the fifteen years, we delayed it until July 1997—the trust would need every day. We elected Toby Rosenblatt chair in recognition of his leadership and equable temperament, and Ed Blakely was elected vice-chair. Toby later expressed how we all felt:

> We had the huge virtue of having a project of great merit. All the people who were involved in saving the Presidio and the Trust board members had no personal agenda. No one would gain anything personally other than what everybody would gain from enjoying the Presidio's beauty, land, buildings, and programs. No one would gain financially. If any of us had to defend the Presidio or the Presidio Trust, we could go in and argue with passion and purity.[24]

By 2002, the environmental and land use lawyer Jennifer Hernandez had replaced Ed Blakely, who had moved to the East Coast. John Garamendi had moved on too. Interior Secretary Bab-

bitt eventually appointed Ira Michael Heyman as his representative in 2000, following Heyman's retirement as secretary of the Smithsonian Institution. Ed Blakely, Don Fisher, Bill Reilly, and Mike Heyman had all been members of the Presidio Council, and Toby Rosenblatt had been an ex officio member. The first six board members appointed by the president had staggered terms; if reappointed after two or four years, they could serve for six or eight years in all. No board member could serve for more than eight years. The term of the secretary's appointee had no limit.

Setting Up the Trust Office

We had to get someone to start up the trust office. In May 1997 Bill Reilly called Craig Middleton. Craig had left Congresswoman Nancy Pelosi's staff in 1993, was staff director for the Presidio Council when it ended in 1994, and was working for the Parks Conservancy when the trust legislation passed. Bill told Craig, "We're going to do a national search for an executive director, but in the meantime, we need somebody to come in and just set the thing up and set up the office, the procedures . . . the first board meeting." Craig remembers his response: "Of course I said yes. . . . My master's was in public administration—what a privilege it was to not only be on the legislative side of putting an innovative structure together for public administration, and then to be asked to be right on the ground floor of putting the actual implementation strategy together!"[25]

Craig's office was in Building 10, a small 1862 officers' quarters. There was no way to hire him because there was no organization. The Parks Conservancy loaned him to the Park Service, and he worked for their Presidio general manager, B. J. Griffin (who had replaced Bob Chandler), who assigned him to the trust. Sitting on borrowed chairs, Toby and Craig met a couple of times a week. Craig could not order furniture or get phones and computer network support. "The Park Service was wonderful. They did all of our contracting for us. They gave me a credit card," he said.[26] Several board members suggested candidates for executive director and for such key positions as house counsel. The Park Service loaned Carey Feierabend from the Presidio Project team and she shared her wide-ranging knowledge of the post. We hoped some Presidio Project staff would want to transfer to the trust as their jobs wound down—later, some did. But we agreed that our as-yet-unnamed executive director should hire his or her own staff.

Craig had to cultivate his relationships with Congress, the Office of Management and Budget, and other federal entities—and the trust had no Washington office. He had to make a request—and justify the numbers—for the budget that the president would submit to Congress.

Craig Crutchfield at the Office of Management and Budget dealt with all the national parks and public lands agencies. The trust was authorized to borrow $50 million for capital projects, so Toby said to ask for that amount. Craig Crutchfield asked, "Do you really think you guys have the organizational capacity to spend $50 million?" They received $20 million in loans, which the trust spent over the next three years.[27]

The First Executive Director

The trust board used a headhunting firm to help find an executive director. The biggest obstacle was the federal cap on executive-level salaries. We thought we could pay whatever it took to get somebody who knew how to turn an old post around, deal with six million square feet of built real estate and a declining 120-year-old forest, and run a small town. The federal executive salary cap was $148,400 (for the Park Service's senior executive service, the cap was $115,000), and the Presidio needed someone with private-sector experience who had been earning much more. It took months to get Congress to lift the salary cap.[28] After interviewing the top candidates, the board chose James Meadows, the executive director of the Lowry Redevelopment Authority, which oversaw conversion of Lowry Air Force Base outside Denver to civilian use. Jim's compensation package—a widely publicized starting salary of $160,000, rent-free living in the former commanding general's quarters, and a bonus plan—was worth much more than the federal executive salary cap but was low for the private sector. Park Service managers said there were experienced people who could do the job for less.

Jim came to the Presidio Trust on January 5, 1998. He described his job: "to be the CEO, to build a staff, to set the initiatives, to set the strong vision for the Presidio, and to implement policies set by the board of directors." He had six months to prepare a financial management program for Congress "as to how we were going to get from ground zero to self-sustainability." He had to set up an organization and the financial apparatus for operating a separate federal agency. Toby's perspective was that he himself had always chaired boards that had the benefit of an effective executive director, so that the board could do "the overview, policy, the guidance, and hand holding . . . and stay out of the operations side." Jim said of the board: "People are always hitting them up to try to have things happen at the Presidio. This board is excellent at fending those off and saying they have to go talk to the executive director. . . . They would let me know that so-and-so is going to call, and keep their hands off."[29]

Jim could be impatient with the Park Service and the public. He spoke of "keeping the national park perspective, not necessarily the National Park Service perspective. . . . The Trust was set up to be a public agency, but to operate as if it were in the private sector, to take advantage of those efficiencies." He said, "You keep your eye on a national focus. You don't let local politics intrude into your mission. When you're looking at preservation and natural [resource] issues, you don't look towards solutions that help San Francisco, you look for solutions that help the country and that might also benefit San Francisco."[30] Jim was more combative than park advocates were used to, and some people complained about his style.

Turf Issues

Before the Presidio Trust legislation passed Congress, the Presidio Project Office of the Park Service printed a handsome brochure, *The Presidio of San Francisco, Gateway to Tomorrow*. A lead sentence of the brochure stated, "The National Park Service will provide overall management of the Presidio's facilities, in concert with a proposed public trust." The Park Service thought it would control the trust as it controls other park partners, and in 1994 it expected a permanent subsidy for the Presidio. However, the intent of Congress in the 1996 Presidio Trust Act was to establish independent management of the Presidio, and a 1995 House of Representatives report deemed the GMPA for the Presidio unrealistic. The trust would manage the Presidio not in accordance with the GMPA but only "in accordance with the general objectives of the General Management Plan . . . approved for the Presidio."[31]

The legislation for the Presidio Trust actually created dual management roles, which inevitably created "turf" issues between the Park Service and the trust. The whole Presidio remains within the Golden Gate National Recreation Area, but the act divides it into two parts: the Park Service takes care of the land along the ocean and bay shoreline (area A), and the trust looks after the inland 80 percent, which has nearly all the buildings (area B; see map, opposite). The trust rents these buildings and uses the money to repair and maintain the buildings, landscape, roads, trails, and utilities, as well as to fund public programs and the trust's administration.

The trust board did not want the Presidio to compete with the 380-plus parks under Interior's budget, so the board did not use Park Service budget officers. Congress did appreciate the programs done by Park Service rangers and expected them to present some on the Presidio. However, the trust wanted to consider more intensive and extensive cultural offerings than would be

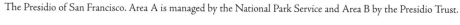

The Presidio of San Francisco. Area A is managed by the National Park Service and Area B by the Presidio Trust.

possible in other national parks, with the expectation that philanthropists and park partners would underwrite these programs. Many of these programs would be different from those offered by the Parks Conservancy or Fort Mason Center.

Many career national park employees, fearing privatization, said that Congress would try to replicate the Presidio Trust management model in other parks. Trust board and staff said the trust should not be a model because the Presidio has more than 764 structures—468 of which are historic—and is unique. We asked Park Service staff and conservationists to help us get this message out, but they focused on the message they did not like: Congress gave responsibility for a national park unit to an agency outside the Park Service.

John Reynolds, a "green diaper baby" born into the Park Service, was the highly respected

director of the Park Service's Pacific West Region. John took exception when people above him perpetuated the myth that "a $25 million park was the most expensive park in the country," explaining that "in any other national park the base [funding] would have just been for the daily operation," and then the superintendent could apply for more money for repairs, housing, and other needs. John and many other Park Service professionals did not believe that the Presidio could ever be sold. "But I think some of the political leadership in the [Interior] Department and the White House believed that it was possible," he said.[32] John was wrong on a major point: the Presidio was *not* a $25-million-a-year operation. That was only what Congress gave the Presidio Trust in its first budget—every year thereafter the trust would get less. The trust would have to earn the rest and borrow from the Treasury for capital investment—to be paid back with interest. When the time came for the trust to pay for all the administration, public programs, operations, maintenance, and police and fire services, and to cover other expenses, while also keeping a reserve fund for repairs, the expected cost was about $50 million a year in 1997 dollars—and that did not include capital investment in buildings and landscape.

Some of the problems originated in the Interior Department. Speaking of the interior secretary, Toby Rosenblatt said, "[Bruce] Babbitt was never particularly interested in the Presidio. . . . He did not favor the Presidio Trust. . . . He never came out here. . . . I remember on one occasion going to Babbitt's office with some of our staff to describe to him the Trust and the financial management plan and where we were going. And he had no interest in it at all."[33]

For a few years disputes kept surfacing between members of the Presidio Trust board and staff and the Park Service and Department of Interior officials, who have very different management and financial responsibilities, as they did between the trust and some members of the public who expected trust decisions to resemble those of the Park Service. We were grateful for the Park Service officials who helped the trust begin its work.

MANAGING THE NEW PRESIDIO

The Park Service gave the Presidio a year of transitional care after the Army left and in 1998 turned over to the trust the central 1,168 acres of the former post's 1,491 acres. The trust faced many challenges: cleaning up old Army waste dumps, updating several hundred old buildings, convincing the public that achieving self-sufficiency by 2013 required a bottom-line focus, and then weathering the 2001–03 economic downturn.

A Landmark Environmental Cleanup Deal

The biggest problem facing the trust was environmental cleanup. For two centuries and a quarter, soldiers tossed their discards over their shoulders—which was not too bad until after World War I because there was little to discard that was toxic. But during the next seventy-five years, the Army filled many gullies with all sorts of unknown materials. These nineteen landfills had to be analyzed and then removed, neutralized, or capped.

The law for the cleanup of military lands calls for a community oversight group, a Restoration Advisory Board of local citizens. Two leaders of that group were members of People for the Presidio. Doug Kern and Mark Youngkin said they were dissatisfied with the Army's efforts and were afraid that the Park Service would settle for too little funding for too little cleanup over too long a time—and that the Army's plan could be finalized before the trust could weigh in on it.

Michael Alexander and Deborah Reames reviewed the Army's plan and said it would not make the Presidio clean enough for a national park. Thanks to them and the community oversight group, the Presidio got community support for a thorough cleanup plan: fifty-four letters (remarkable for such an arcane subject) urging a fully funded cleanup program, which buttressed the trust's plea to Congress for sufficient funding.

In the spring of 1999, the trust negotiated a landmark environmental cleanup deal. The Army had offered the Park Service $6 million for cleanup followed by thirty years of monitoring contaminated sites. Under the terms of the deal, the Army would instead provide $100 million over four years for a total cleanup, to be managed by the trust.[34] The Park Service was reluctant to sign the agreement because it would not be in charge. Two high-ranking Department of the Army officials attended the May 1999 signing ceremony, as did Congresswoman Pelosi and the trust's board of directors. The sole Park Service representative was Presidio general manager B. J. Griffin. Such an important agreement merited a deputy secretary of the interior, or at least a Park Service regional director.

Updating the Old Presidio

After the Presidio's closure was announced, Congress had directed the Army to update the post. Before the trust got under way, the Department of Defense, the Park Service, and a few tenants spent over $115 million on water, sewer, and electrical systems and rehabilitated some buildings and sites.

Despite these millions of dollars spent on infrastructure, much of the old post was still in bad shape when the trust took over. Between 1998 and 2002, the trust spent $16.3 million more to upgrade the Presidio, yet roads, irrigation systems, and other necessities still need repair. Preserving the many historic structures, in a landscape that is also largely historic, is one of the trust's priorities and challenges. One day Jim Meadows followed my gaze from his office window across the main parade ground to the five matching historic 1895 barracks on Montgomery Street. "It will cost $8 million to make each building usable," he said—$40 million of the estimated $589 million (in 2001 dollars) needed to convert the Presidio to a national park.[35] The cost of converting this National Historic Landmark District is unparalleled in the national park system. And many newer buildings need rewiring, access for the disabled, plumbing retrofits, seismic reinforcement, and lead paint and asbestos abatement to meet current codes.

The Presidio's former military housing was seen by many as a partial solution to San Francisco's housing crisis. Some local activists concerned with low-cost housing and the city's growing homeless population asked the trust to let the City of San Francisco manage 463 apartments built in 1953 near Baker Beach. Both the Park Service and the trust wanted the poorly sited complex removed to restore a highly visible area of parkland. The trust intended to earn enough money from the buildings to tear them down and replace them with better apartments in less visible locations. The city wanted to keep them permanently. Housing advocates put the issue before the city's voters in November 1998. The ballot measure won but had no force of law on federal property. The trust signed a contract with the John Stewart Company to manage the Presidio's 1,650 housing units, including the Baker Beach apartments.[36] Nevertheless, the trust was committed to providing low-cost housing on the Presidio. There is a uniquely appropriate low-cost housing program called Swords to Plowshares that houses one hundred needy war veterans in two renovated modern barracks and provides them with job training and counseling.

As more people occupied vacant buildings, the rejuvenation of the Presidio became more apparent. Friends who went to hike and picnic told me that it was looking much better. To meet our financial goals, the trust tried to fix up and rent quickly as many buildings as possible. The economy was booming in the late 1990s, the San Francisco rental market was extraordinarily tight, and everyone knew those conditions would not last forever. Some tenants got tax credits for historic rehabilitation and did self-financed projects. The trust used the borrowed Treasury funds and some rental revenue to finance the retrofitting of other buildings, and to remove unsafe trees and renew parts of the landscape. Jim Meadows had expected to contract out much of the rehabilitation and

maintenance work. Instead, he hired Park Service employees who were experienced with the post's landscape care, building maintenance, and water treatment plant. They remained federal employees, often with bigger salaries, but their jobs were then "at will," as in the private sector. With all this planning and construction under way, we realized that the Presidio presented opportunities for a laboratory of new technologies and sustainable practices. An extensive onsite salvage and recycling program and a "Sustainable Building Guidelines" booklet promoted "sustainability," and the Presidio became a testing ground for new energy and water conservation programs, "green" building materials, and alternative-fuel vehicles.

In the booming economy, the trust board focused on one of the Presidio's biggest problems: the 1969 Letterman Hospital complex. UCSF's negotiations with the Park Service for the ten-story hospital and research building had been unsuccessful. Sixteen developers bid for the right to replace the obsolete, nonhistoric buildings. Of four finalists, the filmmaker George Lucas offered the best combined financial and creative contribution to the Presidio: the Letterman Digital Arts campus. He won the right to lease the 23-acre site and replace the 900,000-square-foot complex with new buildings of comparable density, set on 17 landscaped acres that include a 7-acre meadow.

Mounting Criticism

In April 2000 the trust and the Park Service put on a symposium about visitors' experience and the park's interpretation. Participants said that the record of change at the Presidio gives a unique chance to tell about American expansion in the West and across the Pacific. Others noted that the Presidio's history is a microcosm of the evolution of America's social attitudes toward men, women, and families in the military, and the place of the military and veterans in our society. Another theme was how the Army had changed acres of sand dunes to gardens and forests, and how the Park Service and the trust together were shaping a vegetation management plan to provide more space for native plants, renewal of the Presidio's forests, and restoration of the Army's gardens and lawns (figure 43). The symposium conveyed the message that as the Presidio filled with civilian tenants, it would become a new community. Both the trust and the Park Service wanted visitors to perceive the Presidio as a unified whole.

The symposium was an interlude of harmony amid growing public criticism of the trust. Buildings filled with office tenants, a film center, and Internet companies, as well as nonprofit groups and foundations. Several private schools seized the chance of "swing space" for their students while

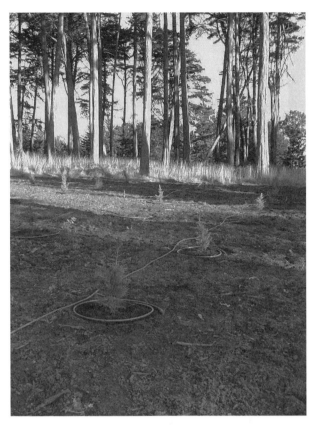

Figure 43. *Historic Forest:* From a distance the Presidio of San Francisco appears as a vast forest. The Army transformed a sandy, windblown reservation into a forested post beginning in the 1880s. Since only a few species were planted, and because many trees were planted in a relatively short period of time, trees are declining at the same time. The Presidio Trust has begun an ambitious reforestation program to transform the even-aged forest into an uneven-aged one, with disease-resistant species to replicate the original species used by the Army. (Courtesy the Presidio Trust, Peter Ehrlich, 2001.)

they remodeled their campuses. Renters came into the housing, some from the trust or Park Service, but most from the general public (ultimately, the trust expects most residents to be people working on the Presidio). Those who believed the Presidio's best future was the visionary global center sketched in the Park Service's 1994 plan felt betrayed. But they did not understand the Presidio's economics: three years before the trust got under way, the Army abruptly moved out most of the activities and personnel that were to pay rent and keep buildings occupied over a five-year transition period. And when UCSF did not lease the obsolete Letterman Hospital, that potential income disappeared; there would be no money from that site for many years. Few understood the harsh impact of these changes on the trust's finances.

Under attack, the trust board and staff became defensive when asked, Why can't you carry out

the 1994 plan? We responded that nonprofits could never fill all the buildings and a limited tenant base would make the Presidio more vulnerable to economic fluctuations. The Park Service sometimes waits for years to fill a building with tenants it deems just right, but neither the trust nor the Presidio's buildings can wait very long. We had to build on reality. Rather than the imposed role of a global center, the Presidio's future might not have a "high concept" but would evolve organically over time, out of the very process of its conversion from post to park, the renewal of its landscape and structures, and the sum of its varied for-profit and nonprofit tenants.

Park Service employees expressed their resentment through bureaucratic obstruction. Reviews of draft interagency documents were late, criticized minute details, and became public without the customary internal discussion. (Superintendent Brian O'Neill was not part of these unfortunate actions.) All of us associated with the trust reached our limit of patience when a Park Service employee—with the approval of John Reynolds, the regional director—went to the *San Francisco Chronicle* on May 4, 2000:

"We don't want to see it become a business park," said Holly Bundock, a spokeswoman for the National Park Service in San Francisco. "The dot-coms have discovered the Presidio, and they're rushing to get in there. We're not against using the buildings that are there. When we managed the Presidio, we rented out about 30 percent of the available space to nonprofit groups. But we think the emphasis [in selecting tenants] should be on philosophical discourse and intellectual stimulation, as opposed to raking in money."[37]

Representatives Nancy Pelosi, George Miller, and the chair of the Interior Appropriations Subcommittee, Ralph Regula (R-OH), called in the head of the Park Service and told him to get his people under control. The Presidio Trust board member Mike Heyman, a seasoned administrator, asked Toby, Jim Meadows, and me to join him in a series of meetings with John Reynolds and Brian O'Neill. We talked through some of the divisive issues.

Public opinion then focused on hard-charging Jim Meadows. A handful of vocal people were repeatedly quoted in the press about how the Presidio could be run more cheaply and with less development. There were no stories about historic building preservation or even the $100 million environmental cleanup. People compared the trust's businesslike style unfavorably with the Park Service and the advisory commission. The constant hostility wore on everybody.

Restarting Post to Park

The trust decided to clear the air by restarting the planning process and doing only short-term leasing until it updated the plan for area B, a big setback in the still-expanding economy. The trust hired more planners with San Francisco savvy and got to work. We hoped to get public input and broader support for a new, realistic Presidio Trust plan. During 2000–2001, Jim Meadows had hired new deputies in real estate and planning who were better able to deal with local political pressures. A new chief financial officer from the U.S. Treasury made the entire financial structure, always fully available for public scrutiny, more transparent. The new deputies were backed by proven leaders: Deputy Director Craig Middleton, a manager of facilities and maintenance, a seasoned legal staff, and a knowledgeable team of specialists Jim had gathered in such areas as natural resources, historic preservation, and history.

The draft plan was released in the fall of 2001. The Citizens' Advisory Commission held a contentious hearing on October 22. Then for several months Presidio Trust staff teams listened to civic, historic preservation, conservation, and neighborhood organizations and made revisions. Preservation groups were the first to understand the depth of the trust's commitment to preserving the National Historic Landmark District. Others gradually began to be more comfortable with the requirements of the trust's legislation.

The U.S. economy had begun a downward slide at the end of 2000 and was tumbling when the draft plan emerged. Under Jim Meadows's aegis, the Letterman Digital Arts complex had been approved to eventually contribute $5.8 million in annual rent to the trust. Until the economy improved, it would be impossible to negotiate another big contract. Internet service providers forfeited security deposits for offices in Presidio warehouses. The rental housing market softened and people began to bargain over their rents. The trust had constructed a state-of-the-art exhibition space in the Officers' Club. Two well-reviewed exhibits of Russian and Japanese art—each touching on an aspect of the Presidio's history—were displayed for several months, but marketing this unknown venue and security requirements were too expensive, so the trust scaled back its near-term expectations.

The management plan was months from completion. Jim Meadows's expansive style had guided the beginning of the Presidio's transformation, but the Bay Area's economy and the Presidio's immediate outlook were significantly depressed. By mutual agreement, Jim left the trust in December 2001. Craig Middleton stepped in as acting executive director, and the planning process continued.

The Presidio Trust Management Plan

The Presidio Trust Management Plan was unveiled on May 21, 2002, in an atmosphere of public support. In response to public requests the plan was more specific about land use. It called for 99 more acres of open space and a reduction from 5.96 million square feet to 5.6 million or less of building space. Residential and office uses would each occupy about one-third of the building space and the remaining third would be available for public use. To deal with the challenges of time and economics, the plan allowed for change, guaranteed the involvement of the public and public agencies in many future adjustments, constrained new construction, and expected more from partnerships.

The *San Francisco Chronicle*'s editorial board expressed its positive reaction:

> The designers rightly play up the preservation ethic woven into the planning framework that will guide the federal park for the next 30 years. . . . But the plan contains a sober-minded slap to wishful thinking about a global study center that pervaded prior proposals. The Presidio needs a mix of uses to inject life, interest and financial health, the new outline declares. This message, contained in a draft two years ago, has touched off worry, much of it overhyped. The Presidio leadership will need to work hard to dispel this suspicion and explain the need to balance development and preservation.[38]

Most of the speakers at a public board meeting in June favored the plan, and the trust board approved it on August 28, 2002. Soon after, Lucasfilms' Letterman Digital Arts project came into the public eye again, as well as the proposed rental of the Montgomery Street barracks. The news media discussed planning and architectural issues and the trust's financial challenge. The trust's board of directors initiated a national search for a permanent executive director.

AN ASSESSMENT

In October 2002 Craig Middleton assessed the trust's first five years. The first three and a half years of the trust's management of the Presidio were in a high-rolling economy. The trust grew from one to five hundred employees, to a full administrative staff with office support and in-house crews for construction. Payrolls grew exponentially. The trust renovated nine hundred housing

units, established cash flow, negotiated the Lucas project, and rented some of the nonresidential buildings. The trust had achieved national stature.

At the time the new management plan was approved, the Bay Area economy had not yet begun to recover. Downtown San Francisco had many office vacancies and competed for renters. The trust trimmed its staff by over 20 percent, but the organization was still too expensive and needed improvements in communication, coordination, and morale. Congress had reduced the trust's appropriation faster than expected, and the trust had to use its money for essentials. Craig presented a less costly work plan for the next five years. The trust would seek private contributions and endowments for trails and overlooks, for restoration of major historic buildings and sites such as the Officers' Club and the main parade ground, and for public programs of national distinction.

The trust's public affairs staff's efforts to get out the word about the trust's goals, work, and finances were having a positive impact on the public's understanding. Craig felt, and the board agreed, that the trust had turned a corner. On December 6, 2002, after interviewing candidates from all over the United States, the board unanimously approved Craig Middleton as the new executive director of the Presidio Trust.

The management plan had incorporated many GGNRA staff suggestions, and most Park Service professionals had accepted the trust. When Jonathan Jarvis became the Park Service regional director in the fall of 2002, he came into a calmer situation. The public also apparently viewed the trust with less anxiety and showed appreciation for the way it was managing the Presidio. The Park Service and the public expressed more understanding of why Congress had created a different kind of governance and had established the trust to keep the Presidio as part of the Golden Gate National Recreation Area and the national park system.

TEN YEARS

In September 2003, Bill Reilly and I were "termed off" the Presidio Trust board, Jennifer Hernandez was not reappointed, and Mike Heyman resigned. Lydia Beebe, Bill Wilson, and Joseph Yew were appointed by President Bush, and David Grubb was appointed by Interior Secretary Norton.

On October 16, 2004, Congresswoman Nancy Pelosi joined Brian O'Neill, Toby Rosenblatt, and Craig Middleton on a stage at the main parade ground to celebrate the tenth anniversary of the formal change from post to park. Toby spoke of the ever-strengthening alliance between the

Park Service, the Parks Conservancy, and the trust and announced a major donation to create Immigrant Point, a new scenic overlook. He summed up a decade of progress: 5,000 people were living or working on the Presidio; nearly all the residential units, including 250 historic homes, were now occupied; 43 nonresidential buildings, including 23 historic ones, had been rehabilitated and leased; more than $35 million of private money had been invested in the preservation of the Presidio's historic buildings; and the trust was now earning over $40 million a year to support the park. Toby gave heartfelt thanks for "the dedication, wisdom, faith, and foresight of the Presidio's many, many supporters in Congress," especially Senators Boxer and Feinstein and above all Congresswoman Pelosi.

Ed Wayburn and I were moved when Nancy Pelosi expressed her gratitude to the people who had supported creation of the Golden Gate National Recreation Area and the saving of the Presidio. We could only wish that a congressman who had been dead for more than twenty-one years could have heard the applause following Nancy's touching and reverential remarks when she lauded the genius of Congressman Phillip Burton.

AFTERWORD

I've told this story so people will not take the Golden Gate National Recreation Area for granted. Almost everyone who drives along scenic Highway 1 past the open San Mateo County cliffs, beside San Francisco's long Ocean Beach, through the forested Presidio, across the stately Golden Gate Bridge, and through the verdant West Marin countryside to Point Reyes National Seashore presumes that this stunning coast was always the way it looks now: natural, open, unified, and protected. In this book I've described what the windshield view cannot reveal to a visitor: how much of this land was affectionately protected piece by piece, and then how the diverse pieces were united by the legislation for the Golden Gate National Recreation Area. I've also told this story in the hope that our experiences will inspire others and that they will take ideas from our efforts to organize successful park campaigns in other places.

Some future advocates may say that we gathered land for this park at a most fortunate time—and they would be right in a number of ways. Most of all, the GGNRA came into being at a time when many people believed in the power of government to do good, and when there was great optimism about the opportunities—and the necessity—for individuals to contribute to the betterment of society, the nation, and the world. The leaders of People For a Golden Gate National Recreation Area shared an outlook shaped by our common heritage and experiences: President Roosevelt's programs during the 1930s Depression, the surge of national patriotism during World War II, President Truman's GI Bill for veterans' college education, the Marshall Plan, which helped rebuild devastated European countries, President Eisenhower's appointment of socially activist Supreme Court justices, President Kennedy's Peace Corps for American public service overseas, and President Johnson's War on Poverty. From the CCC to Headstart, participants in government programs learned to do more and eventually to earn more. Increased self-empowerment inspired thousands of people to participate in progressive movements, including those for women, civil rights, and the environment, so they could prevent harm, right wrongs, and do good.

Thus, we were personally ready to act when officials in President Nixon's administration announced a farsighted park program especially for city people: unneeded military land in some urban areas would be transformed into national parks. We were only too glad to unite behind a program that could make the lands at the Golden Gate a national park! Believing in government of, by, and for the people, we expected our government to save a national icon if we rallied to the cause. We needed political leadership, and it was there for us in the person of Congressman Phillip Burton, who became our movement's political champion. Ed Wayburn and John Jacobs showed me how to organize our group to work with Phil and with Congressman Bill Mailliard, and then PFGGNRA rallied conservation- and civic-minded groups and individuals, our California senators, and more government supporters. In that climate of hope we had little trouble finding a cadre of volunteers to work on the project, and a host of people cheered us on from the sidelines. We got a much larger park in 1972 than almost anyone had dared to anticipate. The same energy and spirit of collaboration carried us through the rest of the 1970s, a period when we helped double the size of the park.

Some land preservation activists are quick to remind me of the advantage we had with Phil Burton as our main advocate in Congress. Certainly Phil's efforts gave us the biggest and best park at each stage of the legislation. As Ed Wayburn once said, "He always helped, but it was not until the GGNRA that I realized how deep his commitment was and how strong he would stand or how consummate a politician he was."[1] I'm deeply grateful for what Phil did for us, but I also remind these activists that they may not be aware of their advantages.

I believe each campaign has to find—and learn how to use—its particular advantages. Usually our legislators had secure seats, so PFGGNRA could take a bolder approach with them. We learned to work with the election cycle. We were bolder at the beginning of a legislative session than near its end; however, in the rush at the end of the 1972 legislative session PFGGNRA took advantage of opportunities to add several hundred acres to the park. We used the time between sessions to prepare information for newly elected or reelected legislators, and sometimes to meet with them.

We also came to recognize how much all of us depended on the efforts of those who came before us. Congressmen Burton and Mailliard, Interior Secretary Hickel, and PFGGNRA did not start with a blank map and a passive citizenry. We had the advantage of several generations of timely conservation activism around the Golden Gate. The city surveys for San Francisco first showed land to be set aside for parks in 1846–47, and shoreline protection began in 1872. The Sierra Club

was founded in 1892, Muir Woods was saved in 1907, the protection of Mount Tamalpais and choice parcels of Marin land started in the 1920s, the saving of Point Reyes began in the 1950s, and the protection of the Marin headlands began in the 1960s. From 1872 to 1970, the forebears of PFGGNRA created an immensely valuable inheritance of publicly owned land that set the precedent for conservation. With a boost of 4,700 federal acres, most of it undeveloped Army land, a century of foresight had saved enough of the Bay Area's natural environment to become the basis for successful protection of the lands at the Golden Gate.

We also discovered the advantage of a roused and educated population. By supporting the training programs of Audubon Canyon Ranch and the Environmental Forum, some of the same people who helped save parkland in Marin County enlisted others to help enlarge the constituency of voters and educators who would encourage environmental preservation at the polls, at public hearings, and in classrooms. Local organizations, county government, and the public have benefited as program graduates have effectively built support for pro-environment candidates in local elections. Some graduates have become political leaders, directed agencies, or held public office. Others are wildlife educators, naturalists, and guides. [2] SPUR's public programs have achieved related results for urban residents, projects, and programs.

To the advantages of timely land conservation and environmental education I would add three others: the people who were part of the effort for the GGNRA were not afraid to dream big dreams, they were able to recognize their prophets, and they enjoyed bipartisan support. Ed Wayburn's imaginative pursuit of "the big picture" in Marin County was from the beginning the basis of PFGGNRA's outlook and fit with Sierra Club ideals. It would be a park with maximum ecological benefit for plant communities and wildlife habitat. It would also be as big an area of scenic open space as possible, for the personal enjoyment and appreciation of city residents—a true "park for the people." Only a broad sweep of open land would make it possible for city dwellers to have the kinds of experiences that visitors have at Yosemite or Yellowstone. When the many-layered historical attributes and diverse recreational and educational opportunities of this park became apparent, public support increased in depth and breadth. With so much to offer, we could envision that there would be something of value to anyone somewhere in this park.

Fortunately for us, Ed and Phil were two prophets who recognized each other and began to work together before the GGNRA. They were ready for the East Fort Miley activists—who were ready for them, and for Interior Secretary Hickel and John Jacobs, after John came on the pro-

posed national park and recognized its value to the Bay Area. The first GGNRA superinten-
dent, Bill Whalen, foresaw that this national park would need ongoing public support and made
the advisory commission an effective catalyst for increased public involvement. The outstandingly
successful, publicly supported Golden Gate National Parks Conservancy got under way during
Bill's time as superintendent and as director of the National Park Service.

Every day, I can see that the Golden Gate National Parks are even better than any of us thought
they could be: they ensure that our dynamic metropolitan area will forever keep its stunning nat-
ural setting. Much of what we did is reproducible, but not in every time and place. It is harder in
some times than in others, which is why environmental protection advocates must take advantage
of opportunities as they come along. Until the end of President Carter's administration, conser-
vationists could count on bipartisan political support, not only for parks but for all kinds of en-
vironmental protection measures. But later, Presidents Ronald Reagan and George W. Bush each
appointed a secretary of the interior, James Watt and Gale Norton, who renounced a balanced
view of their responsibilities, scoffed at bipartisan collaboration, promulgated policies principally
committed to resource exploitation, and undercut environmental protection laws—many of
which had been enacted during President Nixon's administration.

When the GGNRA got under way in 1973, it seemed at first that the future of the parklands would
become almost entirely dependent on the people who would administer them. Yet PFGGNRA
soon understood that the park would also continue to depend on us. We were immensely fortu-
nate that the people involved in the management of this new enterprise cared deeply about the
quality and success of their efforts. From the very beginning, Bill Whalen and John Kern exem-
plified that caring. "We didn't work . . . eight hours a day," Bill said. "We worked fifteen or sixteen—
whatever the job required . . . because we were enthused with the work we had and knew that it
was paying off." Bill and John were at the bottom level of a three-tiered structure: above them, the
general on the Presidio and the Park Service regional director reported to the secretaries of the
army and the interior. In 1995 John could declare to an interviewer: "I'm proud to say that 100 per-
cent of all the negotiations were handled [by] the superintendent, Bill Whalen, or his successors
and myself for the next eleven years—we never had a dispute that we couldn't resolve locally, that
had to go back for higher approval."[3]

Although government employees were managing the park and doing an outstanding job, park
advocates continued to remind themselves of the conservation adage "All of our gains are tempo-

rary; all of our losses are permanent." PFGGNRA has been constantly vigilant. We have had to make sure that private properties within the GGNRA and Point Reyes boundaries are purchased in a timely manner. We blocked development of a music studio at the northern end of Wolfback Ridge, helped forestall a small Sausalito subdivision straddling the park boundary, prevented development of an electrical substation in the Olema Valley and the subdividing of a property on the Bolinas mesa at the southern end of Point Reyes National Seashore. We work proactively. We have reminded county planning staff from time to time of the park's boundaries so the owner of land not yet acquired by the Park Service doesn't try to sneak in a project. We ask people to contact us if they hear of proposed changes or development plans that might harm the park.

Until any parcel of private land included in the parks is purchased by the Park Service, it can be developed. Some of the private land in the GGNRA and Point Reyes National Seashore still awaits purchase. Both parks still have some discontinuous areas because properties have not been acquired. In 2004 there were 114 private tracts totaling 2,887 acres remaining to be bought in the GGNRA. Most of them were in Marin County and under 3 acres in size. Even so, the remaining tracts included the 330-acre Gallagher Ranch in Marin and the 167-acre Picardo Ranch in San Mateo County. At a cost of $102,417,683, the Park Service had purchased 234 tracts totaling 24,681 acres.[4]

The ever-increasing number of visitors more than matches the increase in size of this national park. At best, the figures are estimates. GGNRA Chief of Interpretation Howard Levitt estimated that in 2001 the Golden Gate National Parks had 17 to 20 million visitors, well over the official figure of 15.4 million. Point Reyes National Seashore had 2.4 million visitors that year, according to Superintendent Don Neubacher.[5]

I believe that much of the success of People For a Golden Gate National Recreation Area came from our group's agreement on the size of the park and our tightly controlled organizational structure. PFGGNRA showed flexibility only about strategy and tactics, not about the area of land we wanted to save. Our daily work was issue-oriented. Every public statement or letter in the name of the organization—which usually had to be produced quickly—was reviewed by Ed Wayburn or by me for consistency and quality. We never incorporated PFGGNRA. So much happened so fast that the group met only irregularly to review issues for organized consensus.

The people who clustered around PFGGNRA each offered work, wealth, or wisdom—usually listed as the attributes of effective board members—and while many of us began as amateurs, we soon aimed for "downtown" standards. When Bob Young made a map, Lloyd Scott

arranged for our stationery design, Jim Weinberger wrote draft legislation, and Roger Hurlbert produced the letter I had written, everything was done professionally and on time. (There was one exception, and it oddly worked in our favor. For nearly a year, our information sheets were mimeographed and amateurish. It kept some people from taking us more seriously than we would have been able to handle at that point.)

After the park was authorized, new people joined us. Jo Julin, who helped us with Marin County planning issues and later became a county planning commissioner, worked for a bigger park; Earl Blauner, a lawyer, devoted himself to transportation planning and getting public transit to the park; and Madlyn Stein reviewed environmental documents.

We had very little dissension within our organization. Most of us have seen the energy of other organizations sapped by group infighting. Even if over worthy goals, infighting makes it hard for people to focus their efforts for the battles that are part of any political campaign. Our group has had at least four central strengths, originating with Ed Wayburn, that prevented dissension. The first was to include only those people in the group's leadership who had a broad civic or conservation interest in the establishment of a park of national stature, rather than a personal interest in a few parcels of land or a single activity. The second was to hew to the group's firm and unified agreement about the park's boundaries, which were based on the resources of the land itself and its high value to the public and could be justified in maps, photos, and descriptions. The third was to be as comprehensive as possible and make every effort to include all needed information in any speech or letter, because we rarely got a second chance. And, even if a letter or speech did not win over an audience, the fourth was never to make the writer or speaker feel like a failure. We'd say, "You did OK. Next time, you might want to include something about . . ." Over the years, only a few people felt out of place—they seemed to feel insufficiently individually appreciated—and dropped away.

Since my term on the Presidio Trust board of directors has ended and the Citizens' Advisory Commission has not been reauthorized, I've restarted People for the Presidio. Our meetings give conservation, historic preservation, and civic groups the chance to discuss their concerns about the Presidio and nearby national parklands at the Golden Gate with Park Service and Presidio Trust staff. I've returned to spending much of my time as an activist, but now I help others get involved or plan campaigns, locally and elsewhere. In recent days, I discussed with the Fort Point and Presidio Historical Association's president what her group could do to enliven a Presidio program, reviewed plans for a maritime education center at San Francisco Maritime National His-

torical Park, talked with a friend who has organized a People for Point Reyes National Seashore, and drafted a response to a paper by the leader of a campaign to protect the National Mall in Washington DC. By teaching park advocates to use what I have learned, I hope to ensure their success with campaigns and projects.

People For a Golden Gate National Recreation Area is still active. We are a network of groups and individuals, and we like to boast that we are the longest-lived ad hoc committee on record. Through PFGGNRA, I continue to work in three counties to solve problems and help with projects in the Golden Gate National Parks, Point Reyes National Seashore, and San Francisco Maritime National Historical Park. These efforts also give me a chance to share my experiences with some of the people who will support these parks in the future and carry on the efforts of People For a Golden Gate National Recreation Area—an organization of upbeat, hard-driving, environmentally concerned and politically aware people, who for thirty-five years have been having a good time working together to achieve results we consider worthy of the magnificent Golden Gate.

NOTES

CHAPTER 1

1. The explorer, soldier, and political leader John C. Frémont christened the strait in 1848, but not for California's gold: "To this Gate I gave the name of Chrysopylae, or GOLDEN GATE; for the same reasons that the harbor of Byzantium (Constantinople afterwards) was called Chrysoceras or GOLDEN HORN." John Charles Frémont, *Memoirs of My Life* (Chicago: Belford, Clarke, 1886).

San Francisco's presidio was established by Juan Bautista de Anza's expedition, a party of 240 soldiers, priests, women, and children who, with 1,000 head of livestock, came up the coast of California from northern Mexico. They also established a mission; soldiers helped protect it and the settlements founded in the vicinity. The Golden Gate had been discovered by Europeans only seven years earlier, in 1769, when a Spanish company riding north from Baja California climbed to the top of Sweeney Ridge above Pacifica and saw the capacious harbor of San Francisco Bay spread out before them. In 1775, under the command of Juan Manuel de Ayala, the Spanish frigate *San Carlos* had sailed through the Golden Gate and explored, charted, and mapped the bay. (The other presidios were at Monterey, Santa Barbara, and San Diego.)

2. James Marshall discovered gold on January 24; Mexico signed the Treaty of Guadalupe Hidalgo—ceding California to the United States—on February 2, before word of Marshall's discovery had spread.

3. A memorable description of Fort Point under construction may be found in Richard Henry Dana's *Two Years Before the Mast*.

In 1869 the federal Board of Engineers for Fortifications declared Fort Point outmoded; gunfire had demolished similar forts in the eastern part of the United States during the Civil War. Emanuel Raymond Lewis, "A History of San Francisco Harbor Defense Installations/Forts Baker, Barry, Cronkhite, and Funston," 75, unbound report for the Division of Beaches and Parks, State of California, June 1965, GGNRA archives, San Francisco.

4. The American city of San Francisco was the legal successor to the Mexican pueblo of Yerba Buena and as such the inheritor of that village's "pueblo lands," its commons. Following Mexican rule in 1846, land around the booming port was quickly auctioned off or taken over by squatters. But in 1865 a U.S.

Circuit Court ruling affirmed that San Francisco was indeed entitled to the "pueblo lands," then known as the "outside lands"—the sand dunes west of Divisadero Street and out to the Pacific Ocean. Squatters had also claimed much of this undeveloped land.

5. Boyd Stewart died in 2004.

6. Some of the early parks, such as Mount Tamalpais State Park, did not change hands and continue to be owned and administered by other agencies (see chapter 8).

7. The Antiquities Act of 1906 was first intended to give legal protection to archaeological sites and artifacts located on public land. It also gave U.S. presidents the power to designate national monuments on land under the jurisdiction of the federal government if the land encompassed sites, structures, or landmarks of historic or scientific interest. Many other countries also protect archaeological sites on private land, but the United States does not.

8. Lincoln Fairley, *Mount Tamalpais: A History*, with James Heig, picture editor (San Francisco: Scottwall Associates, 1987).

CHAPTER 2

1. These weapons systems were inactivated in 1974.

2. For example, an 8.91-acre portion of the Frank Valley Military Reservation above the town of Muir Beach was acquired by the county from the General Services Administration in 1960 and named Muir Beach Overlook. Emanuel Raymond Lewis, "A History of San Francisco Harbor Defense Installations/ Forts Baker, Barry, Cronkhite, and Funston," 278–79, unbound report for the Division of Beaches and Parks, State of California, June 1965.

3. The Surplus Property Act of 1944, as amended, 50 U.S.C. 1622(h). This section of the act was repealed in 1972.

4. Personal communication from Margot Patterson Doss, 2001. For thirty years she delighted *San Francisco Chronicle* readers with her column about local sites and trails. Margot Patterson Doss died in 2003.

5. "Congress Asked to Probe Action on Fort Property," *Haight-Cole Journal*, July 7, 1960.

6. Lewis, "San Francisco Harbor Defense Installations," 6–7.

7. Information about Fort Point comes, in part, from John A. Martini, *Fort Point: Sentry at the Golden Gate* (San Francisco: Golden Gate National Parks Association, 1991).

8. Bill Thomas, taped interview by Amy Meyer and Randolph Delehanty, 11/9/01, GGNRA archives.

9. PL 91-457.

10. "Many Eyes Are on Them—Bay Forts in Danger," *San Francisco Chronicle*, July 13, 1970.

11. On May 2, 1962, in recognition of the Presidio's national historic landmark status, the Advisory Board on National Historic Sites, Buildings, and Monuments declared in a memo: "should the Depart-

ment of Defense and the Department of the Army ever declare the Presidio, or any part of it, surplus to its needs, the Department of the Interior and the National Park Service should consider whether all or part of the area declared surplus should be added to the national Park system as a national historic site."

12. "Squeezing Out Marin's Dairy Farms," *San Francisco Examiner*, February 13, 2000.

13. John Hart, *Farming on the Edge* (Berkeley and Los Angeles: University of California Press, 1991), 54. In 2000 the county had 37 dairies.

14. George Wheelwright III was the co-inventor of the Polaroid-Land camera. Both the Banducci and the Green Gulch ranches would later become part of the GGNRA.

15. Katy Miller Johnson, "Catalyst and Citizen-Lobbyist in Washington," oral history interviews by Ann Lage, 1990, in *Saving Point Reyes National Seashore, 1969–1970: An Oral History of Citizen Action in Conservation*, 15, Regional Oral History Office, The Bancroft Library, University of California, Berkeley (hereafter, Bancroft Library), 1993. Other information from this oral history is woven throughout this section.

16. House Committee on Interior and Insular Affairs, *Point Reyes National Seashore, Calif.*, 87th Cong., 2nd sess., 1962, H. Rep. 1628. The National Park Service had listed Point Reyes as a potential national park in a 1935 survey and proposed to protect 53,000 acres of the peninsula, but nothing happened.

17. PL 87-657 included 64,000 acres, of which 11,416 acres are state tidelands. The park gradually expanded to include Drakes Beach and McClure's Beach county parks, additional ranch lands, and partially subdivided land along the park's edges. The park now includes more than 71,000 acres.

18. From the West Marin General Plan map, planning consultants Harold and Mary Summers, Dan Coleman Associates, based on the Marin County Board of Supervisors resolutions of July 10, 1967, amended March 4, 1969.

19. Most of the information about Audubon Canyon Ranch and its effect on Marin politics, here and later in the chapter, comes from the book by the Audubon Canyon Ranch leader L. Martin Griffin, M.D., *Saving the Marin-Sonoma Coast*, foreword by Harold Gilliam (Healdsburg, CA: Sweetwater Springs Press, 1998). Edgar Wayburn was one of Marty Griffin's medical school instructors.

20. Paul N. "Pete" McCloskey, Jr., "An Environmentalist in Congress: Urging Presidential Action on Point Reyes," oral history interview by Ann Lage, 1990, in *Saving Point Reyes*, 321 (Appendix B, letter dated September 16, 1969).

21. President Kennedy proposed the bill to establish the Land and Water Conservation Fund in February 1963 to help states plan, acquire, and develop recreation resources and to pay for new federal recreation lands. PL 88-578 passed the House and Senate with strong bipartisan support and was signed into law on September 3, 1964 by President Lyndon Johnson. The House Interior Committee's report on the bill declares, "It is important that acquisition be undertaken before the land becomes unavailable either because of skyrocketing prices, or because it has been preempted for other uses." The Senate Interior Committee's report insists that "in providing outdoor recreation resources and facilities for the American people, the greatest emphasis should be given to those areas with large concentrations of people."

22. McCloskey, "Environmentalist in Congress," 335 (Appendix G, a memorandum for John D. Ehrlichman from the lawyer John C. Whitaker).

23. William J. Duddleson, introduction to *Saving Point Reyes*, xi, xx.

24. Boyd Stewart, testimony before the Senate Interior and Insular Affairs Committee, Subcommittee on Parks and Recreation, February 26, 1970.

25. John D. Ehrlichman, "Presidential Assistant with a Bias for Parks," oral history interview by William J. Duddleson, 1991, in *Saving Point Reyes*, 355.

26. Duddleson, intro., xxii, xxiii. Bill Duddleson was of great personal help to me in sorting out the details of the S.O.S. campaign.

27. Personal communication from Margot Patterson Doss, 2001; she helped plot this response.

28. Editorial, *New York Times*, Sunday, January 31, 1965.

29. Marin County Planning Department, *The Visitor in Marin* (1970), 4, 11. By way of comparison, the Marin County Convention and Visitors Bureau estimated that in 2003 there were between 200 and 250 bed-and-breakfast and motel rooms between Stinson Beach and Tomales. Personal communication from Lynette Kahn, West Marin Chamber of Commerce.

30. Marin County Planning Department, *Can the Last Place Last?* (1971), i–iii.

31. Personal communication from Marjorie Macris, 2004, the Marin County planning director from 1978 to 1984.

32. In 2002 the Society for Range Management, California section, gave the Stewart Ranch its annual award for excellence in range management; the award goes to a single California ranch.

33. The *alcatraces* (gannets) are large fish-eating seabirds of Spain's inland waterways. The American translation of *alcatraz* is "pelican," but gannets are not pelicans, and pelicans do not nest on Alcatraz.

34. James P. Delgado, *Alcatraz Island—The Story Behind the Scenery* (Las Vegas: KC Publications, 1985).

35. The ad was paid for by the local businessman Alvin Duskin.

36. Peter J. Bernstein, "Parks to the People Move," *San Francisco Sunday Examiner and Chronicle*, April 16, 1972; and Claudia Levy, "Interior Starts All Over on $6 Million Study," *Washington Post*, July 17, 1972.

37. In 2002 Brian O'Neill said that "the energy for the program came from Hickel" and that "Hickel was as proud of this program as of anything he ever did as Secretary."

38. Bureau of Outdoor Recreation, "The Golden Gate—A Matchless Opportunity," December 13, 1969, draft report, 1.

CHAPTER 3

1. "City Assails U.S. Warehouse Plan," *San Francisco Chronicle*, March 27, 1970.

2. "GSA Plans to Gobble Up Open Space at Fort Miley," *Richmond Banner*, May 22, 1970.

3. Anna's way of bringing out the GSA subterfuge with the Fort Miley bunkers in a newsworthy

manner is similar to a tactic we used on other occasions. About the time SPUR learned of the national park proposal, John Jacobs's secretary, Monica Halloran, heard from a friend who worked at the Presidio that some big trees around the historic Officers' Club were to be felled. She phoned Monica, who went to John. He deployed a photographer, then sent a telegram to the post commander: "We have the 'before' photographs. Will it be necessary for us to publish the 'after' ones?" Not wanting such publicity, the Army did not cut down the trees.

4. The date of this draft of the report is December 13, 1969.

5. Brian O'Neill was the assistant chief of the BOR's Division of Urban Park Studies, a principal author of the 1969 National Outdoor Recreation Plan, and the principal staff person for the Golden Gate proposal in Washington. He has been superintendent of the GGNRA since 1986. O'Neill, interview by the author, 9/11/02. Ray Murray was on the BOR special studies team that Secretary Hickel asked to find an alternative to San Francisco's plans for Alcatraz Island. In 2002 Ray was the team leader for planning and partnerships in the Pacific Great Basin Support Office of the National Park Service.

6. Bureau of Outdoor Recreation, "The Golden Gate—A Matchless Opportunity," December 13, 1969, draft report, 1, 2, 5.

7. Ray Murray, oral history interview by Sara Conklin, 7/8/93, 23, GGNRA archives.

8. When I met him in the summer of 1970, Ed was working with Phil Burton to enlarge Redwood National Park, and with Congressman John Seiberling (D-OH) on a bill to preserve a huge part of Alaska within several large national parks and wildlife refuges.

9. Edgar Wayburn, *Sierra Club Statesman Leader of the Parks and Wilderness Movement: Gaining Protection for Alaska, the Redwoods, and Golden Gate Parklands,* 311, 328, oral history interviews by Ann Lage and Susan Schrepfer, 1976–81, Regional Oral History Office, Bancroft Library, 1985.

10. HR 18071 (June 15, 1970).

11. "Building Banned at S.F. Presidio," *San Francisco Examiner,* August 7, 1970.

12. "Laird Letter on Presidio Schools," *San Francisco Chronicle,* August 25, 1970.

13. "Presidio School Site Compromise," *San Francisco Chronicle,* October 21, 1970.

14. Since 2000 the San Francisco Board of Supervisors has been elected from eleven districts. San Francisco is both a city and a county; there is no separate city government.

15. "S.F. Included, Recreation Plan for Big Cities," *San Francisco Chronicle,* September 15, 1970; "Coming: National Parks for City Dwellers," *U.S. News & World Report,* November 23, 1970. The "Legacy of Parks" title was devised by the White House writer Ray Price on July 28, 1970. John D. Ehrlichman, "Presidential Assistant with a Bias for Parks," oral history interviews by William J. Duddleson, 1991, in *Saving Point Reyes National Seashore, 1969–1970: An Oral History of Citizen Action in Conservation,* 15, Regional Oral History Office, Bancroft Library, 1993. Ray Murray told me about the luncheon meeting.

16. "Recreation Plan for Big Cities," *San Francisco Chronicle,* September 15, 1970. Coincidentally, this article appeared on the day of the Marincello hearing at the Marin County Civic Center. On the same

evening, we had the hearing at the San Francisco Board of Education. At this juncture and several others, it was hard to keep up with what was happening!

17. The quotes from Brian in this section are all from the 9/11/02 interview.

18. Murray interview, 7/8/93, 22.

19. The good relationship between Phil Burton and Bill Mailliard was important to our success. In January 2002 I asked Chris Holmes, Congressman Mailliard's last administrative assistant (1971–74), about how Bill and Phil got along. He reminisced, "They'd drink Beefeaters and smoke together and talk in Mailliard's office after work. Often. Bill at his desk. Phil in his socks." In marked contrast, Bill was "patrician." At one time the two congressmen each had three family members in public office. On April 11, 1983, after Phil's death, the reporter Michael Harris told Phil's joke about them in the *San Francisco Chronicle*. "They talk about the Burton machine and the Mailliard tradition of family service." On Burton's epochal achievements in health and welfare legislation see especially John Jacobs, *A Rage for Justice* (Berkeley and Los Angeles: University of California Press, 1995), from which I have taken some of the facts of Phillip Burton's personal and political history (its author is not related to John H. Jacobs of SPUR); and Judith Robinson, *"You're in Your Mother's Arms": The Life and Legacy of Congressman Phil Burton* (San Francisco: M. J. Robinson, 1994).

20. Bill Thomas worked for Phil Burton or the *San Francisco Chronicle* during the park's formative years and was a major ally. Between November 2001 and January 2003, Randolph and I interviewed Bill and had conversations with him to check on facts and dates. We also reviewed a bit of his personal history. Bill had been press secretary for San Francisco mayor Jack Shelley, staff director of the Democratic Caucus of the State Assembly, and then worked on Robert Kennedy's presidential campaign. Disgusted with politics after Kennedy was assassinated, he was working for the *Chronicle* when Phil Burton asked him in 1969 to become his aide. Bill Thomas died in 2004.

21. HR 18922, August 12, 1970. Ayala's name was suggested by Bill Thomas because Phil's wife, Sala Burton, worried about Phil's political opponent, Robert Gonzales, a Hispanic member of the San Francisco Board of Supervisors. Later the staff assured Phil that Gonzales was not a major threat.

22. Bill Thomas told me later that his boss picked up support for the Fort Point legislation (PL 91-457, October 16, 1970) from southern congressmen by telling them that the document authorizing the building of the fort was signed by Jefferson Davis in 1853 when he was secretary of war, several years before he became president of the Confederacy. Papers pertaining to this period of legislation are in the Phillip Burton papers, box 30, Bancroft Library.

23. We later got better results when dealing with Army dumping and tree removal because of resolutions by the San Francisco Board of Supervisors and cooperative newspaper reporters and editors.

24. The national historic site is 29 acres, but PL 91-457 called for only up to 10 acres to be transferred at that time, plus 63 acres of submerged land.

25. John Jacobs left SPUR in 1981 to become executive director of the San Francisco Chamber of

Commerce and retired in 1989. He later served on the board of directors of several civic- and conservation-minded organizations—including the World Affairs Council, the Fine Arts Museums of San Francisco, KQED, the San Francisco State University Foundation, and Point Reyes Bird Observatory—and was president of several of them. He died in 2002.

26. The founder of Earth Day was Senator Gaylord Nelson of Wisconsin. Since 1970, its observance has spread to more than 100 countries.

CHAPTER 4

1. Inner City Outings is now active throughout the United States and Canada; Marlene Sarnat, one of its leaders, was an early PFGGNRA supporter who led groups from some of San Francisco's neighborhoods.

2. Some months later we printed an information sheet with a map that included Ed's northern ranch lands. Michael Fischer then dubbed the shape of the park "a very big tail wagging a little dog."

3. The *Gazette* had a long life, going well beyond the campaign's initial months. It reported on the three House and Senate hearings held in 1971 and 1972, explained the bills that passed in 1972, 1974, and 1978, and, after the passage of the first bill, discussed planning the park. For a few issues it grew to an 8½ × 11 inch newsletter of four pages, to have the room to tell all the news, share all the details of the legislation, and explain the park planning process. The *Gazette*'s last issue was printed in 1979.

4. We switched from an answering service to an answering machine after the first campaign.

5. The first bill, HR 866 (January 22, 1971), had five Republican co-sponsors; the second, HR 3238 (February 2, 1971), had ten Democratic co-sponsors.

6. Edgar Wayburn, with Allison Alsup, *Your Land and Mine* (San Francisco: Sierra Club Books, 2004), 54. One story told about Phil Burton is attributed to the Redwood National Park or Alaska national parks legislation. Phil went to see a congressman who opposed the legislation. He took a map from his pocket and spread it out. The other congressman groaned, shook his head, and said, "No!" Phil took out another map, which included much more land, and suggested this was another way the boundaries could be drawn. His opponent said slowly, "Maybe I'd better look at the first map again." Phil's comment was, "If you show them the depths of hell, the alternative looks pretty good.

7. *Barristers' Bailiwick*, February 1971; and Jerry Wright, "The Battle to Save the Presidio," *Barristers' Bailiwick*," March 1970.

8. I omit parenthetical clauses about abbreviations in the bill's later paragraphs. Lee McElvain, assistant counsel and consultant to the House Subcommittee on National Parks and Recreation, produced the finished bill. One provision would have given to the Department of the Interior, immediately upon passage of the bill, possession of all but the smallest parcels of private land within the boundary. This provision did not survive the legislative process. Known as "immediate taking" or "legislative taking," it was intended to prevent the land speculation that was so costly at Point Reyes National Seashore.

9. Bob Young's good friend, the environmental author John Hart, contributed his knowledge to enlargement of the park north of Mt. Tamalpais State Park. John wrote articles for the *Pacific Sun* describing the possibilities for a greenbelt and park. He described many of the national and historic features of this land in *Wilderness Next Door* (San Rafael: Presidio Press, 1979).

10. By spring 1971 Green Gulch Ranch was no longer a cattle ranch. In addition to his donation of the upland 513 acres to The Nature Conservancy for the park, Wheelwright transferred administration of some 111 acres of the agricultural bottom land to Buddhists of the San Francisco Zen Center, who renamed their area Green Gulch/Zen Center Farm and since then have grown produce. This farm and Audubon Canyon Ranch were expected to remain in private hands unless used for purposes that would have a negative impact on the park.

CHAPTER 5

1. The Wayburns were working on what would become the Alaska National Interests Lands Conservation Act of 1980.

2. These terms of retained rights of use and occupancy for Golden Gate National Recreation Area are similar to those for Point Reyes National Seashore and protect a small number of home owners as well. When a rancher sold his property to the park, he could retain a right of use and occupancy for a time. When a right expires, former owners or their descendants—who receive preference—can continue to ranch by leasing the property from the government. Ranchers are required to manage buildings, land, and animals in accordance with environmental laws, and in an environmentally sustainable manner compatible with historic and scenic preservation and visitor use. Ranchers cannot graze their cattle near creeks, have to keep bulls and cows with calves out of pastures with foot trails, and are required to move fences and gates to avoid conflicts with visitors.

3. In May 1971 the San Francisco Board of Supervisors had passed a resolution in support of a national park that included the Presidio. When the mayor vetoed the resolution on June 4, 1971, we could not get enough votes to overturn it.

4. Some 30,000 acres of San Mateo County, somewhat different from the configuration of this proposal, have since been added to the GGNRA.

5. All the quotes and statements concerning this August 9, 1971, hearing may be found in the record of the House Committee on Interior and Insular Affairs, Subcommittee on National Parks and Recreation, *Hearings on HR 9498 and Related Bills to Establish a National Recreation Area in San Francisco and Marin Counties, Calif.*, 92nd Cong., serial 92-21.

6. Ibid.; letter of Behr and Beuby to Congressman Roy Taylor, May 1, 1972.

7. The jurisdiction of the Trust Territories Subcommittee covers the affairs of Puerto Rico, Guam, the Virgin Islands, American Samoa, Antarctica, and other insular possessions of the United States. At

this time Phil Burton was also a member of the Subcommittee on Mines and Mining, and of the Subcommittee on Public Lands, which includes the National Wilderness Preservation System (but was not on the National Parks and Recreation Subcommittee, which held the House hearings on the legislation to establish the GGNRA).

8. Nancy Larson, at a group meeting on the Phillip Burton memorial taped by Tito Patri, August 26, 1985. Burton and Aspinall had an ongoing power struggle. In December 2001 Bill Thomas told me how Wayne Aspinall called a meeting of his subcommittee chairmen to set the Interior Committee legislative agenda for the congressional session—and did not invite Phil Burton. Bill was tipped off by the Republican counsel for the Interior Committee. Phil went to the meeting and got the GGNRA legislation included on the committee's hearing calendar.

9. Bill Thomas said Phil's offices did have fax machines then. "The first ones had the brand name "Fax" and you strapped the telephone receiver into the machine. I leased two of them in 1969 for the San Francisco and Washington offices. For a while they were sort of a secret weapon for us!"

10. The advertisement originated with the Lennen/Newell Pacific advertising agency. By the time of its last appearance, the name of the agency had changed to Richardson Seigle Rolfs and McCoy, Inc.

11. Bill Thomas told me that Sala Burton vetoed the use of these photos in Phil's campaign. "Neither of them lives in your district," she said.

12. Bill Thomas, taped interview, 11/9/01; John Knox, interview by Tito Patri, 10/2/85.

13. This is the largest donation of land the GGNRA has ever received.

14. All the quotes and statements on this subcommittee's second hearing may be found in the printed record. See note 5.

15. Huey Johnson urged that Marincello be named the Gerbode Preserve, in honor of the generous San Francisco conservationist Martha Gerbode. The property passed from The Nature Conservancy to the Park Service with that name.

16. "Golden Gate, Cumberland Island Bills Go to House Floor," Sierra Club's *National News Report*, August 11, 1972; and Scott Thurber, "An OK for Recreation Area Bill," *San Francisco Chronicle*, August 11, 1972. The paper record does not show what happened, and neither Bill Thomas nor I were sure how changes were made. I never saw a copy of the House committee–amended HR 9498. I do not know whether HR 16444 was just a "clean" version of that bill as it emerged from committee—without crossing-outs and additions—or whether it included additional changes.

17. Morton had been a Maryland congressman. Ed Wayburn also praised Morton, calling him "the best secretary of the interior I ever worked with."

18. "An Interview with John Jacobs," by Gabriel Metcalf, SPUR program director, in San Francisco Planning and Urban Research Association Newsletter/Calendar, Report 374, 5.99.

19. The committee, advisory to the Council on Environmental Quality, was established by executive order in 1969.

20. *San Francisco Chronicle*, September 4, 1972.

21. George Murphy's article, *San Francisco Chronicle*, September 5, 1972.

22. Later, as secretary of the interior in the Reagan administration, James Watt would try to deaccession part of the GGNRA (see chapter 8).

23. Edgar Wayburn, *Sierra Club Statesman Leader of the Parks and Wilderness Movement: Gaining Protection for Alaska, the Redwoods, and Golden Gate Parklands*, 325, oral history interviews by Ann Lage and Susan Schrepfer, 1976–81, Regional Oral History Office, Bancroft Library, 1985. For reports on the tour, see *New York Times, San Francisco Chronicle, San Francisco Examiner*. On November 12, 1972, after Nixon's reelection, the *San Francisco Chronicle* reported the cost of the presidential excursion: "Nixon Ferry Ride Cost $10,000." An inscription by Bill on Phil Burton's file copy of this article notes that the boat was painted so the president would have a photo backdrop free of rust stains, that there were test runs for the boat ride, overtime costs, and also new carpeting "now being used at the [Golden Gate Bridge] district's administrative offices."

24. Robert B. Semple, Jr., "Vexed Nixon Prods Congress on Ecology," *New York Times*, September 6, 1972.

25. All the articles, including the *Washington Post* account, appeared on September 6, 1972. In order here, George Murphy, "Nixon Visits S.F., Pushes Bay Park," *San Francisco Chronicle*; Alan Cline, "Nixon Backs 'Gateway West' but Problems Still Remain," *San Francisco Examiner*; and "A Park Is Dedicated," *San Francisco Chronicle*.

26. Personal communication from Bill Thomas, December 2001.

27. S 2342 (July 26, 1971), introduced by Cranston and Tunney. S 3174 (February 15, 1972), introduced by Jackson, Mansfield, and Allott. Mailliard's bill for the administration was HR 10220.

28. Grace Bassett, "Senate Unit Likes G. Gate Park Bill," *San Francisco Examiner*, September 22, 1972.

29. William Thomas, "Senators Rally Around Big Bay Park," *San Francisco Chronicle*, September 23, 1972.

30. Personal communication from Bill Thomas, fall 2001.

31. I learned about this maneuver from Chris Holmes, Bill Mailliard's former aide.

32. HR 16943.

33. "On Capitol Hill with 'Charlie' Gubser," newsletter to constituents, 10/10/72.

CHAPTER 6

1. As a freshman legislator, Burton had set out to challenge Aspinall's power as committee chair. An advocate for miners and loggers, Aspinall was, in Ed Wayburn's words, an "absolute autocrat." When they first met, Phil told Ed, "I'm going to get enough big-city liberal congressmen to go on the committee until we've overcome the chairman's power." Ed thought Phil "was talking through his hat," but it turned out he wasn't. By the time Aspinall was voted out of office, Phil had manipulated away much of his power.

2. *Congressional Record*, October 11, 1972, H9611–17.

3. Monty Hoyt, "Dunesland Conservationists Stake a Claim in Steel Country," *Christian Science Monitor*, September 14, 1972.

4. "Seashore Is Officially Established," *Marin Independent Journal*, October 21, 1972.

5. The GGNRA's enabling legislation became PL 92-589. The Gateway National Recreation Area, authorized by PL 92-592, encompassed 26,172 acres. Richard Madden, "Nixon Signs Gateway-Park Bill; 30 Miles of Waterfront Involved," *New York Times*, October 29, 1972. Gateway is different from Golden Gate: its separate units in two states do not have geographic contiguity; at the time it was established it was expected to serve some 20 million people—four times more than Golden Gate. Gateway has several ocean swimming beaches, and there is a subway stop in the middle of the wildlife refuge on Jamaica Bay. A major point of similarity between the two parks is the acres of disused military land and facilities, including two nearly-identical Civil War forts: Battery Weed in Fort Wadsworth on Staten Island and Fort Point.

Fewer than half of the fourteen proposed park units studied by the BOR in 1969–70 have come into being. In addition to the GGNRA and Gateway, the Chattahoochee River National Recreation Area is near Atlanta, Cuyahoga Valley National Park lies between Cleveland and Akron, the Mississippi River Recreation Area is centered in Minneapolis and St. Paul, and the Santa Monica Mountains National Recreation Area borders Los Angeles. Indiana Dunes National Recreation Area on Lake Michigan and Jean Lafitte National Historical Park and Preserve in and around New Orleans, although not on the BOR's list, are grouped with these parks.

6. Since 1972, Congress has expanded the park several times, again connecting parcels held by other land protection agencies and organizations. In 2006 the GGNRA had nearly 80,000 acres.

7. A clause to permit purchase of the two San Francisco properties only if the city donated its land was excised before the bill's final passage. The state parklands included Mount Tamalpais, Angel Island, Muir Beach, and the Marin Headlands State Parks in Marin County, as well as the San Francisco Maritime State Historic Park near Fisherman's Wharf and some parcels at Lands End. Some of these parks would later come under GGNRA management, and others would not. The City of San Francisco's shoreline parks between Fisherman's Wharf and Fort Funston were all included in the GGNRA. In both counties, bits and pieces of land belonging to small jurisdictions were also included.

8. The threat materialized in 1983, despite bill language which stated, "New construction and development within the recreation area on property remaining under the administrative jurisdiction of the Department of the Army . . . shall be limited to that which is required to accommodate facilities being relocated from property being transferred under this Act to the administrative jurisdiction of the Secretary [of the Interior] or which is directly related to the essential missions of the Sixth United States Army: *Provided, however,* That any construction on presently undeveloped open space may be undertaken only after prior consultation with the Secretary." This last phrase turned out to be the most important one (see chapter 9).

9. During the last days of the legislative process, Phil phoned me to ask, "Would $35 million be enough to buy the private land in the park?" I told him no; we had calculated a cost of over $50 million. I do not know how he arrived at the $61,610,000 figure, but that was his number. I am sure he wanted the statutory ceiling for land acquisition to take into account the rising cost of land and inflation during the years it would take to purchase the property. The ceiling has been raised three times and in 2004 was $92,000,000, but Congress has actually appropriated much more: by May 2004, $102,417,083 had been spent.

10. Alan Cline, "Golden Gate Coast Park May Expand," *San Francisco Examiner*, November 3, 1972.

11. Judith Robinson, *"You're in Your Mother's Arms": The Life and Legacy of Congressman Phil Burton* (San Francisco: M. J. Robinson, 1994), 603.

12. Scott Thurber, "Greenbelting: Pieces Falling Together in Marin's Open Space Plan," *Golden Gate North*, Spring 1973.

13. Gladwin Hill, "The Land Use Revolution," *San Francisco Chronicle*, September 23, 1973.

14. The May 1999 issue of the SPUR newsletter was devoted to greenbelts, the GGNRA, and John Jacobs.

CHAPTER 7

1. Because the complexity of the Golden Gate and Gateway parks demands a special administrative structure, the title "general superintendent" is in use there. At GGNRA, the title originated early in Bill's tenure, when Fort Point National Historic Site, Muir Woods National Monument, and Point Reyes National Seashore came under the GGNRA superintendent's authority. The Point Reyes superintendent, demoted, naturally resented the change. After a few years, an evaluating team recommended that the Point Reyes park should again have its own superintendent.

2. Phil Burton's letter to the secretary of the army relays his appreciation of John Kern's work: "Several times the Army has in the past year taken actions which could have resulted in a storm of public protest. . . . the Army had the sense to realize that the problem should be turned over to Colonel Kern. In each case he was able to resolve the dispute. . . . It was a great pleasure to me to see unnecessary disputes settled without the necessity of intervention by me." Congressman Phillip Burton to Secretary of the Army Clifford L. Alexander, February 17, 1978, Phillip Burton papers, box 30, Bancroft Library.

3. John Kern, oral history interview by Sara Conklin, November 1995, 6–7, GGNRA archives.

4. There are almost no records from the park's first year. I phoned several people in 2004 to see what they remembered. Bill Whalen told me of hiring the first people on his staff. Ruth Kilday, who came to the park from the Army in March 1974, on the recommendation of the Presidio's controller, Colonel Robert V. Kane, laughed, "Whoever heard of archives?" when I asked about written records.

5. Bill Whalen, oral history interview by Sara Conklin, 3/27/93, side 1, 156, BW (transcribed), GGNRA archives.

6. Ibid., 235.

7. Doug Nadeau, oral history interview by John Martini, 10/6/98, 14–15, GGNRA archives.

8. Baker Beach got one of the earliest park makeovers—I saw it on one of the first advisory commission field trips in 1974. In a swale of tangled trees and bushes, just behind the sand dunes and sheltered from the Golden Gate's winds, a crew had cleared away the most intrusive vegetation and put in picnic tables and grills.

9. Bill Whalen later noted that the demand for tickets came as a surprise to Red & White's management. For a fundraising project in 2003, the Golden Gate National Parks Conservancy began selling a "Save the Rock" package for $6.95. It includes a piece of rubble that would otherwise have gone to a landfill, along with the story of cellhouse demolition that was required to bring the building up to seismic code standards.

10. Kern interview, November 1995, 16–17.

11. Personal communication from Bill Whalen, 2004. The bureau made its request about editing Alcatraz's image through the Department of Justice.

12. Kern interview, November 1995, 14.

13. "The Marina—A Big New Plan," *San Francisco Chronicle*, June 7, 1973; and Carol Pogash, "Inaugural Tour of Golden Gate Promenade," *San Francisco Examiner*, October 14, 1973. Soon afterward Alioto's deputy phoned Ed and me to ask us to endorse his candidacy. We were grateful for Alioto's help on the promenade, but it was his first show of support for the park. And he was not Phil Burton's ally. We each declined.

14. In 1999 the new Mason Street was dug up for the landscaping of Crissy Field, and today it is in the marsh and under water.

15. A major change came about more than twenty years later when the GGNRA management was challenged about its policies concerning dogs. A Park Service regulation, 36 CFR 2.15 (a)(2), requires that all pets, where allowed in national park sites, be crated, caged, or restrained at all times. In 1979 the park's advisory commission recommended "voice control" for pets, and they had been permitted to run off-leash in certain areas of the park, in violation of this nationwide policy. Off-leash activity was especially concentrated at Fort Funston, where areas degraded by overuse required restoration of coastal native scrub dune habitat, and cliff erosion required increased restrictions for public safety. That same year the snowy plovers that frequented Ocean Beach were declared a threatened species. The park moved to restrict off-leash use. A group of dog owners sued the Park Service. On January 23, 2001, the advisory commission acknowledged publicly the 1979 "voice control" policy was null and void since it was contrary to Park Service regulations. All dogs were required to be on leash—and hundreds of people protested. Others favored the leash restrictions. The Park Service is trying to decide whether there can be any place for off-leash dogs in the GGNRA.

16. Tom Yarish, "View to the Right," *Pacific Sun*, October 26–November 1, 1972. The quadrupling of prices preceded the Point Reyes Save Our Seashore campaign. Later increases had more to do with general land price escalation in the Bay Area.

17. The newspapers gave Congressman Mailliard credit for finding the reappropriated funds—$4 million came from Point Reyes National Seashore in his district, and the rest came from Voyageurs National Park in Minnesota. Dale Champion, "Big Bay Park—U.S. Finds Cash," *San Francisco Chronicle*, February [28], 1973, and "GGNRA Finds $5.9 Million; Bolinas Lands Get Priority," *Point Reyes Light*, March 1, 1973.

18. The Trust for Public Land was founded by Huey Johnson after he left The Nature Conservancy in 1972. The Wilkins Ranch was TPL's first transaction.

19. Press release, April 2, 1973.

20. "Shoreline Park to Get Army Land," *San Francisco Chronicle*, June 29, 1974.

21. The last property to be transferred from the Army to the Park Service was the eastern half of Fort Baker on August 1, 2002, after the Army completed its environmental remediation—29 years and 9 months after PL 92-589 was enacted. During the intervening time, many buildings and structures deteriorated, there was little public use of much of the area, and invasive and hard-to-remove pampas grass spread along a large stretch of the fort's eastern waterfront. On October 30, 2002, I went to a ceremony on the Fort Baker parade ground where the National Park Service director, Fran Mainella, celebrated the thirtieth anniversary of GGNRA's authorization and this last transfer of Army land.

22. Bill used the "Laughing Tree" logo from the Washington program for information and T-shirts.

23. Dale Champion's article in the *Chronicle* ran on July 1, 1975.

24. Over time the commission was enlarged to eighteen members and the terms were lengthened to five years. Originally nine nominations (in 2002, thirteen) came from the boards of supervisors of San Francisco and Marin Counties (San Mateo County was included after land in that county was added to the GGNRA), the Association of Bay Area Governments, the East Bay Regional Park District, and PFGGNRA. The secretary of the interior chose appointees from among these nominations. Six appointments (in 2002, five) were made directly by the secretary of the interior, outside the nomination process.

25. Bill Whalen interview, 3/27/93, side 2, 210.

26. Ibid., 128. John Jacobs replaced Bill Thomas in 1977 and served until 1985.

27. I had a sudden personal glimpse of Phil at this meeting, some weeks after I had sent him a letter about land acquisition. He quoted it almost word for word at the meeting, and I said "Thank you" as I walked past him afterward. Phil whispered, "Did I do OK?"

28. PFGGNRA began collecting boundary revision proposals shortly after celebrating passage of the 1972 legislation. The commission agreed with what Ed and I and members of the public requested. Section 4(d) of the park legislation called for a transportation study, which was implemented by the Golden Gate Recreational Travel Study team, headed by Peggy Woodring. Earl Blauner, a PFGGNRA leader who became active after the park was authorized, was our organization's liaison to this study and worked

hard to achieve broad public input and support. Pilot projects for public transit from San Francisco to West Marin showed that regular public transit was too expensive to sustain, but the study did result in improved public transit to West Marin and the Marin headlands.

29. Bill Duddleson's article, "The Miracle of Point Reyes," *Living Wilderness* 35, no. 114 (Summer 1971). Point Reyes National Seashore, September 30, 1971, Phillip Burton papers, box 30.

30. PL 94-567, October 20, 1976. Of the 33,373 acres, 8,003 acres were "potential wilderness"; those acres would get full status after intrusions such as power lines were removed. On July 19, 1985, in PL 99-68, Congress named the Point Reyes wilderness the Phillip Burton Wilderness. In August 1999, notice was published in the Federal Register that following the removal of uses conflicting with the Wilderness Act, 1,752 acres of the potential wilderness had gained full wilderness status.

31. William C. Everhart, *The National Park Service* (New York: Praeger Publishers, 1972), 70. The 1916 act's statement of purpose, credited to the landscape architect and city planner Frederick Law Olmsted, Jr., resonates today: "The service thus established shall promote and regulate the use of the Federal areas known as national parks, monuments, and reservations . . . to conserve the scenery and the natural and historic objects and the wildlife therein and to provide for the enjoyment of the same in such manner and by such means as will leave them unimpaired for the enjoyment of future generations" (16 U.S.C. 1, 2, 3, and 4).

32. Personal communications from John Reynolds and Doug Nadeau, 2002. John began his Park Service career as a planner. When Doug retired in 1998, he was GGNRA's chief of planning and resource management.

33. Personal communication from Nadeau, 2002; and John Hart, *San Francisco's Wilderness Next Door* (San Rafael: Presidio Press, 1979).

34. Personal communication from Nadeau, 2002.

35. In 1976 the Muddy Hollow road corridor was at last eliminated, when Congress designated Point Reyes National Seashore's big wilderness area. After a twenty-year wait, Muddy Hollow became part of 1,752 acres of potential wilderness given full wilderness status in August 1999.

36. Hart, *Wilderness Next Door*, 79. After Bill Whalen became director of the National Park Service in 1977, he officially consolidated the handbooks. From that time forward, all units of the national park system were explicitly expected to receive the same level of resource protection.

37. Personal communication from Ric Borjes, 2002. In 2005 Borjes went to work for the Presidio Trust.

38. "Arguments Seen in Recreation Use," *Marin Independent Journal*, May 13, 1974; Jeff Greer, "A Plan to Wipe Out Signs of 'Progress,'" *Marin Independent Journal*, May 10, 1974.

39. Personal communication from Nadeau, 2002.

40. National Park Service, Golden Gate National Recreation Area, Point Reyes National Seashore, "General Management Plan/Environmental Analysis," 1980, 14–15, 3.

41. Ibid., 35.

42. In 2006 both parks were updating their management plans.

CHAPTER 8

1. Robin Sweeny served more than twenty-five years on Sausalito's city council and as mayor; she has always been exceptionally supportive of the park. From the time he heard of the park until his death in 1998, George Sears gave PFGGNRA generous financial assistance.

2. Jan Holloway and her husband, Maurice, were the major donors to PFGGNRA during this phase of the campaign.

3. Doris Berdahl, "Burton Says: Sausalito Open Space Should Be in Park," *Marinscope* (Sausalito), week of October [30–November 5] 1973.

4. In 1972 California governor Ronald Reagan vetoed the congressional reapportionment bill passed by the state legislature because it favored Democrats. The job of reapportionment was given to three "masters" appointed by the state supreme court, and the districts they drew were even more favorable to the Democrats.

5. Judith Robinson, *"You're in Your Mother's Arms": The Life and Legacy of Congressman Phil Burton* (San Francisco: M. J. Robinson, 1994), 572, 603–5.

6. The House hearing was held in November 1973, before John Burton got to Congress. The committee subsequently passed it, issuing a favorable report in February 1974. The report of the Senate Committee on Interior and Insular Affairs, report no. 93-1186 of September 26, 1974, to accompany HR 10834, duplicated the language of the earlier House committee report.

7. At purchase time, Fitzsimmons said he wanted $9 million for Wolfback Ridge. He owned the land with several other people. A U.S. District Court jury eventually determined the award for the 157 acres. "$3.8 Million Awarded for Land Near Marin City," *San Francisco Chronicle*, July 19, 1977.

8. PL 93-550. Both parks benefit visually from the inclusion of the 270-acre parcel called Bear Valley Flats, but the greatest beneficiaries may be the coho salmon. Olema Creek runs through the center of the meadow in this parcel, and grazing is no longer permitted. Point Reyes staff is restoring the creek's habitat to early twentieth-century quality, reviving a major population of this endangered species.

9. The 1975 Moscone bill was SB 834. The 1976 Wornum bill was AB 2584 and the 1976 Foran bill was AB 3065.

10. Since San Francisco's San Mateo County watershed was placed within the GGNRA boundary in 1980, changes in land use must be reviewed in relation to the protective legislation for the national park.

11. Doelger's housing developments were skewered in a popular 1960s song by Malvina Reynolds about "little boxes made of ticky-tacky."

12. One of the scars of the road battles can be seen today at the Highway 380 exit going east to San Francisco Airport, off Highway 280, going south. Overhead is the interchange of Highway 380 going west. The environmental leader Ellie Larsen, an engineer, found the interchange in a state construction

budget. Although the interchange was built, the rest of Highway 380 was not. Four miles west in Pacifica where the road was to end, Shelldance Nursery now occupies a section of the former road right-of-way—and is in the GGNRA.

13. Eric Rice, "Tunnel Dreams: How Developers with Grandiose Plans Plotted to Build a Devil's Slide Bypass," *Half Moon Bay Review*, November 14, 2001. This and two more of his articles, "Devil's Slide: A Clash of Visions," November 21, 2001, and "Devil's Slide: A Crisis and a Bombshell," November 29, 2001, have detailed background information about the fight over the Devil's Slide bypass.

14. Dale Champion, "First Step Toward Huge Coastline Park," *San Francisco Chronicle*, May 16, 1975.

15. "Two More Plans Tell How to Plan Coast," *Pacifica Tribune*, May 21, 1975.

16. "Extend Golden Gate Area to Coast?" *Country Almanac*, November 5, 1975. Ryan's bill was HR 10447.

17. Bob Young had replaced Bob Raab as Marin County chair for our group, and Bob Raab was aiding our work through the Marin Conservation League, of which he soon became president. Burton's bill was HR 10398.

18. Keith Ervin, "Burton Discusses Park Growth," *Point Reyes Light*, January 26, 1978.

19. John Fogarty, "House Unit Quickly Passes Burton's Record Parks Bill," *San Francisco Chronicle*, May 11, 1978.

20. Seth S. King, "President Signs 'Park Barrel' Bill," *New York Times*, November 12, 1978.

21. The telegram's author was Chris Delaporte of the Heritage Conservation and Recreation Service, October 31, 1978.

22. Robert Ehler Blaisdell essay, in *San Francisciana: Photographs of Ocean Beach and Playland*, comp. Marilyn Blaisdell (San Francisco: Marilyn Blaisdell, 1989).

23. The two April 19, 1979, articles were Russ Cone, "National Park Service Says Sutro Site's Price Too High," *San Francisco Examiner*; and Dale Champion, "U.S. Won't Buy Site of Sutro Baths," *San Francisco Chronicle*. The *Chronicle*'s editorial the next day was titled "To the Aid of Uncle Sugar."

24. The *Post* editorial ran on June 6, 1980; Ward Sinclair's article "Building an Empire" ran on September 8, 1980; and Diane Kessel's in the *San Diego Union*, on August 25, 1980. In 2002 Bill Thomas told me Bob Newman, an aide to Congressman Jerome Waldie (D-CA), coined "park-barrel" (a play on "pork-barrel," slang for political patronage in government appropriations). It was picked up by Gil Bailey of the Knight newspapers and got much play in the press. Bill said Phil and staff didn't like it, but in San Francisco we enjoyed it.

25. Joe Gughemetti's projection, *Big Sur Gazette*, June 1980.

26. By 2004 the park included Mori Point and San Pedro Point, and federal, state, county, and city agencies and parkland trusts owned most of the county's shoreline between the San Francisco County line and Pillar Point next to the town of Princeton. The San Francisco County land is Sharp Park Golf Course in Pacifica.

27. John Jacobs, *A Rage for Justice* (Berkeley and Los Angeles: University of California Press, 1995), 416–17.

CHAPTER 9

1. Elizabeth Drew, "A Reporter at Large—Secretary Watt," *New Yorker*, May 4, 1981.

2. On Macris, see John Berry, "Reagan Cuts Will Hurt Here," *Point Reyes Light*, February 26, 1981; and on Burton, Robert D. McFadden, "Gateway Proposal Surprises Officials in New York Area," *New York Times*, March 29, 1981.

3. On Watt, see Drew, "A Reporter at Large"; on Bingham and Burton, McFadden, "Gateway Proposal."

4. John Fogarty, "Watt Seems to Retreat in Burton's Offensive," *San Francisco Chronicle*, February 23, 1982.

5. Bob Lynne, "The Breathtaking View from Sweeney Ridge," *Peninsula Times Tribune*, January 27, 1982.

6. "Sweeney Ridge Congressional Hearing Friday," *Times* (San Mateo), January 28, 1982.

7. Rick Dower, "Sweeney Ridge Battle Pressed by House Panel," *San Francisco Examiner*, January 28, 1982.

8. Dower, "Sweeny Ridge Battle"; Paula Harrington, "Sweeney Tour Illuminates Opposing Views," *Times* (San Mateo), January 29, 1982.

9. S. F. Yee, "State Alert: James Watt Strikes Again," *The Phoenix* (San Francisco State University), February 4, 1982.

10. On Seiberling, see "Watt Cuts Staff's Help to Congress," *San Francisco Chronicle*, February 5, 1982; on Johnson, John Fogarty, "State Aide Calls Watt a Scoundrel," *San Francisco Chronicle*, February 6, 1982.

11. "Phil Burton Says Watt Should Resign," *San Francisco Chronicle*, March 2, 1982.

12. Three such organizations have greatly helped the GGNRA with delayed or complicated land acquisitions: The Nature Conservancy, the Trust for Public Land, and the American Land Conservancy.

13. The statistics for the Park Service are combined with those for the Forest Service, the Fish and Wildlife Service, and the Bureau of Land Management. Trust for Public Land, "LWCF Federal and State Appropriations, 1965–Present (2001)."

14. "$7.5 Billion for Interior Dept.," *San Francisco Chronicle*, December 31, 1982; Frances Beinecke (president of the Wilderness Society), "Watt's Park Land Failures," *New York Times*, June 16, 1983; and personal communication from Martin Rosen, 2005.

15. "Point Reyes Land Ownership in Turmoil," *Argus-Courier* (Petaluma), May 6, 1983.

16. After some years, John Burton was elected to the California Senate. When he had to retire because of term limits in 2004, he was the Senate's president pro tem.

17. L. A. Craig, "Boxer Backs Park Acquisitions," *Point Reyes Light*, May 12, 1983. The legislation provides for continuation of ranching at Point Reyes and GGNRA alike. See p. 296n. 2.

18. Barbara Gamarekian, "'The Popular Burton' and Her Mission," *New York Times*, July 29, 1983.

19. Personal communication from Judy Lemons, 2003.

20. The Christmas receptions were held at Arlington House, the historic home of General Robert E. Lee located in Arlington National Cemetery: "U.S. Bills Watt $4300 for Parties," *San Francisco Chronicle*, February 25, 1982. John Fogarty, "Don't Knock Watt, U.S. Workers Told," *San Francisco Chronicle*, July 13, 1982.

21. "Watt Quits," *San Francisco Chronicle*, reprinted from the *Washington Post*; and "Reaction from Watt's Foes, Friends," *San Francisco Chronicle*, both from October 10, 1983.

22. "Watt Quits"; and Drew, "A Reporter at Large."

23. Editorial, "Watt's Liabilities," *San Francisco Chronicle*, January 30, 1983.

24. Philip Shabecoff, "Clark Sees Possible Purchase of More National Parkland," *New York Times*, November 3, 1983; and "Bay Area Parks Get $3.5 Million to Buy Land," *San Francisco Examiner*, October 13, 1984.

25. Dave Madden, "Bill Would Force the Purchase of Sweeney Ridge," *Times* (San Mateo), June 10, 1983, and John Fogarty, "U.S. Moves to Buy Sweeney Ridge Area," *San Francisco Chronicle*, July 28, 1983.

26. Personal communication from Martin Rosen, February 2002. Mott, former director of the California state parks, became director of the National Park Service in 1985. Caroline Livermore was Putnam Livermore's mother.

27. Barbara Boxer, ever more energetically supportive of a broad agenda of national park and wilderness legislation, replaced Senator Alan Cranston. Dianne Feinstein was elected to fill the remaining two years in former senator Pete Wilson's term. Wilson had beaten Feinstein when he ran for governor in 1990 and had appointed John Seymour (R) to fill the seat for two years—limited by law—of the four years remaining in his term. Feinstein then defeated Seymour.

28. PL 102-299. Audrey Rust credited Harriet Burgess with "the whole political strategy," and their success with federal appropriations. "If we hadn't had someone with [her] depth of political experience and passion, I don't think we would have succeeded."

29. The lawsuits challenged the environmental study approvals, citing the 4(f) section of the Department of Transportation Act of 1966, and contested the decisions by the California coastal and transportation commissions and San Mateo County.

30. In 2002 Lennie Roberts sorted out the most salient facts of the complex saga of Devil's Slide to help me write this section. She became a member of the advisory commission for the GGNRA and Point Reyes in 1994.

31. As examples of the first type, the Army donated Fort Mason and Marin County donated the Muir Beach Overlook. As examples of the second type, the Park Service bought various ranches and the Cliff House. As examples of the third type, the Presidio (until 1994), Mount Tamalpais State Park, the San Francisco watershed lands in San Mateo County, and Audubon Canyon Ranch remained un-

der the jurisdiction of their respective owners, who could carry on most of their usual and necessary activities.

32. By 1980 the Park Service had spent over $60 million for over 18,000 acres of private land in the GGNRA. The park's original land acquisition ceiling was increased a number of times. But since Congress sets the ceiling, Congress may also exceed it. By 2004 Congress had authorized purchases exceeding the most recent $92 million ceiling by nearly $10.5 million, said Gregory F. Gress, chief, Branch of Realty, Division of Land Resources, National Park Service, Pacific West Region. He told me that compared with other parks in the region, GGNRA land acquisition had been relatively continuous.

33. PL 109-131 was signed into law by President George W. Bush on December 20, 2005. The legislation adds about 4,500 acres to the GGNRA, including the long-fought-for Devil's Slide, as well as the Rancho Corral de Tierra. Any private land may be bought only from willing sellers. In December 2005, POST announced that it had reached its $200 million Saving the Endangered Coast program goal.

CHAPTER 10

1. The saying is an oft-repeated admonition for visitors to our national parks; its origin is lost.

2. *Point Reyes Light*, April 17, 1975.

3. Bill Whalen, oral history interview by Sara Conklin, 3/27/93, side 2, 167, BW (transcribed), GGNRA archives.

4. Charles F. Kettering Foundation, "Federal Advisory Committees, an Important Frustration," report of a conference on federal advisory committees, June 26–27, 1981.

5. Doris Berdahl, "Whole Earth Jamboree over Last Hurdle with Permit Issuance/But a Lawsuit Could Change All That," *Marinscope*, August 1, 1978.

6. Mickey Friedman, "A Hard Look/Ecologists Clash over Jamboree in a Marin Valley," *San Francisco Examiner*, August 17, 1978.

7. This Navy property next to the hospital fence had not been included in the West Fort Miley purchase by the City of San Francisco's park department in 1961.

8. *Congressional Record*—House, August 1, 1984, H 8186 (Congressman Seiberling was chair of the Subcommittee on Public Lands and National Parks, and Congressman Boland was chair of the House Appropriations Committee); Kenneth Weiss, "Congress Drops Parking Lot for VA Hospital," *San Francisco Examiner*, Sunday, September 30, 1984.

9. PL 92-589, sec. 2(f) and sec. 2(i).

10. In 1973 General Stillwell was a big help to Bill Whalen and connected him with Colonel Kern. But the general was not in charge of the Presidio. The commanding officer of the Presidio was always a colonel and the Sixth Army command was a tenant on the post. Therefore, while some officers might help the park, others continued to resent the park and did what they could to subvert the legislation.

11. PL 95-625, amending sec. 2(i). "One up, one down" has not been in effect since the Army left the Presidio, but the Presidio Trust has committed to increasing the Presidio's open space and reducing the area covered with buildings.

12. Verbatim court reporter minutes, GGNRA Citizens' Advisory Commission, June 1, 1983, PFGGNRA collection, GGNRA archives. The word "draft" is important. The Postal Service did a draft EA and never finished it. The Park Service did not insist on a finished environmental document.

13. Gerry Adams's article, "Marshland Planned for Crissy Field," *San Francisco Examiner*, also noted that in 1982 Senator Strom Thurmond (R-SC) had tried to amend the 1983 Defense Construction Act to allow sale of the Presidio and that Phil Burton had led the successful fight against him. Champion's article was "New Shoreline Plan Near Crissy Field," *San Francisco Chronicle*, October 10, 1985.

14. The Sierra Club Legal Defense Fund changed its name to Earthjustice in 1997. The organization was a child of the Sierra Club but was a legally separate entity. The change was made to make it clear that, contrary to what many people assumed, the organization is not part of the club, although the two continue to work together closely.

15. Dale Champion, "Army to Suspend Its Building at Presidio, Rep. Burton Says," *San Francisco Chronicle*, November 1, 1985.

16. Norman Melnick, "GGNRA Advisers Seek Delay of Presidio Plans," *San Francisco Examiner*, November 21, 1985.

17. John Fogarty, "Big Building Project at the Presidio Is Called Illegal," *San Francisco Chronicle*, January 8, 1986.

18. Boxer also said that the Army had failed to notify the House and Senate committees on interior and insular affairs, as required by H. Rep. 92-1391 and S. Rep. 92-1271.

19. Some details of Deborah Reames's memo: the new post office, to be between 9,000 and 10,615 square feet, was obviously designed for use beyond Army needs then being met within 2,398 square feet; the current workforce was 7 or 8 workers, [and] the new workforce would be 39; the 2 jeeps in present use would be increased to 28, and the new use would require 55 parking spaces just for jeeps and employees; the new post office was to be located adjacent to the Presidio's Crissy Field parkland instead of in a more urbanized area of the post; there had been no analysis of the appearance of the project or its effect on the park's open space values; the two alternatives to construction at this site had been summarily rejected: for example, the post office could use the 3,185 square feet now occupied by a bank in the 5,583-square-foot building they now shared, and the bank could move; there was no meaningful public notice of the project giving its size, its location, and the regional nature of its functions.

Judge Schwarzer's February 14, 1986, statement reads in part: "There appears to be no ambiguity in the statute, in that it prohibits all new construction, permits only replacement of a demolished structure by one of similar size, and only after a noticed public hearing. . . . This statute has been carefully considered and fully understood by responsible agencies of the government. Nevertheless, they, and in particular, the

Army, are proceeding as though the statute did not exist at all. . . . A memorandum prepared by the Army's own staff judge advocate in the Presidio, in December 1985, lists a series of failures to comply with environmental regulations. . . . It appears to the Court that the Army made no effort whatsoever to comply with environmental regulations. . . . Now, what this record shows is not laches [undue delay] on the part of the plaintiff, but a course of conduct on the part of the defendants that reflects not only a patent violation of the law, but a deliberate purpose to evade the legal restraints and to stall the opposition in the hope and expectation that before any adverse action could be taken about this project, the post office would be substantially completed, and its opponents would be faced with a fait accompli. . . . If the question is, what side are the equities on, they appear to be wholly on the side of the plaintiff. The Court concludes, therefore, that plaintiff has met its burden by making a strong showing of likely, if not virtually certain success on the merits, irreparable injury to plaintiff, and those it represents, the balance of hardships tipping sharply in plaintiff's favor, and a strong public interest to carry out the plain intent of Congress and preserve the recreational values of the GGNRA. . . . The defendants should understand that the Court would be prepared, upon an appropriate showing, to require demolition of the illegally constructed facility."

20. The record of the hearing is from my notes of that time, and from Dale Champion's article "Panel Hears Complaints on Presidio Plan," *San Francisco Chronicle*, March 28, 1986.

21. Gerald Adams, "Presidio Plans Headed for Trouble, Experts Say," *San Francisco Examiner*, November 20, 1986; and Adams, "Army Agrees to Lower Building That Would've Blocked View," *San Francisco Examiner*, January 8, 1987. After the post office fiasco, the Park Service provided all environmental documents to the advisory commission. Any matter requiring an environmental document had to be placed on the agenda of a commission committee, which determined whether the matter was significant enough to bring before a meeting of the full commission. Additionally, commissioners tracked the agendas of the GGNRA's Project Review staff meetings, and watched for projects that might not require an environmental document but were of general public interest or had potential to damage the park or to cause adverse public reaction. These were calendared first for commission committee review—and then sometimes for public hearing.

CHAPTER 11

1. Nancy Olmsted, *The Ferry Building: Witness to a Century of Change, 1898–1998* (Berkeley: Heyday Books, 1998), 225.

2. Some other association directors were the steamship line owner R. Stanley Dollar, Jr., onetime U.S. maritime commissioner Al Gatov, *Oakland Tribune* publisher Joseph Knowland (who was also chair of the California State Parks Commission), two executives from the Matson Steamship Company, and Thomas Crowley, "whose tugs," according to Dave Nelson, "hauled our vessels around for free from day one."

3. From a speech on October 5, 2000, by Dave Nelson, on the museum association's fiftieth anniversary.

4. The *C. A. Thayer* was one of the largest of the three-masted schooners. The Haslett Warehouse formerly stored canned goods from the adjacent building of the California Fruit Canners Association, which since 1968 has housed the shops and restaurants of The Cannery. In her day, the ferry *Eureka* was the world's largest passenger ferry. The *Alma* was built at Hunters Point shipyard on the eastern side of San Francisco. Descriptions of the ships are derived from several National Maritime Park brochures, amplified by sections of the book by Stephen J. Canright, Lynn T. Cullivan, and William G. Thomas, *San Francisco Maritime Park—The Story Behind the Scenery* (Las Vegas: KC Publications, 2000). The book gives background information about all the ships.

5. Dale Champion, "U.S. Takeover Planned for Aquatic Park Area," *San Francisco Chronicle*, September 4, 1976.

6. Howard Chappelle of the Smithsonian Institution responded, "If this vessel is not procured and established for preservation, I feel no replacement will be available in the future." "Vessels of this kind are really priceless pieces of Americana," declared Frank Braynard of South Street Seaport (both undated quotes are from Dick Jordan's position paper, February 21, 1975). Ed Wayburn solicited help from a former Sierra Club employee in a high position at the State Department of Resources. PFGGNRA endorsed a $10,000 fund-raising drive by the State Parks Foundation and we supplied a list of potential donors.

7. Congressman John Burton, draft press release, March 16, 1975; Dale Champion, "A Venerable Tug Returns to S.F.," *San Francisco Chronicle*, October 29, 1975; personal communication from Dick Jordan, November 2001, with details about saving the *Hercules*.

8. Liberty ships carried troops and cargo and served as floating hospitals in that war and later in the Korean and Vietnam wars.

9. Personal communication from Bill Thomas, 2002, with memories of Harry Dring.

10. PL 100-348.

11. Robert Schwendinger, *International Port of Call: An Illustrated Maritime History of the Golden Gate* (Woodland Hills, CA: Windsor Publications, 1984), 130–31; Masha Zakheim [Jewett], *Coit Tower, San Francisco, Its History and Art* (San Francisco: Volcano Press, 1983), 17–18. Also personal communication from Ric Borjes, GGNRA division chief, cultural resources and museum management, 2004.

12. *Golden Gate National Parks Guide to the Parks*, 2nd ed. (San Francisco: Golden Gate National Parks Conservancy, 2004).

CHAPTER 12

1. The former National Park Service director William Penn Mott once asked me if Bill Whalen got special legislation for Fort Mason Center. I thought that Bill bent the rules a lot, and this was why the

center had not been copied in other national parks. Not so. Rather, having found a group with initiative and community credibility, Bill signed the first eight-year cooperative agreement for the center on his own authority.

2. Bill Whalen, oral history interview by Sara Conklin, 3/27/93, side 2, 228, BW (transcribed), GGNRA.

3. Much of the information in this section came from an interview Randolph Delehanty and I had with Marc Kasky on 8/21/01.

4. In March 2003 the organization changed its name from Golden Gate National Parks Association to Golden Gate National Parks Conservancy. Though all the events recounted in this section took place before the change of name, the new name is used throughout.

5. Much of the information in this section came from an interview Randolph Delehanty and I had with Greg Moore on 9/20/01. The tradition of park-cooperating associations that got the Parks Conservancy under way began at Yosemite National Park in 1925 to help the parks financially on a small scale and gradually spread in a network of associations across the country. In 1935 the National Park System Advisory Board was authorized to advise the secretary of the interior and the director of the Park Service on park-related matters; the National Parks Foundation was created in 1967 to raise larger amounts of money for the parks. The Coastal Parks Association was a brood-hen association: each of the other two parks eventually got its own organization, and the Coastal Parks Association disappeared.

6. Evelyn and Walter Haas, Jr., Fund.

7. The Golden Gate Raptor Observatory's director, Allen Fish, told me about their programs in 2002.

8. Roy Eisenhardt was the conservancy's chair during the planning process for the rehabilitation of Alcatraz and shaped the program for major donors.

9. In 2001 the Parks Conservancy contributed $10.23 million to the park, or 34 percent of the total amount contributed by all cooperating associations to all parks. From a letter by Howard Levitt, Chief, Division of Interpretation and Education, Golden Gate National Recreation Area, to "Everyone," Subject: annual report—cooperating associations, 6/18/02. Also in 2001 the conservancy had a membership of about 12,000; membership grows a little every year. The conservancy had anticipated that most members would be active users, but a survey revealed that many people join because they believe in the value of preserving open space, history, and nature but rarely participate in any of the conservancy's planned activities. Most of the members are older and a little more educated than the general population, and two-thirds come from Marin County and San Francisco, where the results of the conservancy's efforts are most clearly visible.

10. Personal communication from Ric Borjes, division chief, cultural resources and museum management, GGNRA, September 2002.

11. Two of the invasive, nonnative plants widely visible in the park are pampas grass and French broom, said Terri Thomas, the Presidio Trust's Natural Resources Program manager.

12. Most information in this section is from my interview with Brian O'Neill on 9/11/02. In 2002 Brian received a Department of the Interior Meritorious Service Award, "In recognition of outstanding accomplishment in creating and using innovative partnerships to achieve park and community purposes."

CHAPTER 13

1. PL 100-526 established the Base Realignment and Closure Commission.

2. Judy Lemons had worked for Sala on the Rules Committee and on her personal staff. In 2002 she supplied some of the personal information about Nancy Pelosi. Her comments were amplified by the congresswoman's Web site biography, and by her biography in the Congressional Quarterly's *Politics in America*, 2001.

3. Toby Rosenblatt, Presidio Trust oral history interview by Dianna Waggoner, 11/21/00, 2–6, 14, 31–32; also Toby Rosenblatt and Craig Middleton, Presidio Trust oral history interviews by Amy Meyer and Randolph Delehanty, 7/17/02, 20–22 (all of the trust's oral history interviews are in the Presidio Trust library). Toby credits his parents, his grandparents, and the schools he attended for shaping his interest in civic and community work; his mother was board chair of a settlement house in Salt Lake City, and his father served on school and hospital boards. When Randolph and I interviewed the two men, Craig was acting executive director of the Presidio Trust and Toby was chair of the trust's board of directors.

4. Rosenblatt and Middleton, 7/17/02 interviews, 23.

5. To overcome the perception that the 1988 commission acted unfairly, in 1990 Congress passed PL 101-510, which defined a structured evaluation procedure for base realignment and closure. The legislation blocked further attempts to retain the Presidio as an Army post.

6. Brian O'Neill, Presidio oral history interview by Sara Conklin, 5/19/99, 12, 13, National Park Service, GGNRA archives.

7. In 2002 Jim's widow, Charlene, told me, "Jim came home one night and said Nancy Pelosi had asked him to head the council, and he was reluctant because of his very busy schedule. I urged him to take on the job because I felt that he was unique in that both the business community and the environmental community respected him a great deal. So between Nancy and me, we urged him and he accepted."

8. Rosenblatt interview, 11/21/00, 34–38. When Toby Rosenblatt was chair of the Parks Conservancy, Jim Harvey died. A fund of over $1 million was donated in his memory, and the conservancy decided it should be spent for Presidio restoration. The conservancy sponsored the rehabilitation of Inspiration Point and placed the rest of the money in an endowment fund for environmental restoration. When Charlene Harvey became the next chair of the conservancy, she oversaw the Inspiration Point and Crissy Field projects.

9. A General Accounting Office final report with these figures was printed later that year. "GAO, October, 1993, Department of the Interior, Transfer of the Presidio from the Army to the National Park Service," GAO-RCED-94-61.

10. Bob Chandler, telephone interview, fall 2002.

11. PL 103-135.

12. Craig Middleton, Presidio Trust oral history interview by Dianna Waggoner, 9/14/00, 32–33. Duncan's bill was HR 4078.

13. Rosenblatt and Middleton interviews, 7/17/02, 1–2. Congress took ten years to pass PL 103-433, the California Desert Protection Act. It saved 7.5 million acres of Southern California as desert wilderness.

14. Bob Chandler, Presidio oral history interview by Sara Conklin, 5/14/99, 25, National Park Service, GGNRA archives.

15. *Creating a Park for the 21st Century—From Military Post to National Park*, Final General Management Plan Amendment, Presidio of San Francisco, GGNRA, California, July 1994, v, vi, viii, x, 123. The visitor centers' exhibits and programs will require significant private funding. L. W. "Bill" Lane, Jr., provided the major initial contribution.

16. Rosenblatt and Middleton interviews, 7/17/02, 43–44.

17. Ibid., 30.

18. HR 1296, "Legislation to Create a Presidio Trust," Congresswoman Nancy Pelosi's March 1995 press kit.

19. Rosenblatt and Middleton interviews, 7/17/02, 9.

20. Ibid., 9–10, 36–38.

21. PL 104-333, November 12, 1996.

22. Rosenblatt and Middleton, interviews 7/17/02, 6.

23. Official background description of trust board members appointed by President Bill Clinton:

- Edward Blakely, former chair of the Department of City and Regional Planning at the University of California at Berkeley, on leave as chair of the Department of Urban Planning and Regional Development at the University of Southern California.

- Donald G. Fisher, founder and chairman of The Gap, Inc., and a member of the advisory councils for the University of California Haas School of Business and Stanford University's Graduate School of Business.

- Amy Meyer has been working to preserve the Presidio as a national park for three decades as co-chair of People For a Golden Gate National Recreation Area, chair of People for the Presidio, and vice-chair of the GGNRA advisory commission.

- Mary G. Murphy, a partner in commercial real estate law with the firm of Farella, Braun and Martel, and a member and former co-chair of Neighborhood Associations for Presidio Planning.

- William K. Reilly, former administrator of the Environmental Protection Agency, and president and CEO of Aqua International Partners, a private equity fund investing in water projects and companies in developing countries.

- Toby Rosenblatt, president of the Glen Ellen Company of San Francisco, vice president of Founders Investments, Ltd., of Salt Lake City, and chair of the board of trustees of the Golden Gate National Parks Association [Conservancy].

For the final member, Interior Secretary Bruce Babbitt appointed:

- John Garamendi, Babbitt's special assistant and former State of California insurance commissioner.

24. Rosenblatt interview, 11/21/00, 23–24.

25. Middleton interview, 9/14/00, 39—later slightly edited by Craig.

26. Ibid., 39–42.

27. Ibid., 42–43.

28. Ibid., 45; and personal communication from Toby Rosenblatt, 2002.

29. Jim Meadows, Presidio Trust oral history interview by Dianna Waggoner, 12/28/00, 5–6, 17, 19, 20; Rosenblatt interview, 11/21/00, 7 (as for the board's staying "out of the operations side," in 2003 a highly placed member of the staff told me Jim had said, "If a member of the board asks you to do something, do it right away").

30. Meadows interview, 12/28/00, 9, 28.

31. The Park Service estimate of dollar amounts "to be contributed by tenants for capital improvements is highly speculative," the report stated. It further noted that the bill specifically precluded the interior secretary from entering into new leases, concerned that "the Secretary is currently pursuing leases which will return less than full fair market value. Any such action by the Secretary would seriously undermine the ability of the Presidio Trust to achieve self-sufficiency." Committee on Resources, "Administration of Certain Presidio Properties at Minimal Cost to the Federal Taxpayer," H. Rep. 104-234, to accompany HR 1296, 104th Congress, 1st sess., 1995, 8, 9, 11.

32. John Reynolds, Presidio oral history interview by Sara Conklin, 5/18/99, 11, 17–18, National Park Service, GGNRA archives. John Reynolds was deputy director of the Park Service from 1993 to 1996 and general manager of the Presidio from November 1996 to May 1997 and retired after serving as director of the Park Service's Pacific West Region from 1997 to 2002.

33. Rosenblatt and Middleton interviews, 7/17/02, 18–20.

34. Middleton interview, 9/14/00, 44. The cleanup plan agreement was finalized in the spring of 1999. The trust became the lead agency for the cleanup in both areas A and B of the Presidio.

35. The figure of $589 million is the estimate of capital expense for the Presidio until 2030, as shown in the August 2002 Presidio Trust Management Plan.

36. The Baker Beach apartments have been rented to students and others who will be able to move when the housing is eventually demolished. Of the Presidio's 1,650 housing units, 1,100 are homes and apartments that can accommodate two or more people, and 550 are former barracks, bachelor officers' quarters, and nurses' quarters for single residents.

37. Glen Martin, "Battle of the Presidio, Showdown over Development of S.F. National Parkland," *San Francisco Chronicle*, May 4, 2000.

38. Editorial, "A New Presidio Package," *San Francisco Chronicle*, May 22, 2002.

AFTERWORD

1. Edgar Wayburn, *Sierra Club Statesman Leader of the Parks and Wilderness Movement: Gaining Protection for Alaska, the Redwoods, and Golden Gate Parklands*, 313–15, oral history interviews by Ann Lage and Susan Schrepfer, 1976–81, Regional Oral History Office, Bancroft Library, 1985.

2. By 2004 some 1,400 people had graduated from the educational and training programs of Audubon Canyon Ranch. Audubon Canyon Ranch docents continue to lead tours of the ranch, volunteer in the office and store, raise funds, and serve on the board of directors. Skip Schwartz, Audubon Canyon Ranch manager, 2004; also L. Martin Griffin, *Saving the Marin-Sonoma Coast* (Healdsburg, CA: Sweetwater Springs Press, 1998), 89, 91.

3. Bill Whalen, oral history interview by Sara Conklin, 3/27/93, side 1, 235 BW (transcribed); and John Kern, oral history interview by Sara Conklin, November 1995, 6–7, both in the GGNRA archives.

4. Information from Gregory F. Gress, chief, Branch of Realty, Division of Land Resources, NPS Pacific West Region.

5. Howard Levitt added that most other national parks count "visitor days" because their visitors stay many hours, "whereas you might take a walk on Crissy Field for an hour four times in a week." Others have noted that the dog walkers often visit the park twice in a day.

INDEX

Page references to illustrations and captions are italic. Parenthetical identifications of individuals correspond to the offices they held at the time of the events described in the text.

DESIGNER	Victoria Kuskowski
TEXT	12/17.5 Adobe Jenson
DISPLAY	Gotham
COMPOSITOR	Integrated Composition Systems
CARTOGRAPHER	Ben Pease
INDEXER	Barbara Roos
PRINTER/BINDER	Edwards Brothers, Inc.